childsplay

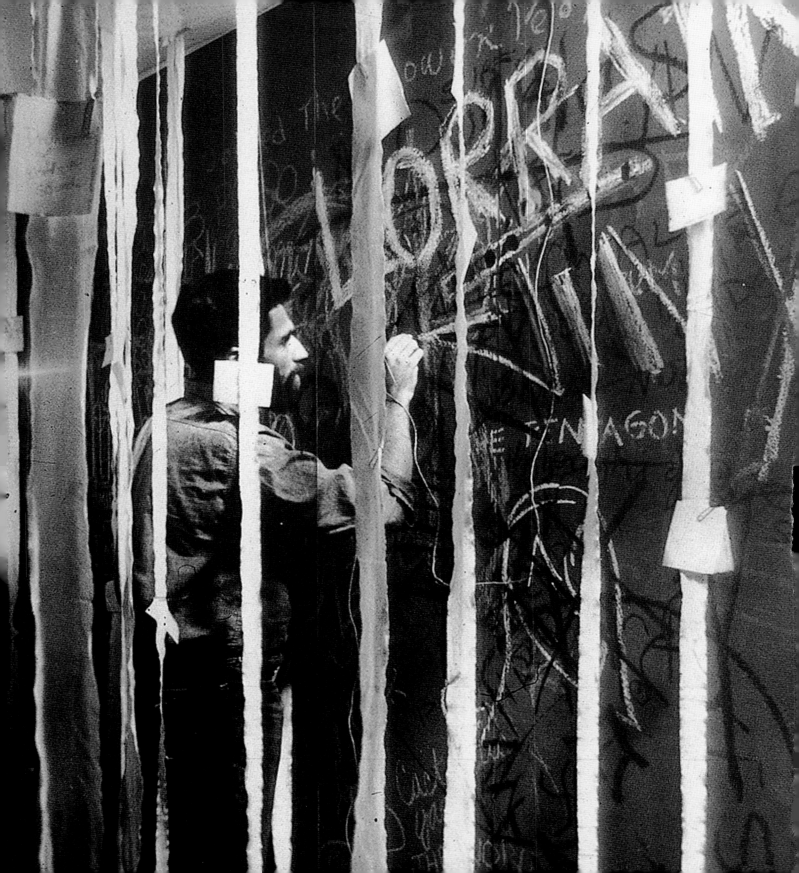

childsplay

the art of **allan**
kaprow

jeff kelley with a foreword by david antin

UNIVERSITY OF CALIFORNIA PRESS BERKELEY LOS ANGELES LONDON

PUBLISHED WITH THE ASSISTANCE OF THE GETTY GRANT PROGRAM

TITLE SPREAD: DETAIL OF ALLAN KAPROW WRITING ON BLACKBOARD
DURING *WORDS*, 1962 (SEE P. 73; PHOTOGRAPHER UNKNOWN). PAGE VII:
KAPROW WITH LASSO, 1940 (PHOTO COURTESY ALLAN KAPROW).
PAGE 227: KAPROW STANDING IN SABURO MURAKAMI'S *PASSAGE*
(POSTHUMOUSLY PERFORMED BY HIS SON) IN THE ENTRANCE TO THE
EXHIBITION "WHAT IS GUTAI?" AT THE HYOGO PREFECTURAL MUSEUM
OF MODERN ART, KOBE, JAPAN, FEBRUARY 2004 (PHOTO: JEFF KELLEY).

UNIVERSITY OF CALIFORNIA PRESS
BERKELEY AND LOS ANGELES, CALIFORNIA

UNIVERSITY OF CALIFORNIA PRESS, LTD.
LONDON, ENGLAND

THE AUTHOR AND PUBLISHER HAVE MADE CONSIDERABLE EFFORT
TO CONTACT PHOTOGRAPHERS AND TO SECURE PERMISSION PRIOR
TO PUBLICATION. ANY PHOTOGRAPHER WHO REMAINS UNACKNOWL-
EDGED MAY CONTACT THE PUBLISHER, WHO WILL CORRECT THE
OVERSIGHT AT THE EARLIEST OPPORTUNITY.

LIBRARY OF CONGRESS CATALOGING-IN-PUBLICATION DATA

KELLEY, JEFF.
 CHILDSPLAY : THE ART OF ALLAN KAPROW / JEFF KELLEY ;
WITH A FOREWORD BY DAVID ANTIN.
 P. CM.
 INCLUDES BIBLIOGRAPHICAL REFERENCES AND INDEX.
 ISBN 0-520-23671-8 (CLOTH : ALK. PAPER)
 1. KAPROW, ALLAN—CRITICISM AND INTERPRETATION.
 2. HAPPENING (ART)—UNITED STATES. 3. CONCEPTUAL ART—
UNITED STATES. I. TITLE: CHILD'S PLAY. II. KAPROW, ALLAN.
 III. TITLE.
N6537.K27K45 2004
700'.92—DC22 2004009707

MANUFACTURED IN CANADA
13 12 11 10 09 08 07 06 05 04
10 9 8 7 6 5 4 3 2 1

THE PAPER USED IN THIS PUBLICATION MEETS THE MINIMUM
REQUIREMENTS OF ANSI/NISO Z39.48–1992 (R 1997) *(PERMANENCE
OF PAPER)*.

for hung

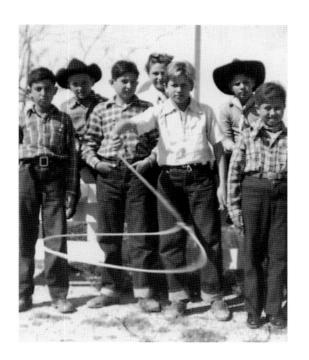

around the age of nine,
 allan kaprow, WHO ATTENDED RODEOS REGULARLY, WAS IMPRESSED BY A
COWBOY ARTIST WHO TOLD HIM THAT, SINCE YOU WIN SOME AND YOU LOSE SOME (AT
RODEOS), IT WAS WISE TO HAVE A SECOND LINE OF WORK, A CUSHION TO FALL BACK ON.
FOR THE COWBOY, THAT WAS DRAWING AND PAINTING. WHEN HE WASN'T COMPETING IN
THE ARENA, HE SOLD HIS ARTWORKS AT A CONCESSION STAND NEARBY. KAPROW TOOK
THE MAN'S ADVICE AND BECAME AN ARTIST.

contents

david antin

allan at work

I've known Allan for such a long time, it's hard to re-member not knowing him. But before I knew him, I knew about him—the way most people in the art world knew about him, even if they hadn't seen any of his early Hap-penings. I was already writing the "Art Chronicle" for Lita Hornick's magazine *KULCHUR*. Jerry Rothenberg and I were publishing *Some/thing,* a poetry magazine we aimed to be open to experimental work across the arts, and I was talking to Bob Morris about using one of his lead pieces for a cover. We were going to print the scenario for Carolee Schneemann's *Meat Joy* (1964) and the text of some of George Brecht's micro performance pieces. Bob suggested we might also want to include some of Allan's work because he was interested in myths. I wasn't sure what that meant or why Bob thought we were interested in myths. Maybe he thought that's what poets were interested in. Or maybe he figured all artists were inter-ested in myths—the Pop artists and Minimal artists in

the myths of contemporary industrial and commercial culture—and Allan and Dine and Rauschenberg and Warhol in its detritus.

When I got to meet Allan not long afterward, it was at "the Factory," Warhol's old studio, where I was going to get Andy to do a cover for the anti–Vietnam War issue of *Some/thing.* We weren't going to pay anything but, like most artists we knew, Andy was against the war, and I was writing an essay on his work for *Art News.* It was to be the first friendly notice Tom Hess would allow in the magazine, so I had a kind of claim on Andy's attention. Allan was there with Ileana Sonnabend, who'd been con-sidering underwriting a series of Happenings with a view to finding a way to make money out of them. But realiz-ing there was no way she could market them, she took Allan to dinner instead and brought him along to "the Fac-tory," where she wanted to buy some Warhol prints. I be-lieve she introduced us and then turned to talk business

with Andy, while we exchanged a few words and waited for her to finish.

The place was filled with goofy activity. The walls as everyone knew were lined with aluminum foil. A horse standing by a pile of fresh manure was munching hay near the elevator. Nico was surrounded by a crowd of half-naked teenagers shepherded by Gerard Malanga, whom Warhol would turn to intermittently and give very precise instructions about mixing colors for the prints he was supposed to prepare. Nico was holding out a microphone and the kids were trying to improvise a soap opera. She offered me the microphone but I pushed it away and told her I'd have my say in print. Ileana finished and went off with Allan and I had my conversation with Andy, who was willing to do the cover and suggested a Viet Cong flag. "What do we know about the Viet Cong, Andy?" I suggested we knew more about America and should do an American Legion slogan like "Bomb Hanoi." That way everybody who was for the war would read the issue. "Great," said Andy, and I went away.

The first time I saw Allan in action was at a performance of Karlheinz Stockhausen's opera *Originale* in Carnegie Recital Hall, for which Karlheinz had persuaded Allan to play and act as the director. I don't know what the German version is like, but in the American version that Allan seems to have put together himself with a little help from Charlotte Moorman, it was a carnivalesque affair with lots of things going on at the same time, lots of props—ladders and scaffolding, a trapeze hanging from the ceiling and lots of colorful people—the "originals" of the title—wandering in and out. There was a kind of audience, mostly on the stage at the end of the hall, while the action was down on the floor. Jackson Mac Low and I, who were recruited to simply read poetry no matter what happened, were seated at the edge of the stage. So we had an excellent view of the proceedings. Allan in his usual jeans was up on a scaffolding, whispering through a bullhorn, apparently to Jill Johnson, who was having some kind of difficulties and had chosen this occasion to freak out. A woman came in with a whole bunch of cats and dogs on leashes tied to her waist. Bob Brown came in in a kind of airport firefighting outfit and set off some smoky flares. Outside the building George Maciunas, who had decided that Karlheinz was a Nazi, had organized a tiny Fluxus protest of about six people with placards. Nam June Paik had to do something on the roof, but got kidnapped by two of Allan's students and handcuffed to a fence. Allen Ginsberg came in looking like a professor out of a 1920s German movie with a little concertina and started a Hare Krishna chant. Allan in his role as director dispatched the willing members of the audience—mostly teenage kids—to find whatever scrap materials they could in the street and come back and build themselves a shelter. A few of the early birds came back hauling junk and bearing messages that the scavengers were wrecking and tearing things apart all along Fifty-seventh Street. Allan went down to look and found Maciunas's strike. He picked up a placard and started to picket alongside Maciunas and Henry Flint. George tried to shoo him away but Allan persisted till George stopped protesting. Then Allan came back upstairs and directed the rest of the seemingly chaotic work to its end in as quiet and orderly a way as he could.

The first work of Allan's I actually got to see was one of a series of Happenings he put together out on Long Island, uncharacteristically under the sponsorship of CBS. This one was on the Montauk bluffs, which at this site dropped abruptly sixty or seventy feet down to a rocky shelf of beach that extended no more than ten yards to the sea. At the bottom of the bluffs about twenty yards apart were two black polyethylene tepees. The script was simple enough. A group of volunteers provided with staves would go down to the small beach, assemble by one of the tepees and at a given signal start trekking across to the other. At that moment, firemen assembled on the bluffs above them would fire from pressurized tubes a vast amount of plastic foam, that would flow down the bluffs, engulfing the volunteers, and make its

way to the ocean, where it would blend with the white foam of the surf.

But things got complicated because of the CBS sponsorship, and the involvement of the fire and police departments. The firemen were part of the event and were going to be on camera. The police were not. This seemed to irritate the police and they took out their irritation by misdirecting people or turning them away. Since CBS was sponsoring the event in order to film it, they undertook to direct the action but they had nothing like Allan's calm. A very officious guy with a bullhorn kept ordering people in and out of the camera frame and kept changing his mind. "Everybody on the left move back! Everybody on the right move to the left! Everybody on the left move to the right! Everybody on the right move forward!" This was beginning to get on Allan's nerves and I heard him muttering to himself, "One more order from him and I call the whole thing off." But the volunteers eventually descended to the beach. Elly—my wife—was in an activist mood and descended with them. They gathered around the black tepee on the right and at a signal from the guy with the bullhorn they started forward. He signaled the firemen and the foam cascaded down the bluff like a white lava flow. The volunteers were engulfed and Elly, who is very small, momentarily disappeared but rose up again covered with foam as the white flood rolled down to meet the surf. If this was the mythical look Bob Morris had in mind, it was pretty grand, but a homemade version of a Cecil B. DeMille spectacular in which the Israelites get engulfed by the flood. And it should have worked out as picturesquely for CBS, though they had a poor camera angle. There was a lone surfer out in the water who'd been hanging around all day, who had the only good angle. With a handheld camera he could have had the perfect take. But like the true professionals they were, the CBS guys never thought of him. They put the wrong film in the camera anyway, and the whole event never got onto the screen.

The Montauk piece may not have been the most typical of Allan's early works, but it still displayed some of their fundamental characteristics. It was a painterly spectacle built out of the play of semiological oppositions and parallels—natural and synthetic, black and white, high and low, earth and water. The plastic foam and the white surf were nearly identical in color but offered the sharpest opposition between the natural and the synthetic. The black plastic tepee skins stood in sharp contrast not only to the natural white foam of the surf and the brilliant blue water, but also to the synthetic white foam of the fire retardant; and the polyethylene, which was as shiny as a black plastic raincoat, also stood out in "logical opposition" to the "natural" Native American housing form within which it was being deployed. The poles that formed the tepee skeletons were not "primitive" skinned tree branches but modern industrial products. So was the wood of the "archaic" staves employed by the participants on the beach, who were uncostumed and wore whatever mix of everyday clothing they happened to come in. Finally, the natural setting—the bluffs, the gullied slope, the deserted stretch of scree-covered beach, and the ocean stood in clear-cut opposition to the plastic foam, the cannons that fired it, and the whole assemblage of firemen, police, TV people and the milling crowd of spectators up above.

What was most striking about the Montauk piece was the sharp discrepancy between the grand scale, glamorous image that was its final result and the extreme simplicity of the logical means employed to generate it. In retrospect it seems to have marked a turning point in Allan's work. Most of the American artists' Happenings of the late fifties and early sixties—works by Allan, Red Grooms, Claes Oldenburg, Jim Dine, Robert Whitman, Ken Dewey—emerged from the experience of painters and sculptors and constituted an enrichment and expansion of their field of action from the virtual space of the gallery wall and off the base of traditional Modernist sculpture out onto the floor and into the environment, even when the environment was only the spectator's standing room in storefront or loft galleries. What the contemporary

artists shared with their historical Dada predecessors like Schwitters and Arp and Ernst was a collage sensibility— that the Americans thoroughly radicalized. What was their own was a colloquial vocabulary drawn from the mid-century urban American industrial landscape they inhabited, a Pop Art sense of vernacular experience, and a carnivalesque desire to break down and obliterate the barriers separating art, audience and artist. The works, whether carefully scripted or sketchily programmed and partially improvised, were experienced as big, messy, noisy and multiform. The Montauk piece was nothing like this. It may have been spectacular but it was precisionist and minimal in design and construction. The stave bearers assembled by one tepee. At a signal from above they moved forward. The foam rolled down the bluffs and engulfed them. They emerged from the foam, made their way to the other tepee and the piece was over. In the end it was experienced as a single image.

This precisionism became more and more obvious as Allan's work moved away from its fifties New York origins. The very next piece after Montauk was done in the Los Angeles area on the occasion of a retrospective of his works that was being mounted by the Pasadena Art Museum. *Fluids* had a lot in common with the Mountauk work. It called for the construction at fifteen different sites around the Los Angeles area of a series of roofless rectangular structures to be built out of blocks of ice. The plan was large-scale in conception because there were fifteen sites and the buildings were sizable—seventy feet long, ten feet wide, and seven feet high. But they were minimalist rectangular structures so thoroughly separated from each other across the far-flung extent of the Los Angeles basin that no one could see more than one at a time. During construction they presented passersby with the scene of a team of workers laboring to erect a bizarre ice structure of obscure purpose, which on completion presented the gleaming image of a minimalist igloo slowly melting in the brilliant Southern California sunlight.

Of course the image of the pristine, completed structure was only one of a whole sequence of images that the work generated between initial construction and final meltdown, which like most of Southern California's architectural history, vanished without leaving a trace. But the image character of the piece, while very striking in a way that many of Allan's pieces had been and would occasionally be, was not its only important feature. There was the conceptual art aspect of the piece, that challenged the single-site theater of traditional artworks by distributing itself in the form of multiple "replicas" scattered across a broad geographical area that could only be held together on a map or in the mind. This was a mode that Allan employed before and would employ again, but was less important in terms of his artistic career than a much less conceptual and much more concrete aspect of the piece—the experience of the work involved in making it.

Building the seven-hundred-square-foot, seven-foot-high enclosure out of blocks of ice was a difficult job for the dozen or so art student workers that had been enlisted for each site. The ice blocks were heavy and cumbersome and cold. They had to be carefully fitted into place to make the building truly rectangular on a ground that had not been carefully leveled beforehand. Each worker had to adapt his or her work pace to the other members of the team. And everyone working on the piece had to deal with all the particular difficulties and contingencies that any serious construction job would entail without being able to rely on the established tools and techniques of the building trade because they were using an unfamiliar material. Yet all this effort was expended for its own sake and voluntarily by each worker, each of whom had to have some strong feeling of accomplishment on completion of a work that they all knew had no other purpose than to be built and then melt away.

Ever since the days of public exhibitions there has always been an inside audience and an outside audience for works of art—the people closer to the concerns of the

artists and the people who seem to have just wandered in from the street. This was as true of the Happenings in their storefront galleries as it was of a Franz Kline show at Egan or a Pollock show at Betty Parsons. In the days of the early Happenings the inside audience consisted primarily of the artist's friends and associates, some of whom helped carry the work out. But over the course of time the inside audience for Allan's Happenings became insiders in a new way. Unknown volunteers took over the participatory insider roles originally played only by Allan's friends. They became the workers who collaborated with him to make the work happen. In a sense this was a democratic elite, because anyone could enter it simply by volunteering. But by entering into the work as participants, this group of insiders became insiders in a more profound way, because their experience of working came to be a very large part of the work's aesthetic content. Over the next ten years of Allan's work, this insider audience would come to be the only significant audience. The contingent audience of outsiders would be eliminated altogether or relegated to the very margins, and the experience of the work essentially restricted to the team or individuals who were so far inside the work they would have to be regarded as collaborators or co-creators. This desire to eliminate an outside audience was widely shared by the sixties avant-garde theater artists of all kinds, ranging from the minimalist Judson dancers to the Living Theatre and most of the Happenings artists.

But Allan's shift from construction of some sort of painting-derived theater to the triggering of a self-reflective articulation of a particular experience had other roots. Consider this passage from John Dewey's *Art as Experience.*

A man does something; he lifts, let us say, a stone. In consequence he undergoes, suffers, something: the weight, strain, texture of the surface of the thing lifted. The stone is too heavy or too angular, not solid enough; or else the properties undergone show it is fit for the use for which it is intended. The process continues until a mutual adaptation of the self and ob-ject emerges and that particular experience comes to a close. What is true of this simple instance is true, as to form, of every experience. The creature operating may be a thinker in his study and the environment with which he interacts may consist of ideas instead of a stone. But interaction of the two constitutes the total experience that is had, and the close which completes it is the institution of a felt harmony.[1]**

Substitute "ice blocks" in this text for Dewey's "stone" and you get a very good description of the experiential aesthetics of *Fluids.*

Now it may seem odd to invoke a philosophical work on aesthetics to illuminate the work of a practitioner of what Allan has insistently maintained was a program of "un-art." But *Art as Experience,* which Allan had apparently read very carefully, offers a theory of experience that is at least as interesting as its theory of art—and maybe more interesting for Allan's work. For Dewey all experiences have a common form, a narrative form, because, as he sees it, *an experience* is not continuous or instantaneous, but an articulated whole with a beginning and end that enclose a sequence of engagements between a desiring subject and a resisting object that comes to some kind of definite resolution. It is this common form of what Dewey calls all *true experiences* that lets him argue that all experiences have an aesthetic component. In his later work Allan takes this argument and runs with it, so that triggering concentrated, self-conscious reflection on any action undertaken—say, vacuuming a floor or brushing one's teeth—will become a way of making art, which Allan calls "un-art" because he prefers actions drawn from the colloquial sphere of human experience. In practice, however, Allan's choices of actions are not so generalized and require more precise examination.

Taking up the role of work in Allan's pieces from *Fluids* on, Jeff Kelley invokes Walter De Maria's 1960 proposal for a program of "Meaningless Work," which made its first appearance in 1963 in the Fluxus-oriented *Anthology* published by Jackson Mac Low and La Monte Young. It's a Fluxus-type proposal, polemical, absurd and serious, that

defines meaningless work as "simply work that does not make you money or accomplish a conventional purpose" and offers as examples—filling a box with wooden blocks, moving them to another box and putting them back again; digging a hole and then filling it up; filing letters in a cabinet and periodically spilling them out onto the floor, etc., and cautions against activities like weight lifting, which though monotonous is not meaningless in his sense because it gives you muscles, and warns against sex, as against other forms of pleasurable work, because the pleasure could come to be understood as its purpose. According to De Maria, meaningless work is "potentially the most abstract, concrete, individual, foolish, indeterminate, exactly determined, varied, important *art-action-experience* one can undertake today." "This concept," he adds, "is not a joke."[2] And indeed it isn't—or isn't completely. In fact, the main reason to consider it a joke is its name.

Beneath the comedy what De Maria was really proposing as the new artwork was a self-referential action. This was simply an extension of the idea of an artwork as a purely self-referential object—that is to say, an object having no other significance than to be reflected upon in terms of its structure, materiality, etc. Only in this case the object was an action. De Maria's proposal was an early literary manifestation of an idea that had been percolating for a while in postwar avant-garde art circles. Among the younger artists of the time there was a great exasperation with the grandiose referential rhetoric that surrounded Abstract Expressionism. They had lost patience with the notion of inner turbulence supposedly expressed by the paintings of Pollock or de Kooning or the mythical universals supposedly addressed by Rothko and Newman. They replaced the notion of external reference with a blunt version of a very old idea—that a painting was a flat surface with paint on it and sculpture a real object of definite materiality, shape and form, whose entire significance derives from contemplating its material and formal characteristics.

Now much, maybe most, of the significance of traditional artworks from Rembrandt portraits to Steinberg cartoons derives from their stylistics, but most criticism of these works will attempt to relate these self-referential aspects to the targets of the representation. Even the critical discourse surrounding completely abstract painters like Mondrian and Kandinsky usually attempts to find some external reference in theosophical doctrines or internal psychic states. But what distinguished the younger post–Second World War generation was their absolute exclusion of external reference and their total commitment to self-reference. The notion of the self-referential object was so popular among the Minimalist sculptors and the Pop and Hard-Edge painters of the sixties that it came to serve as a necessary if not sufficient condition for an artwork. By the early seventies it had become nothing less than a mantra for conceptual artists and structuralist filmmakers. But even if Kaprow shared this idea with most of his friends, the full meaning of Allan's interest in work is not adequately described by the notion of the self-referential action.

First it is probably better to think of the work done in Allan's pieces as liberated work rather than meaningless work. It was work undertaken freely by volunteers for no purpose other than to be experienced and reflected upon—whether it was lining a roadside with tar paper and cinder blocks, or refurbishing a deserted landing strip, or breaking rocks in a quarry or covering them with aluminum foil, or building wooden scaffoldings on the sandstone promontories of Vasquez Rocks. All of these actions were pointless in the manner of De Maria's examples and their pointlessness was often emphasized by their reversal. There was, however, another way in which they were in accord with the proposals of both De Maria and Dewey. They were all actions that provided a definite sense of closure and completion, and a real if absurd achievement. There were no attempts to lift immovable objects or resist overwhelming forces.

But beyond their formal properties, virtually all of Al-

lan's work choices were notably absurd. Absurdity is not a formal characteristic and it is not part of a self-referential reading. It derives from the way a given action, situation or utterance fits or, more precisely, fails to fit, dislocates or disrupts some conventional stable cultural and social understandings, to which it must be referred to have any effect at all. So Allan's work choices were inevitably referential by implication. Even if the frames of reference were not always completely determinate, the edge of absurdity was usually very sharp. Building rectangular igloos in sunny Southern California is terribly funny, as funny as planting palm trees above the Arctic Circle. Building a low cinder-block wall, using bread and jelly as mortar was absurd in its own terms (*Sweet Wall*), because the mortar was nonsensical. But building it in Berlin in 1970 within a short walking distance of the grim Berlin Wall and then casually knocking it over had something of the same comedy effect that the Phil Ochs song "The War Is Over" had in the context of our endless Vietnam War. But while Allan's work choices almost always involved some action or outcome that was absurd, they weren't always funny. A two-person game of "follow the leader" in which the follower had to keep on top of the leader's shadow (*Tail Wagging Dog,* ca. 1981) could be stately and silly or exhausting and grotesque as the leader turned slowly or quickly in relation to the position of the sun and the follower ambled or scrambled after him. The absurd has remained a basic feature of Allan's work, but its role transformed as the work developed and changed in the seventies and eighties.

Work isn't always physical and mental work can be as arduous as manual labor and, as Dewey points out, has the same experiential form. A certain precisionism in Allan's character and developments in the culture and in his life in the 1970s led him to devise a series of two-person pieces involving Edward Hall–like engagements with formalized interpersonal relations.[3] In some, like the three *Time Pieces* of 1973, the only work required was the concentration necessary to monitor and tape-record one's pulse rate or one's breath rate or both and climbing some stairs. But in a manner typical of Allan's two-person pieces, the actions involved a series of escalating encroachments on each participant's sense of personal space, accompanied by increasing degrees of absurdity. In the pulse piece, initially separated partners were required to monitor and tape-record their pulse rates and listen to the recordings, to telephone each other and count out their pulse rates to each other and play the tape recordings, then to meet and climb some stairs together, repeating the process of monitoring, counting, tape-recording and listening.

In the case of the breath exchange this encroachment goes somewhat further, because the two partners, who initially breathe into the telephone for each other, conclude by getting together and breathing into each other's mouths for several minutes. In the final part the piece concludes with the partners breathing into plastic bags so that each partner can inhale the other's packaged breath. The required encroachments were certainly absurd and could, of course, be carried out in a great variety of ways ranging from the perfunctory or clinical, to the farcical. But in the climate of the time these obligatory intimacies also evoked an image of erotic possibilities that could be counted on to produce a great variety of responses, depending on the character and personality of the partners. These intimacies may have been quite mild in *Time Pieces,* but they were more strongly marked in *Comfort Zones* (1975) and *Satisfaction* (1976). That Allan was quite aware of this is apparent from what he wrote to introduce the booklet documenting *Comfort Zones.*

Everyone has an invisible bubble around their bodies. Among its uses, the bubble limits just how close someone may approach before one feels uneasy; it also precisely limits one's approach to another. Among friends the bubble can shrink to a few inches while in public it may expand to twenty feet. In any case the bubble is always changing in encounters between individuals and groups.

While the encroachments required of the partners in *Comfort Zones* were quite formalized, the long durations of close-range eye contact and intense touch, and the ritualized slow and rapid comings together, evoked intense responses from the seven couples participating that ranged from newly discovered antagonisms to tenderness and even visionary states they were unprepared for. The erotic possibilities remained absurd but became even more explicit in *Satisfaction,* where the couples were turned into quartets, in which one member of the first couple, A, is instructed to request "satisfactions" from B. At the beginning of the piece A and B are separated, and A's requests for attention are made telephonically, but then they get together privately and A's requests for satisfaction are more intense.

 praise me
 (or)
 look at me
 (or)
 comfort me
 (or)
 feed me
 (or)
 kiss me
 (or)
 bathe me
showing how

B answering: unhh-hunh
 (or)
 unh-unh
complying if agreeable

For these requests and responses A and B are alone together in some private place, but later they are joined by a second couple, C and D, who come to witness and encourage the first couple and demonstrate for them ways to realize the same sequence of requests, which the members of the first couple can always choose to reject or comply with in a great variety of ways. While the piece was designed with all the formal patterning of a seven-teenth-century court dance, subsequent discussion by the members of the four quartets who participated reflected a wide range of responses running from the farcical to the emotionally disturbing.

Since the audience for these couple pieces consisted entirely of the participants and since Allan's only interest was in their working experience, post-piece discussion assumed great importance. In the earlier works subsequent discussion was casual and random, but in these pieces it became as formalized a part of the work as the post-game wrap-up of a televised football game. Although Allan tape-recorded and transcribed many of these sessions, he never developed an adequate method for representing them. So while they have an electronic archival and textual existence, knowledge of them is mostly anecdotal and depends on the memory of the participants, to whom the post-piece discussion probably offered a kind of formal closure. As a participant in the *Satisfaction* piece I can testify to the mix of comedy and disturbance reported in the post-piece discussion at the M. L. D'Arc Gallery in New York in April 1976, though I don't remember many of the details.

Though the couple pieces of the mid seventies were extremely interesting, they might have simply disappeared after their execution if Allan had not worked out an ingenious method for representing them. For many of these pieces he prepared a booklet—either at the urging of the sponsoring gallery or institution or out of his own desire to memorialize them—combining a very spare group of phrases indicating the actions with a series of photographs illustrating plausible ways of performing them and some prefatory or postface authorial material. The texts were highly formalized, with the appearance and feeling of short poems. This was a textual form Allan had already employed by 1966 in his pamphlet *Some Recent Happenings:*

RAINING

Black highway painted black
Rain washes away

Paper men made in bare orchard branches
Rain washes away

Sheets of writing spread over a field
Rain washes away

Little gray boats painted along a gutter
Rain washes away

Naked bodies painted gray
Rain washes away

Bare trees painted red
Rain washes away[4]

The newer scenarios were as spare but interacted with the photos to turn the booklet into a novel kind of "concrete poetry." The photos themselves were not documents of any performances, but deliberately staged either before or after the associated performance and played with a low-key comedic intent that acted as a kind of disclaimer of their documentary veracity.

Allan's textual experiments with his scripts in the mid seventies led to more radical approaches for offering instructions to performers. Three pieces from 1976—*Pre-Socratic, Frame Works* and *Frames of Mind*—were the most extreme examples of this. In *Pre-Socratic,* which may have been the most enigmatic, the first page consists of nothing more than one laconic participial phrase, two present participles and two adverbs:

TELLING A STORY
OF NIGHT OR DAY

clearing (enough)
obscuring (enough)

The second page offers a brief account of water loss extracted from some text like Cannon's *Wisdom of the Body,* describing sweating by people and dogs, and a short account of the way desert travelers can save their lives by trapping condensation from the cold night air in a covered can. This is followed on the same page by the word "realizing" and four repetitions of the participle "sweat-ing," each bracketed by sets of two parenthetically opposed adverbs: (more) (less); (with) (without); (then) (now); (before) (after). While the scripts have textual affinities with works by George Brecht, the suggestion of narrative and the way in which the script offers itself up for interpretation is quite different. It seems deliberately poised to emphasize the effort of interpretation on the part of the participants. This becomes the fundamental "work experience." The second page of *Pre-Socratic* seems the easier to interpret because the sweating can be accomplished by fairly simple successive physical acts by any one of the participants or simultaneous, contrasted physical acts by two or more participants. The first page is more difficult. Although it seems clear that it requires one or more of the participants to tell a story either involving night or day or appropriate to one of these two times of day in the manner of Indian raga music, it isn't at all evident how to interpret the "clearing" or "obscuring." It isn't evident whether they suggest clearing up or explaining the story or erasing its emotional effect, or deepening, complicating or casting some kind of cloud over it or its effects.

Frame Works is a couple piece, whose script consists of two short anecdotes: the first, one of those heartwarming stories from the AP wire that newspapers use as filler, about a woman who placed an ad looking for her long-lost brother.

"I am looking for Eddie Brown. Close to 50 years of age. I'm his sister. His last address was Hibbing, Minn." A man saw the ad and telephoned. She asked him "Do you have any information about my brother?" "He's speaking," said Eddie Brown. Thus ended a separation of almost 50 years.

The second, a personal celebrity story about the irritation of Dory Previn over being persistently identified as the ex-wife of André Previn in spite of a long list of creative achievements during the six years of their separation, including an Oscar nomination for songwriting, seven albums, two books, seven screenplays and a musical in

preparation for the stage, concludes: "'What do I have to do to convince people I have my own identity?' bemoans the brilliant authoress/composer" in the words of Marilyn Beck of the *Pasadena Star News*.

What to make of these two stories, each followed by a page of very enigmatic suggestions for behavior on the part of the participating couples—the first story followed by the sequence:

couple	(between)
couple	(entry)
couple	(space)
couple	(coupling)
space	(couple)

while the second story is followed by the even more enigmatic sequence:

fitting	(coupling)
fitting	(coupling)

Frames of Mind is similar in its alternation of story and quite abstract suggestions for actions. All three pieces depended upon the participation of very able interpreters for them to have any effect at all, and Allan tended to regard the pieces as failures. They may have required artist participants to interpret them or, for anyone who wanted, to become artists to interpret them. It was my understanding that *Frame Works* proved very powerful for the drama critic Frantisek Deak and the performance artist Norma Jean Deak, when they realized it as part of a special section on performance art that Frantisek and I organized for the American Theater Association convention in Los Angeles in August 1976. Allan's sense of the piece might have benefited from an extensive post-piece discussion session, which wasn't possible because of the number of performance events scheduled for the convention.

While Allan abandoned this type of instruction, his interest in storytelling persisted. This interest was probably inspired by the post-piece discussions, where the representation of the participants' work experience in-

evitably required a resort to narrative. By the 1980s his interest in photographic and video representation of his works seems to have waned, so that Allan's career took a new literary turn as storytelling became the primary way of representing his work. By the 1980s the main and sometimes only way in which Allan's works could be known was by the stories he told about them. Some of these have found their way into print, like the account of *Trading Dirt* (1983–86), which showed up in "it seemed that we'd never been there," an essay that appeared in the fall 1997 issue of *The Drama Review*. But most of them simply get told, in conversation with friends or in more formal talks, and go on to become part of an Allan Kaprow oral tradition.

I've come to know a lot of Kaprow pieces in that way and I have a powerful memory of many of them. I think of one in particular. It was a piece he did in the late eighties for the art department of the University of Texas at Arlington. It was a piece for solo players. Outside the five-story, brick-and-concrete Fine Arts building Allan had deposited a large pile of cinder blocks. The idea was that each person working alone was to carry one cinder block at a time to some place along the steps of the five stories of the concrete stairwell of the art building until he or she had disposed of the number of cinder blocks equal to his or her age, pause for a while, and then carry them one by one back to the pile. It was a long task—to be carried out in privacy, and volunteers signed up for eight-hour time slots. Without knowing who took part in this piece, I like to think I can imagine very well what the experience had to be like.

I imagine counting out the number of stairs to the first landing, multiplying it by the number of landings to the top, then subtracting my age from this—to determine how many stairs I could cover with blocks—and then deciding how to divide the number of blocks among the stairs. Begin from the first step and deposit a block on every other one. That would work—for 50 years if there were 100 steps. Deposit 1 every 3 steps if you were 33. That

would give you one extra for the fifth-floor landing. Cluster the years of your life biologically? Grouping steps into infancy, 3 years; childhood, 4 to 12; teens, 13 to 18; youth, 19 to 30; maturity, 30 to 50; age, 50 to . . . ? Or group them by experiences.

—I discover not everyone tells the truth. What year was that? Four or five. My aunt Sylvia promises to take me to see a brilliantly exciting Russian war picture The Lives of the Red Commanders. *We enter the movie theater and it's a musical with Jeanette MacDonald and Nelson Eddy. At ten I steal the key to the glass cabinet where my aunt keeps the* Encyclopaedia Brittanica *and learn how the steam engine works. I'm twelve. My mother remarries. I can escape her and live with my aunt.* Could I work out the whole staircase this way—one cinder block for each weighty experience? That's more than one for a year. Are there enough cinder blocks? Do I have enough time? Can I finish in eight hours? I still have to stop at the top and reflect. Maybe I have to arrange the

task as "the way up" and "the way down." Heraclitus says they're both the same. But are they for anybody on the staircase? Are they equal? Gertrude Stein says "people are being old for a very short time." For her the way down must be much shorter than the way up. For some people it's undoubtedly the reverse. How to work this out if the act of unmaking always involves carrying the same number of blocks as the making? Maybe take them down much faster than you take them up. Figure this from the beginning, so it's physically possible. This is all somehow suddenly very important. It's my sense of my life that's at stake.

I know that Allan sees his work as "un-art" and wants to see its separation from art, envisioning it as simply an articulation of meaningful experiences from ordinary life. I'm sympathetic to this intention, but I find it hard to distinguish the existential power of this piece, which now exists only in the telling, from that of any other great work of art I've ever encountered.

sweeping the stage

The kind of art Allan Kaprow practices used to be called "Happenings." Often, it still is. A term he coined in 1958, "Happenings" specifically referred to forms of vanguard performance of the late 1950s and early 1960s in which the various arts media (painting, music, dance, and the like) were disguised as ordinary things (newspaper, noise, body movements, and so on) and collaged into "celebratory" spaces as quasi-theatrical events, breaking down the boundaries between the separate arts.[1] The radically commingled arts seemed to envelop the viewer on an environmental scale, creating a "scene." During the American heyday of Happenings, in the decade following 1958, Kaprow came to be known as their foremost theorist and practitioner.

Like any artist, Kaprow moved forward with his work as the historical moment with which he was associated slipped past, and after about 1968 he stopped presenting Happenings per se. Instead, he experimented with increasingly intimate forms of physical, social, and psychological exchange. He called these pieces "activities" and "events," but they are probably best termed "enactments." Though Kaprow's reputation remains fixed in the 1960s, the development of his enactments throughout and beyond that period warrants a thoughtful look. Moreover, because today we know more about the "idea" of Happenings than about the actual works themselves, it is worth revisiting even the early, "famous" Happenings—which, despite their infamy as vanguard events, remain largely unknown.

As the inventor of Happenings, Kaprow has been variously pictured as an avant-garde revolutionary, a radical sociologist, a Zen(ish) monk, a progressive educator, and an anti-art theorist. Happenings—both by Kaprow and by others—have never really been thought of as par-

ticular works of art so much as breakthroughs in the idea of what art could be. This is partly Kaprow's own doing; he's been among the most prolific writers on Happenings since the 1950s, commenting often and at length on their formal innovations, roots in art and society, experimental methods, styles vis-à-vis other artists and different cultural settings, social and technological implications, relevance to education and recreation, and the like. Through his writings, he has both illuminated lifelike performance and reduced it to an academic subject. Scanning his essays from the mid-1950s to the early 1990s, one is left with the feeling that Kaprow's works have already been spoken for—by him.

Yet Kaprow's actual Happenings, activities, and enactments have been remembered (or forgotten) by relatively few; they are represented in art books since 1960 by roughly the same twenty photographs. Little exists to counter the impression among younger artists that Kaprow's works were primarily transitory and somehow immaterial, that their passage into memory, gossip, or documentary images simply confirms their transient nature. Yet, however ephemeral they may seem at an art-historical remove, these works were definitely physically and sensually present in the moment of their enactment: as spaces, materials, actions, processes, encounters, and the like. Kaprow's enactments were concrete, although in the most elusive way: they were composed of people's experiences.

Though the pioneers of Happenings were born in the 1920s and 1930s, the "celebratory" quality of Happenings was adopted by the burgeoning youth culture of the 1960s and promoted by the mass media. Everything became a Happening: rock concerts, war protests, Earth Day, television commercials, Bobby Kennedy, disc jockeys, hamburger ads, pop songs (the Supremes even released a song called "The Happening" in 1966). In the tumult of the times, the fundamental experimentalism of Happenings was misunderstood as a kind of revolutionary, youthful impulsiveness that pushed the (seemingly) expanding edges of some New Age envelope. Happenings became metaphors for and celebrations of the emerging adolescent consciousness, which is roughly how most Americans of a certain age remember them today.

Within the art academies, Happenings are generally regarded as having been models of aesthetic liberation. Art students the world over understand them as having set the stage for almost any art form in which media are mixed in some performative way, be it installation art, performance art, environmental hybrids of art and architecture, process- or systems-oriented art, or even "interactive" digital and telematic works. They correctly know that Happenings were not theater, but uncritically assume that they were early, paradigmatic forms of almost any aesthetic impulse, scale, or system that claims to break a boundary. Happenings were—and remain—metaphors for cultural and artistic liberation.

Kaprow is often cited as a generative influence in all things avant-garde. This is not because he hasn't been an influential artist, but because his own work is so little known. The Happenings are known as myth and art-world rumor, but few know much at all about their specific enactments, and even less is known about their development over the course of Kaprow's career. If Kaprow had continued as a painter, instead of branching into sculptural and performative works early in his career, his works would be catalogued by now and their significance made clear, not only as models of liberation, but as the enactments (the expressions?) of an individual artist. That this has never been done testifies to what extent Happenings are thought of as art-historical period pieces. And yet, as with any work of art, the particulars matter.

This book is an attempt to sort through some of those particulars, to demythologize Kaprow's Happenings and

subsequent enactments by showing something of their materiality, duration, setting, and unfolding—that is, to write about them as tangible artworks, which, in fact, they are. As such, they are hinged to their creative moment; they embody the scale of the artist's ambition as it expanded with youth and gained focus with age. Some works are better than others. They enact a content that is both aesthetic and personal. The works have yellowed with time, so to speak, and must be conserved for an audience that has lost physical contact with them, while faintly recalling something about Happenings.

And by the way, whatever happened to Allan Kaprow?

chapter one john dewey and the ranch

Everyday life is the subject matter of Allan Kaprow's art. Not life in general, but life in particular. Breathing into your partner's mouth, sweeping the street until the pile of litter is too big, going on "a shopping spree at Macy's."[1] What Kaprow calls "lifelike art" looks less like other art—paint on a canvas or a performance on a stage—than like everyday life—say, sweeping the stage after the audience and actors have gone home.[2] Kaprow wants to experience and reflect upon the significance of commonplace activities *without* calling attention to them as art. Before it is art, sweeping is just sweeping. In effect, Kaprow applies—or invites us to apply—aesthetic attention to commonplace experiences. The fact that sweeping a stage is more like life than like art doesn't mean it's a meaningless activity—it's just that it takes its meaning from everyday life. Its meaning as art comes later, when it is accepted by the art profession as yet another example of what art can be.

Such instances abound in the history of postwar American art: flags becoming art, soup cans becoming art, silence becoming art, thinking becoming art, earthen ramps becoming art, social activism becoming art, copies of copies becoming art. As an artist, Kaprow accepts that anything an artist identifies as art becomes art sooner or later: Marcel Duchamp's urinal, Dada puppets, Fluxus cereal boxes, water dripping in a pitcher, a sunburn, street junk, toxic waste, the act of counting, sweeping the stage. His task has been to experience the meanings of life before they are enfolded within the conventions of art. In order to do so, Kaprow has to keep one step ahead of aesthetic convention. Art, in this sense, is a game, a philosophical conundrum, the object of which is to prolong the state of not-yet-art for as long as possible. The point is never to win, but to extend the game ingeniously, constantly deferring its resolution by, among other things, inventing new rules, cheating, finding new partners, or

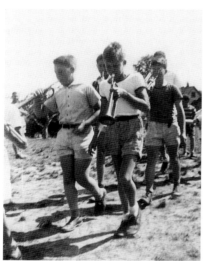

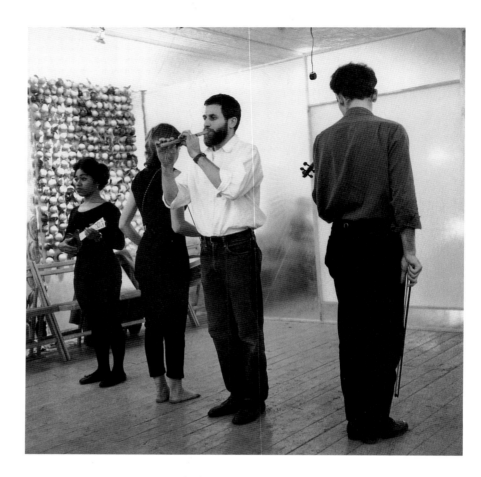

LEFT: ALLAN KAPROW (CENTER) AS A BOY AT THE ARIZONA SUNSHINE SCHOOL NEAR TUCSON, 1938 (PHOTO COURTESY ALLAN KAPROW)

RIGHT: KAPROW REHEARSING *EIGHTEEN HAPPENINGS IN SIX PARTS* WITH SHIRLEY PRENDERGAST, ROSALYN MONTAGUE, AND LUCAS SAMARAS, 1959 (PHOTO © FRED W. McDARRAH)

letting the game play itself out, exhausted, among the goings-on of everyday life.

Kaprow has often referred to himself as an "un-artist," or an artist consciously shedding the conventions of art in order to have unfettered experiences of life. His experiment has been to play at life as an artist—to play, as he once put it, "in and between attention to physical process and attention to interpretation,"[3] in and between body and mind, better to erase the duality.

In his work Kaprow substitutes the conventions of everyday life for those of art: not only its materials, subjects, objects, and occasions, but also its habits, assump-

tions, exchanges, ceremonies, routines, riddles, and jokes. Instead of creating art in a moment of heroic action, he might spend all day cleaning a friend's kitchen floor with Q-tips and spit; shaking hands in a receiving line; carrying a bag of manure (his "troubles") around on his back; waiting for a friend to call; sweating on a hot day and hoping for a breeze. This is not to suggest that Kaprow is uninterested in art; rather, he insists upon a subtradition within Modernism that is more like ordinary life than like other art. Though derived in theory (and in part) from the anti-art traditions of twentieth-century Modernism—Dada in particular—his practice has not been about the repudiation of art, but about the aesthetic illumination of the commonplace.

One of the most important, yet underacknowledged, advocates for the aesthetic qualities of common things was the American philosopher John Dewey, whose influential book on aesthetics, *Art as Experience* (1934), called upon artists to restore continuity between art and the "everyday events, doings, and sufferings that are universally recognized to constitute experience."[4] According to Dewey, artists had become isolated from the flow of daily living in modern capitalist society, resulting in a "peculiar aesthetic individualism" that reinforced in artistic form the ever-increasing gulf between producer and consumer. Works of art, once rooted in "the life of a community," now functioned "in isolation from the conditions of their origin." In order to restore this weakened link between artworks and their *genius loci,* artists were advised to look beyond the aesthetic object toward the experiences that informed it—what Dewey called "aesthetic experience in the raw."[5] This, for Dewey, is the fundamental material of art. "The sights that hold the crowd—the fire engine rushing by; the machines excavating enormous holes in the earth; the human fly climbing the steeple side; the men perched high in air on girders, throwing and catching red hot bolts."[6] Dewey was not proposing fire engines, bulldozers, or skyscrapers as prosaic substitutes for artworks; rather, he suggested that

each is an instrument in a process—a happening—that can be experienced for its own aesthetic qualities.

Though we think of experiences as indeterminate and amorphous, they in fact have limits of shape, duration, density, texture, mood, kind, and so forth that give the experience its aesthetic qualities. Dewey made a key distinction between experience at large and the self-sufficiency of "an experience": while experience is dispersed and often inchoate, "an experience" is set apart from the general stream of consciousness (or unconsciousness), as when "a piece of work is finished in a way that is satisfactory; a problem receives its solution; a game is played through; a situation, whether that of eating a meal, playing a game of chess, carrying on a conversation, writing a book, or taking part in a political campaign, is so rounded out that its close is a consummation and not a cessation."[7] Life, wrote Dewey, is not an uninterrupted flow: it is composed of experiences that often seem unrepeatable, unique, and nameable. These specific experiences, not experience in general, serve Dewey as the root sources of the arts.

A pragmatist, Dewey was interested in the practical value of experience in the restoration of the arts as tools for social renewal. He saw philosophy as socially diagnostic, its function being to locate the sources of conflict in culture. He emphasized experimentation and method over dogma and ideology, believing that intelligence is situational, a condition of changing circumstances.[8] Believing that artists, as much as anyone, had become disconnected from the everyday sources of aesthetic experience in the practice of their profession, Dewey invited them to forget about art for a while and pay attention to the aesthetic dimensions of everyday life. By attending to the aesthetic qualities of common experiences, artists, Dewey hoped, might discover all around them the forgotten sources of art.

Kaprow's formative thinking reflected the influence of numerous mentors, some his teachers, others key figures in the intellectual milieu. He studied painting with Hans

Hofmann, philosophy with Albert Hofstadter, art history with Meyer Schapiro, and experimental music (mostly noise) with John Cage. A "dutiful" student (according to Cage),[9] Kaprow was exceptionally conscious of what he learned—and unlearned—from his teachers. Often, he worked against or away from them, not to throw off their influence, but to see what would happen if their principles were extended in unorthodox directions. For example, he used Hofmann's harmonizing philosophy of "push and pull" as a foil against which to experiment with the aleatory effects of collage, and he applied Cage's

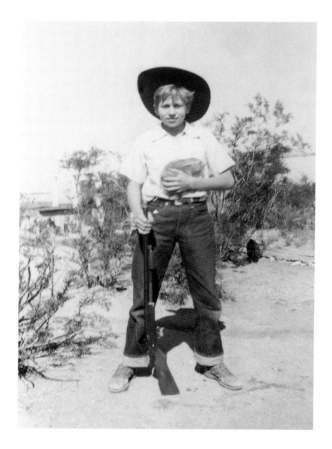

KAPROW WITH HIS PET RABBIT AND RIFLE, CIRCA 1940
(PHOTO COURTESY ALLAN KAPROW)

ideas of chance procedures not to performers but to members of the audience. On the larger question of experience, though, Kaprow's true intellectual father was Dewey, who, writing in the 1930s, saw the task ahead as one of "recovering the continuity of aesthetic experience with the normal processes of living."[10] About the time the philosopher penned these words, Kaprow was living on a ranch for sick children in Arizona. For him, the processes of living were anything but normal.

If Kaprow's philosophical stance toward commonplace experience was confirmed by the currents of mid-twentieth-century American thought, it was formed by his childhood experiences of chronic illness and Arizona ranch life. Born in 1927, Kaprow was a middle-class, assimilated Jewish kid whose father was a New York lawyer and mother a homemaker who often regretted not having pursued a business career. By the age of five, he had developed severe asthma, and within a year was sent away from his family to live in Arizona, as was customary at the time among families who could afford to do so. There, he was effectively disconnected from Jewish middle-class life and thus never identified with the practice of Judaism. His first year in Arizona was spent at the Crouch Ranch, a small working cattle ranch near Tucson outfitted to accommodate a few sick children. For a time, his mother lived nearby, but she soon returned to New York. Kaprow spent the next four years, until the age of eleven, at the Arizona Sunshine School, also on the outskirts of Tucson. During this period, he suffered acute attacks of asthma and was often in bed. Sickly as he was, Kaprow was determined to be a cowboy, participating actively in ranch life and attending local rodeos and Native American festivals. In 1939 he moved back to New York to enroll in the progressive Walden School, but he was sick more often than not and, after a "quickie" bar mitzvah, he returned to Arizona, living at the Brandes School and attending a nearby junior high. In time, Kaprow outgrew the worst of his asthma and once again moved back to New York, where he entered and later graduated from

the prestigious High School of Music and Art (along with classmates Wolf Kahn, Rachel Rosenthal, and Virginia Zabriskie).

Kaprow acquired his interest in art in Arizona, where arts-and-crafts activities gave him something to do when he wasn't feeling well. This combination of chronic illness and arts-and-crafts recreation over a period of nearly ten years not only helped forge Kaprow's solitary character, but also provided him with a formative experience of art as a therapeutic activity—an imaginative compensation for the limitations of a frail body. At the same time, being sick was the price he paid for living as a cowboy in the "Wild West," the land where, in his favorite radio play, the Lone Ranger rode down out of the hills to right injustices, and where, at any moment, the routines of ranch life might erupt with cowboy melodrama, Native American ritual, or the whipping tail of a dust devil as it skipped through the sage. The Wild West was close at hand, the way imagination is, substituting the silver bullets of melodrama for the tedium of being unwell.

Beneath the romantic experience of ranch life, however, nagged a sense of internment, reinforced by the everyday routines of study, labor, communal dining, and adult supervision. As a child, Kaprow regarded his lawyer father as "quite the barrister" who reveled, even from afar, in "laying down the law."[11] This paternal judiciousness seems to have gripped Kaprow's young psyche as the subliminal equivalent of a prison sentence—as if imposed by the father for the sin of being unwell. Even though his ranchmates and caretakers made up a rather large and active extended family of a dozen or so, Kaprow felt banished from his parents and sister, whom he saw mostly over holidays. He remembers feeling a vague kinship with the reservation-bound local Native Americans, whose ceremonies and regional gatherings he often attended. The solemnity and sequestration of Native American gatherings—a stark contrast to the breakneck, melodramatic action of rodeos—seems to have resonated with young Kaprow's wounded side.

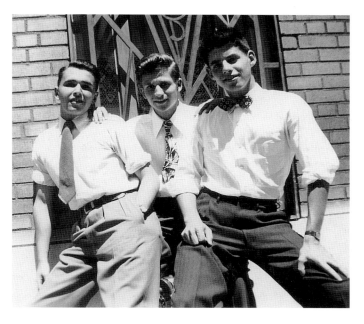

KAPROW (CENTER) AND WOLF KAHN (RIGHT) AT THEIR GRADUATION FROM HIGH SCHOOL OF MUSIC AND ART, NEW YORK, 1945 (PHOTO COURTESY ALLAN KAPROW)

Though he identified with the cowboy dream of independence, and to some extent was able to live that dream in Arizona—riding horses to school, doing ranch chores, attending rodeos—Kaprow was a captive of his own body, whose breathing, temperature, pulse rate, and energy level he constantly monitored. Over time, this attentiveness ripened into an interpretive self-awareness that slipped back and forth between physical (and often fearful) sensations and imaginative (usually playful) interpretations of those sensations. This interplay of body and mind would become Kaprow's elemental definition of experience and, by adulthood, his modus operandi as an artist.

The ranch, promising adventure but also fencing him in, was a metaphor for Kaprow's captivity, and thus for his body too. It set the stage, literally and figuratively, for the environments and Happenings to come, which, as it

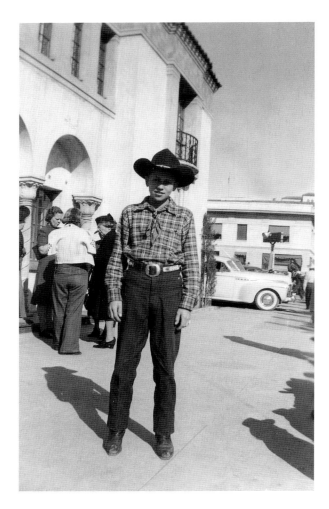

KAPROW, DRESSED AS A COWBOY, AT THE SANTA RITA HOTEL,
TUCSON, 1940 (PHOTO COURTESY ALLAN KAPROW)

turned out, were roughly the size of a corral, a barn, a bunkhouse, a rodeo, or a Native American gathering. Kaprow's sense of communal experience—so central to his sensibility as an artist—was fostered by his experience of ranch life: eating and bunking, working and playing with his ranchmates; going together into town on Sundays; falling ill and recuperating, sometimes together. Amid such communalism, however, loneliness lurked. A site of Wild West reverie, the ranch was also a clinic; at times, a ward. Hence, the experience of internment was suffused with the fantasy of escape, a psychic tension that would resurface during Kaprow's years in academe, when universities and art schools became the "ranches" of his adult life—institutions he both depended on for sustenance and dreamed of escaping.

One afternoon in 1940, when Kaprow was thirteen years old, he and several of his ranchmates were taken by an adult guardian into Tucson to see Tom Mix, the famous Hollywood star of silent Western films. Mix was known to be staying at the Santa Rita Hotel, then the fanciest hotel in Tucson, and the kids spent nearly an hour outside the entrance waiting for him to appear. He was leaving that day; his large white convertible, a 1937 Cord attended by a bellhop, was sitting at the entrance packed and ready to go.

As time wore on, the kids' anticipation began wearing thin, and the desire to see the Hollywood star was overcome by the growing and more immediate urge to eat and drink. When the chaperone suggested crossing the street for ice cream, the whole group bolted—except Kaprow. He wanted to see Tom Mix. Stubbornly, he stood there by the movie star's big white convertible, wearing jeans and boots, a Western shirt, a scarf, and a cowboy hat. He was a little single-minded sentinel among a cluster of curious onlookers. But where was Mix?

For a boy that age, the minutes passed as slowly as the sun in the Arizona sky. The ice cream across the street was tempting, but Kaprow fought off the temptation and squared his skinny shoulders toward the hotel, from

which he knew his hero would soon emerge. Finally, and somewhat menacingly, Mix burst through the hotel's front door. He was loud, boisterous, maybe yelling. He was big, bigger than life, like his image on the silver screen, only here there was something off-script about his movements. Something wasn't right, and in a moment Kaprow knew what it was: Mix was drunk—obviously, staggeringly drunk. It seemed he'd lingered at the hotel bar, tossing back a few too many for the road.

The other kids were still across the street. Kaprow, suddenly wide-eyed at the Wild West nature of his hero's "entrance," found himself standing at the precise spot Mix seemed headed for: his car. And Mix, who'd been bulling his way in its general direction, was suddenly stopped by a scrawny, pint-sized cowboy. It was a standoff.

For a moment, Mix seemed confused. Not wanting to simply swat the kid aside, he very much wanted to get to his car and leave town. Then, as if remembering that he was a movie star, Mix affected a wide, swaggering grin, reached down, grabbed Kaprow's sides with his big hands, picked him up, looked him straight in the eye, and said: "You're going to make a great little cowboy someday." Kaprow remembers the sickly sweet smell of his whiskey breath—powerful, like the actor. Mix put him down, but off to the side, so he might continue to his car. Getting in, he seemed to curse at no one in particular, driving off toward Hollywood with a roar that lingered like an ill breeze. Later that day, October 12, 1940, Tom Mix was dead, having run off the road near Florence, Arizona. The last person he ever spoke to was a little cowboy. This was Kaprow's first encounter with fame. Might the actor's grand exit from Tucson also have been a proto-Happening?

The origins of Kaprow's work are not only the nonsense of Dada performance, the alogical activity of collage, the interior spaces of Kurt Schwitters's *Merzbau,* and the physical entanglement of Jackson Pollock's visual field, but the everyday theater of his Arizona childhood: the drag of an unwell body, the boredom of daily chores, the action of cowboy melodrama, the rituals of Native American performance, the regular care of animals, the volatility of the weather, the communalism of ranch life, the loneliness of exile, the fantasies of escape, the rapture of radio plays, and the general sense that, as a boy, his everyday life was something special—that from insignificant daily routines might spring forth vivid experiences, like the thrashing of a spooked horse. Years before he read Dewey, studied with Hofmann, met Cage, admired Duchamp, and wrote of Pollock, Kaprow had followed the Lone Ranger into the hills, ridden horses to school, and met Tom Mix as he drove off into his own tragic sunset. His life had been mythically American, and anything but ordinary—except, of course, to him.

It is little wonder, then, that as a young artist studying philosophy in the late 1940s Kaprow would be receptive to Dewey's call for the reconciliation of art and life. His childhood experiences told him that the classic mind/body duality of Western philosophy is just a daydream. To puncture that daydream with attentiveness has been Kaprow's self-appointed task ever since.

a prelude

Abstract Expressionism held center stage when Kaprow began his career as an artist in the early 1950s, as it had since the end of World War II. As a genre, it—or at least the ethos surrounding it—was heavy with meaning, and Kaprow, like many younger artists of the time, wanted to unload that heaviness. Theater, film, and photography were cumbersome, but painting, or the idea of painting, was cheap and easy, a medium of lightness and portability, something you could create on the fly.

In 1956 Kaprow invented "action collages," painting-size works composed of scraps of cardboard, sheets of tinfoil, bits of torn paper, and cut-up sections of his own paintings, all slapped onto a canvas in the spontaneous manner of Action Painting, with paint as the paste (see plate 1). His action collages were not burdened with the mythic gravity and heroic seriousness then associated with the New York School. They were raw, wryly humorous works composed of used and discarded materials often gathered from the studio floor—one piece of pasted red paper contained the artist's reminder to himself to "call George Segal." The intensely physical "activity" of affixing had replaced the "act" of painting, but the intent wasn't so much ironic as it was workmanlike.

Collage was vital for Kaprow, because it led in no obvious aesthetic direction—unlike, say, Cubism, which led in so many. He adopted collage not as a technique, but wholesale, as a method of gathering and a system of composing. Collage allowed him to organize heterogeneous materials such as sounds, textures, actions, odors, images—whatever—into provisional compositions of jump cuts, transitions, and abutments that had little to do with aesthetic continuity and everything to do with the discontinuities of daily experience. Collage liberated Kaprow from the need to harmonize parts in relation to a whole. The parts—the materials, objects, processes, and events—could be what they roughly, jarringly, randomly

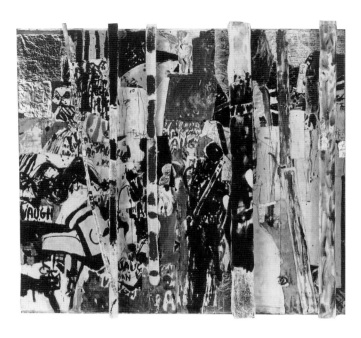

BABY, 1956, COLLECTION OF MUSEUM MODERNER KUNST
STIFTUNG LUDWIG WIEN (PHOTO: GEORGE HURYCH)

were, and this helped shift Kaprow's aesthetic focus away from the internal consonance of an artwork to its resonance in the surrounding world. The question of its value as art, while not abandoned, was replaced by other, more urgent questions: What is the thing as such? What is one's experience of it? What is the moment? Any answers, Kaprow suspected, would not come from theory, but from experience.

The assemblages that followed the action collages were also cheap and easy, even though they were larger and constructed of coarser materials, which Kaprow found on neighborhood streets or in the local hardware store rather than on the studio floor: wood, tar, broken glass, cardboard, muslin, electric wire, lightbulbs. The assemblages were three-dimensional extensions of the materials and making processes of the action collages, and, like them, they retained vestiges of the painting tradition, including the use of paint, a rectangular format, an emphasis on optical experience, and what Kaprow called "the old re-

sponses" to a two-dimensional field.[1] No longer restrained by pictorial convention, those responses could be used to compose works with materials of an everyday sort. Kaprow wanted to replace the "art look" with materials and images that referred to commonplace forms of entertainment and advertising, such as carnivals, shooting galleries, and sandwich boards.

One assemblage, *Penny Arcade* (1956), was about the size of a large painting and was constructed of paint, canvas, cardboard, painted signage, cloth, and wood, through which blinking lightbulbs were visible and behind which doorbells rang when activated by a motorized revolving coat hanger as it ran across live electrical contacts. Though cloaked in the gestalt of abstract painting, *Penny Arcade* exchanged the "art look" for the lightweight effects of a funhouse. For some artists, this sleight of hand amounted to a betrayal of painting, a quest for novelty at the expense of the medium's integrity. For Kaprow, it was a transfer of aesthetic energy from high materials to low. In this sense, the assemblages were early experiments in the lifelikeness of the art-making process. The point was not to imitate life's cacophony by simply mixing things up, but to analyze in a thoroughgoing way all that lifelikeness might entail: Are there sounds that are *not* musical? Lights that are *not* the light of painting? Processes that are *not* "the creative process"? Materials that are *not* the essence of anything, but only themselves?

Another work, *Rearrangeable Panels* (1957, plate 2 and page 16), perhaps the most well-known of Kaprow's assemblages, could be arranged in different configurations. Its nine panels (composed of tar, wax apples, sections of old paintings, mirror fragments, and colored lightbulbs), each eight feet high, could be leaned against a wall (creating a coarsely textured, if subtly colored, bulwark), *be* a wall, or stand on the floor, where they looked like a kiosk or carnival booth. The panels could be arranged by the artist, of course, but also by curators or collectors. This rearrangeability was an early nod in the direction of what would later become a central principle of Kaprow's work: the participation of others. Kaprow was comfortable with

collaboration and ensemble performance—activities typically associated with art forms other than the visual, especially music. By extending the status of "arranger" to whoever might come in contact with the work, Kaprow questioned the myth of the artist as a solitary creator.

By 1957 the assemblages had bridged the distance between Kaprow's background as a painter and the Happener he would soon become. As freestanding panels that were not in the tradition of sculpture (still largely a pictorial tradition), the assemblages activated the viewer's awareness of the surrounding environment, almost as if the "aura" of art had spilled beyond the object and into the room around it. This led Kaprow to the insight that the room itself could be an assemblage, a work of art the viewer would be in, not just near. Less important for what they resolved than for what they foreshadowed, the assemblages were streetwise syntheses of Kaprow's formative influences: Marcel Duchamp's readymades, the "action" of Action Painting, the heterogeneous logic of collage, and, most important, Jackson Pollock's "overall" scale and John Cage's chance operations.

schoolboy puttering

When Cage began teaching a weekly class on experimental music at the New School for Social Research in 1957, Kaprow eagerly attended. So did a number of his art-world contemporaries, including George Brecht, Al Hansen, Dick Higgins, Jackson Mac Low, and, occasionally, George Segal and Jim Dine.

Cage was the author of what was arguably the first Happening-like event, an interdisciplinary performance presented in 1952 at Black Mountain College that involved simultaneous but independent presentations of music, poetry, dance, film, slide projections, and lectures and included the participation of Merce Cunningham, David Tudor, Robert Rauschenberg, M. C. Richards, and Charles Olson, all Cage's friends and colleagues. In the same year, in Woodstock, New York, Cage premiered what is certainly his most famous work, 4'33", a legendary

antiperformance in which Tudor, wearing a concert pianist's white tie and tails, walked onstage, sat down at a piano, and did nothing for four minutes and thirty-three seconds except to open and close the keyboard cover three times, signifying the work's three movements. As the audience waited for "music," the ambient density of "silence" unfolded, filling the hall with the sounds of nervous laughter, breathless anticipation, and the wind blowing in the trees outside. Cage used the audience's expectation of piano music as a psychological

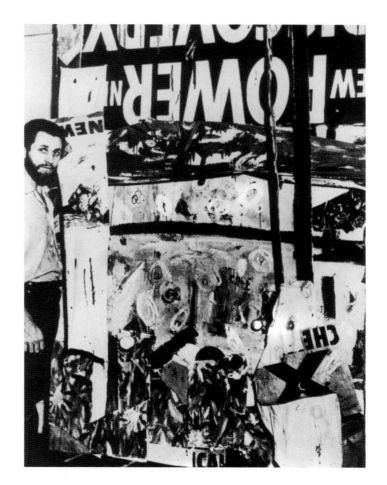

PENNY ARCADE, 1956 (PHOTO: GEORGE HURYCH)

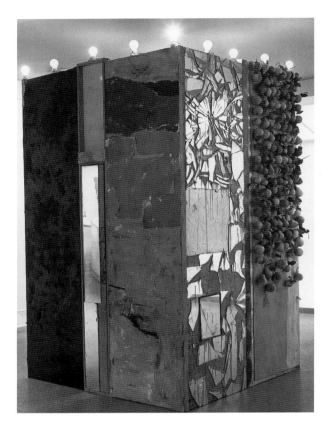

REARRANGEABLE PANELS (KIOSK CONFIGURATION),
PRIVATE COLLECTION, 1957

and temporal frame for the presentation of background noise. Both here and at Black Mountain College, he conferred what might be called aesthetic attention upon chance phenomena.

This creative detachment represented one of the few alternatives to expressionist abstraction for younger artists such as Kaprow, and Cage's class was a formative experience for him. It was there, with the classroom as a kind of performance laboratory, that he first experimented with live and recorded sound in scored event compositions, which would eventually lead to the theory and

practice of Happenings. It would also reinforce a lifelong experimental attitude toward the arts, inspired by what Kaprow would later describe as memories of schoolboy puttering in which one tries to "imagine something never before done, by a method never before used, whose outcome is unforeseen."[2] He was seeking not a style, but a method—a way of composing and presenting the chance operations of concrete, commonplace phenomena. In this, John Cage was his principal mentor.

tape score

For his early forays into performance, Kaprow wrote rigorous compositions. Notated by hand on legal pads, these documents served as a kind of sheet music for the events. In their sketchy, expeditious style, the scores were offbeat hybrids of musical notation and drawing, with stick figures, lines, numbers, words, and points in time running across each yellow page, as if the composer was trying to keep pace with an idea. In this respect, they are linear and methodical.

Tape Score (1957) is an early example of Kaprow's precise, methodical approach to creating events whose complexity when performed overwhelms the logic of the score. This theme, of a system breaking down as it converges with reality, also appeared in an environment later that year and has remained a career-long favorite for Kaprow. The score, to be played by four tape recorders simultaneously, is composed of words written at precise points on a musical staff. It is replete with images we can almost see, sounds we can almost hear, surfaces we can almost touch, and frequencies we can almost feel:

Dripping water in deep can, slowly, drop at a time (not loud); bouncing ball at about 1 sec(ond)/bounce; glass rubbed; shshsh/bang (saw blade) loop; sound cut "blip, blip, blip" on next intervals; then backwards twice; then only overtone; scraped bottle cap; staple gun (backwards except where noted); bottle whistle; Pontiac horn (softly/loud) (backwards, loud); electric razor; music egg; duck squeak; piano (hard,

backwards); tar (waahwaw) overload (. . . on tape); saw; cof-fee grinder (all cut up, low); voice (how do ya do); pyrex dish (struck with soft hammer and hard hammer, 3 seconds each); tearing paper (short, long); bell & flute; ratchet (ssss from Bob's radiator); rubbing on kleenex box; Ford horn; sparrow (fading); meow (dog); orchestral "crash" chord (Beethoven 9th 3rd movement); bell (pyrex dish); clocks; fork (on board); tin foil pieces, leaves (crinkle, rustle); pot with water banged, rolled & slap knife on spring(?); blocks of wood; Bob's radiator and penny arcade; bottles struck & blown; matches; comb plucked, alarm; metal plate struck.[3]

Dazzling but dumb, serious but farcical, sophisticated but slapstick, this early composition not only correlates with Cage's interest in chance operations but also un-derscores Kaprow's lifelong fascination with a certain class of concrete subjects, objects, processes, and events that cannot be easily identified with art in its traditional sense, but that *can* be identified with everyday life. The drip-drip-drip of water or the sh-sh-sh-bang of a saw blade are not abstractions taken from life and suspended remotely in art; they are perceptual concretions, little points of contact with the commonplace composed and presented in such a way as to register aesthetically in our awareness. They are abstracted from life but still con-cretely of it.

The homemade informality of the "instruments" in this work—the bottle whistle, the clock, the Pontiac horn—is set in counterpoint to the strict formality of the scoring. Readers of the score pause on its "notes" of funky in-strumentality and vernacular humor, such as a glass be-ing rubbed, a rubber duck being squeezed, steam escap-ing from a radiator, and an electric razor being switched on. Written in Kaprow's fluid but matter-of-fact hand, these image-phrases weigh upon the page with a prosaic (today we might say low-tech) physicality. One senses a precision of mind in the service of a collage of sensations. In performance, as on the page itself, the sounds made by the instruments and the associations with life that they inevitably produce spill over the strict parameters

of the score, pass into the space and time of the audience, and drift by like music of the everyday, leaving in their wake a quietly ecstatic awareness of ordinary things.

Initially interested in what Cage could teach him about electronic music, Kaprow ended by absorbing Cagean theories about aleatory, mixed-media composition. Never an expressionist in temperament, Kaprow avoided, even as a painter in the early 1950s, gestures of personal con-viction or heroic action. His stance was that of the com-paratively detached researcher (not the convert or the seeker) who sets up experiments in which the unfore-seen might occur. Although the subjects and parameters of his experiments have changed over time, he has al-ways been a method-ist artist, wanting to find out what would happen *if*. In this, he was right for Cage's class, where experimentation was expected, even assigned as homework.

At the heart of Cage's teachings was his refusal to im-pose his will upon the artwork, a radical prescription at a time when the artist's creative intention, decisiveness, and ambition were mythic tenets of postwar American art. Having studied with the great American popularizer of Zen Buddhism, D. T. Suzuki, Cage was predisposed to sit back, as it were, and witness the emptiness, the si-lence, the passage of time—not passively, but as a com-poser hoping to draw the audience's attention away from the traditional subjects of "music," "theater," and "art" by using the framing conventions of, for example, a concert, a play, or a gallery to foreground the ephemera of living. For Kaprow, Cage was an influential teacher in two prin-cipal regards: the practice of chance operations and the equation of noise with music. "It was apparent to every-one," Kaprow recalls, "that these two moves . . . could be systematically carried over to any of the other arts." Kaprow was more interested in following these ideas "well beyond the boundaries of the art genres them-selves," into the places and occasions of everyday life.[4] This approach, which Kaprow methodically developed over the next dozen years, ultimately distinguishes him

blocks of wood—that could easily be carried to class in a bag. Students with a more extensive background in music would often use the musical instruments stored in the classroom's closet, but Kaprow was less interested in making music—experimental or otherwise—than in making noise.

There can be little doubt that Cage's class was one of the most influential workshops in the history of American art: Cagean principles of chance procedures and the intermixing of media rippled throughout the arts for decades. Even so, the class was less a revelation for Kaprow than a confirmation of what he was already doing. Kaprow had received a degree in painting from the Hans Hofmann School of Fine Arts in 1948, but since the early 1950s he had been trying to move away from the figurative abstraction preferred among Hofmann's students and toward a method of making art that was at once physical and extemporaneous. In this, Kaprow was as influenced by the "overall" paintings of Pollock as he was by Cage's aleatory strategies. In "The Legacy of Jackson Pollock," begun in the wake of the painter's death and published in *Art News* in 1958, Kaprow observed that the proper distance from which to view a Pollock painting is the point at which it visually occupies one's entire peripheral vision, surrounding the viewer as it did "the painter at work," so that the viewer may see the fluid weave that the painter saw while creating it. This strict correspondence between the painter's experience and that of the viewer is, ultimately, a physical one; Kaprow's perception of Pollock's painting was through the whole of the body, not just the eyes. "I am convinced," Kaprow wrote, "that to grasp a Pollock's impact properly, we must be acrobats." Kaprow felt himself to be entangled in skeins of paint, effectively inside the painting. The boundary between pictorial space and the literal world collapsed, and the distinction between painting as an object and painting as an experience blurred. This blurring suggested to Kaprow a radical new equivalence between the aesthetic experience of the artist and that of the audience. The fun-

from his mentor. He exchanged the street for the concert hall, the chance encounter for the performance event, everyday experience for the creation of art.

Cage's class was a weekly seminar in which presentations of student scores (chance-operational "homework" assignments from the previous week) as well as works by Cage or guest composers (Morton Feldman, for instance) served to initiate discussions about such topics as randomness and the nature of boredom. Cage once played a record of a Zen Buddhist ceremony in which monks recited mantras and tapped wooden blocks with sticks until some in the class shouted "Enough!"; others wanted more.[5] Kaprow's weekly contributions to the class always involved nonmusical instruments—hammers, saw blades,

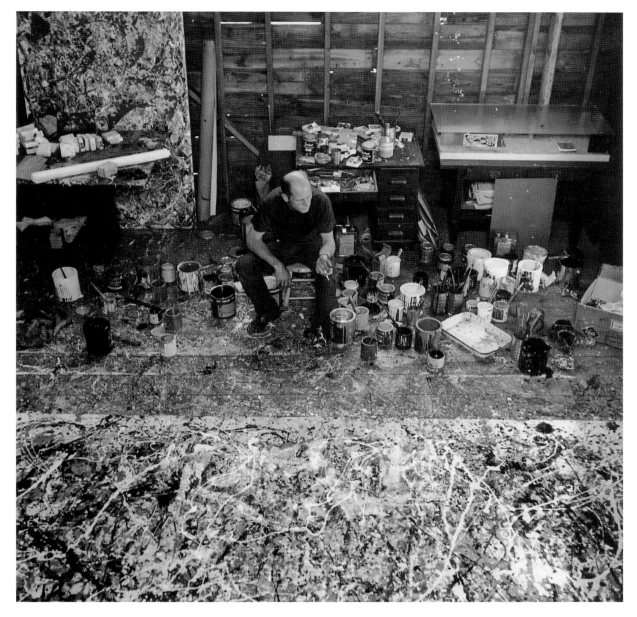

JACKSON POLLOCK IN HIS STUDIO, 1950 (PHOTO © ESTATE OF HANS NAMUTH)

damental lesson Kaprow took from Pollock was that the experience of art could be environmental.

In the free-form tangle of Pollock's paintings and the shrewd physical intelligence he employed to put paint on canvas, Kaprow saw a place and a role for himself as an artist. He saw in Pollock's example an authentic act in a space of his own invention, and he took the meaning of this beyond the boundary of the painting, into the surrounding room, and, eventually, to the street beyond. Cage gave Kaprow ways of operating in Pollock's space using chance, as well as a link between the practice of the visual artist and the philosophy of chance (and the practice of Zen). In this sense, Cage was instrumental. Pollock, however, was fundamental, for his paintings offered Kaprow an optical field big enough to step into. Pollock was physical and Cage ethereal. In one, he found a space for the body; in the other, a time for the mind.

beauty parlor

Within two years of making the first assemblages, Kaprow extended their collagelike elements into the studio, gallery, industrial loft, storefront, or neighborhood church basement until such places themselves *became* assemblages. Entangling the spectator in a multisensory artwork, these "environments" literally set the stage for the artist's Happenings. Being inside one was like being inside an abstract painting. To physically penetrate its visual field was to enter a profoundly modern space in which the artist's imagination had taken shape, albeit crudely, in terms of the human body and its senses.

At this time, the dawn of the space age, with Russian satellites orbiting American skies, space was still a metaphor of human extension and speed, a medium in which objects, materials, processes, and events took form, probed, and traced their trajectories. It was experienced as an envelope for the body and a passage for the imagination. Cold War rocketry hadn't yet eclipsed it; television hadn't yet abridged it; computers were decades away

from imploding it. Our sense of the "real" had not yet dissolved into images conjured of binary relations. Images, once the province of the graphic arts, were moving away from flat surfaces like paper or canvas, toward the object, the environment, or the event, where the power of the visual was reinvested in material, physical, and theatrical forms. The filling up of space with the stuff of art was, by the late 1950s, regarded as an experimental vanguard activity, even if, as in Kaprow's case, that stuff seemed more like litter than like artistic materials.

Kaprow's first public environments were staged in 1958 in the Hansa Gallery, an artists' cooperative started in 1952 by some of Hans Hofmann's former students, including Kaprow, Wolf Kahn, Richard Stankiewicz, Miles and Barbara Forst, Jean Follett, and Jan Müller. (Although they were not founding members, George Segal and Robert Whitman also exhibited at the gallery.) Because of the diversity of its membership—abstract painters, figure painters, sculptors, soon-to-be Happeners—the gallery acquired a reputation for supporting alternatives to the then-dominant New York School. Kaprow saw it as a generally conservative gallery in a generally conservative time, as likely to show conventional as experimental art; nevertheless, because of the heterogeneity of its artists, he found it interesting.[7]

Kaprow's two Hansa Gallery environments (later named *Beauty Parlor*) were attempts to physically involve viewers to a greater degree than was possible with the assemblages by allowing the assemblages to follow their own collagist logic into the three-dimensional geometry of a room. Filling the room with "art," he reasoned, would challenge the social conventions built into the relationship between the artist and the audience, resulting in experiences that were neither performed nor witnessed, but were a synthesis of the two. Inside the frame, there was no place to sit and watch, no stage from which to perform, no privileged space from which the artist might speak. Kaprow wanted to transform members of the audience into performers.

For the first environment, completed in March 1958, parallel layers of cloth and plastic sheets, loosely painted in heraldic bands of black, blue, and red, were hung around the room. Random mechanical sounds came from various parts of the ceiling. In late November of the same year, a second, somewhat intensified environment was created, with a "forest" of raffia strips hanging from ceiling-level netting along with swarms of tiny blinking Christmas lights and a wall of broken mirrors framed by two rows of spotlights aimed at the spectator. An oscillating electric fan circulated chemical odors, and electronic sounds were broadcast from four loudspeakers.

The *Beauty Parlor* environments played on the association of art galleries with beauty parlors and art making with "making up." They also allowed Kaprow to follow the "action" of Action Painting into the literal space of the audience. In 1952 Harold Rosenberg had written famously of postwar painting as "an arena in which to act."[8] The arena Rosenberg had in mind, to be sure, was the immediate vicinity of the canvas, and the "action" was that of the painter painting. Kaprow's arena encompassed the entire space of a room, and his action was to fill the room with everyday stuff. His environments were designed to hide, or at least to contradict, a given architectural interior, reshaping the space according to the irregular patterns and textures of the materials within. The viewer's experience would be of those materials as a kind of organic quasi-architecture flowing "easily within itself."[9]

The visual appeal of the environment was inseparable from the materials and spaces composing it, which produced a collage effect that approximated the optical action of Action Painting. This effect was a formal feature of the environment, but it was also experienced by the spectator as a collage of physical sensations as he or she maneuvered through, say, a half-darkened labyrinth of hay, crumpled newspaper, and chicken wire. The materials and spaces that composed Kaprow's environments were the literal, commonplace equivalents of the shapes, colors, marks, and gestures that composed modern paint-

UNTITLED ENVIRONMENT (LATER NAMED *BEAUTY PARLOR*), HANSA GALLERY, NEW YORK, 1958 (PHOTOGRAPHERS UNKNOWN)

ings. The difference was that the environments were made without "the goal of picture making."[10]

As physical envelopes for the senses, Kaprow's environments seemed at odds with the kind of creative detachment advocated by Cage. Cage mistrusted his student in this regard, believing him to be too internal, too romantic, too physical.[11] Cage wanted to liberate chance operations—periods of silence, the tick of a clock, a stain on a piece of paper—from the controlling will of the artist, objectifying them as aleatory phenomena that could be experienced by an audience. Parting with his mentor, Kaprow wanted to recast spectators as participants in his environments. He did this by composing all-encompassing spaces that blurred the distinctions between performers and audience members. Those present were simply *in* the work: they became variables.

Before he shook off the "old responses" of painting, Kaprow had been annoyed by the presence of spectators wandering through the visual field of an assemblage, aesthetically interfering with his carefully calibrated compositions.[12] At a certain point, though, roughly coincident with his attendance in Cage's class, he began realizing that the presence of people in the work was perhaps the most animating variable of all—and certainly the least controllable. Being interested in the variability of experience, of what cannot be predicted or controlled, Kaprow finally decided to build people into the environments, to physically incorporate them as random elements in a chance-operational collage. This was the beginning of Happenings.

The first use of the word "happening" in relation to avant-garde performance is generally thought to have occurred in an event score, *Something to Take Place: A Happening,* appended to an essay entitled "The Demiurge," which Kaprow published in *The Anthologist,* a Rutgers University literary journal, in the spring of 1959. If that score, which was never performed, was Kaprow's first conscious use of the term, an earlier, perhaps semicon-scious precursor appeared in his "The Legacy of Jackson Pollock." There, in an almost breathless rhapsody, he chronicled the prospects for a "new concrete art" in which would appear "unheard-of happenings and events, found in garbage cans, police files, hotel lobbies; seen in store windows and on the streets; and sensed in dreams and horrible accidents."[13] "Objects of every sort," he opined with confidence, "paint, chairs, food, electric and neon lights, smoke, water, old socks, a dog, movies, a thousand other things," would contribute, whether critics liked it or not, to "the alchemies of the 1960s."[14]

The sweeping romance of these passages springs from the expressionism of the materials, objects, and situations ("dreams and horrible accidents") they describe, as well as from the Whitmanesque cadence of the writing and its thumping Beat undertones. In its final paragraphs, Kaprow's essay prophesies the gritty, urban, Pop sensibility of the 1960s with uncanny accuracy. Seeded in its progressive meter, though, is that little equivocal word "happenings." How did Kaprow mean it? Clearly, it carries no poetic weight in the essay; in the soulful run of images, it comes off as a term of convenience intended merely to indicate that something is happening. Kaprow liked the neutrality of the term. It didn't conjure up, say, theater or the other arts, or, for that matter, lectures or picnics. In a certain sense, the word "happening" was a harbinger, in linguistic miniature, of what became the fundamental philosophical conundrum of Kaprow's career: As soon as he had a fresh experience from life, he began to submit its identity to the meaning and history of art.

"Happening," originally so free of associations, soon became a famous word. In the heyday of 1960s popular culture, it meant just about anything; it lost its particular meaninglessness, its capacity to imply fresh forms of experience without consigning them to an aesthetic convention. But in 1959 "happening" was still a pale signifier of "actions" vaguely undertaken in the realm of art. It took

Kaprow a while to settle upon an event that gave the term the kind of aesthetic, social, and personal meaning that coalesces around an avant-garde moment.

Kaprow did not simply appropriate the physical movements of the visitors to his environments. Human movement did introduce the element of time into the environments, but Happenings were not just environments plus time. Kaprow's goal was to equate the experiences of performers and audience members so that the distinctions between them dissolved, approximating the sequences, counterpoints, and jump cuts (the collage) of everyday life. Time became a kind of timing, and Kaprow began to compose with it. He began writing scores for events in which human actions could be presented as formal abstractions. They were similar to the sound and tape scores that he had worked on in Cage's class, only the hiss of the radiator or the sh-sh-sh-bang of a saw blade had been replaced by actions, as in an untitled handwritten score of 1959:

Male dancer dressed in white shirt with red arm band & ducks & sneakers / emerges from doorway stands 10 secs. / walks measuredly to stool, sits on it perfectly still for a while / Nude Female (who walks out beforehand while crowd is being seated and who sits still on bench) gets up and walks around "posing" in a solemn, stylish way (single poses). Then lies down back on floor . . .

The actions of the dancer and the nude were real, but they were not ordinary. They were formal, stylized, and measured. They only seemed ordinary when compared with the phantoms behind the score: choreographed dancing, a nude posing for a drawing. Compared with everyday walking, standing, and sitting, they were stiff with artifice. In the way that materials and objects filled the spaces of the environments, these relatively mechanical motions filled the time it took to perform them.[15]

Kaprow's primary inspiration for his stick-figure choreography was the avant-garde dance of Paul Taylor, whose simple, mechanical movements he found hypnotic. He was particularly inspired by a performance in which Taylor, dressed in a business suit, assumed simple poses every ten seconds while an operator called time. Kaprow was thinking too of Charlie Chaplin in *Modern Times* (1936), just as Chaplin in *Modern Times* had been thinking of Taylorism, a set of precise mechanical movements developed by Frederick Winslow Taylor to increase productivity among assembly-line workers. In the wings of Kaprow's awareness was also the 1924 *Ballet Mécanique* by Fernand Léger.

More than anything, though, the physical movements Kaprow scored onto paper were formal. Neither expressions of an interior state nor much concerned with appearance, the acts of emerging from a doorway, standing still for ten seconds, walking measuredly to a stool, and then sitting on it were less like dance steps than like common tasks. As tasks, they were not so much performed (except mockingly—recall the nude's feigned poses) as carried out. Their physicality was never an expression of artistic skill; it was merely elemental to the task at hand. The physical movements Kaprow scored onto paper were, in a word, flat-footed.

Kaprow's sense of form has always been flat-footed. You can see it, for example, in his paintings of the early 1950s, especially in the brushwork. Whether in the service of human figures or abstract gestures, Kaprow's brushstrokes seldom transcend or seek their own essence; mostly, they are just plain strokes. Applied firmly, without dramatic affectation, they are less expressive than deliberate, less weighty than physical, less poetic than dutiful. It almost seems as if Kaprow was trying to analyze his way through (and maybe out of) the heroic content of postwar painting one brushstroke at a time. The paintings seem stiff until the viewer realizes how methodical they are. The movements scored on paper have much the same feel. They are represented by stick figures very similar to those in the paintings. Kaprow's "hand" jumps for-

ward not as a mark maker, but as a gatherer, paster, arranger, and composer. In retrospect, his painted stick figures seem like diagrams waiting for the matter-of-fact avant-garde choreography they foreshadow.

communication

Kaprow's first public Happening, *Communication*, took place in the campus chapel of Douglass College, New Brunswick, New Jersey, in April 1958. During the previous six months, he had presented similar but smaller events in Cage's class, and just as he had used that class as a laboratory for noise making, Kaprow now decided to enlarge and complicate the idea of communicating by turning a speaking occasion into a multimedia event. The Happening was presented as one of a weekly series of midday talks for students and faculty, organized by Robert Watts around the broad topic of "communications." Besides Kaprow, speakers included people from the arts (Cage, Watts, Tudor, Rauschenberg, Paul Taylor), the social sciences, and psychiatry.

Instead of giving a speech, Kaprow sat silently in a chair onstage while a tape recorder located in the auditorium's balcony began playing a recording of the speech he wasn't giving. This recording started out clearly, but it was quickly joined by unsynchronized recordings of the same speech from two other machines, also in the balcony. As the three recordings overlapped, the words became unintelligible. The tapes were followed by bells and whistles and the short spoken phrase "How d'ya do?" Kaprow recalls:

Simultaneously, red placards were raised up from the audience, long striped and colored banners were dropped from the balconies, a woman slowly bounced a red ball up and down the aisle, two men sat at a table at the rear of the aisle drawing from a bag of colored tin cans, plunking them down audibly onto the table top while saying certain phrases I've forgotten. I was on the left of the stage near the speaker's lectern, dressed in white tennis clothes, seated silent and motionless on a red chair. Nearby, facing the audience, were a number of upright panels of leaves, mirrors, and white and black encrusted paint. A red bulb flashed regularly (on the lectern). After twenty seconds I arose, walked to the mirrored panel, turned my back to the audience, looked closely into the mirror, examined my eyes in a formal way, and carefully lit dozens of matches, blowing them out one after the other. Following this I returned to my red seat and, I recall, sat there for the remaining time.[16]

Kaprow's classroom experiments had gone public. The occasion of the lunchtime academic lecture had been used as a foil to speak nonsense, make noise, display colors, enact movements, and both engage and ignore the audience. The audience was expecting a speech, and it got a Happening instead. Of course, no one knew it was a Happening, not even Kaprow, since he hadn't yet coined the term, but everyone knew it wasn't theater, or music, or sculpture, or, least of all, a speech—after all, the words were not only garbled, but were accompanied by banging tin cans, banners unfurling, and balls being bounced down the aisle, among other things. No one knew precisely what had happened, but clearly something had. No one knew what it meant, but it seemed deliberate enough to mean something. What was the message? Why was the artist silent? Were the tin cans a reference to childhood treehouse telephony? Were the artist's lighted matches, inside the chapel, symbols of spiritual illumination? When snuffed, were they smoke signals for the audience? Was his examination of himself in the mirror an ironic commentary on the expectation that the artist look within for meaning, or was it just a closed loop of eye-to-eye "communication"?

Kaprow had wanted to see what would happen if the experiments with chance he had conducted in Cage's class were extended to a formal public occasion. What he found, happily, was that the carefully scored parts of his composition were experienced by the audience as a collage of simultaneous and overlapping events. Nonetheless, he felt hemmed in by the formal conventions of the

academic lecture, even as he was contesting them with aleatory nonsense. The architecture of the chapel, designed for the separation of preacher and congregation, enforced a distance between professor and student body, and while the venue provided an interesting backdrop for nonsense, it had the effect of rendering Kaprow's performance a more radical, socially confrontational undertaking than it was intended to be. He wasn't trying to overthrow church or state, but to apply Cagean theory to a more challenging domain than the classroom. What Kaprow found was that the occasion became a form of theater. The experience was too like a premier, his performance thrown into sharp relief against the dignified backdrop of the place. Kaprow began wondering whether a less structured situation—one without props, podium, stage, or audience—might better suit his interests, so he went from the chapel at Douglass College to his friend George Segal's farm.

george segal's farm

In 1953 Segal was delighted to discover "a fellow rebel" living about a mile from his farm in North Brunswick, New Jersey.[17] Kaprow, who had begun teaching at Rutgers that year, had moved onto a property once called the Rubin Farm, and he was using its large concrete barn as a studio. By chance, he'd settled near Segal, a chicken farmer whose farm was also *his* studio, and the two became lifelong friends. Although kindred spirits, Segal and Kaprow were not always of like mind, and their friendship was based as much on what they disagreed over as what they held in common—"mental wrestling," Segal called it.[18] While agreeing philosophically that art should be drawn from the world of concrete things and experiences, Segal and Kaprow "argued incessantly" over how this might be accomplished. Yet despite their disagreements, each felt enormous respect for the other. In the bucolic spirit of the picnic gatherings of the French Impressionists (and as an alternative to the Hamptons,

where so many of the Abstract Expressionists had migrated), they decided to invite other young artists, many of whom were from the Hansa Gallery and shared Segal's and Kaprow's disenchantment with the strictures of the New York art world, out to the country each spring. The basic idea was to have a good time.

Thus it was that Segal's farm became the site of Kaprow's next event, *Pastorale,* which came swift on the heels of his Douglass College performance, in the spring of 1958. The setting was less austere than a chapel and the occasion less formal than a lecture. He was interested in merging the collage structure of *Communication* with the more casual, rural, and recreational atmosphere of the spring picnic. He also wanted to avoid "dumping something" on an unsuspecting audience[19]—in fact, he didn't want an audience at all, but a coterie of artists who, half-suspecting Kaprow's intentions, would be willing to participate in his design. To this end, he and Segal constructed primitive props in a field surrounding Segal's chicken coops, including eight-foot-high poles decorated with satin banners intended to catch the afternoon light, with plastic sheeting stretched between them. Kaprow's plan was to ask the picnickers to jump through the plastic sheeting, sit in the chicken coops rattling noisemakers, paint a canvas together, and engage in a series of slow, ritualistic movements. The whole thing would be a deadpan representation of the themes that then interested Kaprow: liberation, captivity, collaboration, and, of course, method.

The event as Kaprow planned it was not to be, however. The picnickers, who had come out for a day in the country, weren't especially interested in his plan. When he asked—"at the last minute"—for participants, many felt they were being pressed into service for the benefit of another artist's work.[20] Some were against the idea of the restrained, deliberate actions envisioned by Kaprow, committed as they were to spontaneity and emotional expressiveness in painting. Besides, it was a hot day and they had all drunk plenty of beer; veering irreverently

PASTORALE, GEORGE SEGAL'S FARM,
NEW BRUNSWICK, NEW JERSEY, 1958, WITH
CLAES OLDENBURG (BELOW CENTER) AND OTHER
PARTICIPANTS (PHOTOS: VAUGHAN RACHEL)

from the script was inevitable. One artist called Kaprow a "fascist" for attempting to direct his participants. These were not the dutiful students of Cage's class. In the end, the event fell apart, its formal structure disintegrating into a comedy of catcalls and antics.

What Kaprow initially took from this was that his friends were hostile to the idea of an event composition, but upon reflection he realized that his event went awry because he had attempted to impose a disciplined scenario upon an otherwise carefree gathering, and he had done so without adequately informing or preparing his fellow revelers. In an effort to recast the audience as participants, Kaprow had failed to set the stage for participation.

Kaprow had gone from the academic solemnity of the Douglass College chapel to the barnyard irreverence of Segal's farm. Put off by the one and annoyed by the other, he felt the need for a kind of middle condition: a situation that was less formal than a public lecture but more structured than an artists' picnic. While the lecture and the picnic, as scholarly and recreational forms of everyday experience, had helped frame—and shatter—his first public experiments in presenting events, Kaprow was still trying to figure out what new perceptions an event might give rise to if allowed to take place on its own. He realized that he needed a more sympathetic environment, one analogous to a laboratory, in which the proper experimental controls could be applied. Kaprow was drawn to the commonplace, but in 1959 he was still not ready to "just go out of doors and float an environment into the rest of life."[21] He also needed an audience that was more or less prepared to participate in whatever happened.

At this point, Kaprow had been denied tenure at Rutgers, following a controversy surrounding the senior the-

PROFESSOR KAPROW, RUTGERS UNIVERSITY, WITH HIS SISTER, MIRIAM, CIRCA 1955 (PHOTO COURTESY ALLAN KAPROW)

sis of his student advisee, Lucas Samaras. Samaras's thesis mixed photographs of his own artworks with extended poems of one-syllable words, including "fuck." Convinced of the brilliance of his student, Kaprow entreated university officials not to withhold his degree, citing his own encouragement of Samaras's efforts. Samaras was allowed to graduate, but an "inquisition" of Kaprow was quickly convened and, although he taught there for one more year, he was denied tenure. In the wake of this, Kaprow decided to compose a public event that would play itself out within spaces of his own design, amid an audience he would invite and even instruct. He spent the ensuing summer and early fall building a multipart environment for a Happening that he called *Eighteen Happenings in Six Parts*.

chapter three *eighteen happenings in six parts*

Over six warm evenings in early October 1959, in the narrow third-floor loft of the Reuben Gallery, New York, Kaprow, then thirty-two years old, presented *Eighteen Happenings in Six Parts,* a complex theatrical work involving colored lights, recorded and live sounds, various odors, spoken words, and the performance of certain routinelike actions in three open, plastic-sheeted, semitransparent cubicles among which the small, mostly art-world audience moved on cue. Now remembered as the first American Happening and a seminal moment in the history of the avant-garde, *Eighteen Happenings in Six Parts* seemed to some of those in attendance like the end of art, while others believed they might have seen its future. For Kaprow, who had been preparing the composition all summer, it was mostly just over—the beginning of the end of what it portended.

The opportunity to produce *Eighteen Happenings* had been provided by Anita Reuben, who, knowing something of Kaprow's work, had offered him the inaugural time slot in her new gallery with the hope that he might help forge its identity by doing an avant-garde performance. Kaprow had accepted, not so much because he wanted to work in a gallery space, but because he felt that the Reuben Gallery, a raw loft space, had not yet been "contaminated" by art. Over the next three months, during the summer of 1959, Kaprow got on a bus each weekday morning and went to work at the gallery. There, he completed and revised the score, designed and constructed the set, fiddled with the electronic tapes, and, in the final week, rehearsed a complex sequence of events with selected students and friends.

The score for *Eighteen Happenings in Six Parts* was much more ambitious than the unperformed score for *Something to Take Place: A Happening.* Whereas Kaprow regarded the earlier score as "notes on something," part of an ongoing percolation of ideas about aleatory art, the score for *Eigh-*

KAPROW CONSTRUCTING THE SET (LEFT) AND GLUING WAX APPLES ON BOARD (RIGHT) FOR *EIGHTEEN HAPPENINGS IN SIX PARTS,* REUBEN GALLERY, NEW YORK, 1959 (PHOTOS © FRED W. McDARRAH)

teen Happenings was a more concerted effort to conceive and present an event that was beginning to coalesce in his mind as a "happening," for lack of a better term.

Hand-drawn on a grid, the score represents a spatiotemporal sequencing of sounds, images, smells, and physical movements, and looks something like a floor plan. It is more arithmetical in its structure and abstract in its references than Kaprow's earlier event scores. Times are precisely set ("5 minutes, 20 seconds," "give only 10 seconds for words in room 2, ring bell 2 times"). Directions are given for the orchestration of sounds ("1st band sound ends early," "nothing"), for lights to be flashed on and off at given intervals, for specific numbers of slides to be projected at varying speeds ("rapidly," "fast,"

"quickly"), and so on. Directions are also given to the performers ("all movements will be made according to the cardinal axes," "hands on hips," "turn right, swing left foot slowly back and forth, not too far either way"), and each directive is accompanied by a stick-figure diagram of the desired movement or position.

The audience received instructions as well. On note cards given to audience members, Kaprow wrote: "The performance is divided into six parts. Each part contains three happenings which occur at once. The beginning and end of each will be signaled by a bell. At the end of the performance two strokes of the bell will be heard. . . . You have been given three cards. Be seated as they instruct you." This directive was followed by rules about when and where to move and how long the intervals between parts would be. The audience was advised that they would be asked to move on cue through the three rooms in which the "happenings" would take place. Their instructions

SCORE FOR *EIGHTEEN HAPPENINGS IN SIX PARTS*, 1959 (PHOTO: JEFF KELLEY)

MOVEMENT SCORE FOR *EIGHTEEN HAPPENINGS IN SIX PARTS*, 1959 (PHOTO: JEFF KELLEY)

concluded, "There will be no applause after each set." The score also identifies the performers: "Allan Kaprow—who speaks and plays a musical instrument," "Lucas Samaras—who speaks, plays a game and a musical instrument," "Sam Francis, Red Grooms, Dick Higgins, Lester Johnson, Alfred Leslie, Jay Milder, George Segal, Robert Thompson—each of whom paints," and, of course, "The visitors—who sit in various chairs."

The physical environment for *Eighteen Happenings* included a number of props that had been acquired or made for the event, including tables, wooden blocks, an orange squeezer, oranges, a glass, open paint cans with brushes in them, a muslin panel set into the plastic wall dividing two of the rooms, various musical instruments, two red and two purple scrolls poised to fall from positions nine feet above the floor, and an eight-foot-high wheeled construction dubbed the "sandwich man," which had mirrored front and back panels, a record-player torso, a

KAPROW TALKING WITH ROBERT WHITMAN DURING CONSTRUCTION OF THE SET (LEFT) AND TAPE MACHINES (RIGHT) FOR *EIGHTEEN HAPPENINGS IN SIX PARTS*, 1959 (PHOTOS © FRED W. McDARRAH)

paint-can "head," and wooden "arms" that offered numbered and lettered cards. Equipment included several slide projectors, a record player (in the "sandwich man"), eight reel-to-reel tape machines with individually programmed recordings, four loudspeakers hung in the corners of the loft, and rows of colored and sometimes blinking sixty-watt lightbulbs lining the top of each wall. Kaprow also recycled his *Rearrangeable Panels* assemblage of 1957 (adding several "fruit" panels to it) as the north wall of one of the rooms.

As the early October performance dates neared, Kaprow fashioned the invitations: he filled small glassine envelopes with cinnamon sticks, torn and cut-up bits of his own collages, and other tactile stuff intended to appeal

AUDIENCE MEMBERS AT *EIGHTEEN HAPPENINGS IN SIX PARTS*, 1959 (PHOTO © FRED W. McDARRAH)

ditions were made right for a Happening, but he also wanted to know whether this radical new art could take place in the art world. He sensed that heading into the everyday world of commonplace materials, processes, and events would raise compelling and maybe even important philosophical questions about the boundaries between art and life. Ever since his exhibitions at the Hansa Gallery—or even further back, to the days in Hans Hofmann's class in the late 1940s—Kaprow had been working methodically to infuse the heavy-handed, mythically weighted conventions of postwar American art with a sense of the physical, prosaic, extemporaneous quality of contemporary urban experience. Working his way from paintings to action collages to assemblages to environments to event compositions, Kaprow had continually questioned the aesthetic conventions of framing, the relationship between subject and object, the distinction between artist and audience, and the roles of intention, chance, and the senses. Now, all that questioning was about to culminate in a grand experiment. The Happening—with its carefully composed score, geometrically divided floor plan, six sequential parts, three simultaneous performances, eight overlapping sound tracks, ritualized physical movements, "rapidly" or "quickly" projected slides, precisely spoken text, eccentrically constructed props, unequivocal directions to the performers, and terse instructions to the audience—was a compendium of aesthetic conventions being overturned.

Audience members were assigned either to the first or to the second room. They found their seats and waited. Part one began with a single reverberating note from a bell, followed by loud, nonharmonic electronic sounds from the four loudspeakers. The lights of the third room, in the back, were darkened. Walking slowly and in single file, two men and three women proceeded down the hallway to the rooms where the spectators were seated. Michael Kirby, an audience member, recalls that their movements were "clear, simple, and unspontaneous."[2] They walked "slowly, carefully, almost stiffly" and only in

to the senses. These were sent to a "who's who" (or a "soon-to-be who's who") selection of the New York art world, some of whom were asked to help defray costs by making a small donation. John Cage gave five dollars, as did George Brecht; George and Helen Segal gave ten; Robert Motherwell gave ten but didn't attend. Also named on the fourteen-page guest list were David Tudor, Claes Oldenburg, Jim Dine, Jasper Johns, Leo Castelli, Ivan Karp, Dan Flavin, Meyer Schapiro, Richard Bellamy, and Fairfield Porter (who later wrote a negative review in *The Nation*[1]), as well as writers from various other magazines. Clearly, what many would later come to regard as a "spontaneous" Happening was as planned as any New York social event; it was, in fact, a kind of art-world coming-out.

Kaprow wanted to find out what would happen if con-

straight lines, their faces betraying no emotion; they never crossed the space diagonally. The performers copied the poses of the stick figures in Kaprow's preliminary drawings. For example, one man stood for sixteen seconds with his hands on his hips; another, his elbows extended like wings, bent forward as if in a mock bow; and one of the women stood for ten long (and perhaps excruciating) minutes with her left arm raised. A slide projector in the semidark third room cast sixteen color images of children's art and Kaprow's own works against the wall dividing the second and third rooms, while on either side of the projected images, through the plastic sheeting, could be seen the shadowlike "silent, ritualistic movements" of the three female performers. The audio speakers then went silent and the lights in the third room came on. Part one was over.

Part two began two minutes later. The bell rang again, and two men in suits walked slowly and formally down the hallway, each carrying a placard. They began reading their cards simultaneously. One said, "It is said that time is essence . . . we have known time . . . spiritually . . . as expectation, remembrance, revelation, and projection, abstracting the moment from its very self." The other said, "I was about to speak yesterday on a subject most dear to all of you—art. I wanted to speak then about art, but I was unable to begin." At the same time, a recording of one of the speeches played in another room.

Part two was over in less than three minutes. It was followed by a fifteen-minute intermission, during which the spectators, following the directions on their numbered cards, moved to new rooms. When the bell signaled the beginning of part three, everyone was sitting or—since in some rooms there was a deliberate shortage of chairs—standing in a room different from that in which they had started. The mix of people in each room was fresh, friends and couples having been randomly broken up; associates, acquaintances, strangers, even enemies were suddenly sharing space.

A moment later, two women proceeded down the nar-

MEYER SCHAPIRO (CENTER) TALKING WITH GEORGE SEGAL (RIGHT) AT *EIGHTEEN HAPPENINGS IN SIX PARTS*, 1959 (PHOTO © FRED W. McDARRAH)

row corridor, "followed at long intervals by two men and another woman." The first man entered the middle room and sat at a cloth-covered table. The second man, carrying a board loaded with numbered wooden blocks, stood briefly in the doorway and then started to arrange an equal number of blocks on each side of the board. When this man was finished, the first man stood up, walked to the "sandwich man," turned on the record player, and placed the needle on the record, which intoned, "Are the gentlemen ready?" The first man sat back down and faced the second across the table, with the blocks arranged between them, as if preparing for a match. The recording continued, "They shall ready themselves. . . . The time is near. . . . Now is the time. Number 1, his move." In response to this and similar prompts, the two

ROBERT WHITMAN PLAYING A BLOCK "MATCH" (LEFT) AND ROSALYN MONTAGUE SQUEEZING ORANGES (RIGHT) DURING PERFORMANCE OF *EIGHTEEN HAPPENINGS IN SIX PARTS,* 1959 (PHOTOS © FRED W. McDARRAH)

expressionless men moved blocks around the table. Meanwhile, in the first room a woman bounced a ball while another enacted "a series of formal movements." In room three, the third woman stood and "in a soft, lilting style" began a recitation ("Fine cocked-feathered moon, me friend, over and up in the moon . . ."). In the middle room, after the two men had arranged all of the blocks into a large rectangular shape in the center of the table, they ceased to move. The record continued to give instructions, finally ending "in the middle of a word." The high-pitched sounds coming from the record player's speakers stopped, and the end of the woman's recitation was heard throughout the space: "Hackie, drive up here

and let me listen to your meter sing. It alone has the voice of New York City." In the middle room, the men turned off the record player. This marked the end of part three.

The bell sounded the beginning of part four. Electronic sounds resumed. Two men and two women, each carrying a musical instrument (a toy ukulele, a flute, a kazoo, and a violin), entered the first room and stood in a line facing the audience. Independent of one another, they began playing. "Standing with erect dignity, the ukulele player strummed a few quick chords and stopped suddenly," Kirby recalls. "The violin bow was scraped across the strings. The kazoo grunted and warbled. The flute blared shrilly and then went silent." This "concert" could be heard throughout the loft, although it could be seen only by those in the first room. At its conclusion, one of the men, after "solemnly" striking nineteen matches, picked up a spray can from a stool and began spraying a

plastic screen hanging between him and the audience until he was completely hidden from view, reappearing soon after as the spray, a kitchen cleanser, began to evaporate. Part four was over, and audience members moved again to rooms designated on their note cards.

At the beginning of part five, a woman entered the first room, which contained a table arranged with twelve orange halves, twelve glasses, and a juice squeezer. She began methodically squeezing juice from the oranges into several of the glasses. The fumes from opened cans of enamel paint mixed with the aroma of the freshly squeezed oranges. The smell, which Kirby describes as "pungent," was intensified by the "unseasonably warm" weather, the hot lights, and the restricted ventilation. From the main loudspeakers came a "fast and noisy jumble" of sounds and words that included "Lionel trains," "I don't know, but . . . ," and "pretty baby." At the same time, a woman pushed the "sandwich man" from its corner in the third room into the first, where the woman was squeezing oranges. She plugged it into an outlet dangling from the ceiling, and the record player started, blaring out "an old, loud, brassy polka tune."

As the "sandwich man" was pushed through the second room, a man in the audience got out of his seat and approached the muslin panel set in the wall between the second and third rooms. Simultaneously, another man in the third room did the same, so that they faced the same panel from opposite sides. After a moment, they picked up brushes from the small paint cans sitting on the floor and began painting either vertical strokes in red or loose circles in blue. As the paint stained through the muslin, each painter (Robert Thompson and Alfred Leslie the first night,[3] Robert Rauschenberg and Jasper Johns another night) began responding in an improvisational manner to the seeping stains of his partner. As they painted, a man in the second room kneeled on one knee, rolled up one leg of his trousers to the knee, stood, knelt again, and rolled up the other leg. He then "seriously" brushed his teeth. Three performers in the third room read placards

aloud, the readings overlapping: "Would you kindly innocently raise your eyes a tiny, tweeky, single?" "My toilet is shared by the man next door who is Italian." When the readings were finished, the performers stood silently while the lights were switched off and a quick sequence of slides—a "visual poem" titled "Mary Had Fleas" by Kaprow—flashed through the darkness, hanging briefly on the plastic wall separating the second and third rooms. The bell rang, the motionless performers walked out, and a two-minute interval ensued.

The final part of the Happening began when two women walked down the corridor and turned into the middle room, where they stood facing audience members in silence. In the third room, two men entered and stood

KAPROW WITH THE "SANDWICH MAN" DURING *EIGHTEEN HAPPENINGS IN SIX PARTS*, 1959 (PHOTO © FRED W. McDARRAH)

on either side of the muslin screen, where they began performing roughly synchronized movements, including walking to opposite walls and stepping toward and away from the audience. Their movements, silent and semivisible through the plastic wall, contrasted with the motionless stance of the women in the next room. The men completed their movements, walked slowly to the middle room, and stood facing the women. The lights in the third room were turned off for the last time, and a single slide showing, as Kirby describes it, "the expressionless mouth and chin of a bearded man" (Kaprow's) was projected on the screen. One of the performers reached above his head and pulled a string, unfurling the four long purple and red scrolls from a beam suspended above the floor. They fell "like a paper wall" between the male and female performers, who began reading the monosyllabic words and expressions printed on them, including "eh?" "mmmmm," "uh," "but," "well," "oooh," and so forth. Finally, the bell rang twice, the four performers walked in silent single file from the room, and *Eighteen Happenings in Six Parts* was over.

Although it heralded a period of intense experimentation by visual artists, poets, dancers, musicians, and composers, *Eighteen Happenings* was, for Kaprow, less a beginning than a resolution of the materials, methods, and theories of the mentors he had been working with since he constructed his environments at the Hansa Gallery. Like the bell that rang twice to signal the completion of the event, *Eighteen Happenings* signaled the end of Kaprow's formative phase as an artist. He had finally experienced what a Happening looked, sounded, smelled, and felt like. It was a critical success, but it was over.

Even though Kaprow would never again compose anything as complex and calculated in the service of aleatory experience, the experiment yielded verifiable data that he drew upon at least through the 1960s. The performance was a collage of direct and indirect sensory experiences that approximated the cacophony of the everyday urban environment. It challenged the boundaries between performers and audience by mixing them up

and moving them around. Chance associations for the audience emerged from the artist's rigorously enforced script. The performance was conceived as a total work of art but could be experienced only partially. It was segmented over time but had no plot. Its performers undertook tasks but did not act. Its tasks embodied action but were not self-expressive. Words were spoken but did not always make sense. Sounds were broadcast but did not harmonize. The smells of oranges and of enamel clashed in the early evening heat. Couples who came together were directed by cards to separate rooms, where they had separate experiences. The happenings in one room were interrupted by the shadows, sounds, and smells of those in another. Life spilled over into art.

Eighteen Happenings in Six Parts also included references to other art forms: the "action" of Action Painting, jazz improvisation, the planar geometry of Cubism, Cagean silence and noise, Paul Taylor's mechanical movement, Charlie Chaplin's *Modern Times,* Fernand Léger's *Ballet Mécanique,* T. S. Eliot's "The Wasteland," a haiku by Matsuo Basho ("plup plup plup, the oatmeal boils"), the nonsense of Dada, the absurdity of Brechtian theater, the ventriloquist's dummy Charlie McCarthy, the art of children, and, of course, collage. Although it reflected Kaprow's refined awareness of art history and his grab-bag aesthetic sensibility, *Eighteen Happenings* was not heavy with art. If anything, Kaprow's admixture of quotations from the high arts and popular culture—Eliot and McCarthy, for example—lightened the atmosphere of what might otherwise have been an evening of weighty Modernist references (for those who understood them).

For Kaprow, such quotations were more like Modernist background noise, throwaway lines in a new kind of chance-operational theater. The work was commonplace expressionism held in check by chance procedures. In this sense, the performance felt like an index of something being left behind. The atmosphere of existential gravity so important to postwar American painting had been replaced by flat-footed equivalencies among banal, incidental elements. And Kaprow leavened his event collage

DRAWING FOR THE "SANDWICH MAN" IN *EIGHTEEN HAPPENINGS IN SIX PARTS*, 1959 (PHOTO: JEFF KELLEY)

ROBERT THOMPSON PAINTING MUSLIN WALL DURING *EIGHTEEN HAPPENINGS IN SIX PARTS*, 1959 (PHOTO © FRED W. McDARRAH)

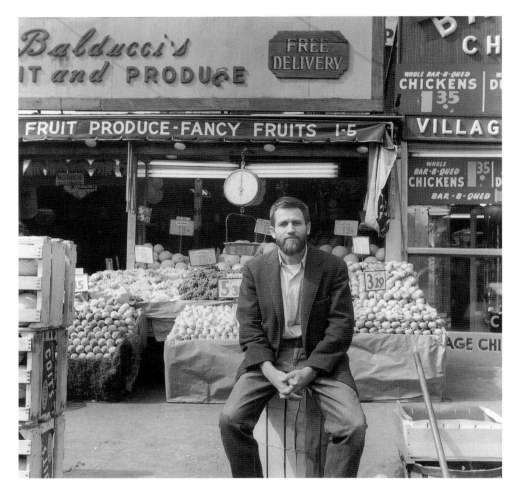

KAPROW IN NEW YORK, SEPTEMBER 15, 1959 (PHOTO © FRED W. McDARRAH)

with enough dumbbell parodies of High Modern masters (Pablo Picasso, Alberto Giacometti, Jackson Pollock, T. S. Eliot, and others) that, despite its avant-garde self-consciousness, *Eighteen Happenings in Six Parts* was occasionally and plainly funny. The Happening was less Wagnerian *gesamtkunstwerk* than kitchen-sink art, a work with everything thrown in. This is not to say that it was unserious—for serious it undoubtedly was—but Kaprow had effected a sense of play among staid and solemn parts.

Thus, a stentorian speech and a pompous soliloquy were joined by a pun-filled haiku, and what at first seemed to be a chess match settled into a game of children's blocks. Kaprow's humor was less like a belly laugh than the quiet appreciation of a riddle. The performance entailed parody but never ridicule; mostly, it invited delight.

For all its complexity and sophistication, *Eighteen Happenings in Six Parts* was essentially an exercise in substituting the conventions of routine activity for those of the

plastic and performing arts. In a Cagean bait and switch, the promise of aesthetic "meaning" was replaced by the "as suchness" of ordinary subjects, objects, materials, processes, and actions. Yet as the performance settled into its prosaic routines, the attentiveness it awakened in its audience conferred upon the entire affair a kind of floodlit awareness of the extraordinary character of ordinary things. Kaprow provided a performance framework in which the kind of aesthetic awareness usually reserved for the artist (and for art) could be shifted to members of the audience. As they became enmeshed in the weave of events, the Happening became *their* experience. Kaprow took the audience through Pollock's space and Cage's time.

Cage was unconvinced. He felt Kaprow had bullied his guests by moving them around and fixing their attention on selected materials, processes, and events. In this, he sensed the driving force of the artist's will, which, in Kaprow's case, he regarded as too authorial and expressionistic. For Cage, those in the audience were supposed to witness the play of chance phenomena; the job of the artist was to get out of the way, not to treat them like chess pieces.[4] This, together with its art-world guest list, its strict compositional structure, and its generally inaugural bearing, must have given Cage the sense that *Eighteen Happenings in Six Parts* was the overblown progeny of his humble Black Mountain College event seven years before.

Kaprow, of course, felt otherwise. He had merely extended Cage's theory of chance operations to include members of the audience. By orchestrating their movements, he could reiterate the randomness unfolding all around. The precision of the formal composition gave way to a collage of sensations, and it was those sensations that mattered to Kaprow. He had accounted not only for the phenomena witnessed but also for the very phenomenon of witnessing. To the extent that his guests felt themselves to be amid impromptu goings-on, their witnessing gave rise to aesthetic experiences that could no longer be claimed by the artist alone. It was the unpredictability—even the unknowability—of those experiences, and not the precise scoring of the Happening, that was its aleatory measure.

If *Eighteen Happenings in Six Parts* was coercive (as many New York Happenings were subsequently perceived to be), it was in the spirit of blurring the edges between composer, performers, and audience, with the ultimate aim of eliminating the audience altogether by offering its members the opportunity to participate in the work's unfolding. The willingness of the audience to be directed from room to room was, in this instance, a tacit, early form of participation, albeit "by design." Cage had continued to separate artist and audience and to rely on the concert hall, or its equivalent, to focus the audience's attention on what he wanted it to experience. His disapproval of *Eighteen Happenings* was prompted by the change in context: the performance space had been extended to include the audience as well as the players.

Kaprow had his eye on the gallery door. The sounds, smells, textures, tempos, movements, materials, and even the directives of *Eighteen Happenings* represented the life taking place on Fourth Avenue, just outside the Reuben Gallery. Over the next several years, he worked his way out of the art space altogether and ventured into the industrial lofts, church basements, hotel courtyards, underground breweries, department stores, train terminals, and telephone systems of the modern urban environment. Out there, he endeavored to call attention to the commonplace without benefit of walls, seats, actors, or stages. He extended Cage's silence—which was, after all, nothing of the sort—into the urban din, where something other than a concert hall or an art gallery was needed to ensure aesthetic awareness. That "something" was work—tasks like eating an apple or throwing a tire. Kaprow's tasks were perhaps of dubious aesthetic merit, but they were nonetheless instrumental in framing awareness, whatever awareness comprised and wherever it happened to be.

chapter four happenings in the new york scene

A change took place in Kaprow's work after *Eighteen Happenings in Six Parts,* influenced in part by the more spontaneous, physical, and youthfully enthusiastic performances of his colleagues. *Eighteen Happenings* may have been the culmination of several years' work for Kaprow, but for other artists it was the beginning of an intense period of experimentation with the performance genre suddenly known as Happenings. Although only a handful of artists were presenting them, the Happenings of the early 1960s quickly gained a reputation for being chaotic, spontaneous, "anything goes" forms of avant-garde theater, and they acquired a certain word-of-mouth notoriety within the New York art world for generating an atmosphere of "frenetic energy and adventure."[1]

In contrast with the precise, methodical approach employed by Kaprow, other Happeners executed raw, roustabout events, an impetuous, often expressionistic theater tossed off in the exuberant spirit of the moment. Few were interested, as Kaprow was, in eliminating the audience, preferring to play to it instead. Still, in the wake of the summative and exhausting *Eighteen Happenings,* Kaprow was attracted to the frank physicality and unrestrained action of others' Happenings, qualities he began to see as possible correctives for his own work. He was looking for a way out of the detached formalism of the Cagean process, and he sensed that a less methodical approach to Happenings would provide the route.

Happenings were as different as the artists who presented them—less an art form than a convergence of interests around the idea of extending visual expression into concrete action and physical space. For Red Grooms, sculptural environments became elaborate sets for a primitivistic, improvisational kind of singsong theater in which performers exclaimed, whistled, called, and participated in rudimentary conversations. Jim Dine's Happenings were more vaudevillian—transcendent and hysteric, but still carefully structured, like a well-timed punch line. He made the "theater" of the painting process

his subject in *The Smiling Workman* (1961), scrawling "I love what I'm doing" on a large, empty canvas, then jumping through it after drinking from several jars of "paint" (tomato juice) and pouring the rest over himself. Robert Whitman, by contrast, was interested in creating poetic sequences of abstract images. His approach to Happenings—a word he rejected in favor of "theater pieces"—was neither physically raw nor theatrically bombastic, but spare and almost delicate in its use of materials (such as fabric, paper, confetti, projected film) and actions (a man hanging above the audience on a trapeze). Claes Oldenburg was more literary, an inquisitive intellectual versed in theory. Having been a reporter in Chicago, he introduced a curiosity about the larger world into his works, which sometimes resembled crime scenes. In *Snapshots from the City* (1960), Oldenburg wrapped him-self in rags and posed for thirty-two tableaux in a room littered with spray-painted cardboard, newspaper, and other urban debris, with each pose momentarily illuminated by a camera flash. He believed Happenings came about when painters and sculptors crossed over into theater, bringing with them their own ways of looking and doing. "Nothing is communicated or represented," he said, "except through its attachment to an object."[2]

Kaprow gave readers a kaleidoscopic sampling of Happenings' "greatest moments" in his article " 'Happenings' in the New York Scene," which appeared in *Art News* in 1961:

Everybody is crowded into a downtown loft, milling about, like at an opening. It's hot. There are lots of big cartons sitting all over the place. One by one they start to move, sliding and careening drunkenly in every direction, lunging into one another,

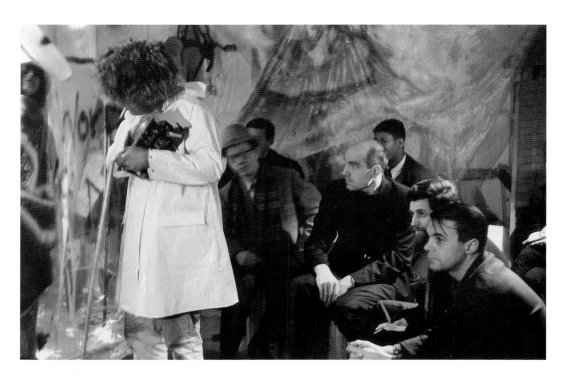

AL HANSEN (LEFT) PERFORMING *RED DOG* BEFORE MICHAEL KIRBY, ALLAN KAPROW, JOHN WILCOX, AND OTHERS AT THIRD RAIL GALLERY, NEW YORK, 1964 (PHOTO © FRED W. McDARRAH)

accompanied by loud breathing sounds over four loudspeakers. Now it's winter and cold and it's dark, and all around little blue lights go on and off at their own speed while three large brown gunnysack constructions drag an enormous pile of ice and stones over bumps, losing most of it, and blankets keep falling over everything from the ceiling. A hundred iron barrels and gallon wine jugs hanging on ropes swing back and forth, crashing like church bells, spewing glass all over. Suddenly, mushy shapes pop up from the floor and painters slash at curtains dripping with action. A wall of trees tied with colored rags advances on the crowd, scattering everybody, forcing them to leave.... Electric fans start, gently wafting breezes of New-Car smell past your nose as leaves bury piles of a whining, burping, foul, pinky mess.[3]

Piles of a whining, burping, foul, pinky mess? This sounds like a different artist, less a Cagean researcher than an aggrieved Beat poet. Though the violence in the description—spewing glass, lunging cartons, slashing painters—hints at Kaprow's desire to "scatter" the audience, his account is entirely fictional, written merely to promote Happenings. After offering readers this surrealistic taste of the "scene," Kaprow reverts to academic form, distinguishing among the different types of Happenings then being practiced: "the sophisticated, witty works put on by the theater people; the very sparsely abstract, almost Zen-like rituals given by another group (mostly writers and musicians); and those in which I am most involved, crude, lyrical, and very spontaneous."[4] Crude, lyrical, and very spontaneous? This, too, sounds like a different artist—certainly not the choreographer of the refined and calculated *Eighteen Happenings in Six Parts*. It sounds, rather, like a composite of all the other artists then doing Happenings. It's almost as if Kaprow had left his research methodologies of the late 1950s behind and jumped on the Happenings bandwagon he'd started rolling.

In the fall of 1958, the Judson Gallery had been established in a cramped basement room of the Judson Memorial Church in Greenwich Village. The Reverend Howard Moody was interested in reviving the social viability of the

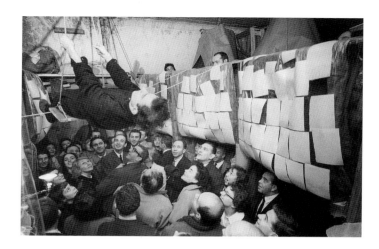

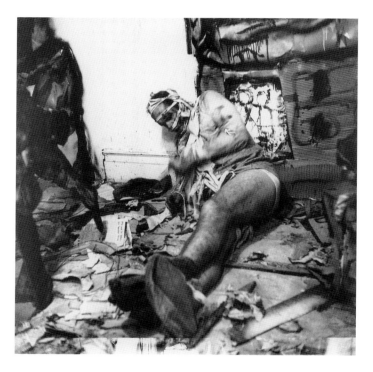

TOP: ROBERT WHITMAN, *AMERICAN MOON*, WITH LUCAS SAMARAS ABOVE AUDIENCE, REUBEN GALLERY, NEW YORK, 1960 (PHOTO BY ROBERT R. McELROY, © ROBERT R. McELROY/LICENSED BY VAGA, NEW YORK, NY)

BOTTOM: CLAES OLDENBURG, *SNAPSHOTS FROM THE CITY (RAY GUN)*, JUDSON GALLERY, NEW YORK, 1960 (PHOTO © FRED W. McDARRAH)

modern church and regarded artists as members of the Judson congregation. Together with his assistant minister, Bud Scott, he reached out to the local neighborhood, giving the gallery over to artists as a place for artistic experimentation and a forum for inquiry into social issues. (Scott later sermonized that if once artists had gone to the church, the church now went to the artist.[5]) With the Reuben Gallery joining the scene one year later, a kind of dual sponsorship of environments and Happenings took place through 1962. Both galleries hosted a number of evening events in which various artists presented individual Happenings in a sort of festive, burlesque atmosphere. The events had to be doable—and given the experimental, low-budget makeup of these venues, this meant they had to be cheap, portable, and usually unrehearsed. They were also brief, unrepeatable, and open to failure. It was the slapdash, improvisational character of this scene that lent Happenings their public reputation as a form of "anything goes" theater. Oldenburg later characterized this moment in history as "a curious mixture of Expressionist aesthetics and Cagean aesthetics." The "scene" around Happenings was both aesthetically expansive and "socially inbred."[6] Kaprow, hardly a roustabout, decided to "step right in."[7]

the big laugh

In January 1960 the Reuben Gallery presented a series of Happenings called "Four Evenings," in which several events by different artists were presented each evening. Kaprow decided, partly as an antidote to the remote high seriousness of *Eighteen Happenings,* simply to provide entertainment. He called his segment *The Big Laugh.*

It was carnival theater, drawing upon circus barking, snake-oil sales pitches, street hawking, and soapbox oratory. Lucas Samaras stood on a chair, holding a "medicine bottle" and reciting nonsense; Richard Bellamy handed out balloons on sticks to people in the audience; Al Hansen entered and began a string of stentorian an-

nouncements: "Ladies and gentlemen! Listen! Listen! Listen!" "The next sound you will hear will be . . . lyric of dove!" "Trumpet delay in spinach!" "Forthcoming! Symbolical-bolical!" "Dressmaker's butter!" "My excellent friends, my good ladies and gentlemen! The aware hare!" "His fourth coming!" "Approaching despair, my friends!" "The enemy approaches!" "Here come our friends!" "Look sharp! There is a reporter!" "Down, down, I say, my good people! Down with the damp!" "The bell for pants!" "Eleven to shoes!" "Sheet of shoat!" "Brute of brat!" "Kugel's kugel! . . . My fine feathered ladies and gentlemen." "The hero arrives!" Each phrase was punctuated by a sound coming from behind a curtain, an electric saw or a handsaw cutting wood or a recording of applause from a record player. Near the end of Hansen's announcements, Oldenburg and Dine, faces painted like clowns, burst through the front door and hurried to ladders on opposite sides of the room. From behind the curtain, Kaprow blew a police whistle. As Samaras finished his pitch, he put down the medicine bottle and inflated a balloon he had taken from his pocket. Oldenburg and Dine mounted their ladders and, on pulley lines suspended just above the heads of the audience, sent muslin banners with crudely painted lips (visual laughs) and words ("Lola!") streaming across the room while they cried "Lola Bola Lola Bola!" Hansen and Bellamy, smiling, moved quietly through the audience, handing out cards and balloons. Samaras stepped off his chair, screeching "Lola Bola!," and continued to screech until he tapped the shoulder of Hansen, who turned and showed him a card from inside his vest pocket (like a dirty picture). Then there were more cries of "Lola Bola!" as Dine and Oldenburg scrambled down their ladders. Samaras popped his balloon, and the players, one after another, laughed exaggeratedly. Kaprow, still behind the curtain with the record player, drowned them out with a laugh track. Bowing to one another, several of the players said in unison, "Thank you, ladies and gentlemen. That is all." The whole performance took about seven minutes.

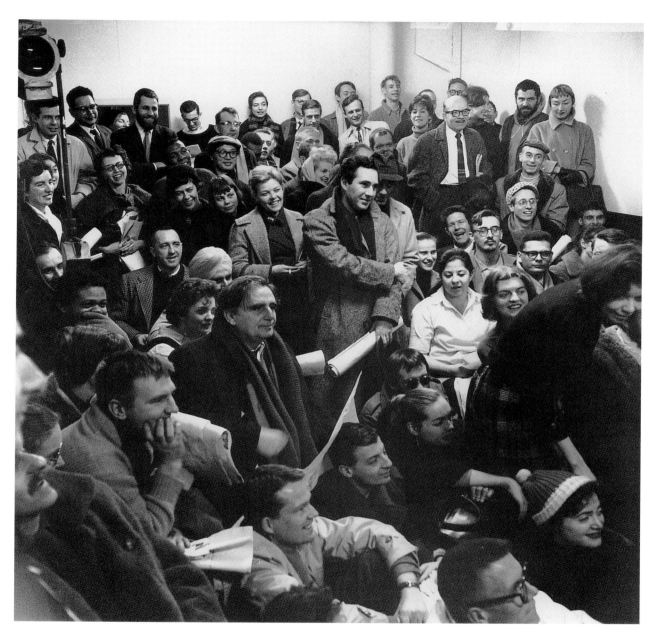

AUDIENCE (ALLAN KAPROW FOURTH FROM LEFT IN BACK) AT CLAES OLDENBURG'S
RAY GUN HAPPENING, JUDSON GALLERY, NEW YORK, 1960 (PHOTO © FRED W. McDARRAH)

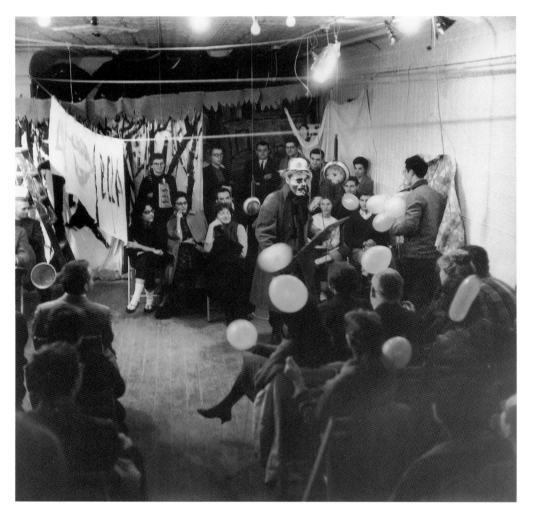

Despite his commitment to a new "total art," Kaprow made no attempt to hide the fact that *The Big Laugh* was rooted in theater. It was, however, a kind of vernacular or "bunkhouse" theater in which the performers played types: pitchmen, barkers, clowns, snake-oil salesmen, soapbox orators, and the guy who wants to show you a watch under his coat. Furthermore, there was no plot, only a quickly paced collage of disjunct and overlapping actions, and although there *was* an audience, the formal performer / audience relationship was constantly jarred by players who, perched atop chairs or ladders, called and announced and appealed, who moved through the room with handouts, and who sent banners skirting the tops of heads. The audience was right in the middle of the

Happening, and the gallery seemed more like a public square, with its admixture of hype and hustle and hyperbole, than a performance hall. The laughter, too, was part of the artifice. No more genuine than the pitchman's medicine, it was incorporated into the performance in the form of visual banners, forced guffaws, and recorded laugh tracks. Since the Happening wasn't particularly funny, Kaprow did the laughing for the audience.

Kaprow had composed a score (especially for the sounds) and had rehearsed the performance once, but the event's frenetic pace and general atmosphere allowed him to loosen the screws, giving his performers greater latitude to improvise and even get things wrong. In the wake of *Eighteen Happenings,* Kaprow felt more refinement would have led to a kind of modern opera, equivalent to what was then being done by Karlheinz Stockhausen.[8] Kaprow had used a handsaw and an electric saw in experiments for Cage's class, but mostly to make noise. Here they were used to a more expressionistic effect, creating abrupt discontinuities, moment by moment, for the purpose of keeping things open: there was no plot, no narrative, no denouement. With references to carnivals and rodeos and medicine shows, Kaprow expressed his interest in a marginal world of antics, resulting in a kind of pre-Pop indulgence—indeed, Kaprow wanted his audience to say, "We've seen this before, only it's nuttier."

coca cola, shirley cannonball?

In February 1960 Oldenburg organized a series of presentations by various artists (including Dine, Hansen, Whitman, and Dick Higgins) called "Ray Gun Spex" ("spex" being an abbreviation for "spectacle" and translating from Oldenburg's ancestral Swedish as "burlesque"). Kaprow's contribution, *Coca Cola, Shirley Cannonball?* was a ten-minute dance routine "performed" by a nine-foot-high cardboard foot and a telephone-booth-sized cardboard torso. Held together from within by a rickety wooden framework, each was hollow and designed for a person

to fit inside, feet on the floor. The curved organic shape of the foot was copied from a painting by Joan Miró, and the torso had tin cans hanging from strings on one side so that it rattled when it moved.

Kaprow's choreography was simple, yet enchanting. The handwritten score instructs the foot to take "2 steps right, 1 hop left, 3 sways, 5 jumps up & down, 1 step forward (not swaying), 6 jumps in a circle around construction (counterclockwise)." The clattering tin cans attached to the box provided the foot's musical accompaniment. The duet between the silent foot and the rattling torso played out on the wooden floor of the Judson Gallery un-

COCA COLA, SHIRLEY CANNONBALL?, JUDSON GALLERY, NEW YORK, 1960 (PHOTO BY ROBERT R. McELROY, © ROBERT R. McELROY/LICENSED BY VAGA, NEW YORK, NY)

der a wandering spotlight. At one point, a voice from the darkness said slowly and remotely, "Hellooo, Sam Spade."

Kaprow saw *Coca Cola, Shirley Cannonball?* as an opportunity to eliminate actors by letting objects—exaggerated body parts—perform themselves in a parody of performance. Like the toy soldier scene from *The Nutcracker Ballet,* the props came improbably to life, but more in the spirit of a slow-motion square dance than a ballet. It was fun. Kaprow appreciated the artfulness of his little ballet, preferring it to the nuttiness of *The Big Laugh,* but the lesson he drew was to never do either again.

Meanwhile, Happenings were becoming very popular. For many, the performances were "of the moment": they created their own scene, and the scene itself was a kind of Happening. *The Big Laugh* and *Coca Cola, Shirley Can-nonball?* were developed, in part, in response to the market pressures of a suddenly "happening" scene. Still, Kaprow saw the increasing popularity of Happenings as a red flag signaling the first of several confrontations with the realities of mass appeal. As early as 1961, in "'Happenings' in the New York Scene," he wrote, "Some of us will probably become famous. It will be an ironic fame fashioned largely by those who have never seen our work." As Happenings became the subject of gossip and rumor, he was moved to confess that "I shouldn't really mind, for as the new myth grows on its own, without reference to anything in particular, the artist may achieve a beautiful privacy, famed for something purely imaginary while free to explore something nobody will notice."[9]

Increasingly, that "something" was the active partici-

AUDIENCE MEMBERS WATCHING THE "FOOT" DANCE, *COCA COLA, SHIRLEY CANNONBALL?*, 1960
(PHOTO BY ROBERT R. McELROY, © ROBERT R. McELROY/LICENSED BY VAGA, NEW YORK, NY)

pation of others in his Happenings. The audiences in *The Big Laugh* and *Coca Cola, Shirley Cannonball?* had remained standing masses, largely unchallenged except by performers moving through and around them. In this respect, their experience was the inverse of the spectators of *Eighteen Happenings,* where a big show was made of moving the audience from room to room. More and more, Kaprow came to regard the audience as the central convention of the performing arts. It had to be eliminated if actual participation in—and direct experience of—his Happenings was to occur. His problem was how to eliminate the audience without canceling the performance.

childsplay

Around this time, Kaprow began noticing how his three small children played together in an unscripted yet wholly participatory way. Theirs was a self-generated kind of play in which a proposal—"let's play house"—would either be accepted or an alternative—"no, let's make a fort"—advanced. Roles would be negotiated, after which the playing would commence *without an audience.* These were the maturation rituals by which children, donning their stereotypical roles, played at life. Kaprow wasn't interested in mimicking children's play in his art, nor was he inspired by sentiments about childhood. Rather, he began seeing "childsplay" as an attitude toward playing that he could imagine in its adult forms.

This was a watershed observation for Kaprow, and it came not from the arts, but from his own backyard. It allowed him to go from being a composer of aleatory phenomena to being a copycat of social and natural processes; from trying to "play" the audience to actively seeking playmates; from orchestrating collages to following the play of events; from writing detailed scores to proposing general plans. His templates for aesthetic experience could now be drawn directly from life, a rich and running montage of games, rituals, routines, exchanges, choices, conundrums, and jokes.

Kaprow's children had shown him the way out of theater, but even their playing needed adapting to the kind of adult nontheater he was after. Their hotly negotiated "roles"—mommy, daddy, doctor, nurse—were too much like the dramatic personae of the stage, so eventually, in place of roles, Kaprow would assign the performance of common routines, tasks, and choices to participants. Childsplay was not merely a source for art in life, but a way of doing things, an operation. In observing its rules and patterns and by reading contemporary game theory and Johan Huizinga's *Homo Ludens: A Study of the Play-Element in Culture* and Erving Goffman's *The Presentation of Self in Everyday Life,*[10] Kaprow was able to make a key distinction that would underlie all his subsequent work: *that games and play are not the same.* In time, he came to see "gaming" as the work-ethical regulation of play in modern industrial society, the purpose of which is to optimize the chances for achieving an outcome, whether profits or victory or, as Huizinga suggests with reference to the ancient Greco-Roman contests, transcendence of life's imperfections and maybe even the approval of the gods. Though neither transcending life's imperfections nor optimizing the efficiency of play concerned Kaprow in terms of his own work, his reading helped him clarify the extent to which games, even on the level of "cosmic happenings," were competitive. During his childhood, competition had been anathema to Kaprow because of his health, and playing had been a largely solitary imaginative activity. Perhaps because of this, he was now both attracted to the sociability of childsplay (he could finally have playmates) and suspicious of the competition brewing among his colleagues and himself as Happenings became increasingly popular.

Ever since *Rearrangeable Panels* (1957), Kaprow had been experimenting with the audience, trying to break it up, move it around, envelop it with junk, mesmerize it with sounds, seduce it with tastes, assault it with smells, cut through it with clownishness, instruct it with scores, and otherwise ring its Pavlovian bells—all attempts to do

away with conventional theater and infuse the audience with an experience of the immediacy of the modern creative moment. What the model of willful participation evident in childsplay suggested to Kaprow was that instead of trying to "eliminate" the audience, he should figure out how to find adults who were willing to play.

This shift from collaging events to playing is among the most important in Kaprow's career. It would allow the personal and social dynamics of participation to unfold in ways that might not have been possible if scored in advance and presented to an audience. It also meant that Kaprow would replace collage with metaphor as the organizing principle of his events; instead of composing events that generated chance experiences for the audience, he would select "a good metaphor"—say, a choice between eating a real apple and stealing a wax one—as the basic plan for an activity. Within the general parameters of that plan, he and his participants would play, *sans* audience.

This approach brought into sharper focus the two kinds of meaning in Kaprow's work: that of the plan and that of the plan's enactment. The choice between eating a real apple and pocketing a wax one is both a parable about virtue and sin and a philosophical conundrum about whether to eat (and thus destroy) a real thing or to take (and thus preserve) its fake. These metaphorical meanings, Kaprow realized, had to be inviting enough to motivate others to participate in their enactment; they are the "let's do this or that" of childsplay, and they are also the focus of the artist's vision for the work. The "good metaphor" is like the "good idea" for doing a painting or making a film. Its relationship to the finished work is generative, not haphazard, and in this sense Kaprow's plans provide part of the meaning of his Happenings and environments. A plan is not the same as its enactment, however; one is an invitation to play, and the other is actually playing. While the invitation is meaningful as metaphor, the enactment of the invitation generates meaning as experience. The spectator "embodies" the metaphor by enacting the plan, and it is this embodiment that constitutes our participation in the work.

With the shift from scoring collages for an audience to proposing plans for playmates, Kaprow ceased conceiving of Happenings in the same way, and he did so at the moment of their greatest popularity in the art world. He continued to present them, but as he did so they slowly metamorphosed into new forms of nontheatrical performance. Youthful energy and popular acclaim had provided much of the purpose of the early Happenings, which were followed by Pop art, the new dance, Fluxus, the new cinema, and an internationalism among artists inclined toward performance. But Happenings for Kaprow had never been a momentary phenomenon; they were stages in the development of a new participatory art—his art. And now he had a theory of participation adapted from childsplay that would take him beyond the antics of the moment.

the apple shrine

In the spring of 1960 none of this was clear. Though a model of willing participation was beginning to form in Kaprow's mind, it would take time for him to work it out in practice. After participating in several contemporary music events ("A Concert of New Music" at the Living Theatre and "An Evening of Sound Theater" at the Reuben Gallery), Kaprow decided to make an environment that would at least bring the individual attendee, and thus the possibility of direct, physical experience, back into the work. That environment was *The Apple Shrine*.

The occasion for *The Apple Shrine* was provided in the fall of 1960, when Reverend Howard Moody asked Kaprow to be the director of the Judson Gallery. Kaprow, who had not yet done any work there, agreed to direct the gallery for a year, and he decided to initiate his tenure by creating an environment.

As a densely packed room filled with physical materials surrounding the viewer, *The Apple Shrine* harkened

back to the environments of the late 1950s. But as Kaprow's first post-Happening environment, it was less an extension-in-space of Action Painting or junk sculpture than a setting for the enactment of certain choices embedded within it. Rather than scripting the audience's movement or the performer's role, Kaprow created a place that invited participation. It embodied a kind of proposition, expressed as a choice between selecting and eating a real apple or taking a fake one. This choice ("faintly stimulating the memory of an old tale"[11]) was offered to viewers after they had negotiated a "modern labyrinth" of narrow passageways constructed from chicken wire, ripped cardboard, rags, tar paper, straw, and "enormous quantities of torn and crumpled newspapers stuffed into the wire from ceiling to floor." In the center of the environment was a gently lit, sanctum-like room in which a three-tiered wooden "altar" had been suspended above the floor. Fastened to this structure was a mix of fresh apples and their plastic, paint-splattered imitations.

Originally, Kaprow had not intended to use real apples, planning instead to reuse the plastic ones that had fallen off *Rearrangeable Panels* over the years. As the environment took shape, however, the symbolic potential of the "temptation" to pick an apple, either real or fake, became central to his thinking. In this sense, *The Apple Shrine* was the first environment to take at least part of its meaning from its setting—a church basement that was also the site of some of New York's most "underground" art. Here, the otherwise ordinary acts of eating an apple or pocketing its imitation took on the added resonance of Eve's choice and Plato's cave. The unlikely equivalence of church and art gallery allowed Kaprow to conflate the ancient religious concern over temptation with the ancient philosophical mistrust of appearances. Here, in "Kaprow's cave," one could maneuver through a jungle of urban debris—a modern anti-Eden—toward the shrine at its center, where one was confronted with the choice between real and fake fruit.

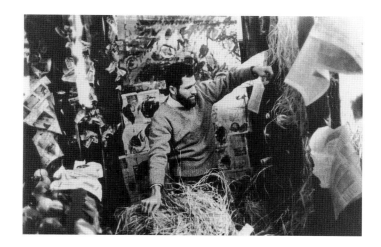

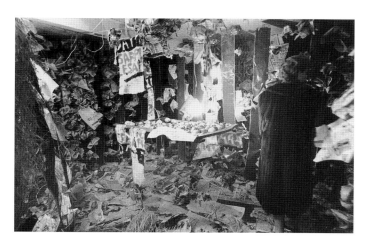

KAPROW PREPARING INSTALLATION (TOP) AND "ALTAR" OF REAL AND FAKE APPLES (BOTTOM) FOR *THE APPLE SHRINE*, JUDSON GALLERY, NEW YORK, 1960 (PHOTOS BY ROBERT R. McELROY, © ROBERT R. McELROY/LICENSED BY VAGA, NEW YORK, NY)

This choice posed an interesting dilemma for the art sophisticate, for even though the real apples could be distinguished by eye, the visual connoisseurship necessary to navigate the labyrinth of a museum was irrelevant in the cavernous half-light of this junk-strewn basement. Other, more physical criteria obtained: in order to "know" which apples were real, visitors had to touch, pick, smell, and finally taste them. If they preferred, they could take

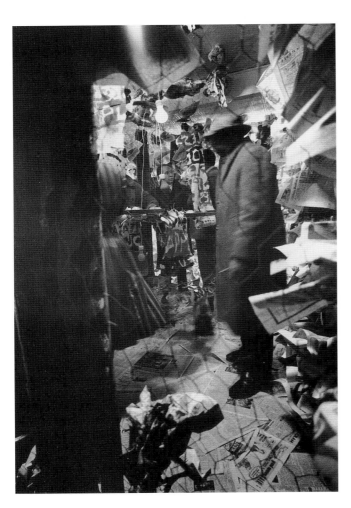

A VISITOR TO *THE APPLE SHRINE,* 1960 (PHOTO BY ROBERT R. McELROY, © ROBERT R. McELROY/LICENSED BY VAGA, NEW YORK, NY)

home a plastic apple. In doing so, of course, they would be "collecting" an Allan Kaprow "original." They could either consume or *consume*—but the bargain was stacked: to collect in this case meant to preserve a fake, whereas to eat a real apple meant destroying (or transforming?) the subject and object matter of art. What the collector got was an ersatz relic that had been through various incarnations; the apple eater got to eat an apple, plain and simple.

At the core of this choice between real and fake apples was a delicious metaphor of the relation of truth to appearances, originals to copies, pleasure to abstinence, and body to mind. Bite by bite, the metaphor whetted the appetite, echoing back through origin myths and philosophical parables, and clashing unceremoniously with modern aesthetic prohibitions ("don't touch!") and formalist critical values about art as an elite optical experience. More important, to eat the apple was literally to embody the metaphor—to "know" its meanings in a direct, physical way, *in* and *as* the body, not just through the mind's eye. This was a moment of truth for Kaprow. When the first apple was eaten, a new era of participation emerged in his work. In this and subsequent works, invitees chose whether or not to perform ordinary physical tasks that were also "good metaphors" whose meanings were drawn from the arts, history, myth, philosophy, and the sociology of modern culture.

As a physical environment, *The Apple Shrine* was itself a "good metaphor," referring variously to underground crypts in Italy stacked floor-to-ceiling with human bones and to the mysterious nature of carnival spook shows, chambers of horror, and the like, all of which Kaprow saw as part and parcel of religious belief. Even the wads of newspaper (the canonical *New York Times*), segments of which (headlines, columns, obituaries, pictures) could be read in the room's dim light, seemed like "a nameless catechism of daily events." There was "an unsought grace" in all this rubbish, but it was a secular street grace that mixed freely with an irreverence—almost sarcasm—

toward religion, which, like aesthetics, enjoined the visitor to neither touch nor ask. Waiting, snakelike, in the choice between real and fake apples was a tongue-in-cheek retort to the question of true faith as well as a serious address to the question of what it might take—at least for an artist—to move the spirit in the modern world. The fact that the place was a firetrap, the piles of junk threatening to engulf visitors in a Hell-like conflagration, added an unintentional spark to the metaphor of choosing between things true and false.

Through 1964 Kaprow's environments and Happenings developed in tandem, pushing and pulling in the process of creating a lifelike art without an audience. During this time, it may have been the environments that served Kaprow best. By framing choices as a way of enlisting participation, the environments became, in effect, latent Happenings. But what "happened" within them was on the relatively private, nontheatrical scale of individuals making simple, physical choices: about whether to pick a real or fake apple, step into a yard full of old tires (and maybe throw a few), exchange one word for another, eat bread and jam, or drink white wine or red. The settings for these choices—a church basement, a sculpture court, a brewery cave in the Bronx—were charged with meanings and associations that helped contextualize whatever "happened" there. They were like forts and tree houses for childsplay. In the end, the environments taught Kaprow that instead of staging an elaborate event, he need only offer people choices.

a spring happening

Perhaps because environments evolved from within a studio or gallery setting, Kaprow continued to regard them as basically static envelopes for sense experience, despite the fact that he had begun to incorporate choices for the audience based on his observations of childsplay. Still, he hadn't yet emptied his Happenings of theater or eliminated their audiences. It was the question of elim-

inating the audience without canceling the performance that he returned to in March 1961, when he presented his first Happening in nearly a year. It was called *A Spring Happening.*

The site of the new work was the Reuben Gallery's street-level storefront space on East Third Street near Second Avenue. (Later in the year, Oldenburg would establish his environment *The Store* nearby.) Therein, Kaprow built a structure he called a "closet," about twenty feet long by seven feet high and two feet wide, with a floor and ceiling, walls on either side, and curtains at either end. Eye-level slots that had been cut into the walls and covered with plastic allowed spectators to peer out into the dark surrounding space. Positioned on the structure's reinforced roof, unseen by spectators, were empty oil drums, an electric saw, and a floor polisher. Several helpers were stationed on the roof to "play" these instruments. Noisemakers, placed throughout the gallery, included a foghorn, a bell, and several large gnarled tree branches (for mock combat among the performers and for banging against the walls of the enclosed corridor). Tape players waited to issue electronic sounds. Behind the curtains at either end of the passageway were an electric floor fan and a gas-powered lawnmower.

Those who had made reservations to attend waited in a partitioned lobby before being guided into the "closet." The sense, Kaprow recalls, was of walking single file into a dark subway car. Some spectators refused to enter, suspecting the worst. Michael Kirby, in his book *Happenings: An Illustrated Anthology,* describes spectators standing nervously inside the narrow room, sometimes joking to relieve the tension of not knowing what was about to happen.[12] Kirby then recounts the following sequence of events: Lights inside the room were turned on and off thirteen times in succession, resulting in periods of total darkness and relative silence, and lights were turned on and off in the spaces on either side of the room, prompting people to peer left and then right through the viewing slots. The oil drums (perhaps ten or fifteen) were thrown

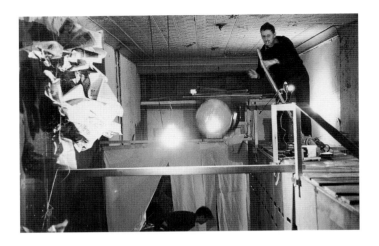

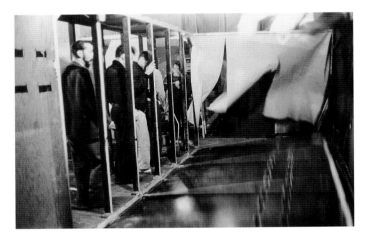

OIL DRUMS BEING THROWN ONTO THE FLOOR (TOP), AND WALLS
FALLING AS THE LAWNMOWER APPROACHES THE AUDIENCE
(BOTTOM) DURING *A SPRING HAPPENING*, REUBEN GALLERY (EAST
THIRD STREET), NEW YORK, 1961 (PHOTOS BY ROBERT R. McELROY,
© ROBERT R. McELROY/LICENSED BY VAGA, NEW YORK, NY)

onto the floor, crashing and rumbling as they hit and
rolled. As the noise died down, growling electronic sounds
from a tape player grew louder and louder until the room
trembled. Other sounds assaulted the spectators—the
sharp but suddenly stifled sound of the bell; the piercing
screech of the electric saw as it bit into wood and quickly
jammed; crackling sounds that came from a loudspeaker
on the roof. Through the viewing slots, spectators could
catch glimpses of the performers in the surrounding
space. Performers lit matches and made hissing sounds,
sometimes right in front of the viewing slots. On one side
of the room, two men dressed in ordinary work clothes
and wielding tree branches fought each other in slow mo-
tion; on the other side, large cardboard boxes lunged and
bumped against the walls of the structure, causing spec-
tators to turn from the viewing slots in alarm. Suddenly,
the two men broke into "real-time" combat and then, just
as suddenly, returned to slow motion. The floor polisher
was pushed along the roof, which was about a foot above
the heads of the spectators, filling the enclosed space with
a roaring sound. The vague shadow of a woman was cast
against a wall of muslin, her shape constantly changing
as the man holding the light moved it to and fro. One per-
former darted along the outside wall of the structure,
washing the plastic-covered viewing slots with soapy
water, which gave the scene beyond a dreamy spectral-
ity. A small wandering spotlight passed over the crouched
naked figure of a woman with broccoli and collard greens
hanging from her mouth. The low sound of an oil drum
being beaten in the lobby was followed, finally, by a pow-
erful roaring sound coming from behind the curtain at
one end of the structure. The curtain parted and a man
holding a flashlight pushed the lawnmower directly at the
startled spectators. At the same time, the curtain at the
other end opened to reveal the floor fan, blowing toward
them. The trapped spectators began to back away from
the approaching lawnmower just as the walls on either
side of the room, which were hinged at the bottom, fell
to the floor, allowing the audience to spill safely out into

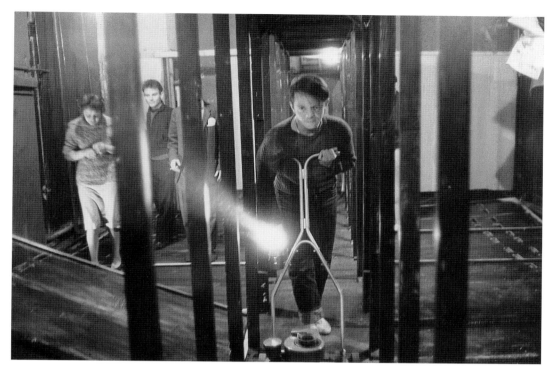

LETTE EISENHAUER, LUCAS SAMARAS, AND STEVE VASEY IN *A SPRING HAPPENING*, 1961
(PHOTO BY ROBERT R. McELROY, © ROBERT R. McELROY/LICENSED BY VAGA, NEW YORK, NY)

the surrounding space. Kaprow recalls Marcel Duchamp (who attended the event with Max Ernst, Hans Richter, and Richard Huelsenbeck) leaping nimbly out of the way.[13]

Happenings in the early 1960s acquired a reputation for squeezing audience members into small spaces and assaulting them with sensory experiences. *A Spring Happening* was an aggressive work in this sense, and it certainly contributed to the infamy. The lawnmower and the floor fan parted the audience as if it were a field of wheat; its dispersal enacted Kaprow's desire to eliminate the audience. The gesture punned on the "spring" of the work's title, of course—springing a trap, people springing out of the way, seeds springing out of a pod—and incorporated the spring rite of mowing the lawn. Still, Kaprow was generally dissatisfied with the event because the only way he

could think to eliminate the audience was literally to force its members from the performance space. It was a crude, avant-gardist tactic he found unsettling, but it nonetheless reflected his impatience with this most resilient of theatrical conventions. Audiences, after all, kept showing up for Happenings, and it may have been Kaprow who felt trapped.

A Spring Happening was a spoof on the avant-garde cliché of shocking the bourgeois audience out of its presumed complacency. It was also an American-type hoopla response to notions of the primitive and the cultural "other" that Kaprow had been reading about in anthropology books. It was a surrealist nightmare, with spectators caught in a small space, blanketed by darkness, jolted by sounds, disoriented by blinking lights, and

exposed to pseudo-exotic pageantry played out beyond the dreamy scrim of the plastic-covered viewing slots. This was Kaprow's own prosaic "theater of cruelty," partly inspired by the theories of Antonin Artaud, who believed spectators should be consumed by the vividness of the theatrical experience, like victims signaling one another through the flames. Artaud's focus was the cruelty of awakening consciousness, and Kaprow's little spring rite was an irreverent, spook-house version of that awakening.

Despite its "advance" on the audience, *A Spring Happening* wasn't all that interesting to Kaprow, except that it moved him one step closer to the street. The storefront site of the gallery gave rise to the sense that the Happening was zoned, as it were, for quasi-aesthetic commerce, not unlike a peepshow in which spectators stole in from the urban night and glimpsed their primal "desires" through the viewing slots. (Oldenburg would more fully exploit this idea of aesthetic commerce with *The Store*.) For Kaprow, the street-level space felt closer in spirit to the urban environment than to the galleries and lofts of the art world, and, together with the basement of the Judson Church, it helped stake out a terrain in which aesthetics could blend with the rhythms of religion and commerce.

yard

In May 1961 Kaprow was invited by the Martha Jackson Gallery in New York to contribute to a group exhibition called *Environments, Situations, Spaces,* a show that included works by Oldenburg, Dine, Whitman, and George Brecht, among others. Kaprow decided to fill the gallery's backyard sculpture court with hundreds of used automobile tires. To do so, he wrapped the several large bronze sculptures displayed there (Kaprow recalls they were by Barbara Hepworth and Alberto Giacometti[14]) with black tar paper, both protecting and erasing them. As the opening date neared, truckloads of old dirty tires were rolled,

one at a time, through the front door of the gallery, across the floor on a protective paper path, and into the courtyard behind, where they were heaved against the walls and piled atop one another until the rubber filled the yard, changing the environment from an urban patio to a neighborhood dump. When the show opened, exhibition-goers were invited to walk out among the tires, to sit on them, or to move or toss them around, and many did. Kaprow called the tire environment *Yard* (plate 3).

Perhaps because of its ancillary relation to the gallery space and the implied critical distance therein, *Yard* became a signature piece for Kaprow, something he has been asked to re-create time and again. In 1961 the contrast between the clean, well-lighted spaces of the art gallery and the greasy mountain of tires outside was astonishing. The essence of *Yard* was not only the physical mound of tires, but also the press of that mound against the gallery, where its swirling organic geometry and "come out and play" invitation offered an alternative to the severe right angles and "don't touch" injunctions inside. It was like a sandbox in the backyard.

There are photographs of Kaprow smoking a pipe while tramping around the tire environment, sometimes with his three-year-old son, Anton, playing nearby. In these photos, taken from above (perhaps from the gallery's second-story window), the artist is shown enveloped in tires, not unlike—in fact, just like—images of Jackson Pollock hunkering down in his studio, surrounded with paintings and paint. The association was no accident. More than any of Kaprow's earlier works, whether environment or Happening, *Yard* was clearly indebted to Pollock, his skeins of paint becoming swirls of rubber, his studio floor now extended to the patio, his postwar expressionism having cooled into a matter-of-fact industrialism, his dead-seriousness softened into a deadpan humor, and his creative delirium settling into an invitation to play. Kaprow wanted to literalize Pollock's example of action by creating a place in which people could act. The photo of Kaprow pitching a tire across his body like a discus was

as much an instruction as a document; this is what he was inviting people to do. The presence of his son was another signal to play. In fact, Kaprow had played often with old tires as a child. One day, he had rolled a tire down a hill in Tucson and it had broadsided a car (an echo of Tom Mix?), causing him to get into trouble. Now he could roll all the tires he wanted: he had turned the only obstacles—the sculptures—into the strange rocks of a postindustrial Zen garden.

Originally, Kaprow had wanted to invite friends to go to a city dump and play around on the tire mounds (which in fact he would do years later). It was just as well that he didn't, since he liked *Yard* much more than *A Spring Happening*. Instead of scattering the audience with a lawnmower, he was inviting the audience to play. Here,

the artist and his audience shared a common ground, both stepping and staggering through the landscape of tires, which was Kaprow's way of incorporating the "strict correspondence" between artist and viewer that he had sensed years earlier in Pollock's paintings. With *Yard*, Kaprow brought the scale of those paintings into a new form of art—an "overall" art ambitious enough to move into the world, worldly enough to be common, common enough to be dumb, dumb enough to be inviting, and inviting enough to be ambitious. Years before, in "The Legacy of Jackson Pollock," Kaprow had written of Pollock's "childlike" ability to become "involved in the stuff of his art as a group of concrete facts seen for the first time,"[15] a rather apt description of his own patio full of tires. The childlikeness of Pollock was here made manifest

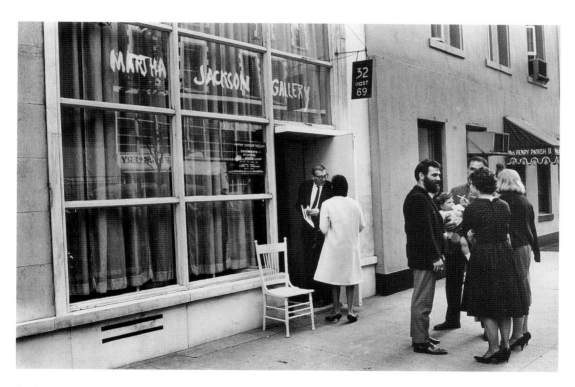

OUTSIDE THE MARTHA JACKSON GALLERY, NEW YORK, 1961
(PHOTO BY ROBERT R. McELROY, © ROBERT R. McELROY/LICENSED BY VAGA, NEW YORK, NY)

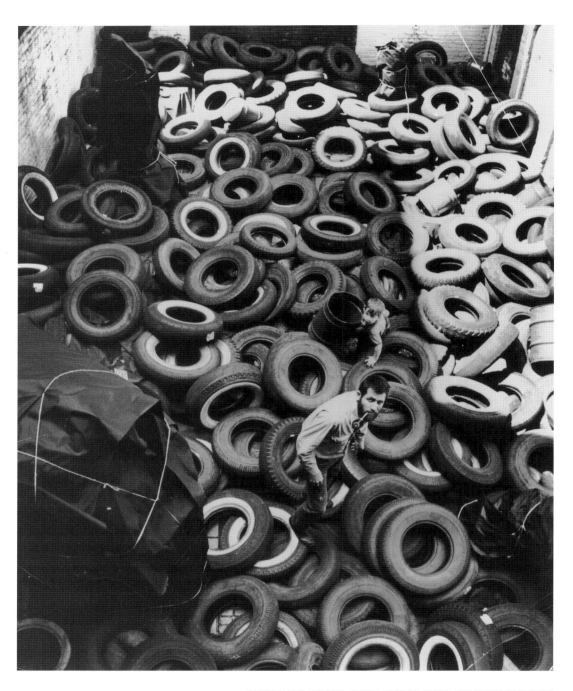

KAPROW AND HIS SON, ANTON, IN *YARD*, INSTALLED IN THE BACKYARD
SCULPTURE GARDEN OF THE MARTHA JACKSON GALLERY, 1961 (PHOTO: KEN HEYMAN)

as childsplay, and the theoretical implications of Kaprow's essay—of painting spilling into the world—was realized in brute industrial terms as rubber spilling out behind the gallery.

The tires Kaprow used for his installation were detritus, used and spent and utterly unwanted. They were also incredibly easy to get. There was lots of talk of planned obsolescence at the time, and *Yard* was a telling comment on society's junk. But it also *was* junk, no matter how Zen-like it was as a garden of rubber. It turned the gallery's backyard into a breeding ground for mosquitoes and an eyesore for the neighbors. The police came, the fire department came, the health department came, and when the show was over, Kaprow found it was nearly impossible to get rid of the tires. It took the gallery's staff weeks to empty the courtyard. *Yard* stopped being a comment

on throwaway culture and became part of it instead. "Polluting" the art world was witty and ironic, but getting rid of the tires meant actually adding to the city dump. Sure, the tires would have gone there anyway, but now Kaprow was complicit in the cycle of consumption and waste. As the tires were rolled out of the gallery and returned to the world, Kaprow realized that he was getting very close to the tire business. The art world, by contrast, was the place he could play with tires all he wanted *without* going into the tire business. He could play in the real world as an artist.

Kaprow's observations of his children playing had been mostly anthropological, but now the lessons of his own experience as a child—a child who sought joy in suffering and art in life—were beginning to infuse his work with a certain Zen detachment. The riddles and routines of

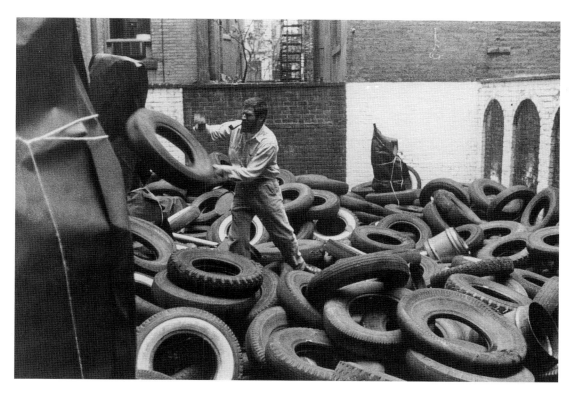

KAPROW THROWING TIRES IN *YARD*, 1961 (PHOTO: KEN HEYMAN)

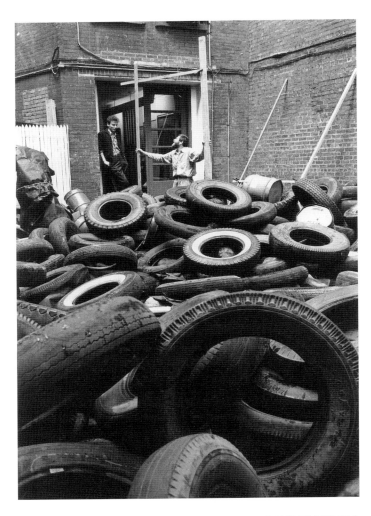

KAPROW WITH LUCAS SAMARAS IN *YARD*, 1961 (PHOTO BY ROBERT R. McELROY, © ROBERT R. McELROY/LICENSED BY VAGA, NEW YORK, NY)

childhood were becoming the philosophical conundrums of the circumspect adult. He was beginning to give himself permission to play at life.

a service for the dead

The year 1962 was a busy one for Kaprow. In March, he presented another Happening, *A Service for the Dead,* as part of an evening of avant-garde performances at the Maidman Playhouse on West Forty-second Street. Called "The New York Poet's Theater," the event included crossover works by Brecht, Whitman, Niki de Saint Phalle, Philip Corner, La Monte Young, Yvonne Rainer, Trisha Brown, Robert Rauschenberg, and Steve Paxton, among others. Wanting to avoid the stage, Kaprow chose the basement, a dank, wet boiler room, for his Happening.

In the theater lobby, an announcer in a top hat stood on a chair and shouted in a Barnum and Bailey voice, "Ladies and gentlemen! Ladies and gentlemen! Your attention, please! The procession will begin. You will please line up in single file behind the musicians." Kaprow described the musicians—who made very little music, but a lot of noise—as a "horse-faced bum," a "peachfuzz adolescent," a "big bearded guy looking like [a] Quaker from Yale," and a "little creepy goatee'd jazzman."[16] Their instructions were to intone one or two mournful notes—"a sort of middle C and a wavering C flat"—as they marched down a pinched, dark stairway to the basement, audience in tow. They passed through a prop room filled with broken furniture, old scenery, a piano, and bins of trash, and then through dressing rooms, some filled with costumes and others empty or dark. In each room, a radio quietly played songs or broadcast the news while the musicians continued playing. Serpentlike, the line doubled back on itself, passing those still descending the stairs, squeezing back through the dressing and prop rooms and into a dark inner passage leading to the boiler room. There, a huge pit dropped perhaps fifteen feet from an iron landing. Abandoned boilers and spent fuel tanks from buildings

that had once occupied the site squatted about like industrial gargoyles, "black guts exposed," "soot all over," and "everything festering and damp." "Clumps of rusted pipe, valves, electrical conduits, exposed wire, bent and broken," were everywhere. Steam pipes on the ceiling were hissing and venting hot water down a wall. The place smelled of "rot and fuel fumes," cut with occasional gusts of cold air from the sidewalk grates up on the street.

Kaprow had suspended four clusters of barrels, garbage cans, and old paint buckets on ropes throughout the boiler room. Five person-size mounds of chicken wire and tar paper with performers hiding inside were positioned on the tops of two boilers and a furnace, on a ledge, and in the pit. Suspended horizontally above the center mound was a ladder with a nude woman (Lette Eisenhauer) lying on it. The scene was lit by only three hanging bulbs, one red and two shaped like flames.

The musicians stopped their dirge in the dark, and in the silence that followed they reached up and pulled on the ropes dangling from the ceiling pipes, sending the clusters of barrels, cans, and paint buckets crashing into one another, creating "an insane thunder" in "every pitch imaginable." "Deafening but terrific," it went on for half a minute. When the racket ended, the musicians trained flashlights on the tar-paper mounds located throughout the room, each one shaking, shuddering, and weaving when lit. At the same time, the performers inside the mounds blew slide whistles, made clucking sounds, squawked "awrrkkk," and barked, gathering intensity as they moved inside their mounds. The musicians then closed in around the mound on the pit floor and began hopping and stomping as it turned and shuddered. Stopping abruptly as the weak overhead lights went out, they aimed their flashlights at the remaining mounds and then thrust them into the faces of visitors as they bulled through the crowd to either end of the room, where they turned the flashlights off.

Suddenly, a siren cut through the space, rising steadily

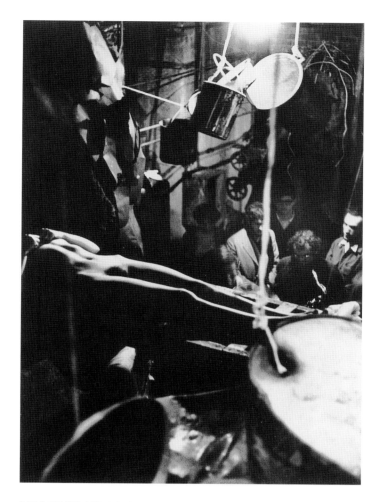

PAILS, DRUMS, AND A SUSPENDED NUDE IN *A SERVICE FOR THE DEAD*, MAIDMAN PLAYHOUSE, NEW YORK, 1962 (PHOTO BY ROBERT R. McELROY, © ROBERT R. McELROY/LICENSED BY VAGA, NEW YORK, NY)

until other sirens broke in, gathering strength, and then falling into a "watery-bubbling-in-the-deep-pipes" sound. A dozen mattress springs began to squeak, metallically at first, but softening into "blocks of groaning." A propane torch was lit by the performer inside the mound in the pit, its blue frame hissing through a hole in the top of the

mound. The flashlights were clicked on and off, faster and faster, until the black air was filled with bursts of light that burned afterimages into retinas. Then the flashlights went out.

From opposite walls, flashlights were trained on the nude woman on the horizontal ladder. The ladder began to gently sway over the heads of the crowd. After about thirty seconds of hypnotic swaying, the woman flung her arms apart, scattering two fistfuls of torn paper over the visitors, then let her arms hang limply by her sides. The performers in the mounds began to moan and hum, sounds the musicians imitated with their horns. Meanwhile, following a drummer whose beat increased in volume as they moved, audience members slowly started moving toward the stairs. The tones of the musicians gradually returned to those of the original dirge, and a white sheet was drawn over the woman's body as the crowd filed up the stairs. They were led out a dark alley and up a second set of stairs to a different building, and then outside onto the street.

A Service for the Dead was most satisfying for Kaprow as a sound piece,[17] but it was also a form of expressionist theater translated into an American vaudevillian vernacular. It was like *A Spring Happening* in its references to the primitive unconscious and in the way it squeezed an unsuspecting audience into a threatening space, but it leavened such ritualistic seriousness with a kind of honky-tonk irreverence. Like many of his colleagues at that time, Kaprow was becoming interested in ritual as a performance technique, but he was careful to distinguish between rituals and ritualisms, the latter being formal, artistic, and ultimately mock adaptations of the idea of ritual. Ritualisms allowed him to play at the seriousness of ceremonies, processions, and other liturgical forms of performance. The result, in this case, was a playful ghoulishness taken right to the edge of a frightening experience, like a kids' game in which participants try to scare one another, even though they know they are safe—indeed, one spectator became momentarily hysterical. Ritualisms also allowed Kaprow to invoke the dank meati-

ness of expressionism without succumbing to it. And even if it was not as participatory as *The Apple Shrine* or *Yard*, *A Service for the Dead* at least involved the audience in these ritualisms as quasi-celebrants or witnesses.

It was never exactly clear, of course, what the ritual was about—what was dying and what was being reborn. Kaprow wasn't interested in telling the spectators what the service meant; instead, he was interested in the high energy of its enactment, which spectators could experience firsthand and interpret as they chose. Empty of narrative meaning, the service was a parody of services. Its meaning was hocus-pocus, equally reminiscent of the bunkhouse skits Kaprow had performed as a kid in Arizona as, say, an early Christian underground Mass. As a ritualism—an empty ritual—it both aspired to the meaningfulness of rituals and deflated those aspirations with mock irony, as when, for instance, spectators were able to "walk on water" by crossing the wooden platforms on the boiler-room floor. What mattered to Kaprow was using ritualisms as vessels for the transmission of mythic energy into physical energy.

It was also telling that Kaprow chose the basement boiler room, not the stage, as the setting for his Happening. On the way down, his guests passed the abandoned regalia of theater before descending to the heart of the beast. The proscenium hall was replaced by a labyrinth of alleys, stairways, and pits; spotlights by flashlights; theatrical narrative by a procession of nonsense. If the sculpture court of the Martha Jackson Gallery had been his backyard sandbox, the Maidman Playhouse became his playhouse for the night.

sweeping

Myth had long been in the art-world air; it was oxygen for many postwar American painters, fueling the angst and the scale and colors of Abstract Expressionism. As the painter Paul Brach remembers, "the New York atmosphere was on fire with myth" after the war.[18] Anthropologists tended to regard myths as archetypes held in

the deep recesses of the savage mind, and everywhere could be felt the psychic weight of Freudian psycho-analysis and the metaphysical loft of Jungian psychology.

While the Abstract Expressionists took myth seriously, the artists of Kaprow's generation were less reverent toward it. Kaprow was skeptical of the heavy reverie that so often imbued mythic art, thinking it corny and insupportable in a modern, technological society.[19] His Arizona childhood, although filled with mythic heroes and ritual-istic tasks, was profoundly secular in its daily routines. Moreover, by an early age Kaprow had become suspicious of his parents' pro forma religiosity, sensing in their oc-casional devoutness the habits and reflexes of religious piety without its contents (his own "quickie" bar mitzvah confirming his suspicions). His detached relationship with religion during childhood set the parameters of his quasi-scientific regard for myths as an artist; he was more interested in the narrative scaffolding of myths than in the moral weight they carried. For Kaprow, myths were conveniently available structures upon which to hang an event, rather like the two-dimensional grid was for painters. *Sweeping* was the first Happening in which mythic scenarios—not just the ritualisms of *A Service for the Dead*—were consciously used as background narra-tives for an event composition.

Kaprow presented *Sweeping* in August 1962 as part of the Ergo Suits Festival in Woodstock, New York. Partly inspired by Happenings, Ergo Suits was organized by a loose grouping of artists—including Charles Ginnever, Peter Forakis, and Tom Doyle—interested in presenting performance works that crossed the boundaries between entertainment, theater, music, poetry, and the visual arts. It was done with a kind of communitarian, free-style spontaneity that echoed the artists' activities then tak-ing place at the Judson Church, and it partly inspired the Yam Festival at George Segal's farm the following year. The idea was to keep things light, in the spirit of an artists' picnic in the country. Here, Kaprow undertook his first nonurban Happening since the event at Segal's farm in 1958.

As dusk settled on the woods outside artsy Woodstock, about sixty visitors began arriving in a small clearing strewn with crumpled newspaper and other debris. At its center lay a pile, perhaps three feet high and seven feet wide, of torn cardboard, paper, tin cans, rags, and the like—the usual Kaprowesque detritus. Hunkered down under this pile was a man wrapped in rags and shredded paper, unseen by the audience. The effect of the pile and the surrounding debris was one of despoiled nature, a dis-tinctly urban intervention in a sylvan glade. Nearby stood a five-foot-high wooden stand adorned with yet more rags and covered with tar paper. A live chicken was tied to the stand by its leg.

As people entered the clearing, they could hear in the woods around them cans rattling, metal banging, women yelling, men calling, children laughing, glass breaking, and whistles blowing, but they could not see who was making the sounds. After everyone had arrived, the noises stopped. Seven or so "workmen" came out of the woods at irregular intervals, dragging cardboard boxes and gunny sacks or pushing wheelbarrows, each filled with junk that was silently dumped on the pile in the middle of the clear-ing. This dumping went on for a while. The pace gradu-ally increased and the workmen began exchanging terse directions like "over here," "more on this side," "throw it on that spot," and so on. After dumping two or three loads, they hurriedly left and returned with armfuls of shovels, brooms, and rakes, randomly handing them out to visitors and indicating that they should pitch in. In a few minutes, almost everyone was sweeping the clearing, pushing waves of crumpled newspaper toward the grow-ing central pile. As they did so, the workmen began or-dering them around in louder and louder voices, until they were shouting, sometimes grabbing a tool from one person and handing it to another. The sweeping became frenzied, and the workmen occasionally admonished vis-itors for not working hard enough.

At the peak of this activity, about a dozen small chil-dren ran laughing into the clearing, each covered with sheets and blankets. They had been instructed to "hop,

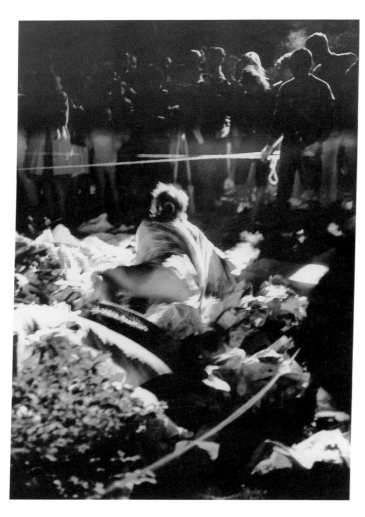

A MAN BURSTS OUT OF A PILE OF DEBRIS, "MADDENED, YELLING, CROWING LIKE A ROOSTER," DURING *SWEEPING*, WOODSTOCK, NEW YORK, 1962 (PHOTO BY ROBERT R. McELROY, © ROBERT R. McELROY/LICENSED BY VAGA, NEW YORK, NY)

crawl, and bump" into the sweepers, distracting them from their work. At this point, the workmen quickly took back their tools and left the area. The children threw off their sheets and blankets and ran into the woods, returning a few minutes later with large balls of string, which they used to wrap a number of the visitors in a "messy tangle."[20]

As darkness approached, a spotlight perched in a tree shone on the pile in the clearing. One by one, the workmen slowly returned and drenched it with buckets of red liquid. (Here, finally, was the "whining, burping, foul, pinky mess" Kaprow had written about in "Happenings in the New York Scene.") By now, the children were gone and the crowd was silent. People stared at the illuminated red mound of sopping junk—a saturated symbolic bonfire against the dimming sky. Faint sounds like frogs croaking and gorillas yawning started rising from deep inside the pile. As the sounds grew louder, the pile began to shake and heave. Suddenly, the man hidden inside burst out, "maddened, yelling, crowing like a rooster, flapping his arms." Staggering about, he careened dizzily, "screaming in every direction amongst the tangle of people," looking for an escape. Noticing the chicken, he stopped "dead in his tracks." A few seconds later, he ran back to the pile and frantically gathered up an armful of wet red rubbish and began throwing it at the chicken. The chicken, of course, became "hysterical, flapping and cackling, adding to the insanity." The man grabbed the unfortunate bird, ripped it from its tether, and, "still screaming and crowing," swung it over his head several times and let it fly. He then dropped "dead" on the mound. The chicken ran into the dark woods.

In the long light of dusk (and with a little imagination), the litter on the ground gave the appearance of fallen leaves. The children, mischievous fairies come out of the woods at twilight, were the true practitioners of childsplay in a forest of lumbering adults. The spotlit pile of debris was a bonfire, the chicken a sacrificial animal, and

the whole event a symbolic out-to-the-country cleansing. This was Kaprow's version of the Augean Stables, with the dung cleaned from the stables by Hercules replaced by human litter, updating and urbanizing the myth. Undertaken by so many, Kaprow's choreographed sweeping offered a disorienting spectacle in the Woodstock woods: sixty-odd people worked furiously at nothing, or, perhaps more precisely, at the wrong thing. It was hard to tell whether the objective was to clean up the place or spread the litter around. The Happening was characterized by a lot of earnest work in the service of very little.

Myths had provided Kaprow with just enough narrative coherence to allow him to forget about storytelling and concentrate on making the Happenings as busy and as physical as possible. In fact, Kaprow wanted to so vivify myths as physical activity that reflection upon their narrative or moral meanings would fade by comparison. His strategy was to give people so much to do that they wouldn't have time to think.[21] A tension thus developed between the participants' expectation of a "moral" to the story, as it were, and the Happenings' refusal to provide one. Kaprow wasn't interested in moralizing; he gathered up myths in much the same spirit as he had scavenged scraps of paper off the studio floor for his action collages. Material was material, and myths were as "found" as any other. In transforming mythic themes into the actions of sweeping up a mound of soggy garbage or screeching like a chicken, Kaprow modernized and materialized ancient literary sources. The key to all the huffing and puffing was to keep things open, to keep the meanings of the myths from weighing down the experience of the activity, and thus to let participants draw their own conclusions about what their experiences meant.

Simply put, Kaprow wanted to *transform mythic scenarios into physical experiences,* to exhaust the symbolism of mythology by enacting its images and stories in vernacular, commonplace terms. He wanted to drain the high into the low. Because Kaprow didn't take the myths se-

riously, selecting and deploying them almost at random, his irreverence came across as parody. It wasn't a pointed parody, which would have been at the expense of the myth, but was a kind of bunkhouse humor in which, say, a struggle among the gods became a pillow fight or, more to the point, a phoenix rising from the ashes became a terrified chicken. The mystique of the myth was dissipated in physical comedy, and this is Kaprow's debt to Charlie Chaplin and Buster Keaton.

By staging a Happening in a forest clearing several hours north of New York City, Kaprow furthered his symbolic withdrawal from the art world. He'd spent a decade working his way through paintings, collages, assemblages, environments, and Happenings, as well as through classrooms, a co-op gallery, a college chapel, a friend's farm, industrial lofts, a church basement, a storefront, a sculpture garden, the boiler room of a theater, and, finally, a clearing in the woods within earshot of where Cage, ten years earlier, had asked a younger generation of artists to listen to nothing—and thus to everything—for four and a half minutes. Cage would probably not have appreciated Kaprow's absurdist bacchanalian carnival, especially all the enforced sweeping, but there it was. By the summer of 1962, Kaprow had learned from his experiments that the *idea* of art was transportable, that as an artist in the modern, everyday world he could carry it around with him in his head. Forms of doing, whether eating an apple, throwing a tire, or sweeping up garbage, were now as portable and available to Kaprow as paint and canvas and brown wrapping paper had once been. Truly, as he had written in "The Legacy of Jackson Pollock," anything could be material for the new art: mythic clichés, ritualisms, busywork, even, apparently, a chicken. Drawing meaning from mythology, anthropology, society, or religion, these forms of doing would, Kaprow now knew, exhaust themselves through commonplace enactment—which is to say, he could use them up in childsplay, leaving in their wake the experience of experience.

chapter five
hoopla

Encouraged by the success of *Sweeping,* Kaprow staged another outdoor Happening, *A Service for the Dead II,* performed on the beach at Bridgehampton in the dusk of a late August evening in 1962. It began with a procession of people moving toward the water, some carrying cardboard boxes and "fluttering bedspreads," others "wheeling a bicycle, rolling a few oil drums and a car tire,"[1] and dragging junk metal. When the procession reached the water's edge, a team of "carpenters" constructed a wooden platform topped with bedsprings. Several men with plastic bags over their heads rolled down the grassy sand dunes, a hundred yards or so away from the shoreline, then threw themselves into several large pits and were buried by others (including some children) up to their noses. A plastic-clad woman rolled down the dunes and slithered along the ground toward the raised platform, from which the carpenters drank and spit out beer, some-

times hitting the woman. The action was accompanied by low booming sounds from behind the dunes. The woman climbed the platform, up onto the bedsprings. The carpenters lifted the bedsprings and the woman down from the platform, which they then set on fire. A screaming man in the crowd brandished a tree limb and suddenly rushed into the sea, which threw him back. A ship's distress horn pierced the evening air. A line of five "noisemakers," people playing drums and horns, marched past the crowd toward the burning platform. They stopped near the woman on the bedsprings, lifted her to their shoulders, and walked slowly and silently toward a large blinking light at the water's edge, trudging as far as they could into the pounding waves before being washed back onto the beach, where they lay motionless.

There was something touchingly futile about these shenanigans by the sea. The rhythmic noises, the funeral

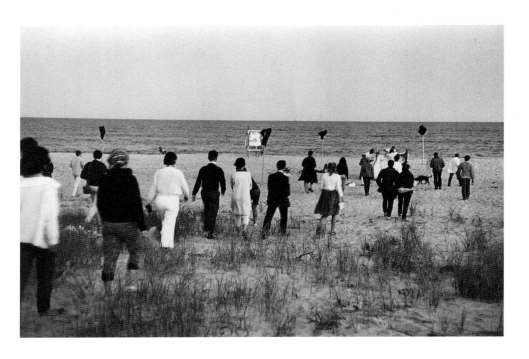

MOVING TOWARD THE SEA (RIGHT) AND PEOPLE BURIED IN SAND WITH PLASTIC BAGS ON THEIR HEADS (BELOW) IN *A SERVICE FOR THE DEAD II*, BRIDGEHAMPTON, NEW YORK, 1962 (PHOTOS BY ROBERT R. McELROY, © ROBERT R. McELROY/ LICENSED BY VAGA, NEW YORK, NY)

pyre, the sacrifice and burial, and the light blinking out over the water were rendered pathetic, even poignant, by the power and indifference of the ocean. The meaning of each part of the performance was of little importance, since its cumulative effect was overwhelmed by the proximity of the forces of nature. This particular stretch of Long Island was known for the preponderance of psychiatrists who summered there, and this had prompted Kaprow to use the overwrought imagery of crossing the dunes from land to sea, symbolic of the divide between reason and the unconscious. The "service" was a synthesis of his two most recent Happenings, *A Service for the Dead* and *Sweeping,* employing similar materials, ritualisms, images, and clichés. Kaprow was getting good at this type of pseudo-somber, tongue-in-cheek re-creation, and it occurred to him that maybe he was coming into a league of his own when it came to putting on a show.[2]

words

The next month, in September 1962, Kaprow responded to an invitation to show at the Smolin Gallery in New York by creating an environment called *Words* (plates 4–5). Kaprow divided the gallery space, which was inside an apartment, into two rooms. The first, outer room, nine by nine feet in size, was the more public, rhetorical of the two. Four colored lightbulbs hung at eye level, and two vertical rows of lights reached from floor to ceiling on opposite walls. On two of the walls, five vertical loops of cloth stenciled with words had been hung side by side, and visitors were invited to roll the loops so that words would align or misalign (recalling a slot machine). Hundreds of strips of paper, each containing a single handwritten word, were stapled onto the other two walls; here, visitors were encouraged to tear off the strips and replace them with others that had been nailed to a central post. All the words on cloth and paper had been randomly gathered from "poetry books, newspapers, comic magazines, the telephone book, popular love stories," and so forth.[3] Crudely lettered overhead signs urged visitors to "staple word strips," "play," "tear off new words from post and staple them up," and "make new poems," among other actions. Fixed to a small stepladder was a sign saying, "climb! climb! climb! climb! staple!" Another sign, "lissen here hear records," directed visitors to three record players, on which recordings of lectures, shouts, advertisements, nonsensical ramblings, and so forth could be played simultaneously.

The smaller, inner room, maybe eight feet square, was painted blue and illuminated by a lone lightbulb. Overhead was a black plastic sheet, creating a false ceiling that made the dark room seem like a graffiti space, recalling alleys and public toilets, in contrast to the brash, carnivalesque openness of the first room. Hanging from slits in the plastic ceiling were torn strips of cloth, and clipped onto these were many small pieces of paper with handwritten notes. Near the entrance, paper, clips, and pencils were provided for visitors to add their own notes. Also hanging from the ceiling, at the end of long strings, were pieces of colored chalk that could be used to write or draw on the blue walls. A record player on the floor played barely audible whispering sounds.

With *Words,* Kaprow bettered his invitation to eat in *The Apple Shrine* by inviting his audience to contemplate the Word, albeit a decidedly secular and pointedly urban Word, calling to mind graffiti, notes passed in class, advertising, political banners, and the like. In a brief catalogue introduction, he declared, "I am involved with the city atmosphere of billboards, newspapers, scrawled pavements and alley walls, in the drone of a lecture, whispered secrets, pitchmen in Times Square, fun-parlors, bits of stories in conversations overheard at the Automat. All this has been compressed and shaped into a situation which, in order to 'live' in the fullest sense, must actively engage the viewer."[4] To engage the viewer, in other words, was to bring words to life—and life came to language through play.

Nearly twenty years before the "pleasure of the text" became intellectually de rigueur on the streets of lower Manhattan, Kaprow was inviting his guests to take pleasure in the random alignments, fleeting abutments, revealing elisions, half-audible utterances, embarrassing associations, fading echoes, silent omissions, and slippery alliances of language. But this wasn't the disembodied sense of the linguistic field that we have suffered since; the words were fragments of the physical environment, a pre-postindustrial architecture of signs, notes, doodles, carvings, shouts, and whispers. This was evident particularly in the outer room, which was a distillation of the city-as-language. If Kaprow's randomness was Cagean, his sense of the surrounding space, of the "overallness" of language, was derived (again) from Pollock, but with a physicality that eschewed aesthetic mannerism and partook of the street speech all around.

The inner room was more subdued, contemplative, furtive. Unlike the blaring signage of the outer room, the pieces of torn cloth hanging inside were like strands of

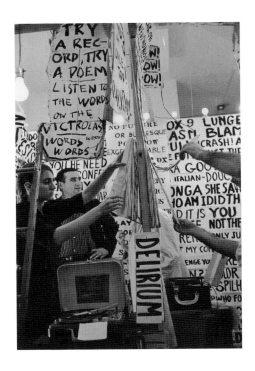

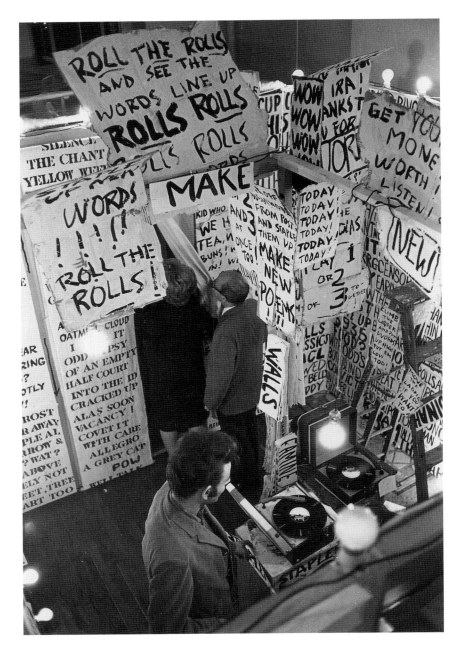

THE "FRONT ROOM" IN *WORDS*: MANIPULATING TEXT PANELS AND ROLL (LEFT) AND
LUCAS SAMARAS IN FOREGROUND (RIGHT), SMOLIN GALLERY, NEW YORK, 1962 (PHOTOS
BY ROBERT R. McELROY, © ROBERT R. McELROY/LICENSED BY VAGA, NEW YORK, NY)

thought suggesting a more private, slower, internal kind of speech. Perhaps Kaprow's sensitivity to this difference came out of his childhood experiences in group homes, where privacy was hard to come by. The inner room was also less arranged, more organic in the ways people left notes or took them or marked on the walls. Thus, a contrast between public and private speech—between shouts and whispers, rhetoric and thought, the polis and the individual, reason and intuition—emerged as the underlying metaphor of *Words*.

Art in the United States was on a precipice, nearing the advent of Pop, and words were about to become one of the great subjects of American art. But for Kaprow, words were neither artifacts of popular iconography nor abstractions; they were sounds resonating in the body, let-

ters painted by hand, pitches made on the street, objects traded like baseball cards, walls that hemmed you in. Kaprow wanted to drain words of literary meaning by inviting people to engage in such ordinary activities as "doodling, playing anagrams or scrabble, searching for just the right word to express a thought," and so on.[5] These actions would literalize—secularize—the Word. The experience of leaving a note for someone or stapling one word over another would supplant the denotative meaning of the words, giving rise to the connotations of doing. Like myths, language could be emptied of meaning through experience—through the experience of play in particular. At a time when Kaprow, as an academic, was continually required to justify his professional station with language, and when he was increasingly known

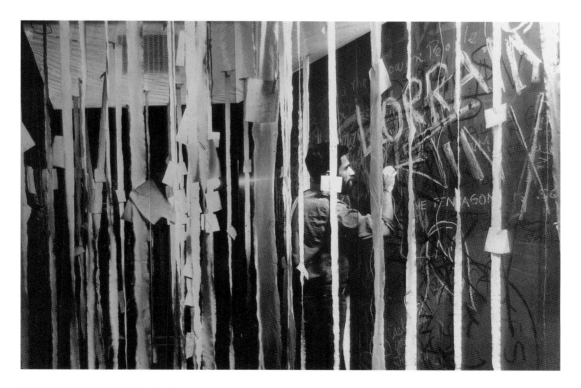

KAPROW WRITING ON THE BLACKBOARD IN THE SECOND, DARKER ROOM IN *WORDS*, WITH
WRITTEN MESSAGE PAPERCLIPPED TO HANGING STRIPS OF CLOTH, 1962 (PHOTOGRAPHER UNKNOWN)

as the spokesman for Happenings, he wanted to get speech out of his system by creating a playground of words. He remembers lots of schoolchildren visiting his environment; he also recalls Mark Rothko showing up one night with a sour look on his face.[6]

chicken

If Kaprow wanted to empty himself of language in *Words,* with his next Happening, *Chicken,* he wished to empty himself of theater. Performed in November 1962 in Philadelphia, *Chicken* was a macabre Ring Cycle, a carnival-like version of the collapse of Western civilization, full of quasi-sacrifices, feasting, and anarchy, followed by a mock restoration of order. In a brief prologue spoken to the audience before the performance, Kaprow said, "I have conceived this Happening as the enactment of a comic-tragedy about ourselves, full of the utterly ridiculous and the painfully stark. These opposing qualities are

KAPROW INSTRUCTING PARTICIPANTS IN *CHICKEN,* PHILADELPHIA, 1962 (PHOTOGRAPHER UNKNOWN)

contained in the several meanings we might attach to the work's title and its main symbol: chicken."[7]

The set, laid out in a large auditorium with the chairs removed and the stage curtains drawn, was composed of five hanging wire-mesh spheres, each containing a plucked chicken and a sixty-watt lightbulb; a nine-foot-high wood, wire, and tar-paper sculpture in the abstracted form of a chicken; a seven-foot-square wooden cage covered with chicken wire, holding a man reading a newspaper and three cardboard boxes containing live chickens; a six-foot-high wooden platform with posts supporting beams thirty feet above the floor (like a gallows), from which a fifty-gallon steel drum was suspended by a rope and pulley; and six large tables arranged in a semicircle around the platform.

Each table was a station for a different "pitchman," who, megaphone in hand, vied for audience members' attention as they wandered by. The pitchmen then poked and examined the dead chickens, lectured about their uses and benefits, gave small broilers away by spinning a prize wheel, and heated eggs with candles, offering them to the audience or tossing them onto the floor. On one table, a man with a dejected look on his face and a dead chicken around his neck would, when tapped on the head by a salesman's pointer, rock back and forth, flap his arms, cluck loudly, and rise to his feet, crowing like a rooster. On another table, a woman with a lightbulb hanging over her head (like the chickens in the wire-mesh spheres) sat inside a closet-sized wooden frame covered with semitransparent plastic—a kind of incubator—while a record player at her feet played clucking sounds.

The wooden cage containing the man reading the newspaper and the boxes of live chickens was overturned several times, the birds becoming hysterical. The giant tar-paper chicken sculpture was demolished. The plucked chickens hanging in the wire-mesh spheres were cut down and handed from one person to another, bucket-brigade style, toward the wooden platform, where they were placed directly beneath the steel drum, which came

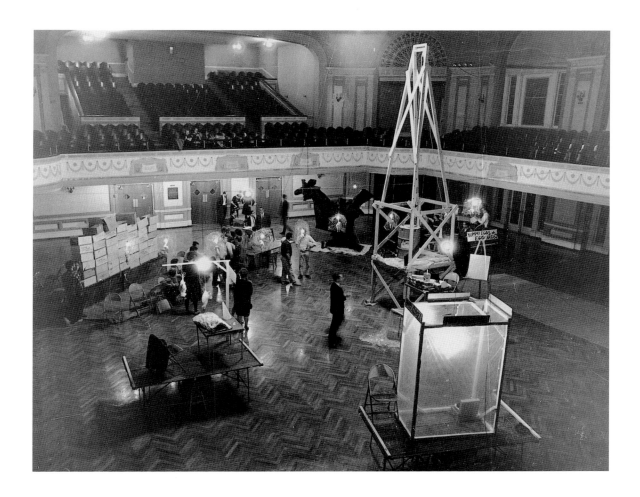

THE SET (ABOVE) AND CHICKEN SCULPTURE
(LEFT) CONSTRUCTED FOR *CHICKEN*, 1962
(PHOTOGRAPHERS UNKNOWN)

down like a piston and crushed them one by one until only a mash of chicken flesh remained. The guillotine allusion was clear. Anarchy reigned. Throughout the set, chickens were broiled, boiled, plucked, diced, offered to the audience, and, in one instance, thrown at a stack of boxes.

The whole bizarre spectacle was as common as a chicken dinner and as morbid as a public execution. It was part sales convention, part slaughterhouse. In the end, two "police officers" pushed their way into the hall, yanked the pitchmen away, and sprayed the overturned cage—including the man and the birds—with a fine white powder. Order was restored.

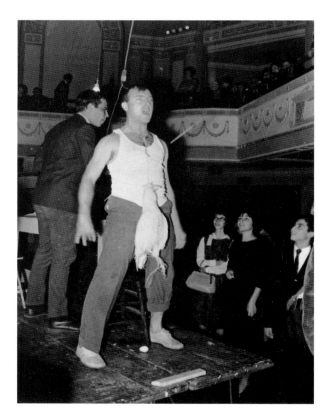

CROWING MAN IN *CHICKEN*, 1962
(PHOTO: ED SABOL)

Chicken cycled from life to death to market to waste, from chaos to control, from food to physical energy to exhaustion. In *Sweeping,* the chicken had been a phoenix; here, it was a eucharistic body being processed into a parody of the society it helps feed. Kaprow was very aware of chicken symbolism, and he used its cyclic, regenerative, sacrificial, and silly qualities as a way of sketching a rough narrative that was progressive and cumulative, with lots of energy and a fresh, unstudied physicality. The theatrics of *Chicken* turned the myths of sacrifice, regeneration, and so on into carnival gags, albeit with a gallows humor and a horrific edge. Kaprow regarded these myths as cultural debris—the refuse of belief systems—and he used them, like he used any other garbage, generously and as a parody of the mythic weight of art: in this case, of theater. Through parody, Kaprow released a participatory energy that was not dependent upon the meanings of the myths, creating an "avant-carnival" that for a moment masked the ordinariness of activities like sweeping or food processing. In a carnival, the ordinary beliefs of society are called up for critique, which Kaprow did in *Chicken* by turning food processing into a spasm of animal sacrifice. Still, his critique was not moralistic; rather, it was an attempt to transform mythic scenarios into narratives of play. Although *Chicken* looked a lot like theater, its purpose was not to create an illusion or advance a story, but to discharge the power of its background myths as physical energy. This was as close to theater as Kaprow got.

courtyard

Happenings, by this time increasingly popular with the media, served a particular purpose for Kaprow. They were his vehicles for working his way out of theater. Since 1959, he had used them as experimental situations in which he could penetrate, squeeze, and scatter the audience; replace dramatic narrative with ritualisms, mythic scenarios, and common tasks; parody the theatrics of

modern urban culture; and dissipate theater's need for culmination by simply announcing the end and then walking away. His use of ritualisms and mythic scenarios had allowed him to compose theatrical events that processed the meanings of rituals and myths into forms of everyday action. If the environments had shown him how to build invitations (to eat an apple, to throw a tire) into physical spaces, his Happenings in Woodstock, Bridgehampton, and Philadelphia had made it equally clear that ritualisms and mythic scenarios (like sweeping trash, witnessing a funeral, hawking goods, and eating a meal) were transportable as well. Performance, in other words, could be its own environment, wherever it happened to occur.

Fittingly, the final Happening of 1962, *Courtyard,* took place over Thanksgiving weekend in one of the inner courtyards of the Greenwich Hotel, at the time a transient hotel in Greenwich Village. In the center of the courtyard, Kaprow constructed a three-story black tar-paper tower— a "mountain." Hanging several stories above it was another "mountain," its "peak" pointing downward. Strewn around the courtyard were crumpled newspapers and used cardboard boxes, and spotlights were located in various windows of the ten-story hotel to illuminate the events. The Happening was sponsored by the Smolin Gallery, and only one hundred people were invited to each of the three evening performances.

In brief, the sequence of events was something like this: The audience entered the quiet courtyard, walking through the debris on the ground, and positioned themselves along the courtyard walls. As they looked up at the tar-paper mountain and its menacing twin, humming sounds, seeming to come from the windows above, began wafting throughout the space and countless small pieces of aluminum foil rained gently down on the crowd. Two "workmen" entered the courtyard with brooms and bushel baskets and started sweeping up the debris on the ground, handing out brooms and asking members of the audience to sweep as well. Some did, while others shied

away. A man on a bicycle began riding aimlessly through the crowd, ringing his bell as he went.

As the bushel baskets were filled with debris, the two workmen carried them up rickety extension ladders that were leaning against opposite sides of the mountain and emptied them into an opening at the top. Spotlights shone on the mountain, which in a moment "rumbled" and "erupted," black tar-paper balls (perhaps thirty in all) spewing onto the dodging crowd below. Next, floodlights lit the upper rows of windows, in which performers enacted a "tenement neighborhood" scene by washing dishes, hammering nails, planting flowers in a flower box, calling children, shouting headlines, yelling greetings, and shaking mops. As they rattled silverware, plates were ejected from the mountain's opening and exploded on the ground among the now jumpy audience.

Three mattresses were lowered from a fourth-floor window to the courtyard. The workmen carried them up the sides of the mountain, placing them on top of one another at its peak. Several cardboard boxes, which had been thrown from the windows to the ground, were then carried up as well and stacked like building blocks on the mattresses. As the workmen were climbing down, a car tire, tied by a rope to the inverted mountain above, was released from an upper window and came swinging through the boxes, knocking them off the mountain and onto the suddenly cheering crowd.

A woman in a pink nightgown (Lette Eisenhauer) strolled into the courtyard holding a transistor radio (playing rock and roll) to her ear. She circled the tar-paper mountain several times, climbed one of the ladders to the top, and sprawled on the mattresses. The two workmen, now wearing "press" hats, hurried up the ladders after her, taking her picture as she feigned cheesecake poses. They thanked her and descended, and the woman, lying supine, switched on a small electric light, which she raised above her body. At this point, the tire swung past again, eliciting a gasp from the audience. The tire passed so close to the woman that it seemed to extinguish the

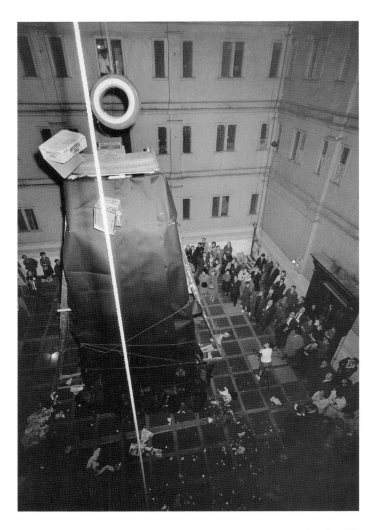

SWINGING TIRE KNOCKING BOXES OFF THE TAR-PAPER "MOUNTAIN" IN *COURTYARD,* GREENWICH HOTEL, NEW YORK, 1962 (PHOTO BY ROBERT R. McELROY, © ROBERT R. McELROY/LICENSED BY VAGA, NEW YORK, NY)

light. (In fact, she switched it off.) Eventually, the tire stopped swinging and came to rest directly above her, and she unrolled four streamers of white fabric down the sides of the mountain before sitting up and hugging the tire to her body. A foghorn blasted from a window, and, finally, the inverted mountain began slowly descending until its lower opening slipped gently over the woman, completely enveloping her, leaving the two massive black mountains touching peak to inverted peak.

Some years later, John Cage made particular reference to *Courtyard* in an interview in which he expressed reservations about what he saw as the "intentionality" of many recent Happenings. He felt that Kaprow's use of myths and symbols created relationships "which the artist had drawn in his mind" and that this added up to a retrograde and perhaps even undisciplined form of theater in which the assertion of the artist's will foreclosed the operations of chance.

In Kaprow's Happening with the mountain, he says that there is this symbol business about the girl . . . and the Earth Mother. That strikes me as drawing relationships between things, in accord with an intention. If we do that, I think then we have to do it better. . . . Happenings don't do it better because they have this . . . carelessness about them. The only way you're going to get a good performance of an intentional piece . . . is to have lots of rehearsals, and you're going to have to do it as well as you can. . . . So when I go to a Happening that seems to me to have an intention in it I go away saying that I'm not interested.[8]

In other words, Cage thought the "symbol business" was what *Courtyard* was about and that if Kaprow was going to present such a conventional performance—that is, with symbols that reflected the artist's intention—he should stop trying to cover it up with avant-gardist hoopla and just make better theater.

For Kaprow, the Happening *was* the hoopla—the discharge of myths and symbols into actions, which in turn led to experiences. He took that discharge seriously— it was his outlet between art and life—but he knew full well that his "symbolic business" was little more than an

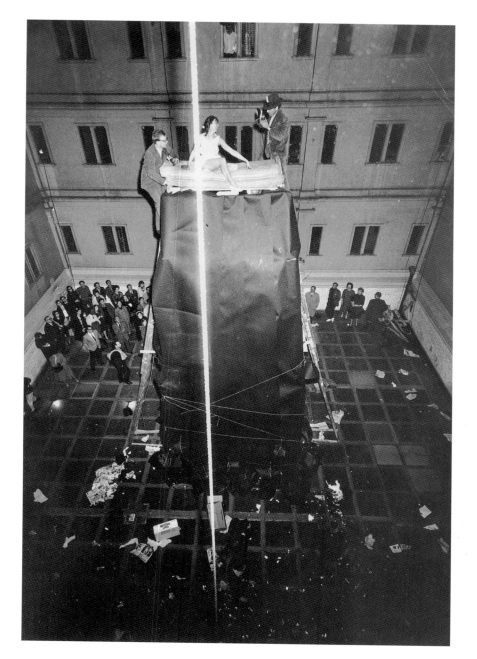

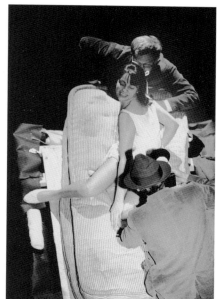

WOMAN AND "PRESS PHOTOGRAPHERS" ATOP TAR-PAPER MONOLITH IN *COURTYARD*, 1962
(LEFT PHOTO BY ROBERT R. McELROY, © ROBERT R. McELROY/LICENSED BY VAGA, NEW YORK, NY;
RIGHT PHOTO BY PETER MOORE, © ESTATE OF PETER MOORE/LICENSED BY VAGA, NEW YORK, NY)

outlandish collage of clichés that allowed the action to move forward in lieu of an "intentional" narrative. The solemnity of the references in *Eighteen Happenings in Six Parts* had been replaced by such hackneyed images as the mountain as Mother Earth or a phallus erupting in the hotel's interior, the tenement scene straight out of *Life* magazine, and so on. These were not the "meanings" of the performance—they were the compositional elements of its narrativeless script—and the clichés were consumed by the bombast of the performance. Kaprow had no more investment in them than he did in tar paper—except, perhaps, in the sense that all were exhausted and, as such, could release energy into the present moment.

Underneath the clichés were a few respectable associations between the site and the event and references to life and the arts. The location—in a hotel for transients—mirrored Kaprow's recent wanderings as a Happener and referred to a fugitive audience or a displaced neighborhood. The tar-paper mountain was a pun on Black Mountain College, where this type of performance had begun. The improbable mirror image of the two massive mountains touching peak to peak paid funky but filial homage to Barnett Newman's recently completed *Broken Obelisk* (Newman was in the audience), and the image of the woman embracing a tire while sitting on the mattresses was a reference to Robert Rauschenberg's *Monogram* (1955–59). But these images, too, were consumed by the cumulative effect of one crescendo after another: a volcano erupting, a virgin being sacrificed, the world being turned upside down. *Courtyard* was pure climax. By the end of 1962 Kaprow was finally rid of theater.

push and pull

In April 1963 an exhibition titled *Hans Hofmann and His Students,* organized by the Museum of Modern Art, made its New York debut in the Santini Brothers warehouse in midtown Manhattan. The warehouse, part of an art storage and shipping business, was a curious place for an exhibition of paintings and sculptures, but it offered Kaprow an ironic foil for an environment. Because the show was up for only one night, the opening reception became a kind of unintended Happening.

The exhibition included works by Hofmann, Robert Beauchamp, Jean Follett, Miles Forst, Mary Frank, Helen

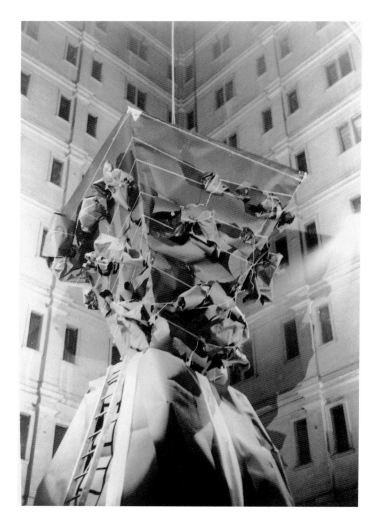

INVERTED "MOUNTAINS" CONVERGING IN *COURTYARD*, 1962 (PHOTO BY ROBERT R. McELROY, © ROBERT R. McELROY/LICENSED BY VAGA, NEW YORK, NY)

Frankenthaler, Michael Goldberg, Robert Goodnough, Julius Hatofsky, Alfred Jensen, Wolf Kahn, Karl Kasten, Lee Krasner, Mercedes Matter, George McNeil, Jan Müller, Louise Nevelson, Robert De Niro Sr., Larry Rivers, Richard Stankiewicz, and Myron Stout. An homage to Hofmann's broad influence, the show was also a de facto reunion of the original members of the Hansa Gallery. The exhibition checklist accounts for "49 paintings, 6 sculptures, and 1 'environment.'" Kaprow called this environment *Push and Pull: A Furniture Comedy for Hans Hofmann.*

Push and Pull was a two-room suite, constructed within the larger exhibition space. Visitors had to pass through one room to get to the other, just as they had in *Words*. The first room was a brightly lit furnished studio apartment, the kind an artist might live in, whereas the second room was like an attic, lined with black tar paper and dimly lit from above by a single bulb. In this second room were wooden crates (the kind used for shipping art), a stepladder, cardboard boxes full of straw and old clothes, a broken television, and sundry other junk, much of it borrowed from the warehouse. The tidy front room was furnished with several chairs, a desk, a dresser, a cot with a mattress and bedspread, a vase of flowers, pictures on the wall (including an older abstract painting by Kaprow), a typewriter, a few books, a mirror, and the like. The chair, desk, and dresser—the wooden objects—were painted bright yellow. Likewise, the walls were covered, from waist height to ceiling, with a yellow wallpaper spotted by violet "potato prints" (a technique associated with childhood art projects), while a deep-red paper lined the walls, dado style, from there to the floor. The impression was of crude Pop wallpaper covering the walls of the little room of Vincent van Gogh's *The Bedroom* (1888). In fact, this work and another painted during the Dutch painter's ill-fated but brilliantly productive stay in Arles, *The Night Café* (1888)—in which van Gogh sought to express "the terrible passions of humanity by means of the red and the green"[9]—were Kaprow's specific inspirations for the intense colors and spare layout of the front room. The po-

FRONT ROOM (TOP) AND BACK ROOM (BOTTOM) OF *PUSH AND PULL: A FURNITURE COMEDY FOR HANS HOFMANN*, SANTINI BROTHERS WAREHOUSE, NEW YORK, 1963 (PHOTOS: PAUL BERG)

tato prints on the wall referred, no doubt, to another famous painting by van Gogh, *The Potato Eaters* (1885).

The "terrible passions of humanity" described by van Gogh were, for Kaprow, mythic clichés no less than were Herculean labors or sacrificial virgins. He built them into his environment the way he had scripted myths and ritualisms into his Happenings. The difference was that here he did so in terms of the dynamic visual equilibrium of his former teacher's theory of art, "push and pull." In essence, Hofmann's theory was founded on visual oppositions—between shapes and forms, colors and their subsets, size and scale, surface and space, mark and field, texture and illusion, intention and accident, action and stillness, and so on. The theory was sweeping enough to account for almost any visual tension that might sig-

nify the equilibria of humanism in modern abstract painting. Hofmann had articulated an ideal of aesthetic intentionality that forever seeks its balance in a pictorial field. In many ways, Hofmann was the philosophical opposite of Cage, for whom human intention got in the way of experience. In *Push and Pull,* Kaprow reflected the competing influences of his mentors—Hofmann's desire for equilibrium and Cage's acquiescence to chance—and in doing so, he reconciled the physical setting of environments and the temporal unfolding of Happenings, although it happened so quickly he may not have noticed.

Push and Pull was indeed "a furniture comedy." (Kaprow had Honoré de Balzac's *The Human Comedy* in mind when he conceived this piece.) On the floor outside the front room of the environment sat an open wooden crate, in

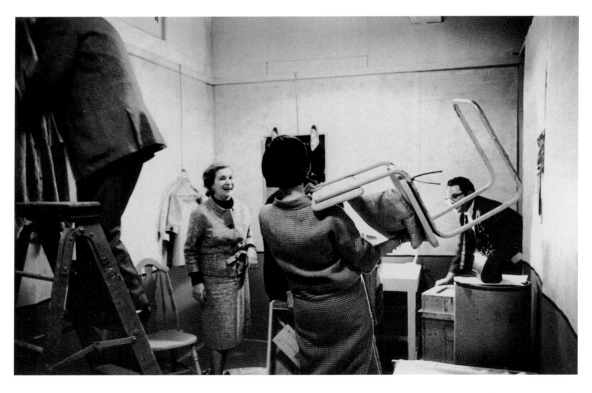

PARTICIPANTS, INCLUDING GEORGE SEGAL (RIGHT), IN *PUSH AND PULL*, 1963 (PHOTO: PAUL BERG)

which numerous crudely printed placards addressed the visitor, providing both "Instructions" and "Points of View." The "Instructions" read: "Anyone can find or make one or more rooms of any shape, size, proportion, and color—then furnish them perhaps, maybe paint some things or everything. Everyone else can come in and, if the rooms are furnished, they also can arrange them, accommodating themselves as they see fit. Each day things will change." Of course, the exhibition was in place for only one evening, not over a number of days, and people paid no attention to the invitation to "find or make" a room. Instead, they entered Kaprow's environment and began enthusiastically rearranging it by moving furniture around, exchanging the contents of the front room with those of the back room, and becoming "artists" themselves by gleefully composing impromptu "sculptures" of, for example, a cot with a sideways chair on top, a high-heeled shoe hanging on the chair, and a banana resting on the toe of the shoe; or a pair of high heels hanging, like a proto-feminist challenge, from the top edge of Kaprow's older painting, as if they were stepping on the sacred pictorial field (the shoes were put there by Kaprow's sister); or a bowl filled with straw and topped with a paper umbrella.

People had fun. They enjoyed the deliciously indecorous permission to make a mess. It was a mess that never devolved into chaos, however. This was due in part, no doubt, to the makeup of the crowd—attendees at an art reception honoring a legendary painter and teacher—but also to the fact that the two rooms were filled with objects that came with their own traditional roles and places in the world—a chair goes here, a flower pot there. Moreover, the theory of "push and pull" had been made manifest by Kaprow in terms of the dialectical tensions within and between the two rooms: the neat arrangement of objects in the colorful front room and the haphazard storage of things in the dimly lit back room gave people something to play around with, but it also served to remind them, like an aesthetic imprint, of the overall composi-

KAPROW'S SISTER, MIRIAM, READING INSTRUCTIONS FOR *PUSH AND PULL,* 1963 (PHOTO: PAUL BERG)

tional "environment" of which their actions were part. They were doing—or their doing was—a kind of "interior" design, and this was humorously reinforced by Kaprow in the "Points of View" placards in the crate outside the front room, on which he had written, with a dry, relentless logic, a brilliant parody of Hofmann's theory of "push and pull" as if it were a matter of interior decoration.

Kaprow's mock exposition begins: "Think of subletting someone's apartment. How can you get rid of the fellow when he is in every piece of furniture, every arrangement? Do you like living with him?" He soon goes on to propose: "Suppose you liked eating off the floor . . . it could be carpeted with food at all times. Design it like a Persian rug and you could eat your way through the designs, right across the room. . . . Maybe formality is the thing. Then carefully choose a big chair, a little one, a bigger table and a very small lamp, and push them and pull them around until they make a significant composition." "Significance" would be determined by having "both a calculated and an intuited reciprocity obtain between every push in one direction, and every pull acting against it in another direction. Significance may be achieved

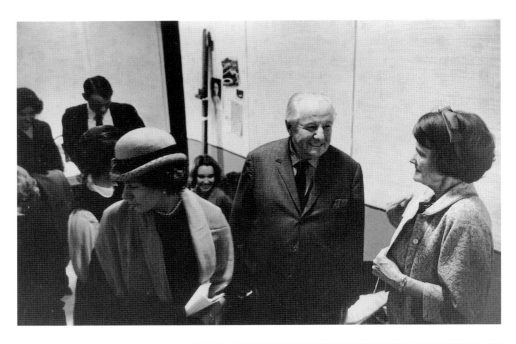

HANS HOFMANN AT THE RECEPTION FOR THE EXHIBITION *HANS HOFMANN AND HIS STUDENTS*, SANTINI BROTHERS WAREHOUSE, NEW YORK, 1963 (PHOTO: PAUL BERG)

within either a structure of symmetries, in which each push-pull relation is made of near-equals; or a structure of asymmetries, where the push-pull relation is realized from near-equivalencies." He cautions visitors not to sit on the chairs, since doing so "will destroy the composition. Unless you once again start pushing and pulling everything around until it works right." After asking things like whether the reader is fat or red-headed, Kaprow suddenly offers, "What about the kids? And their toys? I'd suggest allowing for a variable proportion of three yellow toy ducks to be considered equivalent to one medium sized violet dress (softened by black hair, brown eyes, and a leopardskin bag)." Speaking of the spaces between the furniture, he advises, "The interactivity between negatives and positives . . . may be so equalized as to produce a higher neutrality than the biases of the separate elements. Properly handled, a silence of perfect in-

eloquence will result." He then asks, "Should rooms be lived in or stared at?" After further analysis, Kaprow ends his meditation rhetorically by asking, "How long does it take to develop artistic senses? Why not ask an interior decorator?"

Kaprow's parodies are usually less a critique of something than a deadpan, academically rigorous embrace of it. His embrace of his former teacher's theory of aesthetic reciprocity was so literal that it was comic when applied to the social, psychological, and aesthetic aspects of designing one's habitat. It was a parody of "good composition." This was not to slight or embarrass Hofmann, but, in Kaprow's methodistic manner, to celebrate the complexity of his teacher's signature theory by extending—almost forcing—its logic into the real world, where, yes, it seemed absurd. But *Push and Pull: A Furniture Comedy for Hans Hofmann* may have been something of a nostalgic

piece for Kaprow, a way of at once honoring and yet transcending his teacher's theory by enacting it in physical and social terms. The references to van Gogh's paintings and his "terrible passions" added, to those who understood them, a poignancy that grounded the push and pull of modernist pictorial tensions in a tradition of tragic isolation; even Kaprow, for whom such isolation would have been merely another cliché, was, among all Hofmann's students, the one most separated in his own little environment. Hofmann, who attended the opening, was mostly bemused—amused at best—by his now-famous student's homage. He may also have been dazzled by the array of works presented by his progeny, a cornucopia of responses to Modernism both more and less modern than his own, both retrograde and avant-garde, pushing and pulling away from him in every direction. His theory had spawned a generation of artists, but to Kaprow, Hofmann, standing outside the environment looking in, seemed alone with his theory.[10]

Kaprow would later write of *Push and Pull:*

The public arrived and began moving everything; an exchange took place between the objects of both rooms. Soon there was a mess. Some older women resented this and began to straighten things up, as though they were cleaning house. Other women joined in. Gradually, the two rooms returned to a state approximating what they originally were, and the cycle was complete.[11]

Thus, a grand theory of the forces of abstraction in modern painting was reduced to the reflexive enactment of a domestic ritual—by women. The artist's invitation to rearrange the furniture elicited a gendered response, and although Kaprow saw that response in stereotypical terms—as housekeeping—it was the first time in one of his events that women had asserted themselves as women. In many Happenings of the early 1960s women—usually called "girls"—were used as props, icons, and ornaments to keep things moving. Now Kaprow noticed them as a sociological force capable of rising to spontaneous, if hackneyed, action. Whereas the "cops" had restored order in *Chicken,* these "older women" (the ringleader being Kaprow's mother) set things right in *Push and Pull.* In fact, their decorous uprising was perhaps the most interesting example of how complex and unpredictable behavior can become when utopian theories of art are applied to life.

The Apple Shrine and *Yard* had invited their audiences to make choices and undertake actions, but *Push and Pull* incited an entire Happening. Without quite realizing it at the time, Kaprow had built more than choices for physical action into this environment; he had incorporated the possibility for entire scenarios tied to the domestic interior—"clean up your room," "let's move out," "let's redecorate"—adult versions of "let's play house." In his 1966 book *Assemblages, Environments, Happenings,* Kaprow refers to *Push and Pull* as an "Environment/Happening"; this was the first and last time he would use the phrase. The work started out as an environment and became a Happening, eliding the distinction between them.

Kaprow would make just one more environment, *Eat,* in January 1964, and only then because he was able to gain access to a wonderfully dank and expressionistic complex of caves that had once been a brewery underneath the Bronx. A sacramental piece in which visitors could choose to enter this cave or that, drink red wine or white, eat bread and jam or fried bananas, or climb up, down, into, and out of cagelike wooden structures, *Eat* was a gorgeous event, like a German expressionist film, but Kaprow learned little from doing it, except that some places look too much like art to begin with. This work aside, *Push and Pull* effectively marked the end of a period of experimentation dating from the late 1950s, in which environments and Happenings developed in parallel until, because of adjustments in the trajectories of each, the distance between them narrowed to the point of convergence. *Push and Pull* also marked the end of the "New York scene" phase of Kaprow's career.

on the road

Kaprow's reputation as the father of Happenings, while a simplification, was nonetheless established by 1963. As the presumed spokesman for this quasi-ritual form of performance, he began receiving invitations, usually from younger art professors, to speak about Happenings at this or that college or university art department. Not wishing to be known as the theorist of a once vanguard art, Kaprow quickly began attaching a Happening to his visits as a condition of giving the lecture. Thus his career took a turn away from the New York art world and toward the academic hinterlands, where curious art students and their teachers waited for the latest word about what was "happening."

Kaprow took this turn at precisely the moment that many of his colleagues were graduating from Happenings to Pop art. For most of the other Happeners, Happenings had been experiments whose energies had been released

in the convergence of Cagean and expressionist aesthetics that had occurred around 1960. The gritty improvisations of that convergence, in their embrace of the raw materials and random occurrences of the modern urban environment, made room in the art world for Pop, whose embrace of images and messages and auras was by comparison slippery, ironic, and urbane. Pop art stayed in New York, and Kaprow took Happenings on the road, where their reputation preceded them.

As the harbingers of an unregulated freedom, Happenings were often associated with the prior indulgences of the Beats, especially on college campuses, where avant-garde impulses are usually half a beat behind the art world. On the road, Kaprow might as well have been Kerouac in the minds of students—but only until his own academic style as a pipe-smoking professor supplanted any expectations that he was a chain-smoking poet. The rep-

utation he had a harder time beating, however, was that of the prophet coming to herald a new order; with his slender Ukrainian-Jewish bearded face, he almost looked the part. In lower Manhattan, he was a spokesman; wandering among the colleges, he was a prophet.

Since Kaprow's earliest days as an artist, his career has evolved almost entirely in response to invitations. While all significant artists are invited to show their works, Kaprow has usually been invited to *make* his. He has worked, you might say, on commission, with no studio practice since 1960. Traditionally, the artist's studio has been the experimental locus of his or her work, but for Kaprow, the arts festivals and college campuses he has been invited to have been the loci of his experiments (a locus-in-motion). In this regard, he is something of an art-world maverick (its Lone Ranger). In New York, the experimental scene of the early 1960s was a neighborhood scene; artistic experimentation was concentrated and subjected to the near-immediate review of other artists, and everybody played off everybody else. The neighborhood itself was a Happening (as parodied in *Courtyard*). When Kaprow began traveling outside New York, the scale of the neighborhood changed, and he discovered that *he* was the Happening. The mostly familiar faces in the audience waiting to be swept aside by lawnmowers or pummeled with the sounds of oil drums bouncing around on a tile floor were replaced by the fresher faces of college students and their somewhat nervous teachers waiting to be enlightened by a Happening.

The game had changed. Kaprow found himself in the business of convincing an eager but unsophisticated audience to participate in childsplay. He had to simplify the event scores and tailor the Happenings to a smart but non–New York crowd, and in the long run this worked to his benefit. More significant, the experimental qualities of his works became related less to questions concerning their vanguard status and more to how they addressed and even participated in the urgent questions of modern life. Domestic conflict, built-in obsolescence, the packag-

ing of products and messages, the breakdown of systems, entropy and waste, negotiating human relations, technological change, the drudgery of work, the fear of play, the self-seriousness of art—themes such as these became the leitmotifs of Kaprow's Happenings well into the 1970s (long after he stopped calling them Happenings). *These were the mythic scenarios of contemporary life,* and his works became opportunities to play them out in commonplace terms. If Kaprow wanted a truly participatory art, it had to participate in the life it played at.

In a sense, as Kaprow's art became more and more life-like, his Happenings began to disappear. In New York, they had been art-world experiments; when he left the city, they lost their art-world context and the castaway urban environment that had given them so much of their antirationalist insurgency. Nonetheless, their reputation as radical theatrics only grew in the contexts of Pop art and the burgeoning youth culture. Propelled by the mass media, the myth of Happenings infiltrated the culture at large, its intense, collagist style of performance and fetishized sense of "the now" being applied to everything from youth gatherings to television commercials to the rhetoric of political leaders, and this myth preceded Kaprow wherever he went. Much of his lecture time on campuses was spent dispelling his own mythology (so he could get on with his work). By the late 1960s Happenings were bigger as rumors than they had ever been as events.

Beginning in 1963, Kaprow found himself practicing something closer to the routines of life than the conventions of art. His works began looking more like the sociology of work teams or the negotiations of marriage counseling than avant-garde theater—or even Happenings. By the mid-1960s the term "Happenings" had acquired so much art-world and pop-cultural baggage that Kaprow stopped using it, preferring the more neutral "activities" instead. The works on either side of *Eighteen Happenings in Six Parts* had been so tightly compressed in the experimental milieu of New York that they seemed, in retrospect, like parts of the same Happening. They were ex-

periments conducted for a short time by many artists in a laboratory of shared pluck. But that time was over, and Kaprow was now on the road.

tree

Kaprow's first stop, in May 1963, was George Segal's farm, where the Smolin Gallery was sponsoring the Yam Festival. Charles Ginnever, Yvonne Rainer, Trisha Brown, La Monte Young, Wolf Vostell, and Al Hansen were among the artists who had been invited to perform. Kaprow's contribution was an event called *Tree* (plates 6–9), which the *Village Voice* called "a war game in which no one won or lost except Mr. Kaprow."[1]

In the center of a grassy area about the size of a foot-ball field was a large mound of hay bales piled around the base of a tree. Hanging by ropes from the tree's branches were several quart bottles of beer. Lined up at one end of the field, facing the central mound, were six cars (several of them vintage), and perhaps ten feet in front of each car were short columns of stacked hay bales. A smaller mound of hay bales was stacked near the large mound. On the opposite end of the field were a hundred or so people, many of them the children of those invited to the festival, crouching low to the ground and each holding upright a small leafy sapling. From a distance, the mass of them looked like a young forest. Between this forest and the central hay mound were about a dozen poles stuck randomly in the ground, each with a wad of black tar paper tied to its top, like tar-paper trees.

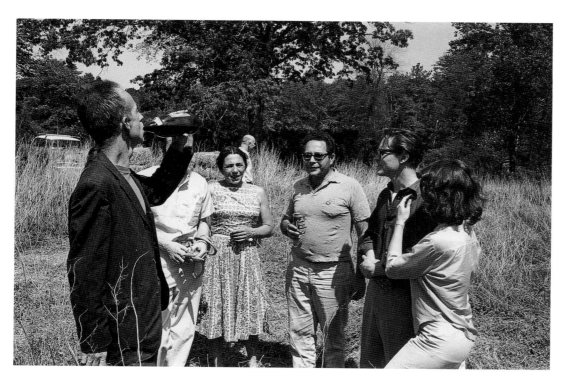

ROBERT WATTS, GEORGE SEGAL, AND ROBERT WHITMAN AT THE YAM FESTIVAL, SEGAL'S FARM, NEW BRUNSWICK, NEW JERSEY, MAY 19, 1963 (PHOTO © FRED W. McDARRAH)

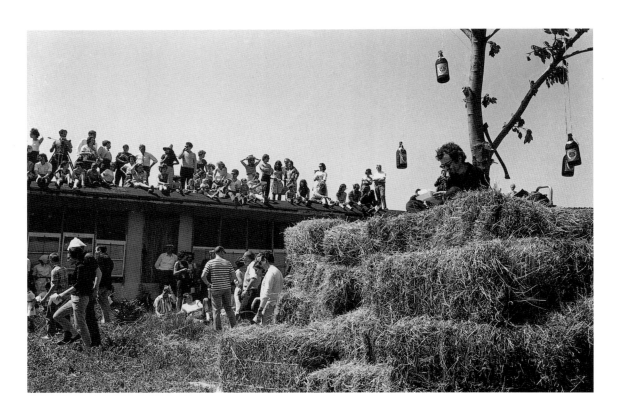

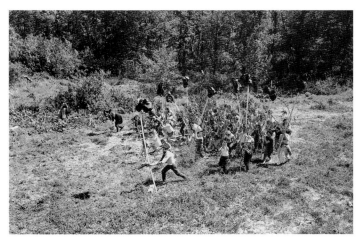

LA MONTE YOUNG, ON HAY MOUND WITH HANGING BEER BOTTLES (TOP), AND KAPROW, LEADER OF THE "TREE PEOPLE," KNOCKING DOWN A TAR-PAPER "TREE" (BOTTOM), DURING *TREE*, GEORGE SEGAL'S FARM, 1963 (PHOTOS © FRED W. McDARRAH)

The activity commenced when a man sitting on top of the central hay mound, La Monte Young, began playing "wild jazz" on a saxophone, "almost talking, laughing, or yelling to himself through the horn."[2] Periodically, he took a swig of beer from one of the dangling quart bottles, then spit it out with "studied relish." At the first sounds of the saxophone, Kaprow, the lead man of the "tree people," emitted a loud and defiant yell, dashed to the nearest tar-paper tree, knocked it down (broke it in half) with a swing of his sapling branch, and slowly knelt on the ground. After cheering the felling of the tar-paper tree, the other tree people crept gradually forward until they were gathered around Kaprow. This sequence was repeated until all the poles had been knocked down and Kaprow and his army were at the foot of the hay mound.

As this was going on, the cars advanced toward the central mound, knocking over the hay columns in their

way and blowing their horns as they went. Each time the columns were pushed over, the passengers in the cars leaped out and restacked them ten feet further on, after which the cars would advance and topple them again. Finally, the cars circled around until they were waiting in a single line, motors off, facing the central mound, at about the same time that Kaprow and his tree people arrived.

After a moment, Kaprow rose up with a roar, stabbed his sapling into the mound, and rushed to the top, where he grappled with Young, who tried to continue playing the saxophone until Kaprow ripped the instrument from his hands and threw it, and him, off the mound. Young then crawled to the smaller mound and began again to play, while the tree people, still in their crouching positions, fanned out around the central mound and planted their saplings in its sides. They then backed away, sat down silently in front of the cars, and waited.

Suddenly, Young stopped playing the saxophone. With everything quiet, Kaprow, on top of his "mountain," began drinking and spitting out beer with a certain "swagger" and even "disdain." Picking up a chain saw, which was lying at his feet, he notched the trunk of the tree rising out of the mound, leaning his weight against it until it fell over. The tree people rose to their feet, cheering wildly for a few seconds. Kaprow then drank some more beer, lifted the bottle over his head, began to sway drunkenly, and fell off the mound, rolling down its banks to the ground. At this moment, Young blew and maintained a single long note, which was overlapped by each of the six car horns in succession until all were blaring, underscored near the end by a foghorn. The crescendo ended at the moment the saxophone player fell off his own little mound.

As a war game, *Tree* was a stalemate, allowing the combatants to expend lots of energy without adding up the score, even as they earnestly played out mythic scenarios of battle—attack and retreat, thrust and parry, raze and rebuild, scorch and replant—that culminated in a mock triumphalism. In the end, Kaprow was king of the

CARS ADVANCING ON HAY COLUMNS DURING *TREE*, 1963
(PHOTO © FRED W. McDARRAH)

KAPROW ON HAY MOUND (ABOVE) AND AFTER CUTTING DOWN A TREE WITH A CHAIN SAW (RIGHT) DURING *TREE*, 1963. (ABOVE PHOTO © FRED W. McDARRAH; RIGHT PHOTO BY PETER MOORE, © ESTATE OF PETER MOORE/LICENSED BY VAGA, NEW YORK, NY)

hill, but, having drunk from the fruits of the tree of knowledge, he became inebriated and cut it down, lost his equilibrium, and was toppled by his own actions—rather like Macbeth, who deposed his brother, spoke to ghosts, and saw the forest move.

out

In September 1963 Kaprow was invited to participate in the International Arts Festival in Edinburgh as a presenter and a panelist for a symposium session titled "Theater of the Future." Luminaries at the festival included Roland Barthes, Eugène Ionesco, and the American movie star Carroll Baker. Since he had never regarded himself as a member of the theater, Kaprow felt out of place from the start. He contended during the panel discussion that theater need not be restricted to the conventional staged play, that it could include "circuses, pageantry, rituals, football games, church services, bull fights, peace marches, political rallies, television commercials, and military war games." This was, predictably, unacceptable to most other panelists. The title of the Happening he presented at the festival, *Out,* reflected his sense that many of the attending dramatists resented his presence there.[3] Certainly, none had ever attended a Happening, although many had heard of them.

Attendees were provoked halfway through the symposium proceedings when Kenneth Dewey, the brilliant San Francisco theater experimentalist, staged a short Happening in which, among other things, a man submitted a resolution to the conference asking that the "precise symbolism" of *Waiting for Godot* be established. Various live and taped sounds filled the hall, and figures staring in through windows high in the hall began calling, "Me! Look at me!" Baker, who was behind the speaker's stand, had been staring at Kaprow, who was seated at the back of the hall. She got up, took off her coat, and began walking and climbing across rows of seats in the audience to get to him. Then they both left. A nude model was

YOUNG MEN BANGING BARRELS AS AUDIENCE MEMBERS LEAVE THE THEATER DURING *OUT*, INTERNATIONAL ARTS FESTIVAL, EDINBURGH, 1963 (PHOTO: ALAN DAICHES; COURTESY GETTY RESEARCH INSTITUTE)

wheeled across the stage on a light stand, while a bagpiper, his pipes blaring, crossed the top balcony, and a pregnant woman with two children entered the hall, mounted the speaker's platform, examined an assemblage of phrenological head studies by the artist Mark Boyle, and then left. According to Kaprow, the delegates to the conference were incensed, but the general audience loved it.

Kaprow's Happening was staged at the end of the conference, after Dewey's event had split the participants into two camps: the outraged theater professionals and the curious public audience. *Out* was conceived as an exit piece in which the crowd in the hall would be led, Pied Piper–like, into a dreary Victorian courtyard, moving out the front doors and through a narrow, sharply angled lane of piled-up car tires squeezed on both sides by steel police barricades, while a procession of seven men, walking in circles around the courtyard, carried tires on their

shoulders. Meanwhile, elsewhere in the courtyard, several groups of men repeatedly knocked down and rebuilt randomly stacked columns of red and white oil drums. One man repeatedly crawled on the drums and fell off, while two others lifted drums and let them drop on the drums beneath them, producing a slow, steady booming that resonated with the pulse of the procession.

Those who elected not to participate could stay inside the hall and watch the procession from an upstairs window. What they saw in the courtyard below was the enactment of what Kaprow later described as "a half-conscious memory . . . of a painting by van Gogh of men

CARROLL BAKER NAVIGATING THE TIRE PATH IN *OUT,* 1963
(PHOTO: ALAN DAICHES; COURTESY GETTY RESEARCH INSTITUTE)

marching hopelessly in a circle around a prison yard."[4] The Happening, with its actors toiling inside its perimeter, viewed by disdainful dramatists from the equivalent of balcony seats, was a metaphor for conventional theater, with those passing through the gauntlet of old car tires and police barricades (both objects common to street anarchy) enduring the sometimes embarrassing and disorienting experience of exiting the theater after a play. The disequilibrium of this experience was compounded as they found themselves outside the theater but "inside" another play. They were subjected at every point of their path through the courtyard to the noise of steel drums crashing and thumping and the sight of men knocking them down and restacking them or aimlessly carrying around tires. It was an industrial Happening, recalling the machinations of Charlie Chaplin's *Modern Times* and echoing back through the tragedy of van Gogh.

After they had run the courtyard gauntlet, a "goodly number" of audience members and a "handful" of conference participants returned to the hall to discuss the Happening with Kaprow.[5] "At that point," he notes, "talk became sensible" and several interesting questions were raised. One had to do with the way in which Happenings seemed to destroy the "aesthetic distance" necessary to evaluate the success or failure of a work, to which Kaprow responded that he preferred "more direct emotional involvement than is customary" and that, at any rate, one could still judge the effectiveness of one's role in the event as long as a certain preknowledge of its purposes was provided. Another, more compelling, question was posed by a Nigerian delegate, who was somewhat offended by what he regarded as the trivialization of the ancient ceremonies of his homeland, which the Happening vaguely resembled. While admitting that he was intrigued by the procession, the man said it was clearly ritual, but ritual without religion. "He thought it strange," Kaprow recalls, "that our Western civilization should produce work so primal and 'crude,' while the intellectuals of Nigeria desired

the opposite."[6] To this, Kaprow responded that his art was industrial, and although it was somewhat coarse in practice, it was not unsophisticated in conception. He observed that Western art had traditionally renewed itself "by using direct and seemingly brutal means" and that, in fact, *Out* was not a ritual, but a ritualism, thereby making no claim to religion.

This exchange showed Kaprow that objections to his work were as likely to be based on cultural misunderstandings as on matters of taste or generational perspectives, and he realized that this misunderstanding was possible even within the Western avant-garde—the Nigerian delegate had simply pointed out an extreme instance of it. Kaprow was profoundly affected by this insight. It forced him to question his own missionary zeal as an avant-garde artist hoping to convert the world to the "most modern" art.

Out was less fun than *Tree* or *Courtyard* or *Push and Pull,* perhaps because Kaprow had finally come face-to-face with the intelligentsia of the theater world. He saw them as talented but stodgy intellectuals who would rather sit on their duffs and talk about "theater" than step out into the theater of late-twentieth-century life.[7] He poked fun at those unable to have fun by enlisting them in a march of uncertain balance and herdlike imprecision. In a dramaturgical milieu still permeated by the hopelessness of Jean Paul Sartre's 1944 play *No Exit,* Kaprow gave any who would follow him a way "out."

Out was also important for Kaprow because he had been forced to conceive it quickly after a more complex proposal involving motorcycles had been canceled by festival officials. He discovered that he was pretty good at acting fast, rather like an Action painter might, and he also sensed in the crisis of the moment a Zen-like opportunity to act. He had reached into his grab bag for oil barrels, tires, noise, and willing local performers, deploying them as a composer might dash off a score, and to a resonant result.

EUGÈNE IONESCO AMONG THE CROWD IN *OUT,* 1963
(PHOTO: ALAN DAICHES; COURTESY GETTY RESEARCH INSTITUTE)

Over the years, some of Kaprow's best works have been responses to unforeseen problems: roadblocks, cancellations, few attendees, the police, catching a cold, sponsors vanishing, bad weather, political assassinations, and general misunderstanding—the entropy and unpredictability of everyday life. He realized that in his line of work, it is better to adapt to circumstances than to act like a prima donna. Everyday life, after all, was what he had been asking for all along.

WOMEN AND HANGING FURNITURE (ABOVE) AND
MEN "BOMBING" FURNITURE WITH ROCKS (RIGHT)
IN *BIRDS,* SOUTHERN ILLINOIS UNIVERSITY AT
CARBONDALE, 1964 (PHOTOGRAPHERS UNKNOWN;
COURTESY GETTY RESEARCH INSTITUTE)

birds

In February 1964 Kaprow was commissioned by the Southern Illinois University at Carbondale to present a Happening somewhere on its campus grounds. Building on his experience in Edinburgh of adapting quickly to circumstances, he composed a small, easily assembled event that, in retrospect, marked a turn away from the more elaborate Happenings of the previous years (although some elaborate events were still to come). *Birds,* composed a few weeks before Kaprow arrived in Carbondale, was the first Happening that truly involved no spectators, with everyone (save a photographer) participating in the activities. This fuller participation was a result both of the work's scale—maybe a dozen art students and their teachers took part—and of Kaprow's expectations. Bruce Breland, an artist and professor who had extended the invitation to Kaprow on behalf of the university, had not specified how spectacular or public the Happening should be. So Kaprow took the opportunity to simplify his event score into something like a poem in five stanzas. It read:

1. Three women swing hanging furniture, and bang trees with sticks.
 Wall men build wall of rocks on edge of bridge.
 Bread man hawks bread and jam, "Bread!, Bread!, Bread!" etc., blows toy pipe whistle.

2. Bread man silent.
 Wall workers go to tree women, taunt them, bang with sticks and rocks on trees.
 Tree women drop furniture.

3. Wall workers carry furniture to pile under edge of bridge.
 Tree women blow police whistles.
 Wall workers bomb furniture with rocks from wall.
 Bread man resumes hawking.

4. Wall workers leave quietly one by one when finished.
 Bread man continues hawking.
 Tree women silent after first wall worker leaves.

5. Bread man slowly bombs rubble with bits of bread, leaves when finished.
 Tree women rhythmically yell in unison "Yah! Yah! Yah!" like crows, as bread man does this and when he leaves they are silent.

As the score suggests, the activity took place over, across, and beneath a small bridge—a simple but well-crafted wooden footbridge spanning a dry creekbed. The "wall workers" used rocks from the creekbed to build a low, rough-hewn wall along one of the edges of the bridge, at one end of which stood a small patio table stacked with loaves of white bread and several jars of jam, with a little protective umbrella opened quaintly above it. The "tree women," dressed for the weather, sat in the winter-barren trees, from which numerous pieces of furniture—old chairs and dressers, mostly—were hanging by ropes.

As the activity unfolded, a kind of ritualized exchange took place between the women and the men, in which actions were traded and gender stereotypes played out. All this took place in the vicinity of the bridge, symbolic of the chasm between the sexes. The men were the builders, the engineers, the heavy lifters, while the women sat perched, like birds (a pun on the slang term for "women"), in their awkwardly furnished nests—in fact, in nests weighted with heavy belongings dangling tenuously above the ground. The women banged sticks on the trees as the men built the wall. The men taunted the women, who responded by dropping furniture from the trees. The men dumped the furniture under the bridge and "bombed" it with rocks from the wall they'd just worked so hard to build, departing "one by one" as the women watched silently from their now empty nests. Meanwhile, the bread-and-jam hawker had been moving among the antagonists, playing a pipe whistle and offering manna

but finding no takers. In the end, he dropped little pieces of bread, mimelike, on the smashed furniture (the ruins of a bad marriage?), as if releasing alms over a grave, or snowflakes on the ground. The women squawked like crows, but were ultimately silent. The little wooden footbridge, almost an icon of plain midwestern Americana, reminded Kaprow, oddly, of the tortured viaduct in Edvard Munch's 1893 painting *The Scream*.[8]

Like myths, stereotypes are frameworks for cultural beliefs. *Birds* represented for Kaprow a kind of scaling-down from the grandiosity of mythic scenarios to the relative pathos of, in this case, the gender stereotypes that trap men and women in their respective roles. Hunkered in their nests, the women were harpies, half woman/half gargoyle. Laboring at their tasks, the men were builders and destroyers, apparently unable to tell the difference between their two actions. In these well-worn roles, the players knew their stories—that is to say, their scripts were already internalized as cultural stereotypes that required just a few simple stanzas to set them in motion. The stereotypes, like myth and ritualism in Kaprow's earlier works, had replaced the narrative script. This was, in its simplicity, an innovation for Kaprow, aligning the goings-on of his activities more closely with those of life, and finally—finally—eliminating the audience.

paper

In March 1964 Kaprow went to Berkeley, where he'd been invited by the University of California to present a Happening as part of a spring arts festival. (Among the other invitees were Anna Halprin and Lawrence Ferlinghetti.) Called *Paper,* the event took place in a multilevel parking garage. The participants were university students. *Paper* involved a woman continuously dancing the twist, twenty-five men sweeping a line of crumpled newspaper, and ten men tipping oil drums end over end; twenty-five cars entering the garage at half-minute intervals, headlights on, driving slowly; each car dumping

a woman's "body," which became part of the line of paper being swept; the cars driving off and then back in a hurry; the drivers jumping out and running wildly to other cars, eventually returning to their own cars, at which point they leaned on their horns for one long minute; the twenty-five women in the paper pile jumping up and wrestling with the sweepers, who capitulated; the barrel men getting up on their barrels and dancing the twist while the women twisted toward them; the women then pulling the barrel men violently to the ground, loading trash into the barrels, and loading the barrels onto a truck, which they drove away, yelling, "Goodbye"; the single twisting woman dancing toward each of the barrel men, still lying on the ground, and kissing them tenderly on the lips; and finally, the cars driving over, loading up the men's bodies one by one, and leaving.

In his handwritten notes, Kaprow is uncharacteristically specific about the symbolism of *Paper*.[9] It is, he writes, essentially a "nature ritual" in which the cars, which have male and female attributes (depending on the model), are not only "agents of the mechanics of nature" but also "primarily vehicles of death," like hearses, "which later become agents of rebirth" as the drivers change cars. The garage is thus "a place of some sacred enactment, with a death-life rhythm." The twisting woman embodies "the sense of the enduring, the mindless, the inevitable . . . a kind of constant." She also represents Aphrodite. The crumpled newspaper is "the wasteland . . . the fallen leaves of civilization, the collected records of everyday life, passing into a nameless sludge." The sweepers are "the male principle," those "who move things about, who do things, who erase dirt, who clean up to start again." They are the "breakers of the winter soil," and in the end they become one "with the papers they sweep."

The women's "dead" bodies are "another aspect of natural forces on the feminine side": "They must be swept into being, into power . . . they are fertilized by being rolled in the paper," which, "collectively, is the stream of life." The women must also destroy the men, enacting the

"devouring side of mother nature." The barrel men are "the keepers of the sacred vessels," who sound out "the physical rhythms, the pulse beat and birth contractions, tipping over, emptying themselves." Like all garbage collectors, they "collect the trash of the world and will take it off to be buried again in a special place, presumably the city dump, where like the dead, this refuse consumed in fire will rise again." The barrel men dance, celebrating the "coming-to-life of the women who immediately destroy them because their task has been completed. They also destroy the sweepers in the same spirit. The male principle is like that of the male bee who in implanting life must die. . . . Thus the women celebrate in joy their own full state, their renewed vitality, their springtime as they drive off in the truck." Kaprow concludes in an almost Shakespearean adieu that "the cars take the dead away, to also be reborn, and the twist gal puts upon their lips the kiss of love and life, like a mother kissing her child good night."

Kaprow's literary descriptions here seem excessive in comparison with his academic writing and his ongoing insistence on the flat-footedness of his Happenings. In the same notes, he describes his work as both "immediate activity" for its own sake and "symbolic activity" for meaning's sake. (Here, without doubt, he uses the term "meaning," in the literary sense, as something we articulate and perhaps even experience through words.) The language Kaprow uses seems incredible, if not parodistic, until we recall that in 1964 the vocabulary of latent symbolic meaning was not uncommon among artists and intellectuals. This parlance, derived from Freudian psychoanalysis and Jungian archetypes, was common, if not quite commonplace, among people interested in "meaning" (of which there were many at Berkeley). The language still seems indulgent, but maybe Kaprow indulged for a purpose, since by doing so he asserted that his participants were able to think "without fright . . . on several levels at once." The parallel play of latent meaning and immediate experience is precisely the creative tension

PARTICIPANTS SWEEPING PEOPLE AND TRASH DURING *PAPER*, BERKELEY, CALIFORNIA, 1964 (PHOTOGRAPHERS UNKNOWN; COURTESY GETTY RESEARCH INSTITUTE)

that discharges art into action—a discharge that only takes place in the doing.

Kaprow never claimed, even at the high point of his interest in ritualisms, mythic scenarios, stereotypes, and archetypes, that the actual experiences of his Happenings were anything close to mythic. He never beckoned symbolic meaning in his works, offering immediate experience instead—the literal in place of the literary. Symbolic meaning was certainly part of Kaprow's creative motivation—it was a kind of energy source, cultural background noise, more refuse to be swept up in the making of the Happening—but he did not assume it would replace the participant's experience of doing. The people who pushed mounds of paper with a broom in a parking garage or threw rocks on furniture in a creekbed were left to draw their own conclusions about the meaning of their actions.

Kaprow discouraged the enactment of "meaning" in his works by substituting seemingly meaningless tasks like sweeping or rolling for theatrical gestures like sweeping or rolling *with feeling*. Which is to say, he hid acting in actions—as well as symbols in stuff, myths in movements, settings in places, and performances in childsplay. In *Paper,* he covered up the dance of a spring fertility rite with trash, with the news as paper trash, with cars as cultural trash, with car horns as noise trash, with empty oil barrels as energy trash, with people as urban trash, and with the parking garage as the temporary storage container of it all. The whole Happening was a death-and-birth cycle performed as an urban-scale spring cleaning.

Spring cleaning of a sort was in the air on the Berkeley campus in 1964. The Free Speech Movement was in the news, and the paper in *Paper,* besides being part of "the stream of life," was the free detritus of all that contested speech. Later that year, when Mario Savio took off his shoes in Sproul Plaza and stepped on top of a police car holding a fellow student activist, arrested for passing out paper, and spoke his famous words about putting one's body upon the gears, upon the wheels, upon the levers, and upon the apparatus in order to make it stop, it would be a Happening with lots of people surrounding a car holding a prisoner of speech, with paper, the debris of political consciousness, everywhere littering the plaza.

household

Later in the spring of 1964, as part of another arts festival, this time at Cornell University, Kaprow took the literalization of trash to an extreme by conceiving a Happening for the Ithaca city dump. In the days before the ecology movement and the Environmental Protection Agency, dumps like Ithaca's were truly hazardous places, where refuse of all kinds was simply tossed off the backs of trucks by individuals, families, contractors, businesses, and even government agencies. In some spots, the dump—a wide, bulldozed clearing in the woods—smoldered twenty-four hours a day. It made a perfect battle setting for *Household*.

Household revolved around the theme of domestic conflict between men and women, and was played out using sexual stereotypes in a kind of children's war game. Perhaps one hundred people attended; most were Cornell students, but the group also included some families with children. They drove from the university campus to the dump in an off-to-meet-the-enemy convoy, with flags and banners (the banners said "banners") streaming from the windows of the cars. Meanwhile, two small groups, one of men and the other of women, were busy building a "tower" and a "nest," respectively, from junk in the dump. The tower (a rather good-looking junk sculpture) rose thirty feet into the air; the nest was a weedy labyrinth of strings and saplings over which was stretched a clothesline with old shirts. The nest and the tower were on roughly opposite sides of the dump's central turnaround, which served as the Happening's contested field of battle.

When the convoy arrived, its members circled the dump on foot, remaining out of sight in the surrounding trees. They waited, watching the builders work. When the nest was finished, the women who built it went inside and began screeching, while the men, their tower now fully

 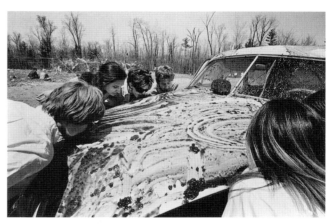

WOMEN BUILDING A "NEST" (TOP), MEN SPREADING JAM ON AN OLD CAR (BOTTOM LEFT), AND WOMEN LICKING JAM FROM A CAR (BOTTOM RIGHT) DURING *HOUSEHOLD*, ITHACA CITY DUMP, NEW YORK, 1964 (PHOTOS: SOL GOLDBERG)

erect, pushed an old wrecked car to the dump's turn-around and began smearing its rusty skin with liberal swaths of strawberry jam. They then went to the nest, pulled the shirts from the clothesline, put them on, and squatted down to watch as the women came out from their nest, walked over to the car, and began licking the jam from its doors, trunk, and hood (in one of the most oft-produced photographic moments of any Happening).

As the women licked the car, the men vigorously be-gan destroying the nest, reducing it to a pile of broken sticks and tangled string. The surrounding "army" of people in the trees began slowly advancing on the central turnaround, blowing whistles and banging pots and pans in unison. After destroying the nest, the men sauntered over to the car (almost in the cocky manner of the Jets and the Sharks in *West Side Story*), where the women were still licking jam. They then violently yanked the women away, literally throwing one woman to the ground. The women, screaming, "Bastards!" at the men, retaliated by running to the nearby tower and tearing it apart with relish, until it toppled like an old building into the heap it had once been. Rejoicing on top of the wreckage, the women taunted the now crouching men, taking off their blouses and twirling them over their heads in a kind of victory twist (a scene reminiscent of the feminist bra burnings of those years).

As the noisemaking crowd gathered closer around the car, the men, their tower obliterated, hurled orange smoke bombs high into the air, adding to the smoke already ris-ing from the dump. They then converged on the car and began beating it with sledgehammers, trying to pound it into a shapeless mass (and quickly finding out how hard it is to destroy a big American automobile). The women, still triumphant atop their victory mound, cheered with every hit. After a while, with the surrounding crowd quietly eating jam sandwiches, the men slackened their

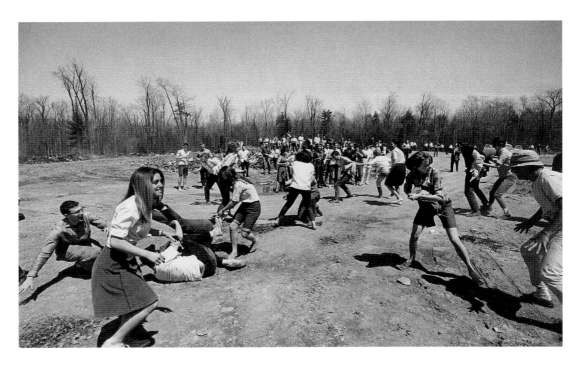

A SKIRMISH BETWEEN MEN AND WOMEN DURING *HOUSEHOLD*, 1964 (PHOTO: SOL GOLDBERG)

efforts, jacked up the car, removed its tires, and, after dousing it with gasoline, set it on fire. The women ran out of the dump, waving their blouses and calling, "Bye!" They got into cars and drove away, their horns blaring until they were out of earshot. The rest of the participants sat quietly, many smoking cigarettes, mesmerized by the car burning in the noonday sun. They quietly left the dump when the flames flickered out.

Household foreshadowed the student protests that would soon rock the country. It was a scenario of smoky skirmishes in which one side countered the probes and forays of the other, resulting in a purposeful stalemate— although the women seemed to get the last laugh, leaving the men to stare at their beaten, burning hulk. The fact that it took place at a smoldering dump site underscored its gesture of anarchy, suggesting that the foundations of life are unstable and that all civilizations are built on the ruins of their predecessors. At the same time, everyone knew it was a mock battle. Like children playing war, they fought in earnest and expended enormous amounts of physical energy without anyone being hurt. *Household* was also a symbolic orgy, replete with corny sexual images and actions—the phallic tower (and its toppling), the womblike nest, the orgasmic smoke bombs arching into the air, the women licking jam off the car, the car itself as both a phallus and a woman's body, the taunting, blouse-less women, and the cocky, sauntering men.

The work's more serious attempt at experimentation, though, involved sexual stereotypes. The relative stalemate between the men and the women reflected Kaprow's awareness of the growing influence of the Women's Movement.[10] Proto-feminism was in the air, and sex-role stereotypes (like all cultural debris) were up for grabs. Kaprow's battle scenario was a theatrical framework that allowed men and women to play out their respective stereotypical roles in a quasi-public setting, which they did with gusto. The fact that the context for the Happening was a dump may have suggested to some that old-fashioned sexual stereotypes ought to be tossed in the trash.

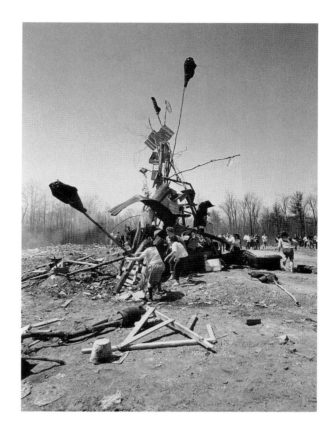

WOMEN DESTROYING THE MEN'S TOWER DURING *HOUSEHOLD*, 1964 (PHOTO: SOL GOLDBERG)

In retrospect, *Household* recalls those heady days in the social interregnum of the mid-1960s when young people on college campuses (which is to say, mostly white young people) were inspired by the example of the Civil Rights Movement in the South, were beginning to hear of the struggles for free speech out West, could sense the early stages of the Women's Movement, were eagerly joining the Peace Corps, and were poised to embrace the aims of the Great Society (perhaps as a way of compensating for John F. Kennedy's death), but *before* the escalation of the war in Vietnam, the numbing back–to-back losses of

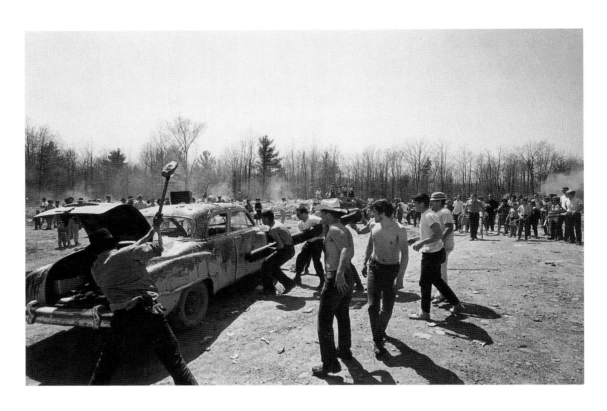

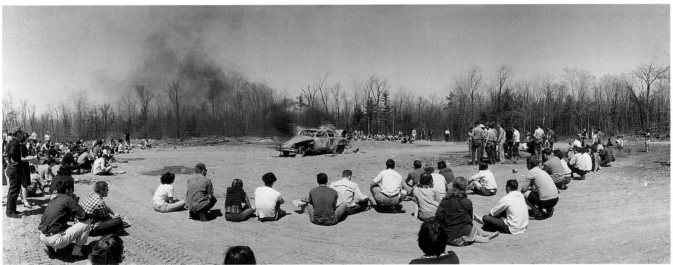

MEN TRYING TO DESTROY A CAR (TOP) AND THE "FUNERAL PYRE"
(BOTTOM) DURING *HOUSEHOLD*, 1964 (PHOTOS: SOL GOLDBERG)

Robert F. Kennedy and Martin Luther King Jr., the shocking explosion of racial tensions in the cities, the sickening riotous police at the Democratic Convention in Chicago, the needless shootings at Kent State University, and the general degradation of the youth movement's idealism into the subcultures of hedonism and rage.

It is important to remember that, while he is associated with the 1960s, Kaprow was in fact a member of the older generation, having come of age a decade earlier. His sense of the early 1960s was one of ongoing crisis emerging from the 1950s, of a world destabilized by fears of nuclear proliferation, radiation clouds, unchecked technological development threatening to destroy the Earth, the Cuban Missile Crisis, the Berlin Wall, the simmering conflict in Southeast Asia, the crime of apartheid in South Africa, the promise of the Civil Rights Movement in the United States, the bid by Third World countries for independence from colonial powers, the assassination of John F. Kennedy, and the increasing unrest on college campuses. The early 1960s, for him, were not so innocent. He was old enough to know that, however new they appeared, the times that were "a-changin'" were predicated on the unresolved military, moral, and social conflicts of the 1950s. These gritty conflicts belied the pop-cultural glossiness that would come to stand for the newness of the 1960s, the "headiness" that would come to a head in the second half of the decade. Perhaps that's one reason so much avant-garde art of the time was made of junk, the unstable, shifting, primitive landfill upon which the seemingly modern world is built.

At the same time, Kaprow sensed in the upheavals of the 1960s an underlying conviction that modern life could be redeemed—that the world could indeed be made better. This conviction, for him, lay at the heart of the outrage expressed by young people against military and political conflicts and especially against social injustice. Though his own work was apolitical—often poking fun at the self-seriousness of political action—Kaprow shared a powerful interest with the artists of his generation in the "real world," where so much that was crucial was taking place. In the role-playing of his student participants, Kaprow not only saw their momentary, perhaps soon-to-be-embittered naiveté, but he may also have glimpsed in their energetic reactions to the sexual stereotypes and battle scenarios of *Household* the radical political actions of the very near future—and in those actions, and on that dump site, the possibility of redemption.

Household is one of Kaprow's most well-photographed and well-known Happenings, and it is also the only one for which a fairly complete (although amateur and anonymous) silent film exists. The unfolding of one episode into the next, the sunny weather, candid documentary details (the women's hairstyles, the men's cocky walk, the dated student clothes, the facial expressions of enthused anticipation, the montagelike movements of the boy-girl skirmishes), and the overall scale of the event offer themselves on film in a way that photographs, scores, journalistic accounts, and memory cannot capture. Put together, the writings and the photos and the little film provide a clear picture of the social and environmental parameters—and in some cases, perimeters—of Kaprow's mid-1960s Happenings.

Having expanded beyond the theater and other cramped urban settings, Kaprow's works were reaching a new, more diffuse scale. They got as big as the places and as long as the times they encompassed. *Household* needed a noonday garbage dump, *Paper* a campus parking garage, *Sweeping* a clearing in the woods, *Service for the Dead II* a beach at dusk. This "expanded field" (to draw on Rosalind Krauss's term[11]) made the dispersion of energy at the close of each Happening all the more apparent to Kaprow: it's one thing to steal away into the night of the big, dark city, but another to drive away from a rural dump site, where minutes before you were engaged in mock gender warfare, and just go home. There was no conclusion to these larger-scale Happenings, only a petering out, like friends calling it a night and going their separate ways. Noticing this dissipation of performance into everyday life, Kaprow decided to make it a prominent feature of his next few works.

calling

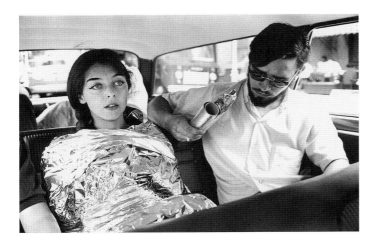

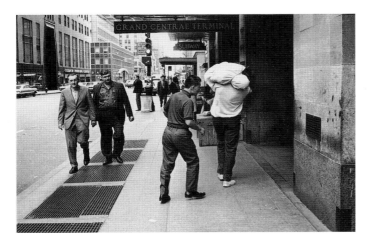

JEANNE-CLAUDE BEING WRAPPED IN FOIL (TOP) AND A WRAPPED BODY BEING CARRIED TO GRAND CENTRAL STATION WITH AY-O FOLLOWING (BOTTOM) DURING *CALLING*, NEW YORK, 1965 (PHOTOS BY PETER MOORE, © ESTATE OF PETER MOORE/LICENSED BY VAGA, NEW YORK, NY)

In *Calling,* a two-day work performed in New York City and the woods of Segal's farm in August 1965, Kaprow extended the experience of dispersion into a metaphor of human cargo. *Calling* began with three people waiting at different street corners. Someone called to each of them from a car as it approached, and they got in. Once inside, they were wrapped in aluminum foil and transported through the streets of lower Manhattan. They were then rewrapped in muslin, dumped in a wastebasket on the street, picked up by another car, and eventually carried into the terminal of Grand Central Station, where they were deposited at the base of the circular information counter. There, after calling out one another's names, they struggled free of their wrappings, walked to nearby telephone booths, and dialed a prescribed number. After fifty rings, the telephone was answered by one of the drivers who had just dropped them off. The driver asked for the caller's name and then immediately hung up.

The next day, an overcast Sunday, the same people—Kaprow, his wife Vaughan Rachel, Michael Kirby, Peter Moore, Dick Higgins, Alison Knowles, Robert Brown, Lette Eisenhauer, Jeanne-Claude, and Ay-O, among others—drove to New Jersey, where they gathered in the woods behind Segal's farmhouse. After brief remarks from Kaprow, all but the three who had been "abducted" the previous day filed, in five small groups, to designated spots in the woods, where heavy sailcloth sacks were hanging by ropes from tree branches. Each group, isolated from the others, quietly waited. The three people who had been abducted waited outside the woods. After a while, Kaprow called, "Come on," signaling the three to enter the woods. As they did so, one volunteer in each of the five groups climbed into the sailcloth sack and hung upside down, perhaps a foot off the ground, with his or her head poking through a hole in the cloth. Meanwhile, the three people began searching the woods together, calling out the names of those who might be hanging in the sacks. When

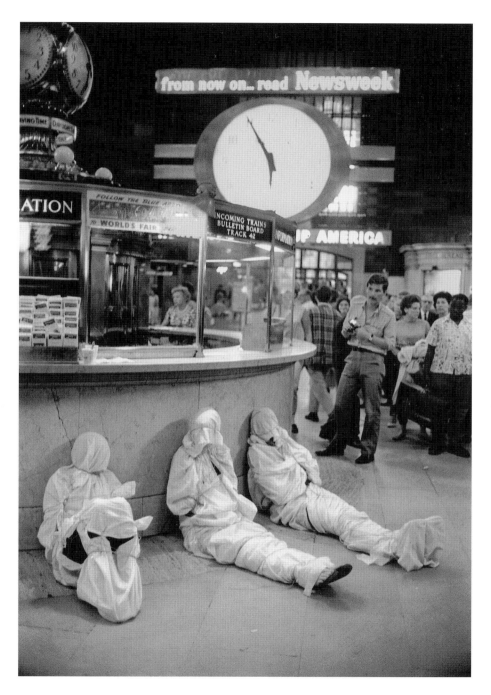

WRAPPED BODIES AT GRAND CENTRAL'S INFORMATION KIOSK DURING *CALLING*, NEW YORK, 1965
(PHOTO BY PETER MOORE, © ESTATE OF PETER MOORE/LICENSED BY VAGA, NEW YORK, NY)

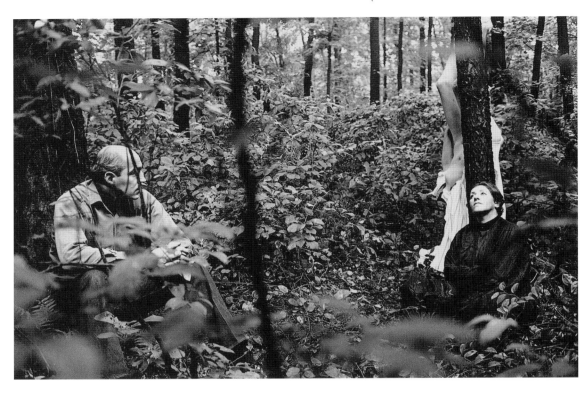

the correct name was called, the members of that person's group replied, "Here," a sound the searchers followed until they found the hanging person, whose clothes they quickly cut or tore off before moving on to the next group. This call-and-response routine continued until each hanging person had been found and his or her clothing stripped away, at which point the trio of searchers left. After a period of silence, the people remaining began calling the names of those hanging in the trees, filling the woods with what Kaprow remembers as "a random vocal symphony" that came from various locations over perhaps a ten-minute period.[12] Soon the pauses between calls grew longer. When silence returned, everyone quietly left the woods.

For those taking part in the Happening, there was a clear contrast between the hustle and bustle of the city and the tranquillity of the country. The logistical arrangements necessary to pick up someone at a street corner, wrap, unwrap, and again wrap them, discharge them, then pick up someone else and deposit them in the city's busiest transit hub before hurrying home to await their phone call—all according to a fairly tight schedule—were antithetical to those required by people seeking each other in the woods. The one demands planning and precision, the other a willingness to wander and wait. The demeanor of the participants also differed according to the landscape: calling from a car window, in the middle of a crowd, or over a phone produced a more fractured

and anxiety-ridden sound than did calling in the woods.

Calling incorporated metaphors of packaging, of the contrast between Eden and Gomorrah, and of metamorphosis. The wrapped people were cocoons being carried away to places of gestation, people being kidnapped off the street by mobsters, crash-test dummies, or corpses deposited, by some colossal bureaucratic miscalculation, at Grand Central Station, depending on their context. But whether they were in the city or the country, on the road or in a tree, the calling kept them together, led them to where they were going, found them, and cut them loose.

Calling was Kaprow's first call-and-response activity. The themes of getting lost, of unclear signals and missed connections, of finding one's way—whether in the urban maze, the technosphere of modern communications, or the labyrinth of human relations—would increasingly characterize his work as he moved through the 1960s. Fittingly, these motifs emerged as his Happenings began to scatter across time and space.

self-service

Calling was not sponsored by anyone, nor was it the result of an invitation; Kaprow just did it himself, asking friends and colleagues to participate. The following summer, he initiated a Happening in the same way, this time extending the two-day city-country structure of *Calling* into a summer-long, three-city menu of activities from which participants could choose what they wished to do. Called *Self-Service,* it was passively supported by the Institute of Contemporary Art in Boston and the Pasadena Art Museum (Kaprow spoke to audiences there about the upcoming Happening). People in Boston, New York, and Los Angeles signed up to enact one or more of the activities available in their particular cities.

In New York, for instance, participants could select from the following:

Rockets, spread over several miles, go up in red smoke, explode, scatter thousands of scraps of paper with messages.

Couples make love in hotel rooms. Before they check out, they cover everything with large sheets of black plastic film.

On the shoulder of a stretch of highway, a fancy banquet table is laid out, food in the plates, money in the saucers. Everything is left there.

People stand on bridges, on street corners, watch cars pass. After two hundred red ones, they leave.

In Boston:

Many shoppers begin to whistle in aisles of supermarket. After a few minutes they go back to their shopping.

On another day, twenty or more flash-gun cameras shoot off at same time all over supermarket; shopping resumed.

In a neighborhood, people inflate, by mouth, a twenty foot weather balloon. It's pushed through the streets and buried in a hole at the beach. The people leave it.

People tie tarpaper around many cars in supermarket lot.

In Los Angeles:

Cars drive into filling station, erupt with white foam pouring from windows.

A car is built on an isolated mountain top, from junk parts. Is left.

Night in the country. Many cars, moving on different roads, about a mile from a certain point, lights blinking, horns beeping sporadically, converge and disperse.

Warehouse or dump of used refrigerators. People bring packages of ice, transistor radios, and put them into the boxes. Radios are turned on, refrig doors are shut, people leave. On another day they return, sit inside with radios for a while, and quietly listen.

These were just several of the offerings for each city. There were about thirty scenarios in all. Some were only for New York or Los Angeles or Boston; others could be enacted in any location. Kaprow traveled to each city to speak with interested participants and to designate contact persons. This allowed him not only to spread word

of the Happening, but to spread around its administration too: while Kaprow dreamed up the plan for the Happening, he largely left the details—who was signed up for which activity and when, how to get to the various locations, what to bring, and so forth—to others.

Self-Service was like a dandelion going to seed, with activities dispersing across the nation throughout the summer (and presumably taking root here and there). The menu of activities allowed participants to choose actions according to their own taste: some might be bold enough to wrap cars with tar paper in a parking lot, while others might prefer the relative anonymity of riding on a bus and waiting for a person with a sad face to get on. According to an activity distribution chart for Los Angeles, no one chose to put transistor radios in used refrigerators, but forty-three people decided to eat sandwiches in phone booths, fourteen to whistle in elevators, eight to count red cars, sixteen to use scavenged car parts to build a car on a hilltop, and seven to wrap cars with tar paper in a parking lot—or at least they said they would. In a lecture to participants before the Happening commenced in June, Kaprow claimed, "*Self-Service* will not suffer at all from indifference or laxity on the part of those who have elected to enter into it. There is nothing to harm. Put positively, there is everything to gain by giving the best one has to whatever one does. No one will take attendance and no grades will be given." The organization required for *Self-Service* was rather elaborate, like planning and serving a multicourse banquet. It wasn't merely a conceptual piece to be realized in the mind; it was—as a flyer for the event proclaimed—"Hundreds of Happenings in Three Cities over Four Months." The gridded layouts used to show what would happen where, when, and by whom are reminiscent of the score for *Eighteen Happenings*. The dispersal of the "audience," each person witnessing an action seeing only part of the whole piece, also recalls that earlier work. Kaprow liked the idea that so much activity would happen in so many places and over so much time, but that almost none of it would be seen—especially by

him. He hoped that participants would get out there and watch for red cars or sad faces, but there would be no way to tell what actually happened. The Happening just went into the world.

Dispersing a Happening was perhaps a radical idea for art, but most of the biggest phenomena in 1966 were already impossible to see in their entirety: communications networks, advertising campaigns in magazines and on billboards, television, the Beatles, the daily flow of the mail, airplanes traversing the nation's skies, dinners being prepared, couples making love in hotel rooms, police looking for red cars on the streets, people whistling in elevators. *Self-Service* was Kaprow's first Happening by network (artists associated with Fluxus had been sending mail art for some time), and it raised the question of what "big" meant in the media age: Was it a single, spectacular event, like a football game, or might it also be an image, a message, or a plan for an activity disseminated throughout a network of nervelike connections?

Kaprow was attracted to the idea of a Happening that used the entire country as a medium for art, but he found this to be a somewhat utopian concept. The actual experience of making countless telephone calls, writing and answering numerous letters, visiting each city to explain his ideas, and issuing written clarifications of what people were being asked to do was more like being a traveling salesman than a network tsar. This was not a McLuhanesque expansion of Kaprow's nervous system, but a rather exasperating and time-consuming dispersal of his attention. It was *he* who was expanding, not the Happening.

Although Kaprow worked very hard to keep *Self-Service* within the range of everyday, concrete activities, he found it to be surprisingly abstract and disembodied. It had been conceived as a way of extending Happenings beyond the authority and creative arena of the artist, but it instilled unexpected doubts in Kaprow about the capacity of the media-age metaphor of "the network" to yield much in the way of physical or communal action.

Those participating "on the ground," as it were, may have experienced something concrete and even communal, depending upon the scenario enacted, but Kaprow—the artist—was left on the sidelines. Despite the successful distribution of the scores for possible actions among the Happening's network of interested friends, associates, and strangers, *Self-Service* was, for Kaprow, less satisfying than he had imagined. In fact, imagining it was pretty much all he could do.

Self-service (along with fast food) was the newest means of expanding American consumption, and it was no accident that Kaprow included activities involving cars, gas stations, launderettes (they were feminine then), supermarkets, picture taking, telephone booths, and sandwich eating in *Self-Service*. The Happening raised the question of who serves the "self," especially in art. Traditionally, the artist's "self" had been served in the creation of the artwork and had in turn served others through that art. In *Self-Service*, the artist delegated the "self" to others in settings where self-service was the standard. As they were taking pictures in grocery stores or shooting off rockets, Kaprow's participants were no longer passive consumers, but activists in the service of themselves.

However appealing the idea of activity fading into the world may have been, Kaprow felt a little lonely when the Happening ended. Sure, he liked the idea of serving up a banquet of possibilities in which his personal taste was subordinate and in which random and unseen events supplanted authorial control. He even liked the idea of not being able to judge his own Happening because, by rights, he had given away its actions. But whatever the activities felt like for his participants, for Kaprow the whole thing felt hollow, less like something he'd enacted than something he'd merely organized. Upon reflection, he realized this was because he had not yet developed a feedback loop, a way of participating in his own work no matter how diffuse or conceptual it became.[13] He had unwittingly denied himself the kind of shared experiences that constitute community, and while Kaprow wasn't particularly sentimental about community, he hadn't gotten into the Happening business to lose contact with others. The whole point was to make contact.

passing through

However unfulfilling, *Self-Service* was a key work for Kaprow, because it clarified the degree to which the work itself was the experiment. More than ever, the purpose of his work was to see what it might become by doing it. It was around this time that Kaprow published the essay "Experimental Art" in *Art News,* in which he identified experimentalism in art as a situation "in which the historical references"—that is, the references that qualify an object, a process, or an event as art—"were missing." While the Modernist avant-garde had once been considered experimental, Kaprow maintained that it was actually developmental, one innovation begetting the next and the next, wiping away the past "in a marvelous gesture of self-sufficiency." Despite its mythologies of giving birth to an era, modern art was nothing *but* history—a succession of histories. Kaprow believed that by the 1960s it was "nearly impossible to make the slightest gesture without calling up references that are instantly recognized as his-

tory." Thus, he invited the reader to "imagine something never before done, by a method never before used, whose outcome is unforeseen."[1] This, to Kaprow, would be an experiment, a Zen-like present moment suspended between a past it has temporarily forgotten and a future it hasn't yet imagined, a moment that is always new because it is always only a moment, not necessarily the next new thing.

gas

If *Self-Service* vanished into the world, *Gas*—a series of Happenings presented over a three-day August weekend in the Hamptons-Montauk section of Long Island—got lost in its own planning and production cycles. Kaprow had been approached by Gordon Hyatt, producer for the local CBS television station of *Eye on New York,* about staging a number of Happenings as the episodic centerpieces

of a television program with a kind of "what I did during my summer vacation in the Hamptons" theme. The project, slated to be broadcast in the greater New York area, would also involve Charles Frazier, an artist who made flying and inflatable sculptures. Kaprow recalls that Hyatt considered the location to be especially important: the Hamptons, where the art cognoscenti vacationed each summer, was an exotic combination of art colony and aristocratic summering spot.[2]

The general idea of *Gas,* which was largely conceived by Hyatt (and supported in part by Virginia Dwan of the Dwan Gallery), was to interject a series of Happenings into the leisure activities of summer vacationers and locals, who would presumably be caught unawares as they disembarked at the railroad station, took the ferry, swam at the beach, and so forth. All sites were scouted and selected by Hyatt, who submitted them to Kaprow for approval; Kaprow's job was to come up with a scenario for each one. Since *Self-Service* was still going on (at least in theory), Kaprow simply adapted many of its features to *Gas,* supplementing them with props and activities from his regular bag of tricks. The difference, of course, was that the scale of events, of spaces, and of expectations was now bigger. Accordingly, the car pulling into a filling station and erupting with foam in *Self-Service* would become a fleet of fire trucks spurting enormous billows of foam down the Montauk bluffs and into the sea. This, Kaprow began to realize, was show business.

The first event of *Gas,* which took place on Saturday, August 7, 1966, consisted of a Kaprowesque parade of children clinging to wobbling weather balloons, adults tumbling oil barrels end over end, people blowing horns, waving flares, and generally making a racket, and two saucerlike hovercraft made by Frazier, which scooted along a few inches above the ground. Kaprow, wearing a motorcycle mask and goggles and draped, shirtless, in a black plastic cape (like some sort of avenging angel), was atop one noisy hovercraft, and a woman dressed in a swimsuit rode the other. The parade, which took place on the street next to the Southampton railroad station, met people getting off the train from New York.

The second event took place later that afternoon at Amagansett beach, where hundreds of people were sunning and swimming. A large black plastic inflatable tower, a mock phallic skyscraper with rows of white "windows" spray painted up its length, was pumped skyward by a nest of vacuum cleaners. It gleamed briefly, like a slick, wobbly shadow of the absent city it signified, until it buckled and sagged to the ground. A herd of children finished the job by jumping on it and tearing it to shreds. Meanwhile, a local rock band played "Satisfaction," the Rolling Stones hit, electrically amplified in the harsh and hollow way one might expect to hear on a beach in the middle of the day. The tower was by Frazier and the band was Hyatt's idea. The joke—about getting no satisfaction—rippled through the crowd among those either old enough or young enough to get it. Hyatt's film included lots of butt shots of pretty girls passing by as the tower rocked its way skyward and back. Kaprow had nothing to do with this event, yet it was probably closer to what the beach-goers expected a Happening to look and sound like than any of the other episodes of *Gas.*

Kaprow found this event embarrassing, even though he had, in fact, approved it. Collaboration, he learned, was neither collage nor a Cagean chance operation; it was an interweaving of egos and agendas, especially pronounced here because of the scale of the television production. Concession and compromise were the orders of the tightly scheduled day. The real drama of the beach scene took place about one hundred yards offshore, where one of two skydivers, aerial elements of the Happening, drifted frighteningly off course and landed in deep waters. Caught up in his parachute apparatus, the skydiver nearly drowned. In the film, the crowd can be seen running to the beach to watch his rescue, leaving the limp black phallus lying in the sand.

On the next day, Sunday, a covey of neatly dressed "nurses" (nursing students from a local college) waited be-

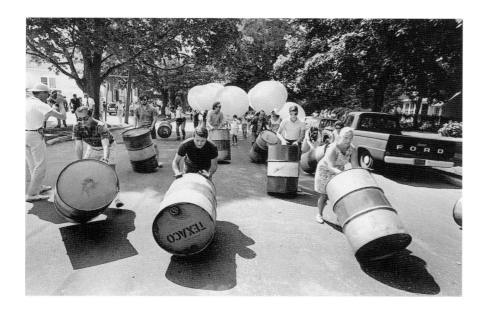

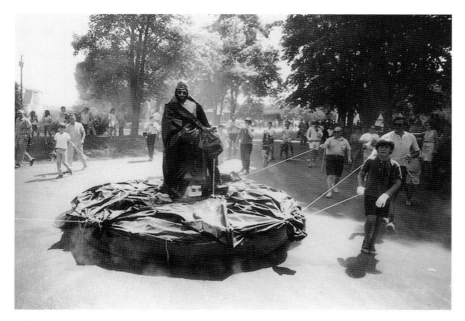

PARADE IN SOUTHAMPTON WITH BARRELS AND BALLOONS (TOP), KAPROW RIDING A HOVERCRAFT BY CHARLES FRAZIER (BOTTOM LEFT), AND A PLASTIC TOWER BY CHARLES FRAZIER INFLATING ON AMAGANSETT BEACH (BOTTOM RIGHT) DURING *GAS*, 1966 (TOP AND BOTTOM RIGHT PHOTOS BY PETER MOORE, © ESTATE OF PETER MOORE/LICENSED BY VAGA, NEW YORK, NY; BOTTOM LEFT PHOTO: BURTON BERINSKY)

"NURSES" HAILING A FERRY (TOP) AND ON BEDS IN THE MIDDLE OF THE ROAD (BOTTOM) DURING *GAS*, 1966 (PHOTOS BY PETER MOORE, © ESTATE OF PETER MOORE/LICENSED BY VAGA, NEW YORK, NY)

hind a black plastic curtain at the end of the dock for the Shelter Island ferry. As the car-laden boat approached, the curtain was pulled to one side and the nurses waved at the occupants like beckoning Sirens. They then ran, en masse, up the hill behind the dock and clambered onto a row of hospital beds that had been lined up along the center of the road. The disembarking cars passed cautiously by the beds, each of which held about five nurses, their legs and hands splayed and waving in all directions.[3]

The next event, held later that day, produced one of the most famous photographic images from all of Kaprow's Happenings: copious billows of foam oozing down the Montauk bluffs, through a procession of people, and into the sea. The foam was produced by several fire trucks parked atop the bluffs and emitted through long plastic tubes (used to fight fires in mine shafts), which had been procured by Hyatt. Several tepee-like wooden structures, menacingly covered in black plastic, had been propped up at the bottom of the bluffs, which eroded in craggy contours onto a narrow, rocky beach. The terrain and the structures contrasted sharply with the soft, surging suds.

The action was simple: when Kaprow gave the signal, a large group of people followed him along the beach and were covered in the manmade "tide." The two moving masses, the people and the foam, intersected and flowed through each other, the artificial tide meeting the human wave where the mountains touch the sea. Children and some adults (including the performance artist Eleanor Antin) were completely covered. Everyone had been given sticks to feel their way along the ground in case they couldn't see above the enveloping foam. Irony of ironies: the wrong film had been put in the television cameras, and the event went unrecorded.

On Monday, two inland events took place: a children's picnic and car-painting party in a rural car junkyard, and a barrel-and-foam Happening in the Springs dump. For the picnic, children were brought by bus to the junkyard, where they were shown the cars, given tempera paints

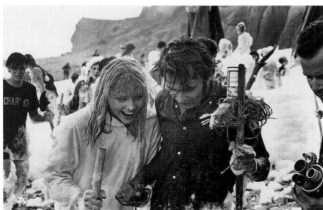

FOAM BILLOWING DOWN THE MONTAUK BLUFFS (TOP) AND ENGULFING PERFORMERS ON THE BEACH IN MONTAUK (BOTTOM LEFT) DURING *GAS,* 1966 (PHOTOS BY PETER MOORE, © ESTATE OF PETER MOORE/LICENSED BY VAGA, NEW YORK, NY). CHILDREN PLAYING IN A CAR JUNKYARD (BOTTOM RIGHT) DURING *GAS,* 1966 (PHOTO: BURTON BERINSKY).

STACKED BARRELS ABOUT TO BE PUSHED INTO A PIT AT THE SPRINGS
DUMP (ABOVE) AND A BOY COVERED IN FOAM (RIGHT) DURING *GAS*, 1966
(ABOVE PHOTO BY PETER MOORE, © ESTATE OF PETER MOORE/
LICENSED BY VAGA, NEW YORK, NY; RIGHT PHOTO: BURTON BERINSKY)

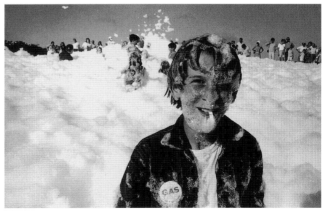

and paintbrushes, and told to paint the cars in any way they liked. Some painted alone, while others formed little groups, within which arguments flared about how and what to paint. Frazier inflated large balloons in the cars and in the nearby woods, and these were burst by the kids or by coming into contact with jagged car parts. Tables were set out, and peanut butter and jelly sandwiches were offered to the kids (among them Kaprow's son, Anton), who by then were smeared and splattered with paint. As they were eating lunch, Frazier set a number of small radio-controlled, helicopter-type flying machines in motion, some of which crashed with a buzz and a clank into the old rusty cars. The children then boarded the bus and went home, judging it, according to Kaprow, a good day.

Perhaps fittingly, *Gas* culminated at the Springs dump later that afternoon. The dump was a rectangular bulldozed pit that sloped, much the way a swimming pool does, from a shallow end toward a deep end, with a cliff face rising abruptly from there. On this day, there was no garbage in it. Several stacks of colored oil drums were positioned along the edge of the cliff. A crowd of adults and children began walking down the slope into the pit. As they walked, they were covered from behind by layers of oozing foam being pumped by the same machines used during the Montauk bluffs event the day before. At the same moment, the oil-drum stacks were toppled over the cliff. The plan was for the people to make their way down to the barrels, take one, and roll it back up the slope through the foam. Many of the children were up to their eyeballs in foam, and the process of finding and wrestling the fifty-five-gallon oil drums to the top involved either Sisyphean labor by individuals or coordinated efforts by groups. Interestingly to Kaprow, everyone took their tasks very seriously, eventually rolling, pushing, or dragging all the barrels up the hill. Many people remained for a while to romp in the foam, or just stand and stare at it. The crew from CBS-TV wrapped the shoot, checked out of the hotel, and returned to New York. *Gas* was over.

Kaprow took a calculated risk with *Gas*. He worked with a television production company to explore the relationship between Happenings and publicity. He was not interested in getting publicity for his work (the broadcast later that fall made no difference to his career); rather, he was intrigued by the fact that childsplay often involves "look at me" moments, when children turn toward adults for confirmation of their achievements before returning to play. He wanted to test the limits of Happenings as attention-getting events on the scale of public spectacle and the mass media.[4] This is not to suggest that Kaprow was subliminally seeking confirmation from some media "parent." Quite the contrary—his motive for agreeing to participate in *Gas* was, basically, to find out what he could get away with. He discovered that although he was able to manage logistics on a spectacular scale, the whole enterprise was profoundly problematic.

Although nearly everyone, including Hyatt, deemed *Gas* a success, Kaprow saw it as a reversion to theater. It was a string of "spectacular" Happenings intended more to be seen than enacted, both during the events themselves and on television. He was able to invest certain events with enough off-the-wall physicality to engage people—indeed, sometimes to cover them up—but his sense of the overall experiment was that it yielded mostly spectacle. What was missing was a feedback loop, which had been lacking in *Self-Service* as well. In *Gas,* the feedback provided by experience was replaced largely by the false feedback of narcissism on a mass-media scale, in which the culture, through the mirror of television, watches itself having a gas.

In the end, the experiment failed because *Gas* participated in the popular clichés of what Happenings were. Everybody was supposed to have a gas (hence all the foam and gas-filled balloons), and having a gas was naturally associated with (what else?) summertime fun. This expectation of leisure activity mixing easily with what was "new" in the art world—the art world on summer vacation—coincided with the blossoming of the youth culture just as it was beginning to be associated

in the media with revolution, protests, and tear gas. The segment with the rock band on the beach, the black inflated tower, and the giddy, scrambling crowd suggests the extent to which Happenings, in the United States, anyway, had already been interpreted as new, youthful phenomena portending a flighty but fickle—and maybe even unsettling—change.

Gas was Kaprow's most spectacular Happening, and his last spectacular Happening. He had been extending the scale of his events for several years, but he had also been moving away from spectacles. *Gas* was a calculated exception. Scale and spectacle are not the same, of course, and while he remained interested in increasing the scale of his Happenings (as he had in *Self-Service*), his experience in the Hamptons reminded him that spectacles—even those conceived as experiments for television—did not offer the kinds of physical, social, human-scale experiences he was after. Leaving New York had been liberating but also deceptive, because it fostered the illusion of the work moving "out there" into the world, where, becoming part of life, it might expand to worldwide proportions. Kaprow found that the landscape of human-scale experiences is not vast but intimate, not romantic but prosaic and particular.

The next year, against the gathering storm of moral indignation about the war in Southeast Asia, Kaprow gently parodied the theater of social protest by staging Happenings of quiet dispersals (*Flick* at New York University) and bizarre sit-ins (*Interruption* at the State University of New York at Stony Brook). In the latter event, women students created a "lie-in" by sprawling in the corridors of the humanities building among heaps of old books, crumpled newspapers, and class notes; in the former, marchers circled "slowly, endlessly, silently, carrying absolutely blank signs."[5] Clearly, like a colorful hot-air balloon set aloft in turbulent weather, the Happening as an art form was drifting toward the occasions of pop-cultural entertainment and the sites of civil unrest. Kaprow wanted off.

pollockland

Some artists beat their drums without expression, but in times and places where others pick up the unintended notes. One such note that August weekend on Long Island echoed through the two most unpublic sites, the car junkyard and the Springs dump. The Springs was where Jackson Pollock had lived, and for all anyone knows the car in which he died may have been among those the kids were painting. Put the two places together in the context of Kaprow's own history, and one hears a mournful note, as if it were a private tribute to the great painter. Indeed, Kaprow had once visited the hallowed barn with its holy skeins of paint and met Lee Krasner, its keeper, there. But in truth, he never gave the connection a thought when foam was pouring down the slope of the dump, nor had he in planning the event. He was too busy with details and impatient firefighters who wanted their trucks back. He harbored no reverential thoughts of a painter he had never met but had once memorialized in print. His was a determined irreverence in Pollockland, a test of the art colony's cliché that too much success (this was television, after all) spoils a good artist. Still, his work, when pondered at a distance, or in memory, invites this kind of meaning making. Is it a fiction? Of course it is, but so is the conjoining of memories, scripts, and photographs from which we conjure a sense of the rhythms of the Happenings—which were open and elusive, and in this case nothing more than gas.

fluids

"Meaningless work," wrote Walter De Maria in 1960, "is obviously the most important and significant art form today."[6] By "meaningless work," he meant work that "does not make you money or accomplish a conventional purpose." Making paintings to sell in a gallery, or weight lifting, which builds muscles, would not be meaningless work. "Putting wooden blocks from one box to another,"

he wrote, "then putting the blocks back to the original box, back and forth, back and forth, and so on, is a fine example of meaningless work."[7]

De Maria might have been describing *Fluids,* a multisite Happening in Los Angeles commissioned by the Pasadena Art Museum as part of a midcareer retrospective offered to Kaprow in October 1967. In each of fifteen separate locations throughout the Los Angeles area over a three-day period, work teams of between ten and fifteen people constructed, block by block, walled rectangular enclosures of ice. Each enclosure was perhaps seventy feet long, ten feet wide, and seven feet high. The October weather was warm, and the ice structures began melting as they were being built, taking as long as twenty-four hours to liquefy. Kaprow had organized the event in collaboration with museum officials; sites had been identified, permissions obtained, permits acquired, insurance arranged, volunteers signed up, and ice deliveries scheduled for every two or three hours over a Thursday, Friday, and Saturday. Thus, each ice structure—depending on its location, the size and efficiency of its crew, the promptness of ice deliveries, and the temperature—was in a different state of construction or liquefaction at any given moment. The task was the same in each location, but the variables determined the particulars of each crew's experience.

In terms of work, *Fluids* was the antithesis of *Self-Service:* instead of participants choosing from a menu of very diverse activities to be carried out in three different cities, they were given a single task to undertake, and all activity took place within one greater metropolitan area, in three days rather than four months. The three-day time frame of *Fluids* paced the activity in such a way that Kaprow was able to show up and work at nearly all the locations. Not only did this afford him the physical and social experiences of an extended-scale work, but it also boosted morale among the work crews.

Building a walled enclosure of ice blocks is not a sim-

ple task, and plenty of on-the-spot engineering and crew coordination was required. For instance, the crews discovered that rock salt was necessary to bind the ice blocks together and that each wall had to be precisely lined out and plumbed so that it wouldn't warp, sag, and collapse as it got higher. The possibility of people slipping and falling while lifting and carrying the heavy blocks, or otherwise injuring themselves, was real. The work was,

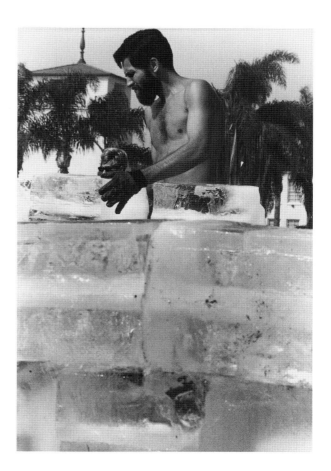

KAPROW WITH ICE BLOCKS DURING *FLUIDS,* 1967
(PHOTO BY DENNIS HOPPER)

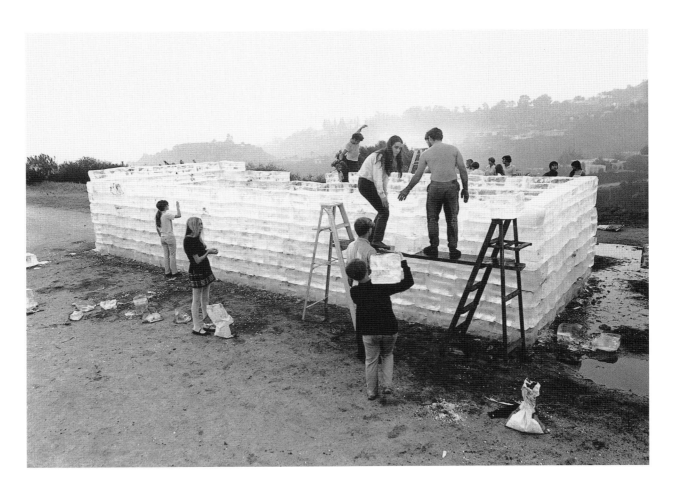

PARTICIPANTS CONSTRUCTING AN ICE ENCLOSURE ON
A HILLTOP LOT IN BEVERLY HILLS (ABOVE) AND
CONSTRUCTION NEAR THE LAIL BROTHERS BODY SHOP
(RIGHT) DURING *FLUIDS*, 1967 (PHOTOS BY DENNIS HOPPER)

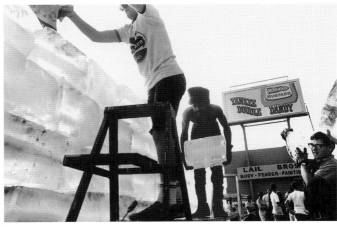

in De Maria's sense, meaningless, but Kaprow's workers quickly became engrossed in their tasks. The job had to be done.[8]

For Kaprow, getting around to the various sites was a way of collaborating with his participants, since, in each case, he showed up to work, not just to bless the event. At the same time, moving from site to site allowed him to notice the different contexts in which the enclosures were being built, each of which conferred upon the task and its object a set of associations more or less specific to its site—associations his participants also may have noticed. For instance, at a lot next to a McDonald's hamburger stand in Pasadena, the bucket-brigade rhythms of building an ice enclosure resonated with the behind-the-counter teamwork necessary to serve fast food. The same rhythms taking place at the Play Yard, a children's center in Temple City, suggested children playing with wooden blocks or building forts. At Pierce College in Woodland Hills (with its "ample supply of willing students"), the image conjured was of an "education factory."[9] Under the Colorado Street Bridge in Pasadena, notions of a kind of reverse engineering (melting) as well as a resemblance to the nearby Rose Bowl came to mind, as did the transfer of energy involved in liquefaction at another site, in the shadow of the Jade Oil & Gas Company. A truckload of melting ice blocks in the parking lot of the Lail Brothers Body Shop on Pico Boulevard suggested the obsolescence planned into automobiles. The block-by-block construction of a walled enclosure, when performed in a driveway abutting stacks of various styles of decorative bricks at La Cañada Rustic Stone in Pasadena, seemed an out-and-out parody of bricklaying. At an abandoned city incinerator, the ice blocks melting appeared to be a kind of drip-by-drip incineration. In the backyard of a private suburban residence in South Pasadena, the ice enclosure was the frozen, near-size equivalent of the adjacent swimming pool. There the ice enclosure looked big; on the hilltop lot of the Trousdale Estates in Beverly Hills it looked small—and suddenly natural.

The ice structures prompted an awareness of scale, not only architecturally, but also in terms of the working process. Using blocks of ice to build an enclosure about the size of the trucks that delivered them involved a job that was bigger than an individual and smaller than a bureaucracy. The Happening put Kaprow in a role analogous to that of a building contractor whose crews are working at various job sites throughout the city. Because the task required teamwork, the process was social, and the scale of the task allowed the nature of that teamwork to be negotiated at each location by the individuals involved. It was this on-site socialization that proved to be the most interesting variable to Kaprow. As in childsplay, would the "born leaders" take over and the "followers" fall in line? Would the men assume the heavier burdens while the women played supporting roles? How would the rules of the game be negotiated among adults earnestly participating in meaningless work? And what, in each case, was the payoff, the individual or group resolution of this theater of seemingly displaced activity? Did people just go home by themselves at the end of the day, all wet and tired, or did they retire in newly bonded groups to the nearest bar and grill to recount the day's events? To what extent did they become friends (if they weren't already), and for how long? Were their friendships, forged in an experience of common purposelessness, as temporal and fluid as the object of their shared labor? Did they break the ice?

Kaprow would never know the answers to most of these questions, except in the form of his own experiences as he moved from site to site. He knew both more and less than the members of a single crew did. Because he was "the artist," he received firsthand accounts, secondhand reports, and gossip, each contributing to his overall impression of the undertaking.

Fluids was composed of constantly changing states: of matter, of weather, of place, of scale, of mind, of work, of temperature, of dissolution, of memory, and, once or twice in the smoggy-red late afternoon light, of grace. The ice enclosures inevitably provoked curious stares from passersby, but *Fluids* was not a spectacle. It was ongoing

work that was set apart from other work only by its indifference to conventional notions of accomplishment—an indifference expressed in the slow dissolution of solid objects into damp spots.

Impermanence, natural versus industrial materials and processes, entropy, repetition, boredom, "slow information" (a phrase often used to describe the "theater" of Minimalist materials), site-specificity, and primary structures were part and parcel of the art world in 1967, and Kaprow's minimalist ice cathedrals were wry commentaries on these "current conditions"—a witty weather report on the aesthetic phenomena of the day. In their material, modularity, simple geometry, and "slick" surfaces, the structures punned on Minimalist sculpture; in their melting, they punned on Process and Conceptual art. In the way they awakened awareness of the contexts in which they were temporarily positioned, they referred to Marcel Duchamp's infamous urinal (also an object with a vacant core); indeed, Kaprow's ice enclosures were the physical embodiments of Duchampian "cool" indifference.

As an occasion for making something, *Fluids* felt closer than his previous works to the planning, production, and distribution cycles of the workaday world. It was meaningless work seriously carried out. This seriousness was not an affectation, but the way people actually work: the enclosures weren't going to get built unless someone built them. In *Self-Service*, Kaprow's scenarios had been somewhat absurdist, owing as much to the Fluxus spirit of nonsense as to the rhythms of everyday life: cars don't really erupt with foam in filling stations, whereas bricks, and even blocks of ice, are laid in rows every day. With *Fluids*, the plan was simple enough to avoid absurdist theatrics, and yet extended enough to be social without sacrificing its hands-on physicality. The sensibility underlying the construction of the ice enclosures was at least as indebted to the nineteenth-century Shakers as it was to modern art or to the modern world. The so-called

meaninglessness of art and work became, in the doing, a kind of communal craftsmanship. It acquired meaning without pretense.

David Antin observes that Kaprow's Happenings (even extravaganzas like *Gas*) were more like barn raisings than spectacles.[10] This brilliant observation establishes the social parameters of Kaprow's sensibility as an artist—about as far as the senses can reach without snapping their tethers to the body—and hints at the traditional American experiences behind them. The modernity of *Fluids* lay in its logistical extension, its functioning as a network of organizations, resources, locations, services, and volunteers. Its multiplicity and simultaneity were its modern ideas, but the hands-on experience of building the ice enclosures was arguably premodern, even grounded in antimodern sentiments. Its practical rhythms were those of the bucket brigade, not the automated assembly line or the calculated media event. The people who participated, most of them young, were drawn to *Fluids* not because it reiterated their already saturated experiences of life in the modern metropolis and its media spheres, but because it seemed to offer a close-quartered communality that, while new to them, was rooted in the premodern past.

The empty centers of the ice enclosures may have been, for Kaprow, puns on the Zen concept of "nothing," but in retrospect they seem to suggest something curiously unfulfilled, not unlike the sense then felt by many young people that something profound was missing at the heart of modern living. This was precisely the moment, in the afterglow of the Summer of Love, when hippie communalism offered alternative "families" to alienated kids, and although the tribal dimensions of the late 1960s youth culture were mythologized as the psychic coordinates of the new age, they were in fact deeply romantic spaces in which utopian ideals of community could take naive refuge in a savage, war-torn, leaderless world. Undoubtedly, for many of Kaprow's young work-

ers the experience of working on the ice enclosures represented values that were evaporating from society. This is not to discount the social activism of the times, but to account for the glimpses of the communitarian world many were hoping for "when the revolution comes."

Several anecdotes from *Fluids* set it in its social moment. At the McDonald's work site, a Marine recruiter on his way to lunch stopped at the half-completed ice structure and, appreciating the evident teamwork, tried to convince several young men to enlist; they, in turn, tried to convince him to desert. It was a genial standoff. As dusk settled on the hilltop site of the Trousdale Estates, a young motorcycle cop checking out the permit for the Happening told Kaprow, "I've got something for *you*," and good-naturedly tossed several police road flares into the just-finished enclosure, filling it with a gaseous pink light that radiated in the early evening sky. The cop, it turned out, was an off-duty art student. A few whimsical helpers pressed themselves against the glowing walls like they were hugging Mother Earth. The ice-delivery drivers, who had initially been hostile to the project, broke out several cases of beer that they had bought for Kaprow's workers, and everyone—students, truckers, and the cop—had an impromptu celebration on the hills overlooking Los Angeles.

Kaprow, of course, intended none of this. *Fluids* embodied a central paradox of Kaprow's work: although Happenings were experimental forms of art, they also tended to yield traditional, if unconventional, experiences—experiences of the present tense, the physical body, social exchange, communal effort, friendship, and storytelling. While they were antiformalist in the sense that they were open to the subject matter of the everyday world, and modern in the sense that they took their places in and alongside the everyday activities of that world, Kaprow's Happenings of the late 1960s and early 1970s were also conservative insofar as they explored and even conserved what might be called the preindustrial

scales of American experience. With experimental art, you never know what you're going to get. *Fluids* devolved into a series of physical, social, and communal experiences. At the very moment when the myth of Happenings as revolutionary gateways into a new reality was spreading throughout universities and ascending to greater heights in the media, Kaprow was narrowing his focus upon the particularities of human social experience.

For one older employee of La Canada Rustic Stone, the specter of a crew of mostly shirtless young men working earnestly on their ice-block enclosure within a few feet of where he daily stacked and unstacked bricks by hand was worse than meaningless work; it was a mockery of work, no matter how much these self-styled "bricklayers" sweated. Kaprow noticed the man, who looked to be in his sixties, scowling and muttering under his breath and casting an occasional hostile glance over the whole proceeding, and tried to talk with him but was rebuffed. He later found out from the company's owner that the man was an Italian immigrant who had worked hard all his life, raised a good family, and sent his kids to college. Now, some college kids seemed to be mimicking his labor to no discernible purpose. Their so-called work would evaporate in the sun and be gone the next day, while his would always be there, waiting to be stacked and unstacked, like the meaningless work described by De Maria, until he was too old to carry on. Photographs of the ice enclosure pressing close against the stacks of decorative bricks reveal the inescapable irony of their juxtaposition—and it wasn't just an "art" irony. It's easy to see how the near abutment of the real work and the play work could only have been interpreted as a slap in the face by a man for whom manual labor was neither a recreational option nor a communal ideal. Sometimes art is very clear in its messages, whether those messages are intended or not. Here, an otherwise playful comparison of bricks and ice blocks, which might have been seen by an art audience as a critique of the superficiality and disposability of suburban

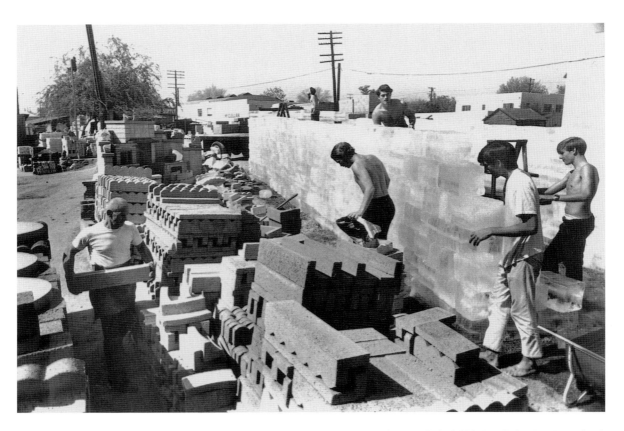

housing tracts (middle-class ice castles), was inadvertently turned into callous contrast.

From this experience, Kaprow learned that being an artist in the everyday world involved ethical considerations that aren't always apparent in galleries and museums. In the context of the sprawling metropolis, Kaprow's workers were just like any others, but next to the man in the brickyard, they were unconscious parodists, and he an unwilling object of their parody. The man had been drafted into the Happening because of his proximity to its goings-on. Kaprow was humbled. He certainly hadn't intended to offend anyone beyond the way people are often offended by art. He realized that there *are* innocent bystanders near art, and that he had to give them a way out. The ethics of his works would now be those of choice, for choice is the basis of participation.

Fluids took the fun out of *Gas* and the spectacle out of Happenings. It wasn't much to look at, and it took a lot of work. With its many sites and melting objects, it was an unintended metaphor for the itinerant state of Kaprow's career. Between the spring of 1968 and the fall of 1969 Kaprow was in an almost constant state of motion, traveling weekly between his home in New York and Berkeley, where he was co-director of Project Other Ways

(an experimental education program for teenagers), as well as to such places as Chicago, St. Louis, Albany, Austin, La Jolla, and various locations in Europe to do his works. His sense of the present moment was less Zen-like than jet-lagged, although the physical labor demanded by his Happenings may have helped clear his head between flights. The works, too, were subject to the space and time warps of jet-age travel (postmodern itinerancy?), as themes of dispersal, transference, refilling, keeping travelogues, being on the road, traveling in circles, plotting absurd courses, waiting for arrivals, waiting for phone calls, and moving from place to place dominated the scenarios of the next several years.[11]

In December 1967 Kaprow did an event in Chicago called *Moving* (sponsored by the Museum of Contemporary Art), in which participants were asked to furnish apartments with secondhand furniture that had been purchased for the event. The participants would briefly occupy one apartment—perhaps eating a meal together—before packing up their belongings and moving on to the next, rolling stacks of chairs, boxes, lamps, even a piano through the streets like bands of urban nomads. *Moving* was familial and friendly and required less labor than *Fluids* had, but it was just as fluid in its wanderings from place to place.

During this same period, Kaprow was looking for another job. He was on sabbatical from Stony Brook, where he had been teaching since 1961 (and where he had been given tenure), but his reputation there was on the wane, due in part to *Interruption,* the Happening he had staged there in 1967. (Colleagues had complained that Kaprow had turned the hallways into a fire trap, and he had been forced to apologize.) He spent much of 1968 talking with officials from the University of California, San Diego, and the as-yet-unbuilt California Institute of the Arts in the Los Angeles area about teaching and administrative positions. Kaprow's home life was also unsettled during this time. He was now the father of three children, a boy and two girls; the oldest was ten, the youngest an infant.

Vaughan was a full-time mother, but he, because of his travels, was a part-time husband and father. Underlying this was the tragic accidental death in 1966 of their two-year-old daughter, who had been killed by a passing car in front of the family's house in Glen Head, Long Island. The recurring waves of guilt and remorse within the family reinforced the sense of an absence at its core. Home was no longer a refuge—if it ever had been. The themes of walls melting, of furniture moving, and of being scattered in space and time were as reflective of the itinerancy of Kaprow's life as they were integral to the indeterminacy of his art.

runner

Between February and August 1968 Kaprow kept up a blistering pace, enacting ten Happenings in nine locations across the country. The first of these was *Runner* (plates 10–11), which took place over three days along a private suburban roadway outside St. Louis. Sponsored by Washington University, it coincided with the presentation of Kaprow's retrospective (organized by the Pasadena Art Museum) at the Washington University Art Gallery. On the first day, a mile's length of tar paper, weighted with cinder blocks placed every twenty feet, was laid along the shoulder of the road. This procedure was repeated twice the next day, the second and third layers of tar paper and blocks being laid over the first, beginning at opposite ends of the mile-long stretch each time. On the third day, all three layers were removed from the roadside.

The roadway was owned by the Forest Ridge Land Corporation. It ran along a ridge on which houses were under construction, so the activity of laying tar paper and cinder blocks echoed the house-building activity in the surrounding countryside. In this 1960s suburban context, with housing developments springing up like boomtowns on the prairie while inner cities were becoming ghost towns, *Runner* was a laborious parody of the American saga of trailblazing. It was also a playful reference to

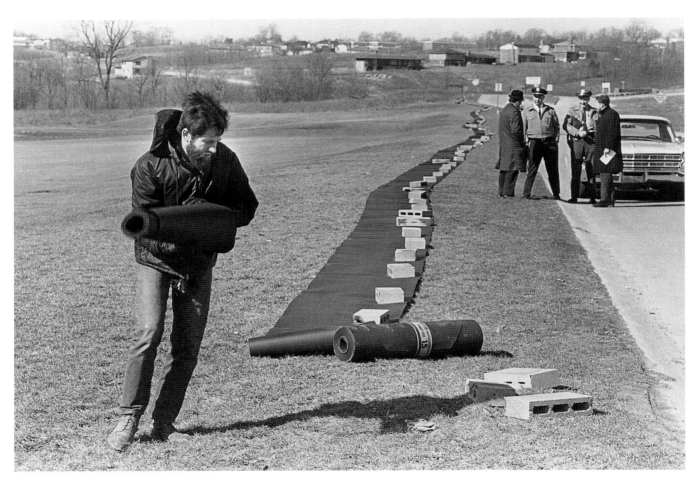

KAPROW OUTRUNNING THE POSSE DURING *RUNNER*, ST. LOUIS, 1968 (PHOTO: JOHN MILLAIRE)

stereotypes of Western films: the Cowboy's skill of back-tracking and the Indian's adroitness at leaving no tracks. Kaprow and his helpers were not pioneers, however, and they didn't loom large against the sky. Rather, they were dwarfed as never before against the barren expanse of the Missouri countryside. Kaprow's reputation as the "pioneer" of Happenings—of a modern, new, expansive art—seemed curiously at odds with the nose-to-ground activity of rolling tar paper and placing blocks for a mile across Missouri.

This was, though, a stricter analogue of the experiences of nineteenth-century pioneers—who crossed the bucking and dipping contours of the landscape one step at a time—than we might experience today by driving along the highway. The activity of placing the blocks on the tar paper became something of a body mantra—a constant, incremental measure of the physical experience of working one's way across the land. The pioneers' experience of getting to California (where Kaprow hoped to go) was most likely one of unrelenting physical motion and boredom punctuated by moments of breathtaking beauty and heartbreaking sublimity. In this sense, *Runner* was a pioneering activity, not just as avant-garde art, but as a communal experience stretching itself as far as time and space (and the boundaries of private property, for insurance reasons) would allow.

In a predictable parallel with the experience of the pioneers, Kaprow even got "ambushed," when the cops showed up looking for permits. In a photograph of *Runner,* university officials in the distance reassure the inquisitive police while Kaprow, alone in the foreground, steadfastly ignores the encounter, leaning into his work as he prepares to unroll yet another length of tar paper (recalling pictures of Pollock painting). Receding into the distance as far as the eye can see is a wavy black tar-paper ribbon held in place by an equally wandering pathway of light-gray blocks, like the tracks of a meandering horse or the footprints of a drunk (recalling Charlie Chaplin's idiosyncratic gait). One senses in the apparent single-mindedness of the task a curious isolation from the near-mythic scale and the communitarian character of the event.

In his notes on *Runner,* Kaprow comments on three levels of meaning.[12] The first is a formal structure of symmetries: materials are brought to a site in the beginning and removed in the end; the first and third days involve a single action reversed, and the second day involves two opposite actions; and the materials and activities echo the setting. The second level of meaning concerns social commentary: useless work becomes useful as recreation; useful work becomes useless when technology takes its place; play becomes socially useful, and even necessary, when more leisure time is available. "My work," he writes, "is philosophical, not instrumental. Rather than being social criticism it seeks social insight. The more active it is (in fact) the more reflective it becomes in time." Thus, even in notes to himself, Kaprow downplayed the significance of formal structure and social commentary in favor of direct experience, the third level of meaning to which he refers. If you don't do the work, he seems to be saying, you can't reflect upon its meaning, and the more and better work you do, the more deeply reflective its meanings may become.

Runner was Kaprow's first true landscape Happening—that is, it was the first Happening that was not framed by a room, an urban setting, a beach, a glen, or the woods. It was open and exposed to the elements. Kaprow realized that this play between the surrounding landscape and the work at hand was reciprocal, each measuring the other. For the first time, he could sense a creative tension on an ecological scale between the activity and its setting, a tension that involved neither entertainment nor spectacle, and a scale that brought into focus just how intimate, how small, how human his work really was.[13] The world, after all, is not simply a setting, but, in its human proportions, it is the ingrained locus of experience. The constant play between what is in front of us and what is around us, between where we are and where we are go-

ing, helps locate us in the flow of experience. It feeds back to us the psychic coordinates that offer a sense of whether we're lost, about to be found, or just passing through.

transfer

A few weeks later, Kaprow conducted a Happening called *Transfer* (plates 12–14) in and around Middletown, Connecticut. Sponsored by Wesleyan University, it involved loading roughly twenty oil barrels onto trucks at an oil and chemical storage yard and then moving them first to a quarry, then to a city park, the local dump, a shopping center, the university sports field, the lawn in front of city hall, a nearby ski slope, and finally back to the storage yard. At each site, the barrels were stacked in various configurations (pyramids, walls, columns, piles) and spray painted different colors (black, white, silver, red, and green).

Since the empty barrels came from an oil and chemical storage yard, the participants wore gloves and were aware of the possibility that they were transferring residual toxic materials from site to site. They also wore masks

BARRELS BEING SPRAY-PAINTED DURING *TRANSFER*, MIDDLETOWN, CONNECTICUT, 1968 (PHOTO: WAYNE McEWAN)

during the spray painting. This hint of toxicity lent a morbid humor to the entire undertaking and suggested that the "contents" of art could be dangerous. Even so, the process of transferring toxic materials—a commonplace in modern industrial society—was understood by the participants to be as festive as it was dangerous.

Photography had a self-parodying role in *Transfer*. After each new stacking of the freshly painted barrels, Kaprow and his helpers would adopt postures of mock solemnity or feigned jubilation for "triumphal photos," with hands on hearts, arms raised in victory, bodies at attention, and the like. Kaprow was poking fun at the art world's need for images, objects, and documents—the residue of experience rather than the experience itself. Perhaps because people had been photographing his Happenings for years, in *Transfer* Kaprow appropriated this process; if the camera was going to document something as mundane as stacking, unstacking, and transferring barrels, he might as well offer it a series of photogenic moments.

Photography had become a primary means of documenting works of Conceptual, Process, and Earth art that could not otherwise be accounted for by the gallery system. Artists Kaprow liked and respected—Robert Smithson, Michael Heizer, Dennis Oppenheim, De Maria, Christo (to whom *Transfer* was dedicated), and others—used photographs to record sites of postindustrial ruin, to extend a project into the media, to catch the passage (the performance) of time (often as an artwork deteriorated), and to call attention to the unresolvable differences between here (a New York gallery) and there (say, the Nevada desert). Kaprow's professed attitude toward the photographic documentation of his work was one of indifference, and, in fact, he never retained a photographer for that purpose. People took pictures, sometimes casually and other times professionally. They often sent pictures to him and he kept them, or sometimes he would buy them. He was not opposed to the documentation of an event as long as the act of documenting it didn't interfere with the work itself.

PARTICIPANTS STRIKING A "TRIUMPHAL" POSE (TOP LEFT), A SALUTE (TOP RIGHT),
AND A FINAL POSE (BOTTOM) DURING *TRANSFER*, 1968 (PHOTOS: ANDY GLANTZ)

At the same time, the photographs were useful in disseminating information about Happenings and other activities. (Kaprow used them for this purpose in *Assemblages, Environments and Happenings*.) They were also useful as evidence for his academic vita, by which he justified his professorial rank. In fact, were it not for his career as a professor, much of the visual (and even written) documentation of his work in the 1960s would almost certainly have been scattered or lost—a speculation buttressed by the fact that, for the most important Happening of all, *Eighteen Happenings in Six Parts,* Kaprow permitted only rehearsal photos and a few pictures of the set. He did not want performance pictures taken.[14] A decade later, Kaprow had come to accept the presence of cameras as part of the ambiance of his Happenings, and he got pretty good at dodging or ignoring them.

The active presence of the camera thus became part of *Transfer,* a metaphor of consciousness attending to itself, a parody of self-importance, and a backhanded way of documenting the work. The funniest picture is the final one, where the oil barrels, painted black, have been returned in a heap to the storage yard from which they were taken. In effect, they have been dumped. Sitting forlornly at the base of this heap is the crew. Its members, including Kaprow, affect poses of slack-shouldered dejection, faces in hands, apparently disappointed that the game is over. They look like kids who've been called home for dinner.

round trip

In March 1968 Kaprow went to the campus of the State University of New York at Albany. There, he did a work, called *Round Trip,* in which two groups of students rolled balls of cardboard, paper, and string in opposite directions along the same route. The plan called for the big ball to lose material as it was being rolled, eventually disappearing, and for the little ball to gain mass until it was too big to roll. As the groups of rollers passed each other at the midpoint of the loop, the balls would presumably be the same size. The event had been planned for downtown Albany, but because the university's administration had been concerned about the propriety of such an undertaking, it had limited Kaprow's activities to the campus. Kaprow had initially regarded this decision as a cancellation of the Happening, but an agreement was reached when the university offered him a more interesting route for the Happening: an underground passageway that connected the main buildings of the campus in roughly the same rectangular footprint as a city block.

The passageway existed because of the bitter-cold winters in Albany, and through it flowed the pipes and conduits, as well as the material supplies, that the buildings above required. Despite the simplicity of the route and the symmetry of the plan, what Kaprow and his helpers discovered was that the process of making the balls and moving them through the passageway was anything but simple or symmetrical. Used paper and cardboard are difficult materials to keep together as they are

ROUND TRIP, STATE UNIVERSITY OF NEW YORK AT ALBANY, 1968 (PHOTOGRAPHER UNKNOWN; COURTESY GETTY RESEARCH INSTITUTE)

wadded into shape and rolled, especially as they get bigger; conversely, it's hard to shed materials without the ball completely falling apart. At what point would the object be too large or too small to roll? And who would make that decision? The balls acquired monumental form, but also formlessness. Entropy applied at either end, followed by the *really* boring task of cleaning up.

The image in Kaprow's mind was of eccentric folk artists who spend their lives collecting string or building towers with soda bottles and grout.[15] In this, *Round Trip* was both a swipe at high art and an example of the elevated interest among professional artists in "low" processes. Its eccentricity was accented by the routine activities of the university's maintenance personnel, who shared the passageway with the Happeners. Kaprow was interested in this interface of useful and useless work, an interface that sometimes involved figuring out how the real workers and the play workers could maneuver around one another. A sense of class division was present, but not to the extent that the employees felt mocked—probably because rolling a big ball of paper refuse, while a metaphor of everyday work, looked sufficiently unlike their own real work to seem mocking. *Round Trip* was disruptive in the way a parade is. It could be considered a parody of the student protest marches of the time, with the huge ball a cardboard pun on the world that young people were trying to shape, change, and direct. It may also have reminded Kaprow of his own never-ending travels.

The real experiment had to do with how plans, even simple, symmetrical ones, break down in the doing. Life getting in the way of art was exactly what Kaprow was hoping for. He didn't know how it was going to happen, but he knew that it would. It is in contrast to the most elegant plans that life's inelegance plays itself out most inevitably. To Kaprow, that inelegance *was* life. Things get too heavy; things fall apart; things get in the way; things get boring or become matters of the heart. You just never know.

record II

That same month, March 1968, Kaprow went to Austin, Texas, where the university was showing his retrospective exhibition. Roger Shattuck, who was teaching art history there, took him to a quarry outside town that was rumored to have contributed much of the marble to the nation's Capitol. With its disorienting geometric interplay of massive cut rocks and the labyrinthine spaces around and between them, the quarry looked to Kaprow like a stone-faced hall of mirrors. It was during this preliminary trip that he decided to return the next month, in April, and conduct a Happening in which certain large rocks would be covered with aluminum foil while other smaller ones would be pummeled with sledgehammers.

Called *Record II,* the event involved a small group of university students. The idea was to cover and break the rocks on the first day of the Happening and spend the second day distributing photographs of the activity in the student district of downtown Austin. In the quarry, the aluminum foil reflected the sky, seeming to dematerialize the mass of the rock with an opaque light. Meanwhile, the activity of hammering stones reinforced the participants' inward gaze, the task at hand being so much smaller than the mazelike environment.

Photography added another layer of reflection to the event. In a variation on the way Kaprow used the camera in *Transfer,* he requested that pictures be taken of participants as they pressed quarry walls with foil or pulverized rocks with hammers. These photographs were tacked to the sides of buildings, taped to storefront windows, and stapled to telephone poles in Austin, all without explanation or attribution. Kaprow enjoyed the idea of spreading anonymous images of the Happening in an urban labyrinth already plastered with posters, announcements, and photographic images. A curious equivalence emerged, in which the photos were to the downtown neighborhood as the activity of breaking rocks was to the quarry—both microcosmic instances of what took place anyway in their respective environments.

PARTICIPANTS DRAPING ALUMINUM FOIL ON QUARRY WALLS DURING
RECORD II, NEAR AUSTIN, TEXAS, 1968 (PHOTO: HOWARD SMAGULA)

Ironically, the photographs of the mostly young men breaking rocks made their efforts seem heroic, even epic, when in fact breaking the rocks—after the first few swings—must have felt puny and futile to the participants. Indeed, fewer rocks were broken than photographs taken. In one picture, shot from below by Shattuck, a fresh-faced Jim Pomeroy (who would become an important Conceptual and performance artist in the San Francisco Bay Area) is shown standing tall against the Texas sky, his shirtless, boyish torso reminiscent of a Greek kouros sculpture. Another photograph catches Kaprow and Pomeroy in midswing, bringing their sledgehammers down upon a small boulder, in what was clearly a reference to Gustave Courbet's *The Stone Breakers* (1849).[16]

The downtown area in which the photographs were distributed was extensive, but the photographs were tiny and barely noticed; the setting made them antiheroic, like litter. This was the key inversion of *Record II*. It was like going to the moon: a big undertaking that was entirely invisible except for a few widely distributed, heroic pictures. The "record" of the event was scattered throughout a field of like information, rendering it invisible as documentation. In this sense, Kaprow was adding ground (rather than figure) to ground, a strategy he often employed as a way of making art disappear into its real-life surroundings—with the amusing irony that here the photographs were mostly of figures. Predictably, but in this case tragically, real life intervened in the form of Martin Luther King Jr.'s assassination; as Kaprow's crew was leaving photos here and there, a crowd of angry mourners passed by with the power and turbulence of a rocket launch. In the wake of that passing, after learning what had happened, the Happeners disbanded and went home.

arrivals

Later that month, Kaprow was invited by Nassau Community College of Garden City, New York, to conduct a Happening involving its students. Kaprow, familiar with

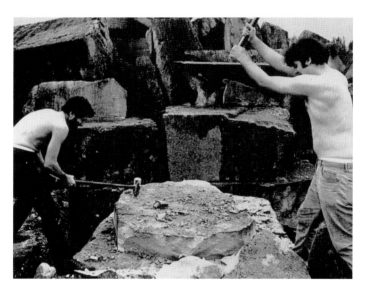

JIM POMEROY WITH ANOTHER STUDENT HAPPENER (TOP) AND STONE BREAKERS KAPROW AND POMEROY (BOTTOM) DURING *RECORD II*, 1968 (PHOTOS: HOWARD SMAGULA)

the area, knew of an abandoned airstrip near the college, its runway faded, cracked, and overtaken by grass. With this site in mind, Kaprow designed an activity, *Arrivals*, in which participants—about a dozen students—would edge and sweep the runway, fill its cracks with tar, repaint its faded directional lines, and then sit on the tarmac holding small mirrors, which they could scan over their shoulders for reflections of arriving airplanes.

Everyone knew, of course, that the planes would never arrive. Repairing the runway would be for nothing; waiting for "arrivals" would be futile. Knowing this lent a tragicomic air to the proceedings. Futility and nothingness had been weighty existential themes a generation earlier, and to invoke them now through essentially meaningless activity was to mock the high seriousness of a previous era with absurdist humor. Like the characters in Samuel Beckett's play, Kaprow was, in his own flat-footed way, waiting for Godot.

Kaprow may also have been poking fun at the pseudo-mystical pretensions of the 1960s generation, whose members were often his eager (and sometimes overly eager) participants, and for whom sitting on a runway waiting for an airplane to appear in a mirror might just be akin to waiting for enlightenment in a lotus position, stoned. After all, flashes of illumination are what art, life, and religion are supposed to supply if one works well enough and waits long enough. Knowing that planes would never arrive, though, changed the nature of the game, offering a Zen-like clue that perhaps waiting might be its own deadpan reward. Earnestly scanning their mirrors for planes, participants may instead have caught glimpses of themselves, thereby sensing the ironic, narcissistic loop in which they were caught. At some point, earnest (or even ironic) waiting slumps into boredom, the body reminding us that we're tired, hungry, hot, or late for class. As it happened, some students left when the work got hard, while others hung around until the planes didn't come.

Kaprow also knew—and the students didn't—that the field they edged, swept, tarred, and painted was very near the site from which Charles Lindbergh had departed on his first transatlantic flight in 1927 (the year of Kaprow's birth). Knowing this was not a prerequisite for participating in the event; in fact, Kaprow purposely didn't mention it in his introductory lecture about the Happening the night before the event, since it might have lent a plaintive, romantic atmosphere to the goings-on. As always, he preferred that his participants carry out commonplace tasks without adopting dramatic personae or preconceiving the "meaning" of the experience. They were not to be actors. Instead, meaning would emerge from each person's experience of the activity, and Kaprow didn't want to preempt the freshness of those experiences with too specific a historical reference. Besides, an abandoned airstrip already means something—a modern ruin, a site lost in time—but with sufficient vagueness to permit us the meanings of our own experiences while still suggesting a metaphorical intention behind the activity.

Prior to *Arrivals*, Kaprow had seen the 1962 film *A Dog's Life*, which presents a seemingly endless spectacle of human absurdities, including the so-called cargo cults that emerged in the South Pacific after World War II. Having been suddenly exposed to all manner of military aircraft, which, when the war ended, just as suddenly disappeared, certain New Guinea islanders took to waiting for the planes to return, sometimes for years, often constructing decoys (from abandoned military equipment) intended to lure the planes back from wherever they had gone. In thinking about this, Kaprow realized that while it was easy to focus on the cargo cults of exotic, faraway islands, it was worth remembering that we had them here too, in the advanced industrial nations of the West.

With perhaps the exception of Amelia Earhart, who also went away and never came back, the greatest American aviator to "disappear" was Lindbergh—not because his groundbreaking flight in the *Spirit of Saint Louis* was a failure, but in the sense that his stunning success and worldwide fame were overshadowed by a string of terri-

ble losses, both his own—the kidnapping and murder of his infant son—and those he inflicted upon the nation, perhaps out of an inflated sense of his own public influence, when his friendship with Hitler, his anti-Semitism, and his isolationist prewar politics destroyed the myth of his innocence. It was as if Lindbergh, the great American aviator, had flown away and never returned.

By tarring the runway's cracks, painting its lines, and edging the grass overgrowing it, Kaprow and his companions were constructing a kind of decoy airstrip in the mock hope of luring mythic airplanes back to this forgotten Long Island site. To that extent, the metaphor of the cargo cult lay just beneath the surface of the proceedings, as a kind of semiconscious, absurdist purpose for otherwise meaningless working and waiting. It may also have occurred to Kaprow that, given the frequency of his own air travel, the cargo cult closest to home was that of his family. Indeed, Kaprow lived just a few miles away. And was there not also a time when he, a little Lone Ranger in Arizona, awaited over and over the arrival of his parents? A deep personal longing underlies this piece, as the practice of waiting does throughout so much of his career. By selecting this particular airstrip, Kaprow was equating Lindbergh, an American hero, with a tragic absence.

We all have mythic figures with Achilles' heels who ultimately fall before history, whose loss and losses we grieve, and for whom we wait and whose visage we think we see in every hero following. Have we not continued to wait for the next Lindbergh, as we waited, in 1968, when this modest work was enacted, for the next Kennedy—or, that very month, for another Martin Luther King? In the wake of political assassinations and social upheavals, and as the war in Southeast Asia began to go terribly wrong, Kaprow drew upon the seemingly primitive behavior of Pacific Islanders to conceive and execute a work about our own fleeting heroes, our own loss of innocence. Sitting on the tarmac of Lindbergh's mythic ascent, we scan the mirror for the gods and see only ourselves. In fact, cargo cults—metaphors of unrequited longing—are neither extraordinary nor foreign, for there are many nestled among us today, pathetically but hopefully sending out their beacons, waiting for angels, for deliverance, for Godot.

chapter eight the education of the un-artist, I

Increasingly in the late 1960s, simplicity and open-end-edness were characteristic of Kaprow's written plans (he no longer called them scores). They told participants what to do, but never how to do it. The Happening didn't have to be performed "right," but, given that the plan seemed doable, people tried to do it right anyway. None-theless, the well-conceived design inevitably disinte-grated into the unplanned contingencies that constitute practical reality.

Kaprow owed the evolving simplicity of his plans more to George Brecht than to anyone else.[1] He had met Brecht through Robert Watts in the 1950s, while he was teach-ing at Rutgers. Kaprow regarded Brecht as an intellectual Minimalist whose works—or whose scores for works—were remarkable as much for their *potential* action as for their enactments. They were, it may be argued, intended as much for enactment in the mind as for physical per-

formance. Kaprow judged Brecht a brilliant compressor of action into thought, as in *Three Aqueous Events:*

ice
water
steam

Or in the somewhat more pedestrian *Three Broom Events:*

broom
sweeping
broom sweepings

The first piece charms the reader's awareness as it rises through three states of matter, and the second passes our attention from an object to an action to the by-products of their imagined engagement. In another work, Brecht invites the reader to "arrange to observe a sign indicat-ing direction of travel," then, to "travel in the indicated

direction," and, finally, to "travel in another direction." What charmed Kaprow here was the idea of "arranging" to observe something (a sign) that indicates something else (a direction); it was all so proper and reserved, and about as far removed from actually *doing* something as you could get without losing contact with the possibility of action. For Kaprow, a plan was a prelude to action, and so he performed *Three Aqueous Events* by fixing himself a glass of iced tea on a hot summer's day—as elegant an enactment of Brecht's score as the score itself.

In the early 1960s Brecht's sense of reserve and de-

DIGGING A TRENCH FOR *COURSE*, CEDAR RIVER, IOWA CITY, 1968 (PHOTOGRAPHER UNKNOWN)

tachment had helped Kaprow realize his own contrasting urge toward action, and by decade's end his influence could be seen in the simplicity of Kaprow's written plans. In Brecht's works, simplicity introduced an intended ambiguity—the scores could be enacted mentally, physically, or socially—but Kaprow's motives for simplifying his plans were different. He wanted language that would get out of the way of action, not hang like a potential action in mental space. He began using gerunds like "carrying," "pouring," "digging," and "bucketing" that would deflect the reader's attention away from the printed page and into a mental image of a familiar, real-world activity. By adding *ing* to his words, Kaprow changed directives ("carry") into shared assumptions ("carrying"); it was as if one were already engaged in the action. And with a clunky charm, he would sometimes press nouns ("bucket") into service as verbs ("bucketing"), making clear his intention to put words in the service of action. He was not interested in wordplay, but in childsplay.

course

Between May and August 1968 Kaprow produced a number of works that continued playing out themes of transition, settlement, and opposition and that left anonymous, unattributed evidence of his activities after he had come and gone.

One such work, called *Course,* took place in May along the banks of the Cedar River near the University of Iowa in Iowa City. It involved using a backhoe to dig five small tributaries angling away from one side of the river, each about fifty feet long and as deep and wide as the backhoe's bucket. The plan was to pour pails of water gathered from the river into the first tributary at its uppermost point, hurry downstream, catch the same water before it flowed back into the river, and carry it upstream to the next tributary. The procedure would be repeated at each of the five tributaries. Along the way, some of the water would undoubtedly flow past those trying to cap-

ture it, making for a comedy of leaks in an otherwise watertight plan—another of Kaprow's Sisyphean tasks. The plan read:

Digging tributaries to river
Bucketing out the water
Carrying it upstream to first tributary
Pouring it back in

Bucketing out that water
Carrying it upstream to next tributary
Pouring it back in
And so on, till no more tributaries

After the tributaries had been dug and the first buckets of water poured, everyone soon realized that to get the water to flow back toward the river instead of being absorbed into the freshly dug trenches, the tributaries would have to be lined with plastic. The black sheeting they used was a nice touch that rendered the trenches even more artificial than they already were. After a decade of Happenings, Kaprow knew that life would intervene no matter how refined the plan. Between the simple directions of the plans and the complex experiences of carrying them out lay plenty of room to improvise, socialize, and cheat. A decade earlier, the elaborate scores had been intended to guarantee collagelike experiences for the audience. Now the few lines of text, despite their simplicity, were open to an unpredictable play among Cagean variables—in this case, involving machinery, bureaucracy, logistics, and people.

As participants along the Cedar River scooped buckets of water from downstream tributaries, carried them upstream, and poured them into other tributaries, the physical and social experiences of enacting the plan replaced the plan. The attempt to do the Happening according to plan was overridden by the entropy of doing it at all. Once people realized that they would never get most of the water upstream, they relaxed and began to socialize as they worked, and eventually work became play. Some of the conversation among members of this genial bucket

BUCKET BRIGADE AT THE RIVER'S EDGE (TOP) AND "BUCKETING" A TRENCH DURING *COURSE,* 1968 (PHOTOGRAPHERS UNKNOWN)

brigade was about how much of the rest of their lives the Happening was like.[2]

Course was also a comment on the inexorable tug of mainstream art on anti-art, its attempts to draw anti-art back into the currents and conventions of the art world. This was a truism, almost an art-world in-joke, but the deeper question for Kaprow was how one actually lived out the truism. What was the relationship between the putative activity, as described in the plan, and the unplanned experiences that emerged in its name, like forming bucket brigades, spilling water on one's shoes, or passing along gossip? In this sense, *Course* referred not only to the run of the river but also to the course the activity took in its effort to follow, improvise, and elaborate upon the plan.

Course referred as well to the earthworks that were being dug, cut, blasted, and bulldozed by artists throughout the remote regions of the American West. A general question at the time was how and whether such works—or the related photographs, plans, drawings, and texts—should return, like tributaries, to the artistic mainstream. For all the talk of their "unpossessability" at the time, the attraction of the gallery system proved difficult to resist, a fortune *Course* parodied with good-natured fatalism.

Course also parodied the ways we imitate the processes and cycles of nature, often in the belief that we are subduing or converting them to our own uses. By engaging participants in hard work that accomplished nothing, the Happening commented on the futility of our attempts to control the natural environment. Kaprow, however, was not an environmentalist. While sympathetic to the aims of the newly established ecology movement, he did not share its idealization of nature as an autonomous realm to be safeguarded from human intervention. *Course* was human intervention, and, with its backhoe-dug trenches, a fairly brute example. Kaprow was more interested in imitating nature, or in imitating ourselves imitating nature, than in the politics of preserving it.

If Brecht kept his distance by "arranging" to do something rather than doing it himself, Kaprow kept his by doing something that was already being done. He was a copyist. Throughout his career, he had copied clichés, stereotypes, myths, rituals, truisms, natural cycles, and the patterns of children playing, each providing his "theater" with a nontheatrical template for human experience. In copying, or in copying copying, there is already a natural distance—the distance from what we think we are doing, or from what we are supposed to be doing. Beneath the truism, cliché, ceremony, or myth, there was always something the participants of Kaprow's Happenings were *actually* doing—something they wouldn't know until they did it. And *that* was what Kaprow was hoping to experience from experience.

project other ways

Kaprow shared with many of his colleagues an interest in Zen philosophy and a curiosity about its application to education policy. Kaprow, Brecht, and Watts had often talked of reforming American education back when they were attending John Cage's class together. One of the implications of Cage's experimental approach to composing, and thus to teaching, was that educational experiences might turn on forms of improvisational play—that play, instead of work, was perhaps a better motivation and method for learning. Likewise, by the late 1960s Kaprow had developed the Happening into a form of philosophical inquiry that was inherently experimental, encompassed a wide range of subjects, and was enacted as a matter of the participant's experience, not the artist's theory. In this respect, John Dewey, for whom "doing" was "knowing," was Kaprow's true intellectual father, especially given Dewey's legacy in the field of modern American education. If the experiential impulses for the Happenings can be traced to Kaprow's Arizona childhood, where ranch life and schooling were one and the same, and if his methodological underpinnings came out of Cage's class in avant-garde tactics, then one can fairly say

the early 1960s New York scene phase of his career was something of an aberration, an avant-gardist interlude in a life of educational environments and self-schooling.

In the Happenings of the early 1960s the drama was theatrical, collagist, zany, haphazard. By the end of the decade, a Happening by Kaprow was no longer something you went to, but something you and a few others undertook. Performers were no longer mixed in with the crowd; there was no crowd, only volunteers. Resonance tended to reside in the specific settings, communitarian experiences, and big ideas (like imitating nature, or turning work into play) that were part of the background noise of 1960s American society.

At the same time, Kaprow became less judgmental about his work, less drawn to its meanings, less driven by his own creative intent. In fact, he adopted a new kind of creative intent: the intent to be nonjudgmental. He was becoming an alogical strategist, deliberately not stopping the action, letting it take its unpredictable course, seeing where it might go. It was at this point that Kaprow began to call what he did "un-art," which suggested the decamping of art into life. He wanted to be in life as an artist—or as an artist might if not constrained by professional protocols. Thus, the process of "un-arting" represented nothing less than the deprofessionalization of the arts—another big idea.

While at Stony Brook, Kaprow had written a grant application to the Carnegie Foundation to fund an experimental educational program in which artists would be brought into colleges and secondary schools to introduce teachers to new forms of interdisciplinary art (like Happenings) that might enliven the often hidebound curricula entrenched there. Not surprisingly, Stony Brook had rejected the money (around $80,000). Somewhat surprisingly, the public school system of New York City had too. Kaprow then met Herbert Kohl, a professor of education at the University of California, Berkeley, and together they approached the university's administration, only to be rejected once again; Kaprow heard rumors that certain faculty members at the Lawrence Radiation Laboratory—the "Rad Lab"—were fearful that bringing Happenings to campus would result in students "planting bombs and fucking in the aisles."[3] In 1968, just as the Carnegie Foundation was ready to rescind the grant for lack of a sponsor, the Berkeley Unified School District took the program.[4] Thus began Project Other Ways, which operated out of a Berkeley storefront at 2556 Grove Street (now Martin Luther King Jr. Way).

The program was heralded by a poster placed on numerous school bulletin boards around Berkeley. Its message, "SUPPOSE," suggested, as art critic Thomas Albright put it, "such other suppositions as 'you couldn't write and could only take pictures,' 'you used graffiti as a text book,' 'you had to make music with only a rubber band,' [and] 'you had to write your own Dick and Jane.'"[5] Kaprow told Albright that "each 'suppose' could be a curriculum," and an "event plan" was devised to replace the teacher's conventional lesson plan.[6]

The idea was to integrate the arts into curricula, both by training teachers and by bringing artists from the local community into the schools to work directly with the kids. Happenings would be one of the "easy to do" features of the project. Kaprow could experiment with childsplay among children, but Kohl, who is known as the father of the open schools movement of the 1960s and 1970s, was more political in his interests, seeing the project as an opportunity for artists to intervene in the static routines of public education.[7] To this end, artists from Oakland and Berkeley were hired to work out of the storefront and in the schools. Painters, musicians, storytellers, and the like were brought together in the context of an interdisciplinary approach toward the arts and a non-métier conception of the artist.[8]

At Project Other Ways, Kaprow found himself a kind of "jester presence"[9] in an organization attracting artists who wanted to subvert public-school curricula and who saw Project Other Ways as a local political lightning rod. This sentiment was fueled by the virtual military occu-

CLOTHES RETURNED TO A THRIFT SHOP DURING *CHARITY*, BERKELEY, CALIFORNIA, 1969 (PHOTOGRAPHER UNKNOWN)

SILHOUETTE PAINTED ON THE SIDEWALK DURING *SHAPE*, BERKELEY, CALIFORNIA, 1969 (PHOTO: DIANE GILKERSON)

pation of Berkeley during the second half of May 1969, when National Guard troops were called out by Governor Reagan to suppress public unrest over the struggle for People's Park. Moreover, Kohl was displeased with Kaprow's travel schedule, which caused him to be in residence one week and gone the next. So was Kaprow; the traveling was killing him. This tension exacerbated their ideological differences, Kaprow wanting artists who would play in the schools, and Kohl wanting artists who would radicalize education. Kaprow's was a benign vision, Kohl's a revolutionary one.

Still, Kaprow did some important work while at Project Other Ways. Between March 7 and May 23, 1969, he organized *Six Ordinary Happenings* for the streets of downtown Berkeley. In the first, *Charity*, old clothes were purchased from a used-clothing store, washed in public laundromats, and returned to the stores from which they were purchased. In *Pose*, participants carried chairs through town, occasionally sat in them, were photo-

graphed with an Instamatic camera while they sat, and left the photos behind before moving on. *Fine!* involved parking cars in restricted zones, waiting nearby for the police to write a ticket, taking a snapshot of the ticketing, making out a detailed report, and sending the report, the snapshot, and payment of the fine to the police. For *Shape,* high-school students, using water-soluble spray paint, painted the silhouettes of their bodies on sidewalks, on streets, and in fields, after which photographs and reports were sent to the newspaper. Dishes were the props for *Giveaway.* Stacks of them were placed on street corners, photographed, and left; on the next day, the same street corners, now without dishes, were photographed again. In *Purpose,* a small heap—a "mountain"—of sand was moved repeatedly until there was no more mountain, the working sounds of which were recorded and re-recorded until there was no more sound on the tape.

"As an artist," Kaprow said at the time, "I'm concerned with happenings because of their pointlessness. As an educator, I recognize their point."[10] Indeed, his "six ordinary Happenings," all conceived for and enacted in the streets, tapped into the social and political pulse of a city in revolt by the acts of contributing to charity, watching and writing reports on the police, outlining bodies on the ground, leaving and giving things away in public, sweeping the streets—and by making the news. Berkeley was Kaprow's playground at the moment it was everybody else's battleground. To some, his "ordinary" Happenings seemed irrelevant or even indulgent in this highly politicized context. But when the streets are laced with tear gas, patrolled by the National Guard, spattered with blood, and crackling with gunfire, perhaps ordinariness—just going about one's business—is a radical alternative to the waves of proletarian outrage and police violence coursing through the boulevards of the city.

The experimental question underlying these six Happenings was how to introduce activities that looked nothing like art into a nonart environment that did not expect them and, once they had come and gone, could not ac-

count for them—a string of aesthetic negations that left little but ordinary experience in its wake. Nonetheless, these "ordinary" Happenings were sequenced in such a way as to double back on themselves (writing a report of a cop writing a ticket, buying clothes from a charity and then returning them, taking photographs and then leaving them on the spot), triggering an awareness of the activity as something not quite ordinary after all. Ordinary activities, self-consciously arranged, yielded extraordinary experiences. There is nothing unusual about buying used clothes, washing used clothes, or donating used clothes to charity; but when these activities were strung together using the same clothes and the same charity, the effort was spent in the service of just getting back to the beginning. The fact that there was nothing to show for the effort was a reverse indicator of what in fact had been acquired: an interesting experience. No matter how ordinary the plan, the experience of enacting it was something special, especially in Berkeley in the spring of 1969.

Kaprow's *Six Ordinary Happenings* were furtive in a streetwise manner, almost shadowing the movements of

DOORWAY PLACE SETTING LEFT DURING *GIVEAWAY,* BERKELEY, CALIFORNIA, 1969 (PHOTOGRAPHER UNKNOWN; COURTESY GETTY RESEARCH INSTITUTE)

police and protesters, activists and informants, the repressive weight of the state and the fleet-footedness of grassroots organizations. As such, it was important to Kaprow that the Happenings were now fairly easy to do, since ease of implementation was a sure sign of their deftness. The artist no longer had to bend over backward to find his way into the world; he only had to lean into the streets, and there it all was: the "vastness of Forty-second Street" that Kaprow had written about in "The Legacy of Jackson Pollock," retrained to the scale of a Berkeley neighborhood.[11]

Several years earlier, a landscape architect named Karl Linn had told Kaprow about London's pocket parks—bombed-out lots that had been salvaged by the locals and made over into parks. The idea charmed him, perhaps because it involved recycling rubble and transforming a devastated urban space into what amounted to a makeshift playground. (*Yard* had been a kind of pocket park.) At Project Other Ways, Kaprow put the idea into practice by working with locals in a number of Oakland neighborhoods to reclaim empty lots and turn them into parks. He did this in conjunction with officials in the Oakland Unified School District, who located possible sites in the poorer sections of Oakland and helped identify neighborhood elders who might support the project.

Working with volunteers from Project Other Ways and neighborhood kids, Kaprow cleaned up the garbage on the lots and used the better junk to create paths, birdbaths, bandstands, strings of electric lights, play areas, seats, and eccentric assemblages. Old chairs, for instance, were stacked into a tower at one site, and an abandoned car body was painted and made into a playhouse (not unlike those in *Gas*) at another. Those involved hoped that the parks would become focal points for neighborhood socializing. The parks were fun to make, but they were vandalized as soon as they were finished. The neighborhood elders were disappointed and volunteers were discouraged, but Kaprow was characteristically philosophical—

the parks had come from rubble and were returned to rubble. While this sentiment ran counter to the socially progressive orientation of many of Kaprow's colleagues at Project Other Ways, it was part and parcel of his interest in transitory experience. The pocket parks were failures because of the dissolution of the temporary communities they brought together under the banner of experimental education.

It was during this period that Kaprow heard of an empty lot in Berkeley, owned by the university, that might make a good pocket park. He met in April with university officials, who seemed interested in his proposal to temporarily appropriate the lot for this purpose. Word seemed to have gotten around about the pocket parks in Oakland, since it was somebody at the university who suggested that Kaprow consider the vacant Berkeley site. The idea of co-opting unused urban plots had a certain proletarian cachet at this particular moment and place in American political history. Kaprow's riff on the London Blitz became "the people's" improvisation on the local balance of power—or that of their interlocutors. Indeed, Kaprow never was able to work on his Berkeley pocket park because three weeks after his meeting at the university it was seized by activists and became People's Park—and as tear gas drifted over the Grove Street storefront several blocks away, Kaprow watched in jaded detachment (the worst kind of Zen) as the worst kind of "happening" unfolded.

cal arts

Kaprow left Project Other Ways at the end of its first year. He felt the opportunities to play in the Berkeley schools were overshadowed by the political maelstrom sweeping the Berkeley streets. Besides, he'd been offered a job at a new art school in Los Angeles that seemed to embrace many of his ideas of progressive education—the California Institute of the Arts. He had been considering the job

for some time, and in the summer of 1969 Kaprow packed up his family and moved from Long Island to Southern California.

CalArts (as it was almost immediately called) was a curious and not always harmonious mix of its founder's vision and the visions of the artists who actually put it together. Its founder and primary funder was the late Walt Disney (who died in 1966). He and his brother Roy had envisioned an ambitious school for the arts in which the various arts disciplines would be housed together in a single training facility. A merger of the Los Angeles Conservatory of Music, founded in 1883, and the Chouinard Art Institute, founded in 1921, CalArts represented a bold, yet naive, conception of the commingled arts as a utopian community of creative individuals—a kind of "whistle while you work" Bauhaus. An architectural cutaway drawing of the new campus on display at Disneyland in 1971 showed in a crisply rendered style freshly scrubbed young men and women dressed in slacks and skirts (except for the dancers, who wore tights), painting and acting and dancing and animating and performing classical music in the brightly illuminated spaces of Walt Disney's dream school.

The reality was somewhat scruffier. The young people who showed up in the fall of 1970 for the school's first semester had their classes at a temporary campus in Burbank because the sleek Valencia campus was still under construction. The students were anything but Disneyesque; with their countercultural dress and vanguard dispositions, they were the kind of kids who, in those days, would have been discouraged from entering Disneyland. Their image comported poorly with the founder's dream. Stories of unfortunate surprise encounters between sunbathing or skinny-dipping students and horrified trustees in the early days of CalArts are legendary.

What the Disney organization never really understood was that a great faculty had been assembled under its aegis. Herb Blau, the theater director and theorist who was the provost of CalArts, had done most of the hiring. In the year or so before the school opened its doors, Blau was in effect the director of day-to-day operations, gathering artists from around the country and from across the arts disciplines. He hired Abstract Expressionist painter Paul Brach as the dean of the School of Art and Kaprow as the assistant dean. Working with Blau, Brach and Kaprow hired a garrison of artists, including John Baldessari, Stephan von Huene, Miriam Schapiro, Lloyd Hamrol, Judy Chicago, Nam June Paik, Wolfgang Stoerchle, Alison Knowles, Peter Van Riper, and Allen Hacklin, among others. In the School of Design (which extended the concept of design to include all of culture), Sheila Levrant de Bretteville was hired, as were Morton Subotnick and Ravi Shankar (the Beatles' sitar teacher) in the School of Music. The School of Critical Studies, run by sociologist Maurice Stein, was put forward as the mixing place for the various arts disciplines and the breeding ground for whatever hybrid forms of artistic expression and social criticism might emerge.[12] In those first few years, the utopianism of the original Disney vision for CalArts was often retooled into serious Marxist and feminist agendas that were anathema to a Magic Kingdom aesthetics, but were at least as utopian.

The Feminist Art Program, a precursor of which had been conceived by Chicago at Fresno State College in 1969, was instituted by her and Schapiro at CalArts in 1971, initially with a radical, separatist bent: that fall, Schapiro, Chicago, and their students *left* the CalArts campus to establish Womanhouse, a project in which they transformed a vacated residential building in Hollywood into a series of art environments that were woven throughout the building, as well as a space for performances that ran for the month of January 1972. This lurch toward society, which was seen by some as a rejection of the very generous facility Disney had bequeathed his future students (and maybe employees), echoed the interdisciplinary jockeying for position then going on within the in-

stitute. Stating one's commitment to the new hybrid arts was one thing, but actually instituting that commitment in programmatic, curricular terms was another. The School of Film, for instance, was less than willing to lend art students its equipment (fearing it might be used for God-knows-what purposes), and, while the feminists were separating themselves from the School of Art, a group of mostly male painters, including Eric Fischl, Ross Bleckner, and David Salle, focused in on the discipline of painting with an intensity that belied its presumptive status as a dying medium. From Kaprow's perspective, the School of Theater was less experimental than cultish, and the School of Dance, under Bella Lewitzky, was not at the vanguard. Despite the interdisciplinary rhetoric that suffused CalArts in its first few years, most of its departments worked to consolidate their holdings and advocate for their own identities within the overall bureaucracy.

Still, the prevailing atmosphere at CalArts, at least initially, was one of high expectation and unfettered experimentation. Everyone knew that CalArts was an elite and prestigious place. Admission standards were rigorous. One of the school's early innovations was that students were not just students, but young professionals, and were to be treated with the respect and expectations thereby due them.[13] However scruffy they seemed, and despite the saccharine suffusion of "Walt's Dream" throughout the institution, the first wave of CalArts students, both undergraduate and graduate, were pretty good artists. Almost despite itself, a great art school had been born.

publicity

As the first semester got under way, Blau asked Kaprow to stage a Happening with students as a public-relations event that might draw attention to the school and exemplify its interdisciplinary ideals. Kaprow agreed, although he really didn't want to do another big Happening. Reverting to a spectacle, while certain to guarantee a good show, would inevitably be a major pain—but then again, a big Happening would likely mobilize the energies of the CalArts students, thereby serving the larger pedagogical objective of getting painters, sculptors, filmmakers, dancers, musicians, actors, poets, designers, and aspiring critics together. It would stir things up, reinforcing the institution's expectation that the young artists mix across the disciplines.

What Kaprow came up with was *Publicity*. Students were to form into work teams and, using two-by-fours, improvise wooden structures on the jagged sandstone peaks of Vasquez Rocks, a well-known picturesque site in the desert north of Los Angeles where Hollywood movies and commercials were (and are) often filmed. While the students were building the structures, several camerapersons (including Paik, Shuya Abe, and Paul Challacombe), carrying portable but bulky video cameras, audio recorders, and small monitors, would roam the site filming the most interesting activities while being beckoned by work teams vying for attention and hoping to be filmed. The video recordings were then to be immediately played back to the workers, who could watch themselves working moments before. The idea was that the recordings might affect the workers' subsequent activities, generating "new ideas, changes, reconstructions" and maybe "more recordings."[14]

On October 6, 1970, Kaprow gathered perhaps a hundred students in the lunchroom of the Burbank campus and gave his customary pre-Happening lecture. The atmosphere, already charged with the newness of CalArts, was further infused with anticipation about taking part in an actual Happening. "Are you going to the Happening?" swept the campus in a flurry of breathless whispers. The students' sense of what a Happening was drew heavily on the popular culture of the preceding decade. Although Kaprow explained the general plan, the legacies of Woodstock, which had taken place just fourteen months earlier, and Earth Day, a "global happening" from the previous spring, pulsed beneath the surface with a utopian promise of "community."

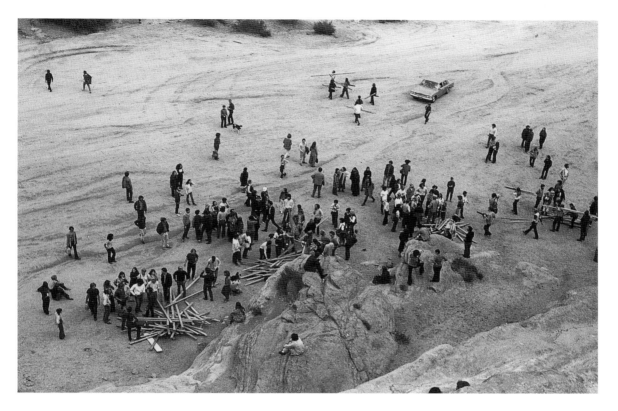

PARTICIPANTS GATHERING INTO TEAMS FOR *PUBLICITY,* VASQUEZ ROCKS,
AGUA DULCE, CALIFORNIA, 1970 (PHOTOGRAPHER UNKNOWN)

October 6 was a warm, overcast day. Everyone boarded
yellow school buses and headed north to Vasquez Rocks.
This was D-day for CalArts, and the students, eager, sus-
picious, or merely along for the ride, spilled out of the
buses and onto the dusty plain at the base of the sprawl-
ing formations like an army of little people at the feet of
a slumbering sandstone Gulliver. They formed into work
crews of perhaps a dozen members and began claiming
and dragging lumber off into the hills, which were soon
sprinkled with colonies of artists erecting delicate, web-
like structures.

The visual scale at Vasquez Rocks was integral to the
experience of the Happening. The structures appeared

diminutive or heraldic, depending on the viewer's per-
spective. Members of a work team could look up from the
task before them and catch glimpses of competing teams
huddled on an adjacent slope or moving, antlike, along a
distant ridge. The social and physical nature of the ac-
tivity contrasted dramatically with the pictorial qualities
of the scene. In fact, the environment was so scenic it was
as if the Happening were being staged against a picture.

Once again, Kaprow asked people to do something
without telling them how to do it. The students were left
to form their own work teams, to select lumber, and to
choose a building site, whether a peak, a ledge, or a
ravine. They had to agree on what kind of structure they

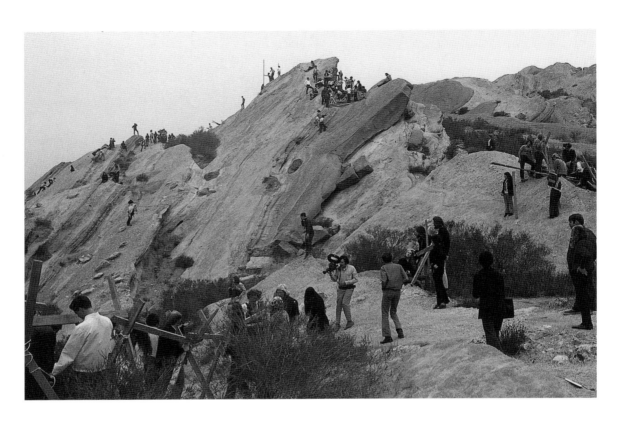

FILMING WORK TEAMS (ABOVE) AND AUTHOR IN
FOREGROUND WITH OPEN SHIRT (RIGHT) DURING
PUBLICITY, 1970 (PHOTOGRAPHERS UNKNOWN)

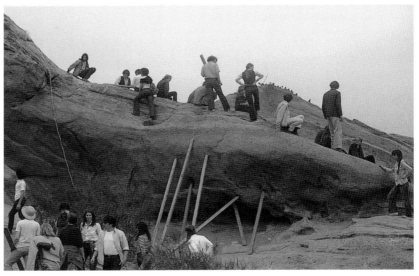

would build—usually as they were building it—and figure out how to work together. Kaprow had used work teams before, but here their social dimension was underscored by the fact that students who barely knew one another were being asked to work together in a public undertaking of dubious, or at least uncertain, merit. For some, the experience was disquieting, like waiting on the sidelines to get selected (or not) by a schoolyard basketball team. Others jumped right in, with leaders taking the initiative and followers lagging behind or watching from a distance.

With bullhorns squawking and hands waving, members of each team summoned, beckoned, and beseeched the camerapersons to struggle up a slope or shimmy along a ledge and videotape their own badly engineered, quasi-tripodal "sculpture," lashed loosely together with rope. Some structures were hoisted off the ground by their creators or dragged along the rocks to a new location. Some fell apart altogether. As the work progressed—or digressed—loners would occasionally break away from their crew and scamper up a hillside. Knots of concerted social activity were unraveled by the abrupt wanderings of prodigal students who, drawn to the distance by the romance of distance, sooner or later returned from their reveries to rejoin their little impromptu tribes and participate in the endearingly familiar childhood ritualisms of setting up camp, claiming ground, following the leader, building a fort. Both playful and heroic, the task of erecting wooden structures on a sandstone moonscape was rife with displays of competition—among the students, between the work teams, and against nature. Performance was poking away at pictorialism from within, the "scene" pressing back its considerable weight upon the Happening.

The spectacle played itself out as a kind of Cowboy-and-Indian siege (the tripodal structures sometimes resembling tepees) or as a boomtown epic set against a Hollywood backdrop familiar to this generation of artists, the first weaned on television, as a cinematic cliché of the Wild West. Many of the early *Lone Ranger* television episodes from the late 1950s had been filmed on this terrain, and it had frequently served as a setting for Western films—which is to say, for the mythic reenactment of what actually took place throughout its washes, gullies, and trails one hundred years before. The acts of staking one's claim, taming the land, competing for territory, and erecting overnight "communities" were the clichés of movies and television. As he had done so often in other Happenings, Kaprow mobilized those clichés in the service of present-tense experiences that were themselves metaphors. In this case, the task represented the establishment of CalArts: the fragile construction of a utopian edifice devoted to the avant-garde arts in the arid suburbs north of Los Angeles, an edifice that was also the dream of the preeminent creator of visual fantasy in the twentieth century. The site itself, for all its geologic grandeur and rugged picturesqueness, was really a movie location, already subordinate to its cultural function as a setting for historical visual fantasies.[15]

It is not insignificant that Kaprow inserted video cameras into the event. Their presence not only afforded students the opportunity to call attention to themselves and their "accomplishments," but also pantomimed the status of the site (and of nature) as an image in an emerging world of images (that Susan Sontag would later describe as the newest habitat of human consciousness).[16] Kaprow wondered whether the students would be influenced by seeing pictures of their activity, so he built in the narcissistic loop that enabled them to watch themselves working—a technological upgrade of the reflective surfaces (usually mirrors, sometimes broken ones) that he had used in environments as far back as those in the Hansa Gallery. Puns on self-portraiture and parodies of inner reflection, Kaprow's reflective surfaces had always offered participants brief respites from whatever they were doing; instead of wading through a forest of hanging raffia (in 1958) or lugging lumber up a hillside (in 1970), they could take a break and admire an image of themselves. These were little escape hatches from reality, offering

egress into the world of images, fantasies, and thoughts passing beneath the surface of everyday activity.[17]

In seeking the camera's attention at Vasquez Rocks, the students enacted the basic metaphor of the Happening, which was to generate publicity by doing something "newsworthy." With protests against the war in Vietnam by then a commonplace, the relationship between public events and media coverage was obvious; television cameras did not just follow sit-ins, demonstrations, and riots, but helped trigger them. Political protesters had learned to wait for the arrival of the cameras before launching into marches, slogans, and acts of civil disobedience. In the world of political theater, this symbiosis between political performers and the electronic me-

APPROACHING MARAUDER WITH LIGHTED FLARE DURING *PUBLICITY*, 1970 (PHOTOGRAPHER UNKNOWN)

dia warped actual events into a media spectacle sold as news to the general public. Kaprow saw this as a feedback loop on a mass-communications scale, not an objective representation of events: the loop *was* the event. In the same way, the Happening at Vasquez Rocks was a pseudo event, a publicity stunt caught in its own narcissistic loop on the outskirts of Hollywood.

While most of the students were out working among the rocks, Kaprow was confronted with a bizarre and dangerous challenge to his authority as the artist responsible for the Happening. Stonewall Jackson, a student who had been admitted to CalArts as a member of a two-person artist team and a self-styled leader of a cultish, nomadic commune of mostly female nonstudents who hung around the school (and who once attempted to "kidnap" Kaprow and take him to the moon aboard a plywood spaceship being built on the campus), arrived at Vasquez Rocks in a rented Ryder truck with several male lieutenants wearing stockings and ski masks over their heads. One, lying prone, rode atop the truck, holding aloft a lighted road flare. As the truck stopped at the base of the rocks, Stonewall jumped out. He announced in a collegial but nonnegotiable manner that he and his comrades were going to set alight the remaining wood, presumably as a way of superseding Kaprow's Happening with one of their own. Within seconds, they were pouring gasoline on the lumber. Kaprow, fearing a conflagration in the tinder-dry desert, picked up a board and told these motley, modern-day marauders that if they got anywhere near the wood with their burning flares he would kill them. A big, muscular German student stepped in and dragged several of the raiders away from the lumber before any fires were lit. Perhaps taken aback that someone as "cool" as Kaprow, the guy who invented spontaneous, "anything goes" Happenings, would take the side of the law in this Wild West showdown, Stonewall and his gang withdrew. To Kaprow's astonishment, in this setting—so much like the one he had always imagined for his boyhood champion while listening to the *Lone Ranger* on the radio—he

had found himself bushwhacked by marauders who had ridden in to burn the place down—and like the Lone Ranger, Kaprow and his trusty sidekick had fought them off and saved the day.[18]

The confrontation brought Kaprow face-to-face with the nihilistic undertow of Happenings in popular American culture. They constituted a myth in which youthful celebration and permission could descend into juvenile indulgence and license—often in the name of a fashionable anarchy intended to provoke "the establishment"—or, in a more sinister sense, provide a pretext for the lifting of sanctions against irresponsible or reckless behavior. This raised in Kaprow's mind a host of questions about the ethics of art conducted in the realm of everyday life. The consequences of aesthetic actions undertaken in Vasquez Rocks, a public, nonart setting, nearly resulted in a dangerous, destructive wildfire. A Happening could spark the combustible feelings of alienation and discontent developing within the adolescent American psyche. As Stonewall's nomadic CalArts "family" attested, beneath the surface of Keseyesque communalism lurked the seeds of a Mansonian harem.

Most of the students were unaware of this drama, however, and *Publicity* ended not with a crescendo, but with a general slackening of effort. The structures came down, board by board, ending in a haphazard pile of lumber at the staging area, soon to be picked up and returned to the lumberyard. As the afternoon wore on, students lost interest in their tasks and drifted down to the base of the peaks, dragging their lumber with them. There, they compensated for the lack of dramatic climax by spontaneously erupting into a "happening" of their own: waiting for the buses to take them home, they began beating several empty trash cans with sticks, accompanying their own drumming with a communal, singsong cadence. This neo-primitive incantation provided a dramatic culmination to a day of geographically dispersed and theatrically unrewarding activity—one with feeling, one that was youthful, tribal, and celebratory. As the students

drummed and sang and swayed, the sounds they made echoed up through the sandstone pinnacles, like messages to the universe. It looked like a sequence from *Woodstock*—not the concert, but the movie—in which a throng of muddy concert-goers bang away on pots and pans and sing to their own ecstatic rhythms. But by then Kaprow had left, not wanting to see the Happening degenerate into a parody of itself. At Vasquez Rocks, life imitated art—once again.

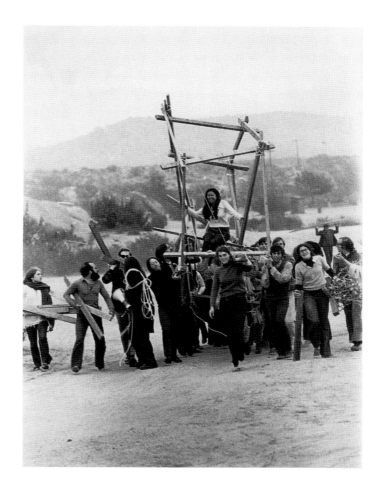

POST-HAPPENING CELEBRATION FOR *PUBLICITY*, 1970
(PHOTOGRAPHER UNKNOWN)

feminism

Kaprow had been aware of the Women's Movement since the early 1960s, and he supported it as a matter of social justice. The Feminist Art Program at CalArts promised to explore the links between art and society, as well as to challenge dominant male stereotypes about the "nature" of the creative process, and in these respects Kaprow was interested in what feminist artists might add to the unartistic experiment. He had personal reservations, however, about the zeal with which feminism in the arts was being prosecuted as a utopian agenda. Kaprow had always mistrusted zeal in art, no matter what its subject matter; he felt it slipped too easily into jingoism, often in the name of sound humanitarian reforms. As a pedagogical matter, he found many feminist artists overriding in their social commitment to the extent that education sometimes stiffened into indoctrination.[19]

It was assumed by many activist artists that Happenings, if scaled to the ideological proportions of feminism, might change society. Students would often raise questions and issue challenges about the social efficacy and political purpose of Kaprow's art. They wanted to change the world; Kaprow wanted to play with it. Nevertheless, feminism did change Kaprow's work. In fact, the influence went both ways. Young artists such as Suzanne Lacy and Aviva Rahmani were influenced by his embrace of the everyday. At Womanhouse, Chris Rush enacted the monotonous rhythms of scrubbing the floor, while Faith Wilding sat waiting—"for my breasts to develop," "to get married," "for the first gray hair"—and slowly rocking.[20] Kaprow liked their use of such commonplace and everyday actions as the subjects of social commentary, but he was uninterested in tapping into its voltage, either as an artist or as a teacher. He encouraged his students to look away from art and toward the everyday, but he tended to discourage subject-matter agendas of any kind. Kaprow distinguished between subject matter and content: for him, content (or meaning) should be "emergent," arising from the experience of doing something, whereas meaning in feminist art was impelled by personal experience, where it unfolded as communal consciousness. This was not the transformation that interested Kaprow as an artist. For him, the act of sitting in a chair and waiting was about experiencing waiting, with its attendant moods, discomforts, and expectations. For feminist artists, it was more likely a representation of the powerlessness and subservience so often experienced by women.

Still, the feminist enterprise at CalArts heightened Kaprow's sensitivity to gender issues and power relations between the sexes. Thereafter, he adjusted the power relations in his works to accommodate feminist discourse, forging a more determined, subtle, and even mischievous equality of role playing. The early 1960s battlefield standoffs between men and women were transformed into taut, psychological equivalencies of couples negotiating the maze of social and sexual conventions, engaging in a low-grade contest of well-intentioned but ultimately awkward maneuvers. Who opens the door for whom? Who undresses first? How many thank-yous are enough? In these scenarios, which ran into the late 1970s, men and women were equals-but-opposites, symmetrical elements in asymmetrical situations. In this way, Kaprow changed thematic material into behavior; the idea of social equality between the sexes was transformed into a psychosocial pantomime between participants. Instead of questioning why men were brought up to open doors for women, Kaprow simply foregrounded the behavior.

Through behavior games, participants in Kaprow's works could step away from their concerns about power relations between women and men, because they knew from the start (it was evident in the score) that neither side would win. Kaprow took the power out of human relations, discharging its social currency. He wanted to see what would happen if conventional assumptions about the social "meaning" of certain behaviors were stripped away, even though the behaviors were still performed. If you don't kiss to endear yourself to someone, but simply to see what happens when you kiss, the conventional meanings associated with kissing fall away, leaving only kissing. Subject matter falls away, leaving whatever do-

ing something means: its contents. Thus, any sexual tension in these scenarios would emerge from enactment; it would not be given as a social agenda.

Probably the most significant feature of feminist performance adopted by Kaprow, around 1973, was the consciousness-raising follow-up session, a convention of the early 1970s in which artists and members of the audience (initially only women) discussed their own experiences as well as the social and political implications of the work after a performance. Over the years, anecdotes from participants had contributed to the mystification of Happenings by rising up around them as art-world or counterculture gossip. (Indeed, Kaprow had come to feel, especially during the 1960s, that gossip was the true medium of his art.)[21] This gossip helped spread the infamy of Happenings at the same time that it obscured their human scale. Kaprow felt the need to fold those experiences back into the work, if for no other reason than to satisfy his own curiosity about what they were, so he adapted the feminists' closing circle to his purposes.

Kaprow didn't encourage social critique or personal sharing, but he did want to know what had happened to those who had participated in a given work. If the point of his experiments was to find out what was actually going on beneath what his subjects were or weren't doing, then he was losing his data as his subjects took their experiences away with them at the end of an activity. Good stories were going untold. Kaprow didn't realize it at the time, but his decision to invite participants to meet in follow-up sessions and discuss their experiences was the beginning of an oral, if not quite literary, dimension to his work that would continue and crystallize in subsequent decades.

In light of the widespread feeling at the time that art should do something for society (and the fact that many socially oriented artists at CalArts felt he had been ducking his responsibility in this regard), Kaprow's adaptation of the feminist follow-up session might be seen as a concession to these utopian imperatives. But Kaprow had never felt that responsibility. It is important to remember that he came of age during the 1950s, when American artists were generally apolitical. The legacy of the Stalinist betrayal of communist ideals and the McCarthy witch-hunts of the 1950s helped imbue in many artists, especially the Abstract Expressionists, a prejudice against joining anything or trusting anyone other than themselves. Kaprow had internalized this mistrust of ideology at a young age, and he was uncomfortable with the idea of jumping on the feminist political bandwagon. Besides, as a sickly child living on an Arizona ranch, Kaprow had been a loner long before his political consciousness was molded by the superindividualism of the postwar New York scene. Since childhood, being an artist had been synonymous with being alone. Even during World War II, which he had been old enough to serve in (though his asthma prevented him from doing so), Kaprow had tempered his patriotism with the sense that, as an artist, he—that is, his kind—was not really accepted by the American public. As a high-school boy, this experience of alienation informed his sense of empathy for those on the margins of society, an empathy he felt toward women in the context of 1970s feminism.

Kaprow did not see experimental art, especially his own, as a meaningful tool for social change, however. His interest in the idea of a follow-up session in which participants could talk about their experiences was empirical, not political—he just wanted to know what had happened. The social efficacy of the experiences was not judged. Playful outcomes, disturbing outcomes—it didn't matter. Each story was welcome. Kaprow had borrowed and adapted a formal feature of feminist practice, but not its social agenda. As participants recounted their experiences, he was able to hear firsthand (and really for the first time in a systematic way) what had actually happened beneath the conventional assumptions about what a given behavior was supposed to mean. As stories began to accumulate, Kaprow became aware of an emerging oral dimension to his works. This, in turn, spelled the end of his itinerant period, since the stories, and the experiences they stood for, no longer scattered to the winds.

chapter nine the education of the un-artist, II

At CalArts, Kaprow began thinking of his works as forms of teaching. Unlike the Happenings of the previous decade, which were enacted for and with a public audience, the works in and around CalArts were tailored for a select group of students in the context of an educational experiment. Throughout his academic career, Kaprow had been regarded as an anti-art radical: an artist who didn't make art. At CalArts, he found himself in an experimentalist milieu that encouraged such forms of creative research as play and meaningless work. More like a laboratory than a lecture hall, his "classroom" often spilled into the hills, gullies, streambeds, and subdivisions adjacent to the Burbank and Valencia campuses. Although the city dumps, rock quarries, and abandoned runways of the 1960s had been laboratories of a sort, it was at CalArts that Kaprow returned to the experimental setting most familiar to him—John Cage's classroom, only now as the teacher.

The idea of the classroom (albeit an "open" one) changed the format of the works: they became more like demonstrations or assignments and less like performances; in order to make a point, they had to be deft; the scale of each activity was necessarily intimate, as between teacher and student or among members of a class; and they were now parts of a curriculum in the education of artists—or, as Kaprow put it in a series of essays published between 1969 and 1974, "The Education of the Un-Artist."

In these essays, Kaprow writes of the increasingly blurred boundaries between contemporary art and the natural, social, and technological environments in which it participated. Observing the "lifelikeness" of much art practice of the time, he likens Conceptual art to language, earthworks to farming, his own performance activities to the operations of organized labor, videotaped body art to deodorant commercials on television, and so forth. In

these "likenesses to life," Kaprow divines a "cosmic Happening," in which everything imitates everything else: city plans are like the circulatory system, computers allude to the brain, children's play scenarios mimic adult behaviors. The practitioners of lifelike art do not merely copy life, he says; instead, they are attracted to the mimetics already present in the "life" fields—that is, they imitate imitating. "When it is clear that the most modern of the arts are engaged in imitations of a world continuously imitating itself, art can be taken as no more than an instance in the greater scheme."[1]

Copying and playing were the cornerstones of Kaprow's curriculum in the education of the un-artist. In this experimental sense, education was restorative, even redemptive; this he took from Dewey, who had called upon an earlier generation of artists to rediscover the everyday sources of their works in an effort to revive the atrophied connection between art and experience. At a moment when Modern art was still widely seen as "an isolating discipline," Kaprow saw the task of the un-artist as restoring "participation in the natural design through conscious emulation of its nonartistic features."[2] The job of the artist, in other words, was to play, and the payoff for playing in, and with, the world was to feel a part of it. Such was the redemptive power of play for an artist who had been sick and isolated as a child, for whom art and play and education had been fused in the formative experience of healing (the body's own redemption).

By shifting operations "away from where the arts customarily congregate," the un-artist, in becoming "an account executive, an ecologist, a stunt rider," could adopt "an attitude of deliberate playfulness toward all professionalizing activities well beyond art."[3] Thus, the un-artist is one who changes jobs. Slipping between and among various professional categories could be an adult way of playing. One senses here a deeper sort of itinerancy—perhaps freedom—guaranteed by the freedom to invent the rules, even to cheat. Kaprow theorizes this slippage between professions as "signal scrambling" in an age of increasingly programmed behavior, part of an ongoing process by which the arts proper would be "phased out" as "various forms of mixed media and assemblage" (light shows, sales displays, space-age installations, and so on) would overtake both "high brow art and mass media." Artists would position themselves between the arts, and art would become a "lowercase attribute," not a defining essence.[4] This assertion, that the un-artist would be a generalist, not a specialist, was the inverse of Clement Greenberg's position that each artistic medium is exclusive to itself and separate from the sphere of general culture. Kaprow's "most important short-range prediction," as he put it, was that "the actual, probably global, environment will engage us in an increasingly participational way," offering "former artists" new ways of participating in its processes, wherein they might discover new values, like copying and play.[5]

Kaprow's rhapsodic "paint, chairs, food, electric and neon lights, smoke, water, old socks, a dog" of the 1950s gave way twenty years later to such phrases as "the sky, the ocean floor, winter resorts, motels, the movements of cars, public services, and the communications media."[6] The images in Kaprow's writings were no longer rheumy and expressionistic, but technologically upgraded and scaled to global proportions. The "world" of the artist had expanded beyond "the vastness of Forty-second Street" into the realm of information systems, natural cycles, and social processes. In the "Un-Artist" essays, Kaprow describes a world that most artists would have agreed existed and would likely have probed with their works, but seldom (if ever) abandoned their art for. The big pictures he describes were mostly true, even prescient (that systems technology would dominate, that nonvitalist terms like "cybernetics," "responsive systems," and "field" would replace the old vitalist and mechanistic metaphors, that hardware would give way to software, that the arts would blend into forms of recreation and entertainment), but they were generally not the pictures most artists saw themselves in.[7]

Nonetheless, the idea of art dispersing into the physical and social worlds had tremendous resonance for artists in the early and mid-1970s. Tapping into the long-standing American tradition of tilling art back into life, this dispersal also recast artists in the roles of welders, heavy equipment operators, geologists, architects, research scientists, and the like. During the early 1970s the industrial materials and processes of 1960s Minimalism spilled out of the gallery door and into the remote regions of the American West, where they were used by artists to create earthwork sculptures and expanded fields for aesthetic perception and experience. Art seemed, in fact, to be dispersing into life—as physical phenomena, natural processes, celestial cycles, "cosmic happenings." The impulse among many artists was to extend and settle their works into the material environment beyond the gallery and its market infrastructure, an extension Kaprow saw as further evidence of art imitating life.

He wasn't wrong in his assertion that artists were un-arting. But they weren't doing it to be rid of art; rather, they were following the material, spatial, temporal, systemic, industrial, ecological, and social implications of their works into the world at large. Though art took new forms of life, the idea of art was extended, not abandoned. It became art as thought, art as body, art as counting, art as erosion, art as walking in circles. In this respect, Kaprow was wrong about the disappearance of art per se, but right about natural and cultural life fields becoming models and templates for artists. While few were willing to "unburden" themselves of art, many were interested in finding art in life.

tracts

In the weeks following *Publicity,* Kaprow began teaching the first course in Happenings at CalArts. As part of that course, he conducted an activity involving the construction and deconstruction of parallel cement footings on a hillside above the school's temporary campus in Burbank.

Called *Tracts,* the activity followed an orderly plan: participants, about a dozen students, were asked to construct wooden forms, pour a set of concrete footings, let them dry, break them into rubble, mix the rubble with fresh concrete to make a new set of footings while burying the leftover rubble in trenches, break up these footings, trench their rubble, and finally level the ground. But there was fine print. Besides forming and unforming the footings, participants were asked to lay out the footings of each set in parallel and to first increase (with the initial set) and then decrease (with the second set) the footings' size and separation by a factor of two as they went along. For example, the first footing of the first set might be three feet long and two thousand feet from the second footing, which would be six feet long and four thousand feet from the third, which would be twelve feet long and eight thousand feet from the next—and so on. If the first footing of the second set was six feet long and one thousand feet from the next, the second would be three feet long and five hundred feet from the third. Characteristically, Kaprow did not indicate how long or far apart the footings should be, nor when construction should stop and destruction begin. Could the footings *really* be sited eight thousand feet apart on a Burbank hillside? Conversely, how close together could two footings be laid, even if the mathematical paradox of infinite divisibility suggests that these "lines" of cement would never touch, since the space between them was to decrease only by half each time?

As an idea unfolding in the natural landscape, *Tracts* both expanded and contracted beyond human perception. As a physical undertaking, the result was somewhat different. Participants were asked to figure out just how big and far apart to make their footings, as well as how small and close together. As they did so, they ran up against other, unforeseen thresholds, like physical and psychological tolerances for pouring and pummeling cement, the weather, the demands of competing class schedules, how long it took the cement to dry, and the

PARTICIPANTS BUILDING FORMS AND MIXING CONCRETE (TOP) AND BREAKING UP A CONCRETE FOOTING (BOTTOM) DURING *TRACTS*, BURBANK, CALIFORNIA, 1970 (PHOTOGRAPHERS UNKNOWN)

feeling that a simple plan was spiraling toward absurdity and beyond anyone's interest in its completion.

The work took about a week. Students came and went. In the end, they didn't set the footings too far apart or too close together, nor make them too long or too short. It took longer for the cement to dry than anyone, even Kaprow, had imagined. Breaking the footings with sledgehammers was easier than it might have first seemed, probably because they weren't very well engineered to begin with. The chunks of broken cement were hand-loaded into wheelbarrows and carted through the trees and up the hill, where they became the already ruined foundation of the next footings. Kaprow hauled the cement mixer in his old truck as far up the hill as he could, until the workers finally decided that they had gone far enough.

The expanding and contracting cement footings echoed the boomtown residential development then taking place in the hills and valleys north of Los Angeles. Like that development, *Tracts* was a process with no end in sight. It was also a legitimate construction project, both in its own right as a physical enterprise and in relation to the busyness everywhere visible along the Burbank hillside, where the campus of Villa Cabrini, a turn-of-the-century Catholic school for girls named for its founder, Mother Cabrini, was being filled up with determined avant-garde activity. While the permanent CalArts campus was being built out in Valencia, some twenty miles north, Villa Cabrini was being outfitted for its role as a staging ground for contemporary art of every stripe. Thus Kaprow's cement footings didn't look that different from much of the renovation work then taking place all around the campus.

Tracts was not an epic work; it mostly went unnoticed. It was much different from *Publicity,* with its Hollywood scale, movie-set site, and faux Woodstock communality, and some of the students now shoveling dirt and pouring and pummeling cement footings may have been confused, if not disappointed. There was no public affirmation of one's "work" here, just some personal calibration

of when enough was enough, and that in light of their teacher's evident deliberateness about following the plan. Still, the students maintained a steely internal enthusiasm—or at least a dogged sense of duty—about getting the job done. If he was willing, so were they.

The activity was literally to build and bury itself; it was all process and no product. When the last chunks of rubble were trenched and the ground leveled, there was nothing left to show for all the work. And it was work. In fact, the length of the trenches had to be doubled to make enough room for all the concrete rubble. Having approached in reality neither its mathematical extension nor subdivision, the pulverized concrete shoveled into trenches was a simulated ruin and a mock testament to the collapse of rational plans in the face of concrete reality. It was activity *made* concrete, *as* concrete. Had there ever been a clearer metaphor for Kaprow's intentions?

Given the meaning of the word "tract"—a region, a territory, an expanse, or a treatise, a principled foundation, a statement of agreement—Kaprow's activity resonated with the fact that CalArts was attempting to establish for itself a physical and philosophical foundation. It also symbolized the process of getting a college education: lots of work took place, foundations were laid and abandoned, territory may even have been expanded, but there was little to show for the process—at least immediately.

Tracts sprang from Kaprow's fascination with systems theory.[8] In its aesthetic dimension, systems theory describes works of art as operating within and across various organic and inorganic systems such as neighborhoods, information networks, weather patterns, norms of social interaction, and so on. Kaprow had been allured by collapsing systems as by little else since the late 1960s, having first learned that systems can be designed to produce chance operations and unpredictable results in Cage's classroom. By allowing the "systems" in his work—symmetries, procedures, and routines—to go haywire when they encountered practical reality, Kaprow posited inefficiency as a positive value, a scientific (and

American) alternative to Surrealist automatism and Dadaist absurdity. To the post-Existentialist French and postwar Germans, works like *Tracts* were expressions of hopelessness, of dehumanizing social and industrial systems beyond redemption. To Kaprow, systems were redeemed by chance—which is to say, by the enactment of experience.

Tracts focused Kaprow's attention on the notion of inefficiency. For Americans, inefficiency is a name for unpredictability, and waste is its predictable result. Kaprow's curiosity about wasted time and effort might be seen as a critique of the Protestant work ethic, or at least of the capitalist adaptation of it to the production of goods and services. In a deeper sense, though, that ethic was already at play in Kaprow's work, since he saw work, no matter how monotonous, as redeeming experience. In effect, he had adopted the work ethic (sans its religious judgments) as a method. But Kaprow added this: that *work itself is redeemed by inefficiency*—by the unexpected contingency or unanticipated variable—and *can thus be a kind of creative waste*. Un-art. This embrace of inefficiency, but for Kaprow's workmanlike optimism, might be seen as un-American.

sweet wall

Kaprow's European works usually took place in the context of the art world. In Italy, Germany, France, and Spain he was most often sponsored by galleries, festivals, and museums, whereas in the United States he was primarily invited to universities and art schools. Because Happenings had signified generational and social change in America during the 1960s, whenever Kaprow went to Europe he was announced as the father of Happenings.

Moreover, his presence in Europe was cast in the energized light of Fluxus, whose members and activities George Maciunas had been promoting since 1962. Though most of the loosely knit members of Fluxus were Kaprow's friends, including Alison Knowles, La Monte Young,

KAPROW, CHARLOTTE MOORMAN, AND WOLF VOSTELL IN EUROPE, 1970 (PHOTOGRAPHER UNKNOWN)

Dick Higgins, Al Hansen, Jackson Mac Low, George Brecht, Yoko Ono, Nam June Paik, Charlotte Moorman, Robert Watts, Ay-O, Geoff Hendricks, and Robert Filliou, he and Maciunas disliked each other, a feeling stemming, it seems, from a struggle for leadership related to Kaprow's role in the early 1960s as the presumptive spokesman for Happenings and Maciunas's ambitious intention to incorporate all vanguard performative art into the theory and history of Fluxus. Indeed, in 1962 Kaprow had been listed by Maciunas as a Fluxist in Europe and had received from Maciunas an unbidden contract offering exclusive representation of his career. In a subsequent phone call, Kaprow, who claims to have thought Maciunas was joking, laughed off the offer, to Maciunas's lasting antipathy.[9]

Fluxus was not named as a movement until it was already an attitude among artists. For Kaprow, that attitude of playful indeterminacy emerged partly from Cage's class, as well as from concrete poetry. The early works of many soon-to-be Fluxists delighted Kaprow. Brecht's *Three Aqueous Events* (1961) and Ono's *Cut Piece* (1960) sug-

gested a reduction of the baroque indulgence that typified Kaprow's own post–*Eighteen Happenings* events of 1960. Kaprow admired this proto-Fluxus attitude of respect for idiosyncratic and laissez-fare behavior under the rubric of humoristic detachment. He even admired Maciunas's encouragement of a disregard for high art and an appreciation of the ambiguities and paradoxes of commonplace, unimportant things (like noises and unfinished meals). It wasn't always clear, however, that Maciunas's distaste for authority in the larger world found its way into his relationships with the artists whose works he championed—or, in Kaprow's case, whose works he had tried to champion. After Maciunas left New York for Europe and "put Fluxus together as a movement" in 1962, Kaprow thought that subsequent Fluxus performances—during the mid-1960s—leaned generally toward a burlesque idea of Happenings, and thus toward theater. Still, he felt a kinship with its practitioners and has often been thought of as an honorary member of Fluxus. Were it not for the ill feeling between him and Maciunas, Kaprow speculates that he might well have been thought of, at least in terms of his early works, as a member of Fluxus on its "neo-Baroque, fanciful and bombastic" fringe.[10] Overall, Fluxus was for Kaprow a stimulant and an object of much admiration, but not a generative influence.

Compared to the expressionistic, spectacular, political, shamanistic, and often abject performances then being staged by many of his European colleagues—Joseph Beuys, Wolf Vostell, and the Viennese Actionists, for example—Kaprow's workaday routines were pedestrian. The hopelessness, angst, and absurdity Europeans may have seen in Kaprow's inefficient routines, and thus their implicit critiques of modern society, were of little interest to him. More interesting were the methods by which chance might be invited into a set of social relations. Although he enacted roughly the same scenarios in Europe as in the United States, they took on particular cultural accents and inflections abroad. Kaprow felt that the American landscape was flatter and less emotionally inflected than that

of Europe, with its piazzas, gardens, courtyards, boulevards, cathedrals, and monuments. His European works were enacted against a more concentrated (and consecrated) background of history, national identity, and political necessity. The cultural and emotional stereotypes that were part of those backgrounds varied from place to place. Thus, Kaprow's works were experienced and talked about differently in Europe than they were in the United States, despite the fact that the routines were virtually the same.

In November 1970 Kaprow was invited to participate in *Happenings and Fluxus,* an exhibition at the Kölnischer Kunstverein in Cologne, for which he conducted a work called *Sawdust.* In a variation on the actions of *Tracts,* participants reserved time at a local carpentry shop, where they shaved a wooden beam, one saw-blade width at a time, into sawdust, which was then mixed with glue in a wheelbarrow and poured into a trough, where it hardened back into a beam; this beam was then exhibited in the *Happenings and Fluxus* show (along with a few other documents and relics and an iteration of *Yard* that Kaprow really didn't like). Kaprow saw his reconstituted beam as a symbolic bridge between the carpentry shop and the museum, giving the museum the object it needed—a kind of mock object, really—while giving participants the experience of shaving the wood and then reconstituting it.

The exhibition took place in the context of a lot of drunkenness and acrimony among artists who actually had much in common but whose egos turned the gathering into, as Kaprow recalls it, "a sea of misleading hostilities."[11] While there, he met the gallerist René Block, who invited him to come to Berlin. Charmed by Block's off-the-cuff invitation, Kaprow went to Berlin and did *Sweet Wall,* one of the works for which he is most well known.

Sweet Wall involved building, in an empty lot, a wall of cinder blocks about five feet high and one hundred feet long. The "mortar" between the cinder blocks was fresh bread and strawberry jam. Perhaps a dozen people, including Higgins, worked with Kaprow. They spent an afternoon building the wall, then, when it was completed, they pushed it over. Like *Tracts, Sweet Wall* was a process of building and destroying.

It was a drizzly, dreary day, and the site was located near the skeletal ruins of buildings that had been bombed during World War II. It was also within sight of the Berlin Wall. The political symbolism of constructing and knocking over a mock wall so close to the Cold War's most concrete expression of the Iron Curtain was, of course, evident to all. The Berlin Wall was not only the foremost political and architectural feature of the city, but also the psychic dividing line between the postwar East and West. Kaprow was fully aware of the political implications of his little wall, but he was more interested in the actual process of laying out, layering up, mortaring together, sighting, pushing over, and then cleaning up the concrete blocks, which, by then, were smeared with sticky jam and wadded with dirty, wet bread. The few minutes it took to push over the wall were memorialized in photographs that alluded to the wish of a divided nation, images that were nearly twenty years ahead of their time. The wall didn't fall at once, in a crescendo; it had to be coaxed down section by section—the bread and jam was pretty good mortar. The collapse was yawning and slow, with the concrete blocks hitting earthen base notes as they tumbled into the muddy lot. Despite its physical proximity to the Berlin Wall, its toppling was anticlimactic, at best.

Sweet Wall was seen by the art world as a political Happening, which contributed to a somewhat romanticized view of Kaprow's work in Europe. And why not? The Happening had the little wall, the big Wall, the bombed-out setting, the joke about sweetening the embittered barricade, the critique about using resources like food not for eating but for totalitarian mortar, and, ultimately, the image of the wall falling down. The police even showed up during its construction; they left after Block convinced them that the event was more art than politics.

There was another, underlying political discourse to the work that was entirely unpredicted, and this is what most interested Kaprow. It happened that an East Berliner had been killed the day before trying to cross the Spree River, and the authorities were dragging the river for his body near where Kaprow and his friends were working. Hence the preponderance of police in the area, wondering, perhaps, whether the impromptu little wall

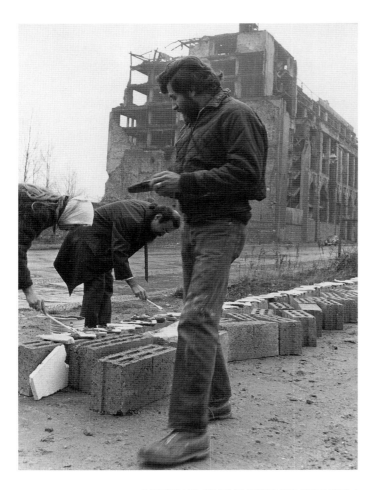

KAPROW AND OTHER PARTICIPANTS SPREADING A BREAD AND JAM "MORTAR" DURING *SWEET WALL*, WEST BERLIN, 1970 (PHOTO: ARCHIV GALERIE BLOCK)

with bread and jam pinched between its blocks was some kind of memorial. More poignant, Kaprow found out from a fellow worker that this was also the spot where Rosa Luxemburg, a major socialist figure of the 1920s, had been beaten and her body dumped. These kinds of historic echoes can filter into a working process just like unexpected technical problems or pleasant conversations with a stranger. They are not meanings per se, but they emerge meaningfully, like leaves gusting around an empty lot until someone notices. Lindbergh's airstrip, the Lone Ranger's movie set, Luxemburg's murder site—historical memory had faded at each place until someone working there had remembered—briefly, partially, perhaps incorrectly—before returning to work.

What Kaprow did have in mind while building and toppling his wall was the knowledge that everywhere in Europe there are lanes and streets where once there had been walls of stone. Fortifications since medieval times for this or that fiefdom, a few remained but most had been leveled by force or time. He also knew that perhaps the most famous toppled wall had surrounded Jericho and had been blasted to dust by Jewish trumpets. The irony of Kaprow, an ethnic Ukrainian Jew who looked the part, pushing down a wall in Berlin amid the still visible rubble of World War II was faint as he went about his labors, but present like the German drizzle. Other walls came to mind—those that had sealed in ghettos, those against which Jews had been shot, or those against which they still wailed—just thoughts that came and went as the wall was built and then toppled. Of this much Kaprow was certain: sooner or later, bitter or sweet, all walls come tumbling down.

scales

At 6:01 in the morning of February 9, 1971, the 6.6-magnitude Sylmar earthquake hit the northern half of Los Angeles, killing sixty-five people. Labyrinthine freeway exchanges collapsed like reeds into narrow canyons, the

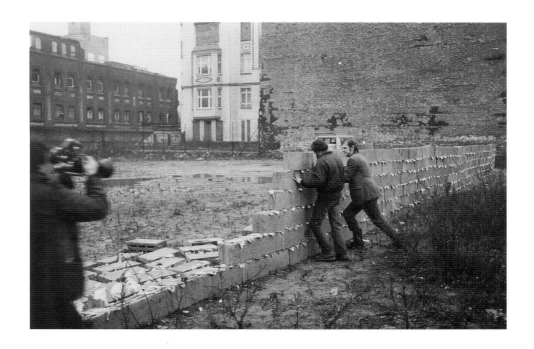

PUSHING DOWN THE WALL DURING *SWEET WALL*, 1970 (BOTH PHOTOS: ARCHIV GALERIE BLOCK)

earthen dam of a reservoir nearly broke above the San Fernando Valley, fleets of police motorcycles rolled through the streets like the advance guard of an occupying army, a veterans' hospital (where many were killed) fell in on itself, and the wings of a new, as-yet-unoccupied seven-story sanatorium (once considered as a temporary site for the CalArts dorms) fell outward, opening up like the petals of an awful flower. At the Villa Cabrini campus in Burbank, the old brick buildings were severely damaged, necessitating an early relocation of the students and faculty of CalArts out to the unfinished Valencia campus. For months thereafter, artists and construction workers commingled in a way that must have reminded Kaprow of his own work.

Today, CalArts sits like a modest manufacturing plant alongside the freeway in Santa Clarita, once called Valencia, a fully populated northern district of greater Los Angeles. In 1971 it seemed like an oversized, avant-garde squatter in an area that was otherwise mostly open, although everybody knew it was slated for development. The school was out of place, and its hilltop location underscored a certain monkish detachment from the kind of urban environment in which Modern art had traditionally flourished. Students looked down with impertinent disdain on encroaching middle-class suburbia, and from their backyard patios suburbanites undoubtedly looked back with suspicion and alarm.

On a hazy fall morning in 1971 a half dozen cars pulled up and parked outside the newly completed Valencia campus. The cars' occupants, each carrying a concrete block, got out and walked into the building, a self-consciously modern, eleven-acre, multilevel structure that looked as if it had been designed to reinforce the idea of a grand alliance and easy confluence among the arts. In fact, it was rather easy to get lost inside it.

After they'd entered the building, the interlopers—actually Kaprow, Vaughan Rachel, Tony Ramos, and about a dozen other CalArts graduate students—went to a particular stairwell and enacted the following plan:

placing cement blocks on steps on 1st floor stairway to form new steps going up
climbing them

carrying blocks to second floor stairway
repeating placements
climbing them

carrying blocks to third floor stairway
repeating placements
climbing them

carrying cement bocks to different 3rd floor stairway
placing them on steps going down
descending them

carrying blocks to different 2nd floor stairway
repeating placements
descending them

In other words, the participants were to ascend three flights of the same stairwell to an upper floor, then search for a different stairwell to go down one flight, and then search for a different stairwell again to go down another flight. In the middle of each flight was a landing, and the group elected to lay blocks only on one half of the full flight of stairs (on a zig, but not a zag), allowing them to fulfill the plan without overly exerting themselves. They worked out a system: On the three flights up, they carried the blocks to the beginning of each staircase, laid them up the steps one by one, returned to the bottom, then walked single file up the narrow block path to the top. They then cycled back down to pick up the blocks, beginning with the bottommost, until all had been carried to the next staircase. There they began again. On the flights down, they carried out the same process in the opposite direction.

The challenge was to do this without getting knotted up. After some initial confusion, participants began to follow each other in sequence, setting down, walking upon, and picking up their blocks in a repeating chain, which means it took three passes for the entire group to reach the next level. One student tried to cheat by waiting at

the top of the stairs to set down his block, but the group scolded him, calling him to the bottom to climb back up and unburden himself; they wanted him to do as much work as they were doing. Finding stairways down meant wandering through the halls with the blocks until the right route could be determined. The group was relatively unfamiliar with the interior of the newly completed building, so it took some effort to conceptualize their location within its labyrinthine corridors, walls, and stairwells. For the students, it mirrored the larger task of finding one's way through the school's bureaucracy and interdisciplinary philosophy.

Cage would have hated and loved *Scales*. Each time a block was set on a step, it was slid into place against the wall, and the halls echoed with the sounds of grinding, scraping, crunching, striking, and thumping. As Kaprow's class rotated up and down the stairs, the sounds became almost percussive. Kaprow was playing the materials and spaces of the building like a brand-new instrument. In a deceptively orderly manner, he and his band of players "practiced," ascending and descending the stairs as if playing scales. They were also, of course, "scaling" the stairs, imitating the building of the building, and parading through Disney's new dream school in a little avant-garde game of follow-the-leader. On their way down, one could imagine, too, in the succession of quick-stepping bodies, the unfolding accordion geometry of Marcel Duchamp's descending figure in *Nude Descending a Staircase (No. 2)* (1912).

Scales was a seismic work, a processional Richter scale coursing its way high and low between the floors and along the corridors of the art school. The earthquake had rudely interrupted the utopian self-absorption of CalArts, which was now ensconced in its new suburban dream factory. It took years to settle in at the Valencia campus and to subvert the expectations of the grand aesthetic that had been built into its interlocking design. Social stratification, ideological stress fractures, pedagogical fault lines, departmental ruptures—all were rumbling be-

WALKING ON AND CARRYING CINDER BLOCK STEPS IN THE STAIRWELL IN *SCALES*, 1971 (PHOTO FROM VIDEO: JEFF KELLEY)

neath the surface. Such were the tensions of throwing the arts together. It took ten years of aftershocks to shake off Walt's dream. Kaprow's little—and little-noticed—parade was among the very first tremors.

easy

In February of 1972 Kaprow and his class enacted the following plan:

(dry stream bed)
wetting a stone
carrying it downstream until dry
dropping it

choosing another stone there
wetting it
carrying it upstream until dry
dropping it

Called *Easy,* the piece was designed for the gullies and streambeds of a large tract of undeveloped land across the parkway from CalArts. The text was simple and the materials—stones and wetness—were at hand. As with *Tracts* and *Scales,* students were asked to carry something, but instead of bags of cement, concrete rubble, or cinder blocks, they were asked to moisten and carry a stone of their choice until it dried. The carrying was neither a burden nor a group activity, but the private passage of the bearer. It was a little walkabout, like a personal wandering in the desert.

By this point in Kaprow's career, one of the conventions of his works was to parallel the dominant art movements of the day, but just out of range, like an Indian shadowing a wagon train. He had done this with Action Painting, Pop, and Minimalism, and now he did it with earthworks. Whether trenches, mounds, tunnels, or jetties, earthworks were usually situated in the remote regions of the American West. They were animated by the natural processes of erosion, decay, and the rotation of Earth on its axis. They were also extensions into the landscape of the industrial impulses of Minimalism, so that tools like earthmovers, dynamite, and small planes became commonplace among the artists working in the deserts of Nevada, California, and Utah.

Kaprow admired Michael Heizer and Robert Smithson, who aligned their practices with natural systems, cycles, and materials beyond the art world. Still, he felt that as objects (if that's what they were), earthworks were too like sculpture, and as productions, too like Happenings. For the largest earthworks—like Heizer's *Double Negative* (1969) and Smithson's *Spiral Jetty* (1970)—tons of earthen material were moved by brute industrial means. In *Displaced, Replaced Mass* (1969), Heizer lifted three granite boulders from a peak near Lake Tahoe and, using cranes and flatbed trucks, transported them to waiting cryptlike depressions in a dry lakebed near Silver Springs, Nevada, some fifty miles away. The boulders would have ended up there in a few million years anyway; the artist was just speeding up the natural process. Kaprow, aware of such ecoindustrial theater, composed a short walk in a streambed with two stones.

Easy was easy to do. The class just crossed the road and did it. No real logistics were involved. It didn't cost anything. It was probably the least "produced" of Kaprow's events. In the past, Kaprow had invited people to do something without telling them how to do it, but he had usually supplied the tools and materials: the ice blocks, concrete blocks, shovels, tar-paper rolls, used furniture, sledgehammers. Here, he supplied only the text and suggested a tract of land upon which to carry out the plan, letting his students choose their stones, how to wet them, where to drop them, where upstream and downstream were located, and so forth. In fact, most of the choices were theirs. For the first time in his career, almost all the decisions were left to others. He simply offered an idea of something to do, an offering nearly Brechtian in its elegance and detachment. But he wanted to see it done, because, as a researcher, he wanted to see how his students would attach meaning to their choices.

A STREAMBED NEAR THE CALARTS CAMPUS IN VALENCIA, SITE OF *EASY*, 1972 (PHOTO: BEE OTTINGER)

The students gathered near an upstream gully and began selecting stones. The choices immediately became matters of personal significance; the "right" stone had to be located, one with which the carrier felt some connection. It had to be the right size, the right shape, the right color, and have the right surface—a magic stone, an art stone, a happening stone. The next question was how to moisten the stones, and since the streambed was dry, novel solutions were advanced, each involving the body as a source for wetness. Some students put the stones in their mouths, the most obvious solution. Others held them in armpits or groins, upping the ante, as it were, on

the psychology of wetness. And Kaprow remembers several students even peeing on their stones. Sweat, saliva, urine—body fluids all. Wet stones in hand, individuals began meandering downstream, waiting for the moisture to evaporate.

How long does it take for a damp stone to dry? How long in time? How long in distance? Does it take longer for saliva to evaporate, or urine? Does a stone in an open palm dry faster? Does holding a stone in a sweaty palm prolong the drying process—especially while walking upstream? Each student discovered different measures of time, distance, and evaporation—one thinks here of Duchamp and his *Three Standard Stoppages* (1913). When a given stone dried, its carrier stopped in place and dropped it on the ground, but not always immediately. By the time they had been carried downstream, the stones had become precious; they were the very reason for the journey. Tossing them was difficult. The stones were signifiers of emotional attachment, so maybe they did mean something after all: they meant meaning. Giving them up meant giving up meaning, and tossing them away was difficult.

Giving up the stones was also an acknowledgment that they were once again dry. The wetness of the body, so charged with romance, repression, and release, had evaporated. Smithson, writing about the "mental weather" of the artist, had shifted the then-common comparison between "hot" and "cool" art to one between wet and dry. He associated wetness with the "dank brain" of the romanticist, preferring the desert, which was less "nature" than a concept: "When the artist goes to the desert, he enriches his absence and burns off the water on his brain."[12] In this sense, when the stones dried, the students lost their mystical connection to them. They turned from amulets to, well, stones.

The task of finding a second one was suddenly less innocent. The first stone had been intuitively chosen; there had been no prior stone to compare it against. It was personal because it was the first. The second stone, by contrast, had an impossible burden: it had to be as good as the first, but since the choice was really a tradeoff in which the first stone had to be discarded, it couldn't be: its selection was tainted by comparisons with a tragic ideal. Once you move forward, you *can* come back, but you can *never* come back to the beginning. The perfect choice can be made only once, the first time, before you know it's the only time; all subsequent choices are made in its wake, and they are made over and over again in light of the original, which casts a shadow on all subsequent choices, unless we can truly let go of the first one, which we try to do by earnestly making a second choice—and a third, a fourth, a fifth. We seek the ideal but repeat the trauma of separation. Zen, in this instance, would mean to separate value from the choice, to pick not *the* stone, but any stone *as if for the first time*—so that it would mean nothing in itself, but might carry you along in the present moment for the time it takes saliva to evaporate walking up a dry streambed on a sunny day.

Easy was a parable about attachment to one's burdens and about the different kinds of weight—sentimental, physical, existential, tragic—burdens can have. It was also a tiny earthwork, a gentle two-stone parody of the industrial scale of much contemporary outdoor sculpture. At the time, with the first phase of the ecology movement in full swing, many earthwork sculptures were criticized as callous interventions in the natural landscape. Yet, however monumental they may have seemed on the covers of art magazines, they remain little more than artists' scratchings on the land. Smithson called the landscape a concept that swallows up boundaries,[13] and Kaprow knew the hills and gullies near CalArts were too vast to be contained by experience—a set of indeterminate coordinates in a wandering internal topography of time and distance. In principle, the landscape is a place we can never get to or get away from. In practice, we can only be in it, but sometimes, if we pay attention—when we put stones in our mouths and our saliva evaporates as we meander downstream—it can also be in us.

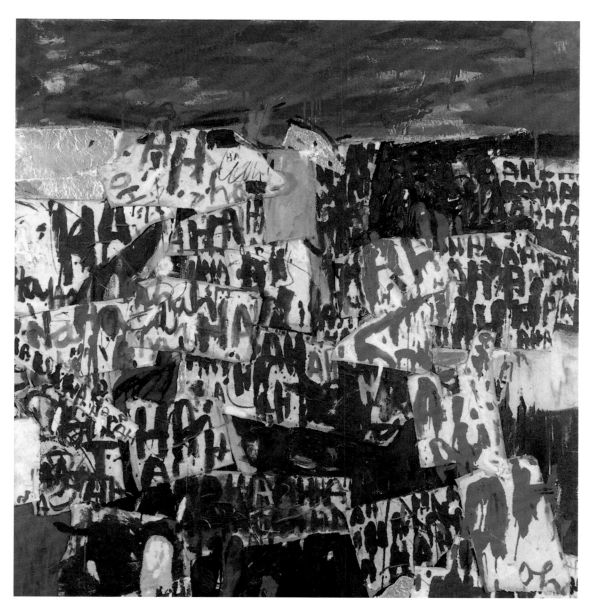

PLATE 1. *HYSTERIA*, 1956, PRIVATE COLLECTION
(PHOTO: GEORGE HURYCH)

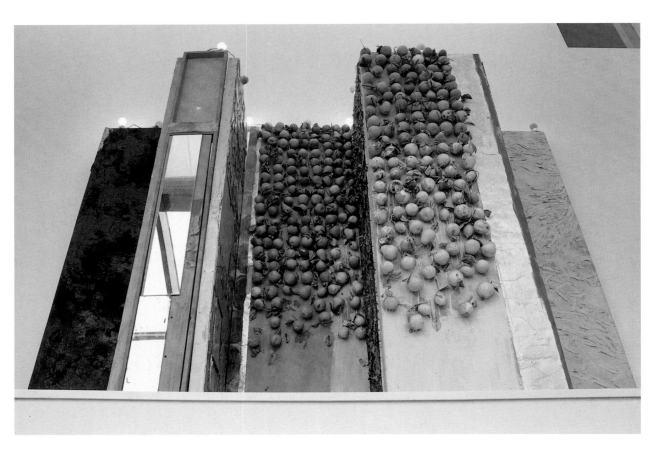

PLATE 2. *REARRANGEABLE PANELS,* 1957–58,
PRIVATE COLLECTION (PHOTO: MARC SOURBRON)

PLATE 3. *YARD*, 1961, OVERHEAD VIEW, BACKYARD SCULPTURE GARDEN,
MARTHA JACKSON GALLERY, NEW YORK (PHOTO: KEN HEYMAN)

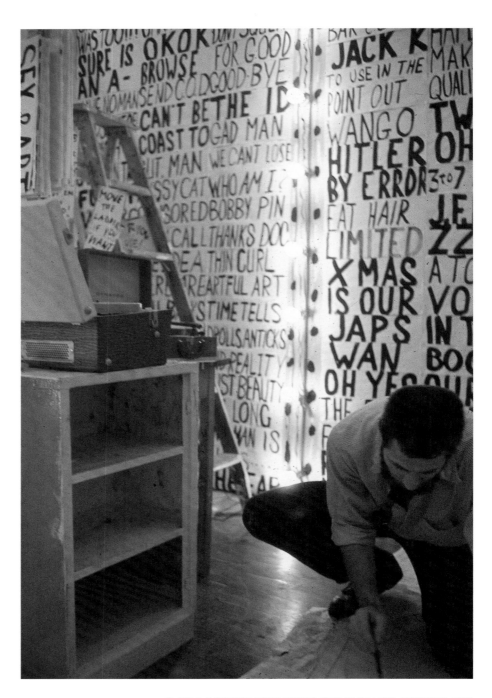

PLATE 4. KAPROW MAKING *WORDS*, SMOLIN GALLERY, NEW YORK, 1962
(PHOTO BY ROBERT R. McELROY, © ROBERT R. McELROY/LICENSED BY VAGA, NEW YORK, NY)

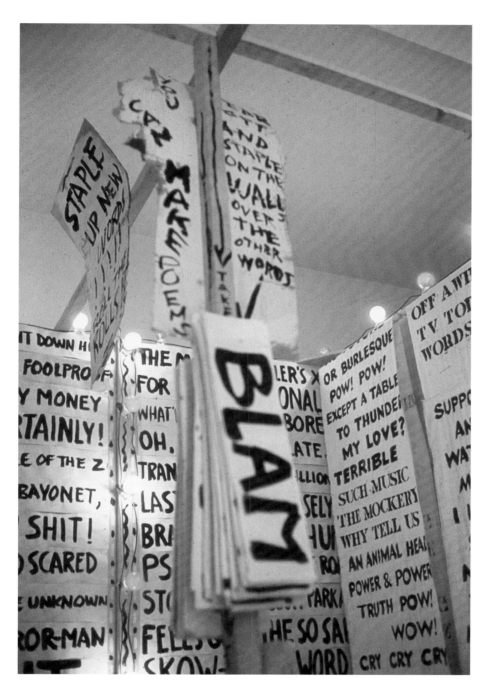

PLATE 5. COLORED LIGHTBULBS IN *WORDS*, 1962
(PHOTO BY ROBERT R. McELROY, © ROBERT R. McELROY/LICENSED BY VAGA, NEW YORK, NY)

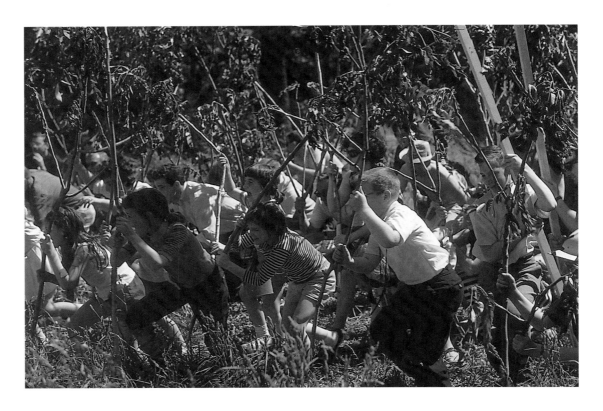

PLATES 6 AND 7. TREE PEOPLE WAITING TO ATTACK (ABOVE) AND
KAPROW STRIKES A WOOD POLE (RIGHT), *TREE*, GEORGE SEGAL'S
FARM, NEW BRUNSWICK, NEW JERSEY, 1963 (PHOTOS BY ROBERT R.
McELROY, © ROBERT R. McELROY/LICENSED BY VAGA, NEW YORK, NY)

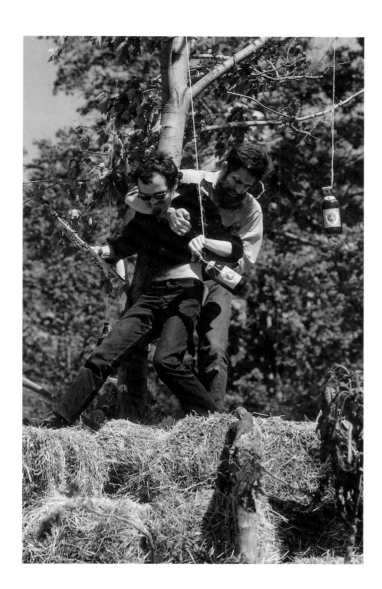

PLATES 8 AND 9. KAPROW STRUGGLES WITH LAMONTE
YOUNG (LEFT) AND KAPROW PLAYING DEAD (BELOW),
TREE, 1963 (PHOTOS BY ROBERT R. McELROY,
© ROBERT R. McELROY/LICENSED BY VAGA, NEW YORK, NY)

PLATE 10. KAPROW WITH BLOCK, *RUNNER,* ST. LOUIS, 1968
(PHOTO: JOHN MILLAIRE)

PLATE 11. PARTICIPANTS LAYING TAR PAPER AND BLOCKS, *RUNNER,* 1968
(PHOTO: JOHN MILLAIRE)

PLATES 12 AND 13. GETTING BARRELS FROM DUMP
(ABOVE) AND SPRAY-PAINTING BARRELS RED
(RIGHT), *TRANSFER,* MIDDLETOWN, CONNECTICUT,
1968 (PHOTOS: ANDY GLANTZ)

PLATE 14. TRIUMPHAL POSE ON STACKED BARRELS
IN PARKING LOT, *TRANSFER,* 1968 (PHOTO: ANDY GLANTZ)

PLATE 15. CLASSROOM ENVIRONMENT AT
UNIVERSITY OF CALIFORNIA, SAN DIEGO (WITH ARTIST
HUNG LIU ON LEFT), 1985 (PHOTO: JEFF KELLEY)

PLATE 16. REINVENTED *BEAUTY PARLOR*,
MILAN, 1991 (PHOTO: JEFF KELLEY)

PLATE 17. OVERVIEW OF PAINTED FLOOR, HANGING PLASTIC,
AND SILK WALLS, *BEAUTY PARLOR,* 1991 (PHOTO: JEFF KELLEY)

PLATE 18. REINVENTED *APPLE SHRINE*,
MILAN, 1991 (PHOTO: JEFF KELLEY)

PLATE 19. FIAT ON BLOCKS SURROUNDED BY ROWS OF NEW TIRES,
YARD, MILAN, 1991 (PHOTO: JEFF KELLEY)

PLATE 20. KAPROW IN *REARRANGEABLE PANELS*
IN PARIS, 1994 (PHOTO: JEFF KELLEY)

baggage

If *Easy* was about attachment to one's burdens, *Baggage* was about getting rid of them. In April 1972 Kaprow went to Rice University in Houston, where he and a group of perhaps twenty students enacted the following plan:

driving to airport
with suitcases of packaged sand
(tagged with owner's name)

loading them
on airport underground train
waiting
until train returns
removing suitcases
stacking them together

taking them at random
driving to shore
there emptying sand
refilling suitcases with beach sand
driving them to city United Parcel Service
for delivery to owners

Easy had been easy. *Baggage* was a simple plan that depended on existing transportation systems for its enactment. Participants bought old bags, briefcases, and suitcases from a thrift store, stuffed them with plastic bags filled with sand from a campus construction site, drove them to the Houston airport, and sent them on an unsupervised trip on the underground railway that connected the airport's terminals. The participants then reclaimed the bags, briefcases, and suitcases, loaded them back into their cars, and drove them to the Galveston shore. There, they emptied the bags, briefcases, and suitcases on the beach, filled them with dirty beach sand, and drove them back to Houston, where they mailed them home from the United Parcel Service center.

Each step along the way—by foot, car, airport rail, and ground carrier—Kaprow's group encountered different degrees of resistance: some of the suitcases were heavier than others; negotiating airport and downtown traffic

was the usual pain; airport police were mildly alarmed by the spectacle of long-haired young people loading bags onto trains and then not getting on board with them (a scenario unimaginable today). UPS initially refused to mail the baggage because it was full of sand; it relented when Kaprow agreed to package each bag in a cardboard box, to make it look more like the kind of containers that UPS normally shipped. Kaprow was amused that UPS, a distribution system that shouldn't care what it was shipping as long as it didn't break the law, balked at shipping the extra-heavy suitcases of a band of college students because they and their baggage looked suspicious. The UPS agents did not believe the contents were sand (why would anyone want to ship sand?), and thought the students were lying to cover up some nefarious undertaking. The keepers of a system, no matter how presumably neutral the system may be, will always intervene if they feel the system is not being used for its intended, if unstated, purpose. In the end, the boxes were shipped to parents across the country, who probably wondered why their children had sent them boxes containing suitcases full of sand.

With *Baggage,* the psychological burden of the stones in *Easy* was literalized as physical deadweight. The agreeable streambed meander became a confrontation with an urban-transportation labyrinth and its attendant bureaucracies. Perhaps this scaling-up of the weights, measures, and methods of transport—of turning palm-sized stones into briefcases, bags, and suitcases full of sand—reflected Kaprow's sense of the weighty expectations of such sponsors as Rice University when commissioning a Happening. He thus made *Easy* harder as a way of meeting those expectations without reverting to an actual Happening.

But the meaning of the piece was less about carrying one's burdens through life than about trying to unload them, only to have them return. Like a merry-go-round, the airport-terminal railway and participants mailing packages to themselves were closed loops: participants could leave their bags on the train, but they came back

GATHERING SAND FROM A CONSTRUCTION SITE (TOP LEFT), WAITING FOR AN
AIRPORT TRAIN (LEFT), AND DUMPING SAND ON THE BEACH IN GALVESTON
(ABOVE) DURING *BAGGAGE*, HOUSTON, 1972 (TOP LEFT PHOTO:
BOB COVINGTON; LEFT AND ABOVE PHOTOS: JIM CALDWELL)

to the platform; they could mail their bags to their parents' house, but they'd catch up with them when summer rolled around.

Another cycle operated on a scale larger than that of mass transit, though, and that was the ocean tides. By the time Kaprow and his group reached the Galveston shore, the sky was dark and the moon was out. They stopped by a grocery store for food and a department store for supplies before camping on the beach, where they roasted chicken over an open fire and talked about life, Happenings, and packages of sand. This campfire communalism was probably what some of the students expected from a Happening. When dawn broke, they began returning their sand to the sea in various ritualized and romantic ways. Some chanted mantras while scattering sand on the dunes, some poured clean, dry construction sand on the dirty, wet beach, waiting for the waves to wash over it and pull it out to sea, and a few dug little hollows into which they poured their sand, privately but ceremoniously, as if burying a pet.

Kaprow was playing scales again: orbits on foot, by car, in trains, via carrier—and now, at the edge of the earth, out to sea. And there, where rocks are pounded into silica granules over millennia, Kaprow understood his bags of sand to be more than physical density. They were the residue of time, invested with a human sense of timelessness, or time beyond comprehension. Everyone knew that emptying and scooping up sand from the beach was

KAPROW (CENTER) AND OTHERS MAILING BOXES OF SAND AT UPS DURING *BAGGAGE*, 1972 (PHOTOGRAPHER UNKNOWN)

an infinitesimal act, a kind of minuscule, private offering at the edge of an infinite expanse.

The moon, which became enveloped in fog shortly after Kaprow's group reached the shore, had an imaginative hold on the proceedings. It produced the timeless tidal cycles that the group was imitating when they returned sand to the sea (before stealing a little back). But something even bigger was going on that night. Coincident with the two-day activity was the *Apollo 16* manned mission to the moon. Between April 16 and 27, 1972, three American astronauts made the journey heavenward and back as the nation watched on television. In fact, images of lunar surface excursions, with silver-suited men bounding across the moon's fine gray powder (lunar sand), had flickered like a campfire on a row of television monitors in the department store where the group had earlier purchased camping supplies for the beach. At that very moment, there were men on the moon— actually up there, walking on it. Their orbit traced the farthest human extension into space, and their story, like the story of Happenings, could be gathered up only as images or conversation or gossip. Like the students camping on the Galveston beach, the men on the moon were scooping up sand to take back to Houston.

burbank

In September 1972 Kaprow and his students did a piece that was dedicated to Luther Burbank's experiments with the grafting and cross-fertilization of plants, enacting the following plan on the CalArts campus:

leafless branch fixed to leafy branch
leafy branch fixed to one without
pix of leafless branch fixed to leafy branch
pix of leafy branch fixed to one without
plastic leaves fixed to leafy branch
plastic leaves fixed to one without
leafy branch fixed to leafy branch
leafless branch fixed to one without

As enacted, this nearly poetical text, with the word "fixed" running down its center like a spine, describes a process in which living and dead branches, plastic leaves, and Polaroid photographs were taped or pinned together in the easy-to-reach branches of young trees newly planted around the CalArts campus.

Burbank was an homage to mutation—unplanned changes in nature. By grafting different species, organic and inorganic things, and images onto living trees, Kaprow and his students enacted a process that produced a mutant strain. In *Baggage,* Kaprow had intervened in an existing transportation system. Here, he dutifully maintained an existing transplantation culture—a metaphor of Southern California, no doubt, where, it is said, everything's a hybrid and everyone's a transplant.

More interesting to Kaprow, though, was the question of what was real. Were the plastic leaves less real than the leafy branches to which they were fixed? Were the photographs not real things too? Was a dying branch cut from another species of tree less real than the live branch to which it was taped? Is something growing real in a way that something withering is not? What *was* a Polaroid image of a plastic leaf taped to a leafless branch, anyway? In a sense, such questions were themselves mutations, philosophical outgrowths of the many acts of "grafting" that composed this work. All equally unanswerable, they constituted a parody of the utopian strain of science that seeks to improve life by breeding out its imperfections. Kaprow was interested in the screw-ups, so he designed a system that was as elaborate as iambic pentameter to optimize them.

meteorology

A week or so after sprucing up the trees on the CalArts campus, Kaprow arrived in Düsseldorf, where he had been invited by Inge Baecker, of Galerie Baecker in nearby Bochum, to enact a work.[14] He selected the banks of the

Rhine River, which separates Düsseldorf from Cologne, as the site for his event. The weather was predictably dreary, and Kaprow decided to respond to the rainy conditions. The following plan was enacted on September 13, 1972, with perhaps a dozen people:

sheets of plastic suspended against the rain
people dry beneath them

moving slowly, quietly down to bay
gathered water poured into bay

(places exchanged: dry people suspending sheets, wet people below)

moving slowly, quietly upslope
when above, gathered water poured on ground
to return to bay

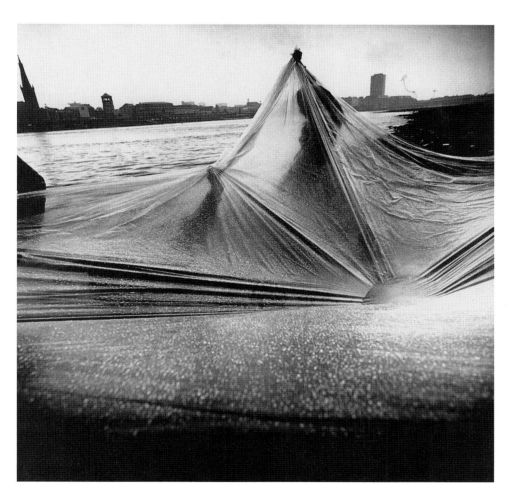

CARRYING WATER DOWN TO THE RHINE RIVER IN *METEOROLOGY*, DÜSSELDORF, 1972 (PHOTOGRAPHER UNKNOWN; COURTESY GETTY RESEARCH INSTITUTE)

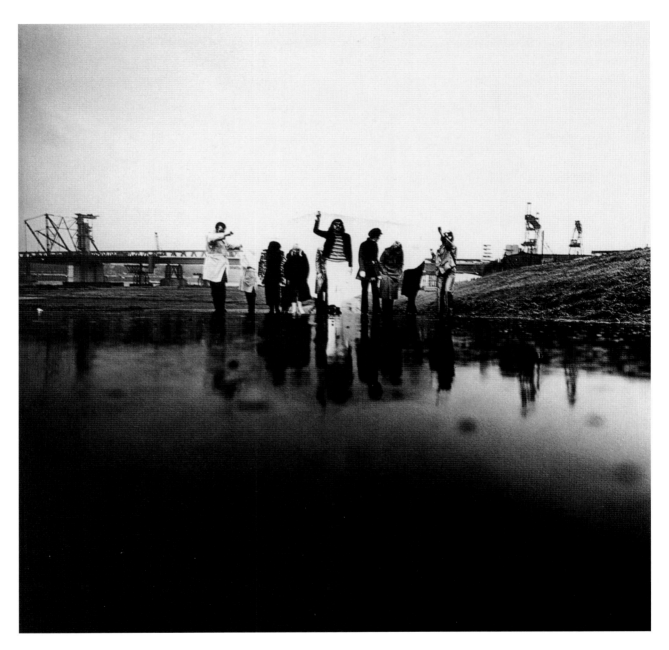

CARRYING WATER UP FROM THE RHINE RIVER IN *METEOROLOGY*, 1972
(PHOTOGRAPHER UNKNOWN; COURTESY GETTY RESEARCH INSTITUTE)

In this work, Kaprow imitated in an unscientific way how rain is collected and measured by meteorologists. Half of the participants held aloft a large plastic sheet, under which the other half crouched; as they moved slowly toward the river, water collected on top of the sheet, and this was dumped into the river on their arrival there. On the return trip, the participants changed places and the process repeated, only this time the collected water was dumped on the ground. Rainwater was carried to and from the Rhine in equal measure. On both trips, those holding the sheet got wet and the people crouching beneath stayed dry; by the end, everybody was wet. The plastic sheet collected water and the people absorbed it.

On the surface, *Meteorology* seems like another of Kaprow's even trades: water was carried down and up the slope, people changed wet and dry places, and so forth. But the text is unusually suggestive, employing modifiers like "slowly" and "quietly" to indicate not only what needs doing, but also the manner in which to do it. Action that is slowed and quieted becomes internal and contemplative, and asking a group of Germans to move in this way down to the river (Kaprow called it the "bay") invoked a mystical stillness. In 1972 the Rhine, which flowed out of the Eastern Bloc, was highly polluted, and Düsseldorf, like the other big cities of Germany, was still marred by crumbled buildings and empty lots from the bombings of World War II, even as the architecture of commerce and industry sprouted among them. It was a ruined landscape in transition: the perfect setting for the enactment of clichés about German soulfulness.

The transition from the devastation of war to the renewal of industry was fraught with new forms of aesthetic and ecological ruin; the cranes and bridges looked like seedy Gothic skeletons, and the water was fetid and malodorous. In this postapocalyptic setting, the act of carrying accumulated rainwater to the river could be seen as a symbolic purification, a West German redemption of an East German sewer. Perhaps, however, it was simply the addition of more acid rain to the brew. If so, pouring rainwater into the Rhine was a truly useless undertaking.

Uselessness wasn't just parody for Kaprow. It emerged from his intention to carry out a plan that, with its symmetries and permutations, added up to nothing. It was paradox. In California, uselessness might be considered a marker of personal freedom—that is, liberation from the obligation to produce useful things. In Germany, however, uselessness was akin to hopelessness. This was the Rhine of ancient legend, not some nameless dry gully. In the photographs of that day, the event is framed almost as a proto-Green political action set against a moody river and a brooding sky. The figures are shown standing on their own inverted reflections on the wet sidewalk, as if walking on water, asking the viewer to see them as the saviors of nature or the children of the new Germany. Elsewhere, they are seen moving to and fro beneath the billowing plastic sheet like anti-industrial mimes in an anarchistic carnival tent.[15]

The photographs of *Meteorology* illustrate how an otherwise deadpan event can be shaped and represented according to the subliminal expectations of the photographer, who, in this case, anticipated an absurdist revelry with Marxist accents set in a romantic landscape of industrial ruins along a mythic river. At the same time, Kaprow all but invited a romantic reading of the work by tapping into clichés of German soulfulness. Like the myths that were pressed into service during the 1960s, cultural clichés were commonplace compositional devices that were quickly exhausted in their enactment. In Europe, Kaprow often used them as starting points. He wanted to find out how people actually behaved in a given scenario, but sometimes the clichés just enacted themselves.

chapter ten # the education
of the un-artist, III

As far back as 1970, Kaprow had become aware of a distinction in his work between formal, commissioned events on the one hand and off-the-cuff, almost throwaway pieces on the other. Ever since, he had been oscillating back and forth between invitations from others to produce major works of art and his own increasingly frequent inclination to toss off responses to the moment.[1] By the early 1970s Kaprow understood that the throwaway impulse in his work, mistaken by some of his sponsors as the result of unpreparedness or professional irresponsibility, was perhaps the key to its engagement with ordinary life. Expediency, having to figure out what to do on the spot (or close to it), was becoming part of his creative process, much as it had when he'd pasted scraps of cardboard and old telephone messages—whatever was at hand—to his canvases in the mid-1950s. Expediency opened the works to different constituents than the audiences of the professional avant-garde: students and personal friends in particular. Consequently, the works of the 1970s were increasingly scaled to the situations and occasions in which students and friends might be encountered: class projects, workshops, travel, weddings. Throughout the 1960s Kaprow had never had the chance to think through the question of expediency. Now, no longer feeling the need to create major works of avant-garde performance, he was able to just show up and do whatever he did.

One of the legacies of the Modernist avant-garde was the idea that art is better than life, or at least that life is redeemed by art. Since the early 1950s Kaprow's goal had been the creation of a totally new art; by being "the most modern artist,"[2] he would help illuminate modern life—if only his own. Now, in the 1970s, he was questioning his avant-garde heritage; having succeeded in creating a to-

tally new art, and having been recognized for doing so throughout the interested modern world, he found himself wondering whether it was really true. Had he in fact created a new art, and, if so, what light had it shed on living? What had he learned? Who had he become? Was he just another expert—a specialist—in a field he'd helped invent? Was his art in fact the focus of a better life (as art was supposed be), or merely another delusion?

Kaprow's entreaty, in his "Un-Artist" essays, to drop out of art was not just antiprofessional rhetoric; it necessitated an honest effort on his part to try to do so. Colleagues at CalArts sometimes challenged this oft-stated goal, especially since it was patently obvious that he remained gainfully employed, both as a professor and as a commissioned artist. Paul Brach likened Kaprow to a union member who keeps misplacing his union card (more or less on purpose), only to have a colleague or earnest apprentice scurry up behind him, card in hand, and say, "Mr. Kaprow, you forgot this."[3] Some felt that if Kaprow really wanted to drop out of the art world, he should stop accepting commissions from its galleries and institutions.

Perhaps the most important insight in this regard involved a shift in thinking: Kaprow began to see friendship as the social context in which the work might unfold. Among other things, this meant that, instead of being sponsored by a patron to create a work for participants, Kaprow would bear the expense of producing the work himself, among friends, or, if the event were sponsored, he would identify the social and psychological scales at which friendship became the operative value. Friends aren't just people one knows already, but people one *gets to know* through interaction or exchange. Kaprow's point wasn't to restrict his work to his friends, but to manifest the boundaries of friendship within a structured activity— even among strangers—thereby bringing the sponsor into compliance, as it were, with his desire to work on a more intimate scale—a scale closer to the goings-on of personal contact than to the machinations of professional art.

Thus, a search for the scales of intimacy characterized Kaprow's works of the 1970s. Since no art-world blueprint existed for the kinds of lifelike scenarios approaching those scales, he turned, as he often had in the 1960s, to studies in sociology and anthropology. Kaprow continued to read Erving Goffman, but he was especially interested in the writings of sociologist Ray Birdwhistell, who explored the way body movements carry precise meanings within specific social groups, functioning as a kind of language that helps illustrate, clarify, intensify, regulate, and control the back-and-forth nature of conversation. Much as he had been impressed by Paul Taylor's mechanical dance movements in the late 1950s, Kaprow was now taken by the way Birdwhistell systematically analyzed body language by filming, say, two people standing and talking, playing the film back at slow speed, and then scrutinizing the subtle, nonverbal, and usually unconscious negotiation of physical space between them.

Besides being generally attracted to the formality of Birdwhistell's studies, Kaprow took from them the idea that small behaviors are much more revealing than big ones (perhaps it's not war we should be studying, but how many times we blink when talking to the boss). He was also interested in the way body language might complicate and contradict what people say to one another, and out of this interest an awkward kind of misdirected encounter (especially between women and men) emerged as a leitmotif of the scenarios of the mid- to late 1970s.

Increasingly, Kaprow took the structuring of his activities, whether for friends or for patrons, from the sociological theater he saw in the world around him. In these all-too-human exchanges, which became the lifelike subjects of his art, he sensed a carnival of latent comedy, intimacy, exchange, trust, betrayal, and friendship. And by their nature, they were scaled to the sociopsychological parameters of small groups, like students in a graduate seminar, a married couple, a half-dozen friends, participants in a workshop, or a few professional colleagues

who happened to be in Berlin at the same time. Which is to say, Kaprow sought friendship wherever he could find it.

highs

In February 1973 Kaprow went to the University of Kansas in Lawrence, where he enacted the following plan with a group of twenty or so art students:

A.
moving a thermometer very slowly to a light bulb
until the temperature is highest
moving it slowly to a warmer bulb
and so on

B.
moving a light bulb very slowly
until a cast shadow of a light bulb is clearest
moving a brighter bulb similarly
and so on

C.
being guided very slowly to a light bulb, eyes covered
until the heat on the eyes is greatest
being guided slowly to a warmer bulb
and so on

D.
brightening the daylight with a light bulb
adding a brighter bulb
and so on
until the day is brightest
until the day is least bright
until the light is brightest

With this four-part work, called *Highs,* Kaprow contrived a homespun system of standardized measurement involving a row of eight hanging lightbulbs, ranging from fifteen to three hundred watts, and a thermometer to measure their heat. Against these measures, he contrasted the subjective experiences of the students as they felt the radiating heat of the lightbulbs on their faces or

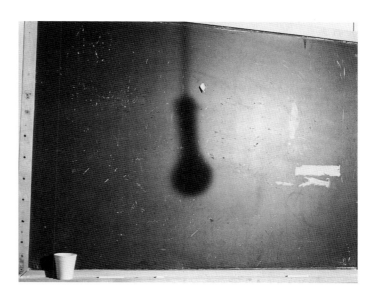

CASTING A CLEAR SHADOW OF A LIGHTBULB (TOP) AND BEING GUIDED TOWARD A LIGHTBULB TO FEEL ITS HEAT (BOTTOM) DURING *HIGHS,* UNIVERSITY OF KANSAS, LAWRENCE, 1973 (PHOTOGRAPHERS UNKNOWN)

watched for the shadow of a lightbulb on the wall. Out of this contrast emerged an imprecise field of action, in which a phalanx of maximum standards—the highest, the clearest, the greatest, the brightest—dissolved into waves of individual and subjective determinations that were themselves cast in doubt. Is the heat on my eyes really the greatest right here? Is the shadow the clearest now? When is the day brightest?

As a system, *Highs* promised more than it could deliver. Students reported that "the only high in the whole thing"

BRIGHTENING THE DAYLIGHT WITH A LIGHTBULB DURING *HIGHS*, 1973 (PHOTOGRAPHER UNKNOWN)

was the act of leading one another, eyes closed, from lightbulb to lightbulb.[4] Since the increases in temperature were extremely subtle, the degree of concentration required to sense those changes tended to warp perception until it was no longer trustworthy. Science was thwarted at every stage in the experiment, resulting in mock science. All that remained were impressions.

The lightbulbs, of course, referred to the cliché about having a bright idea. The brightness, however, was sensed obliquely, seen as a shadow or felt through the eyelids—in other words, experienced not as illumination but, ironically, as forms of blindness. Through the ostensive study of the objective characteristics of the lightbulbs, only subjective data were accumulated, if they were remembered at all. If *Highs* was mock science, it also poked fun at the youth culture's emphasis on emotionalism—its highs and lows, its illuminations and dim-wittedness. Attentiveness, it seemed to suggest, often results not in illumination, but in dullness and uncertainty. In the end, *Highs* was important to Kaprow because it was so unimportant.

Kaprow's relationship with new technologies had always been ambivalent. As early as 1964 he wrote: "The astronaut John Glenn may have caught a glimpse of heavenly blue from the porthole of his spaceship, but I have watched the lights of a computer in operation. And they looked like the stars."[5] Ten years later, Kaprow cast video-art environments in less wondrous terms, as "a lavish form of kitsch" in which good artists were seduced by "fancy hardware" that failed to elicit actual participation. The mind of the audience, succumbing to "the glow of the cathode-ray tube," went dead. "Until video is used as indifferently as the telephone," he concluded, "it will remain a pretentious curiosity."[6] Starting in the 1950s with reel-to-reel tape machines, Kaprow was often drawn to the technologies of the day: audio and video recorders, live video feedback and television broadcasts, telecommunications networks, instant photography, and the like. Dismissive of the utopian implications of new technologies, however, Kaprow enjoyed them to the extent that

they offered him systems of possible miscommunication. What attracted him was not the hardware, but the human behavior—the software—it elicited.

One of the great myths of the communication age is that we can extend human experience—thoughts, feelings, memories, relationships, agreements—across vast spaces in concurrent time, that present time compensates for absent space. In the 1970s people could sense the coming media hallucination, but few understood the instruments that would track and project it. For Kaprow, the telephone was usually enough, for through it he could dial into a network that promised to extend the senses beyond the constrictions of space—the same basic network that conducts our digital hallucination today. What he found there were thresholds beyond which the senses could not extend their reach without becoming senseless and useless. He didn't need fancy machines to measure that extension. The body can only stretch so far and still be a body that matters. Everything extending from there is a matter of smoke and mirrors.

basic thermal units

In March 1973 Kaprow returned to Germany, where he continued to explore his interest in the play between measurable phenomena and subjective experience. He conducted a work in four parts, *Basic Thermal Units,* which took place in Essen, Duisburg, Bochum, and Remscheid over a period of two weeks. The activity involved the performance of two simple tasks: raising or lowering the temperature of a body and, correspondingly, but in a separate location, raising or lowering the temperature of a room. These tasks were carried out in their four possible combinations: cooling a room and heating a body, cooling a body and cooling a room, heating a room and cooling a body, and heating a body as well as a room.

Kaprow's instructions for the group in Remscheid were:

COOLING A ROOM
HEATING A BODY

for perhaps three hours
decreasing the temperature
of a room
by opening a door, a window
by using an air conditioner
watching the thermometer's fall,
e.g., 5 , 8 , 10 . . .

phoning someone to raise
their body's temperature
by lying in a bath
increasing the heat
of the water
until it feels 5 , 8 , 10 . . . warmer

phoning repeatedly
until the room's too cold or
until the body's too hot
saying, or hearing, that
the limit is reached

In Bochum, the participants followed these instructions:

COOLING A BODY
COOLING A ROOM
for about three hours
lying in a bath
decreasing the temperature
of the water
gradually adding ice
feeling the body cool

phoning someone to lower
their room's heat
to equal the decrease felt
in the cooling body, e.g., 5 , 8 , 10 . . .
by opening a door, a window
by using an air conditioner . . .
watching the thermometer's fall

phoning repeatedly
until the body's too cold or
until the room's too cold
saying, or hearing, that
the limit is reached

Participants in Duisburg followed these instructions:

HEATING A ROOM
COOLING A BODY
for perhaps three hours
increasing the temperature
of a room
watching the
thermometer's rise, e.g., 5 , 8 , 10 . . .

phoning someone to lower
their body's heat
by shedding clothes
by applying ice packs
until the body feels 5 , 8 , 10 . . . cooler

phoning repeatedly
until the room's too hot or
until the body's too cold
saying, or hearing, that
the limit is reached

And those in Essen followed these instructions:

HEATING A BODY
HEATING A ROOM
for perhaps three hours
adding layers of clothes
one after the other
feeling the body warm

phoning someone to raise
their room's heat
to equal the increase felt
in the warming body, e.g., 5 , 8 , 10 . . .

phoning repeatedly
until the body's too hot or
until the room's too hot
saying, or hearing, that
the limit is reached

Since in each of the four cities the bodies and rooms were in separate locations, information about their changing temperatures was relayed over the phone. For example, someone sitting in a bathtub adding ice to the water would periodically guess about his or her decreasing body temperature and phone those guesses to his or her accomplice, who would lower the room's thermostat accordingly. Or a room in an apartment would be heated or cooled—doors and windows opened or closed, the air-conditioning or furnace turned on or off—and its occupant would note its rising or falling temperature and phone someone in another apartment, who would then add or remove clothing, or heat or cool bathwater, until a presumed match in body temperature was achieved. This process continued for about three hours, until the rooms or the bodies were deemed too hot or too cold to continue.

In these scenarios, Kaprow asked his confederates to quantify their sensations according to thermometric standards and then relay those data over a telecommunications network. In theory, the reduction of vague physical impressions to basic thermal units and their subsequent electronic transmission is a tidy technological means of bringing body and environment into harmonious accord. Owing to the accuracy of thermometers and to telephonic immediacy, they would share the rhythms of their rising and falling temperatures in objective, quantifiable terms that would, presumably, bridge the distance between them. Participants would thus feel the heat of another's body in the room, or the draftiness of another room on the body.

This idea is poetic and probably intellectually satisfying, but it's just not the way the way the body experiences changes in basic thermal units. As usual, there were no epiphanies during the enactment of this work, no moments of feverish awareness or cold cognizance. As time and temperature passed, it was easy for participants to wander off in thought and then suddenly notice the heat on their brow or the chill down their back; the thermal and temporal units just kept ticking away faster than the body could register them. To have noticed these incremental changes in temperature, Kaprow's participants would have had to monitor their attentiveness as if it, too, were a thermometer.

Basic Thermal Units was a pun on Marshall McLuhan's

famous axiom that if you stand in a tub of water and increase the temperature one degree per hour, you won't know when to scream. Kaprow was the master of the anticlimax; he left the melodramatic fantasies of global media outreach to others. The gap he was trying to bridge was the one between body and mind. The efforts to coordinate them through instruments of measurement and communication were futile, perhaps ironic, but they echoed perfectly the deepest healing instincts in his life. Think of the images enacted here: the body away from its room; constant "telepathic" contact; moving from city to city; opening and closing windows and doors; looking for new playmates; cooling a feverish body in a bathtub; warming a chilled body with extra blankets; and always, always monitoring the body with the mind.

In the mind of an adult, basic thermal units are arbitrary numerical measures, socially prescribed. As conventions, they seem to mean something objective, but they cannot be precisely tied to feelings of heat and cold. In the mind of a child, feelings of heat or cold might be menacing signs of the onset of illness, just as being far away from one's room, or one's home, could be a plaintive measure of abandonment. In the text, Kaprow suggests that participants shed or add layers of clothing or put ice in the bathwater, all remedies for childhood fever or chills. He asks that they call one another by telephone as soon as physical sensations are experienced, a metaphor for an almost panicky need for reassurance. Kaprow's experimental interest as an artist was in the way that variables tend to fall outside the system, and how social exigencies and psychological impressions can spiral beyond the orbit of objective criteria. Underscored in this event, however, was a poignant and personal yearning to be made well and taken home.

time pieces

In September, Kaprow went to Berlin, where he'd been invited to participate in Aktionen der Avantgarde, a festival organized by the Neuer Berliner Kunstverein. There,

he enacted a three-part work, called *Time Pieces,* in which processes of the body—breathing and the beating of the heart—were measured by various clock analogues. Structured as a number of exchanges between partners, the work went like this:

PULSE EXCHANGE
turning on a tape recorder
counting aloud one's pulse for a minute
(noting count)
once again . . .
and again . . .
listening to tape

telephoning a partner
counting aloud one's pulse for a minute
(noting count)
playing previous tape over phone
partner doing same

meeting somewhere
one counting aloud his/her pulse for a minute
(noting count)
once again . . .

climbing some stairs together
turning on both tape recorders
counting aloud, and together, each other's pulse for a
minute
(noting count)
listening to each tape
recorders off
counting aloud, and separately, each other's pulse for a
minute
(noting count)

BREATH EXCHANGE
turning on a tape recorder
breathing rapidly into mike for a minute
counting breaths
(noting count)
once again . . .
and again . . .
listening to tape

telephoning a partner
breathing rapidly into mouthpiece for a minute

PULSE EXCHANGE (ABOVE) AND BREATH EXCHANGE (RIGHT)
DURING *TIME PIECES*, BERLIN, 1974 (PHOTOGRAPHERS
UNKNOWN; COURTESY GETTY RESEARCH INSTITUTE)

counting breaths
(noting count)
playing previous tape over phone
partner doing same

climbing some stairs together
turning on both tape recorders
each partner breathing into his / her mike for a minute
(noting count)
listening to each tape
recorders off
again, each partner breathing for a minute
counting breaths
(noting count)

breathing into each other, mouth-to-mouth, for a minute
drawing the breath in and out
(noting count)
once again . . .
and again . . .

PULSE-BREATH EXCHANGE
turning on a tape recorder
holding one's exhaled breath for a minute
counting pulse by tapping mike
(noting count)
once again . . .
and again . . .
listening to tape

telephoning a partner
holding inhaled breath for a minute
counting pulse by tapping mouthpiece
(noting count)
playing previous tape over phone
partner doing same

climbing some stairs together
turning on both tape recorders
each partner holding inhaled breath for a minute
each counting his / her pulse by tapping mike
(noting count)
listening to both tapes at once
again, climbing stairs together
holding inhaled breath for a minute
each counting his / her pulse
(noting count)

exhaling breath into plastic bag, sealing it
once again, climbing stairs together
inhaling each other's bagged breath

meeting somewhere
each partner holding exhaled breath for a minute
counting each other's pulse by blinking eyes
(noting count)

Time Pieces was enacted by thirty people in times and places of their choosing over a three-day period. It was preceded by an initial meeting and followed by a review; otherwise, partners carried out the exchanges independently. What they learned, as Kaprow later noted, was that the work "was a clinical examination of one's own and a partner's body processes." This formal, scientific examination was, however, "a way of monitoring feelings, sometimes strong ones, which were never specified beforehand, but discovered in the process of carrying out an apparently objective plan."[7] Even though it was "apparently objective"—which is to say, formal and repetitive—the plan also called for numerous intimate exchanges—participants taking each other's pulse, breathing into each other's lungs—that might elicit powerful emotions. It was as if the partners were monitoring each other's vital signs or keeping each other alive. For all their formality, this and other similar works of the 1970s elicited an astonishing range of emotional responses from participants.

The underlying pattern of *Time Pieces* involved repeated instances of intimate contact interrupted by separations and of separations intimately coupled. Recordings of pulse and breathing rates were brought into the same moment—although never in precisely the same rhythm—as a participant's actual heartbeat and respiration; yet even if they were confluent in time, these recordings—because they *were* recordings—were still necessarily separated from the participant. When participants shared the same time by making contact over the telephone, they were distant in space, and when they

came together in space, they were separated by timing. Even the plan itself—formal, neutral, mechanical, spare—was nothing like the physical and psychological intimacies it fostered. Beneath its orderly surface, healing and rending can be felt in the activities of counting heartbeats or breaths, listening to your recorded voice, climbing stairs with a partner, or breathing into a partner's lungs or a plastic sack. Participants were brought into and out of accord with their own heart and breathing rates, and with those of their partners, by counting in real time, listening to recordings of themselves counting, counting with their partners, and listening to their partners' recordings. There was much timing, but little was in time. It was as if hearts were trying to beat together, or breaths to blend, but in counting so closely, participants heard only echoes.

One interesting outcome of *Time Pieces* was the production of a small booklet in which the written plan was printed along with several black-and-white photographs showing people enacting its scenarios. The year before, with *Easy,* Kaprow had prepared a photo-and-text arrangement that was published in the July–August 1974 issue of *Art in America,* and this gave him the idea to generate "how-to" booklets for his events. Not wanting to control the experiences of others, Kaprow had learned to function over the years as a motivating presence who quickly slipped into the role of an ordinary participant in his works. Now, he hoped that the booklets would function like musical scores, making it possible for others to perform and interpret the works on their own. He seemed to be flirting with the possibility of withdrawing his authorial persona altogether. In theory, this would relieve him of the burden of authorizing each enactment and, perhaps, allow the works to be experienced by greater numbers of people.

To this end, the photographs in each booklet were posed and formal, almost stiff, in the manner of Kaprow's stick-figure drawings of the late 1950s. "The photos," he writes in the booklet's notes, "are *illustrations* rather than documents of the actual event." They were diagrams of something yet to happen, a distant echo of *Something to Take Place: A Happening* from 1959. Kaprow did not want the booklets to be seen as documents, so he modeled them after the plastic emergency cards in the seat pockets of airplanes, in which the arrangement of images and text is minimal, diagrammatic, and clear. Most important, he didn't want the booklets getting in the way of the activities they were proposing by giving hints about how an action should be performed or what it meant. They were designed to be unexpressive and unevocative, without being deadpan or ironic. They were just illustrations, Kaprow believed—pedagogical tools, teaching aids.

This is not how it turned out. Between 1973 and 1979 Kaprow produced eighteen booklets, each designed in the same dispassionate manner. By decade's end, he had come to regard their production as a misguided strategy. The booklets tended to function as stylistic templates that corrupted enactments of the works. Having studied the spare, "conceptual" arrangements of images and texts, people found it nearly impossible to shake off their influence during the enactment of a score. (A study Kaprow conducted in Los Angeles among people who had enacted the work confirmed this.) It was as if the style of the booklet itself was being imitated. The fact that the booklets were in visual accord with the spartan, black-and-white "look" of much Conceptual art of the time made it difficult *not* to see them as aesthetic artifacts of the moment. They were the new works of Allan Kaprow—indeed, they were immediately collected as artworks.

The booklets gave rise to a common perception of the works of the late 1970s as being remote, detached, and "conceptual." Some thought they were too "California."[8] People also continued to believe that, despite the written disclaimers in many of the booklets, the photographs were documents of actual works, no matter how obviously posed. This is understandable, since there were documentary photographs everywhere during the 1970s: of earthworks, Process art, performance, Body art, Con-

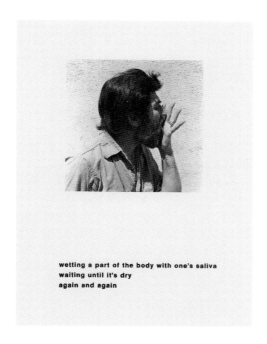

wetting a part of the body with one's saliva
waiting until it's dry
again and again

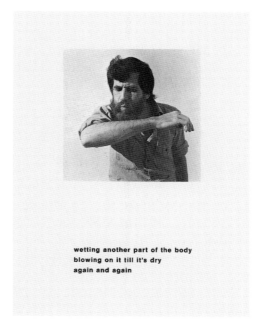

wetting another part of the body
blowing on it till it's dry
again and again

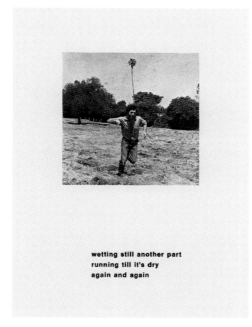

wetting still another part
running till it's dry
again and again

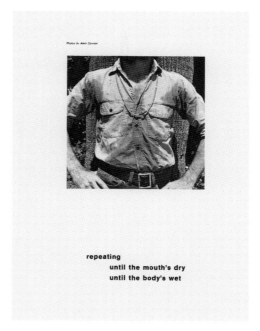

repeating
until the mouth's dry
until the body's wet

BOOKLET FOR *AIR CONDITION*, 1975 (© ALLAN KAPROW; PHOTOS: ALVIN COMITER)

ceptual art. Unwittingly, Kaprow's elemental style tapped into the mid-1970s fashion for gray-toned visual reserve. It didn't matter, though, because the photographs were too generic to be inviting, anyway. As the 1980s drew near, Kaprow had to accept the reality that he, and not his instruction manuals, was the more inviting.

3rd routine

The works of the 1970s depended upon fewer participants than had those of the 1960s. In part, this was because not that many people were interested in participating (some wanted Happenings instead). The more important reason, though, was that the focus of the works tightened on the experiences of human exchange.

Within a two-year period, from early 1973 to roughly the beginning of 1975, Kaprow sharpened his focus on routines, moving from a kind of industrial psychology to the taut intimacies of social interaction. Connecting the two was the idea of the body as a contested instrument of objective and subjective measure.[9] Kaprow began exploring questions of intimacy and formality of behavior, as well as points of contact and exchange that could be either direct and physical or mediated by such devices as tape recorders, telephones, and televisions; all are links that can both connect and disconnect an exchange. In the works of the previous decade, formal relations had underscored the creation of communal systems of working; now the events were intended to explore the unanticipated psychological voltage of private interaction.

Happenings had been directed outward, engaging the world of materials, processes, and people surrounding the artist, but the activities of the mid- to late 1970s looked inward, toward the psychology of human interaction. They were no less rich and textured for their introspective focus. The world of expectations, hesitation, embarrassment, habits, routines, fears, and glee, it turns out, is as vast as "the vastness of Forty-second Street." Because the new pieces were intimately scaled and relatively private, they dropped beneath the radar of art-world awareness. No matter. The psychological charge they carried was in the doing, as in breathing into a partner's mouth, exchanging clothes, grasping hands until they were wet, or dragging a limp body down a hall. There was no role-playing here, only the enactment of routines.

A routine is defined in Webster's as "a regular, more or less unvarying procedure" that is "customary, prescribed, or habitual."[10] It is a kind of behavioral background noise. Kaprow was drawn to routines because they are behavioral patterns likely to break down under the strain of conscious enactment. Within these patterns lurk experiences that can change the meaning of the routines.

In July 1974 he enacted *3rd Routine*, a complex work commissioned by the Kolnischer Kunstverein based on the themes of memory and the fantasies that are built up when we try to remember. It was carried out by only Kaprow and Inge Baecker in two two-room suites at the Dom Hotel in Cologne. *3rd Routine* employed the full panoply of video technology available at that time. The plan reads:

1.
A, privately making video tape of him/herself entering own apartment, greeting imagined B waiting there

making second tape of imagined goodbye;
of leaving B in apartment

re-recording tapes again and again until
effect is exactly right

2.
A, leaving video camera facing front door,
monitor in nearby room showing motionless image
(closed circuit, no tape)

at appointed time, A watching monitor,
waiting for B's arrival,
watching and waiting longer than expected; at last seeing
B's greeting on monitor

3.
A and B together, viewing tape of greeting;
viewing tape of leaving
A leaving

B, carrying out similar process in own apartment: making both tapes, waiting for A, watching A arrive, showing the tapes, taking leave of A, as A did of B.

3rd Routine was composed around the social conventions of greetings, goodbyes, and excuses for being late.[11] The two participants address each other only through videotape or closed-circuit broadcast. The video technology objectifies their fantasies about each other and functions as a means of surveillance (in front of which to perform, behind which to hide), as an aide-mémoire, and as an influence on subsequent behavior. The camera is used to record courtesies for a person coming later, to broadcast arrivals to someone in another room, and for one participant to speak to the partner sitting next to her or him. Here, technology furnishes the modern windows, mirrors, and surfaces of human relations, an echo of Leo Steinberg's three principal roles for the picture plane: transparency, reflectivity, and opacity.[12]

In his notes on *3rd Routine,* Kaprow writes, "I had for years thought about the way we surround an important meeting with rehearsals of what we are going to say and do, and after it, with rehearsals of what we could have said or done." With videotape, he could make these fantasies into "retrievable realities."[13] How one partner greets another, says goodbye, or makes excuses about being late becomes evident when those acts are videotaped, and these records may convey actual—and unintended—perceptions, estimations, and opinions that conventional forms of social intercourse are usually designed to mask. The mix-up here between the true reality of a one-on-one exchange and the created reality provided by the videotape reverses the normal order of fact and illusion. Kaprow recounts that "the fantasies were preserved on video tape and acquired the presence of hard facts, while the

realities of all our unrecorded moments had passed into oblivion or into the distortions of memory." The idea of rehearsing one's hellos, goodbyes, and apologies underscores the point that all such acts are routines in the vaudeville of everyday social exchange. By recording and playing them back, they become reflections in a technological hall of mirrors.

Using video (or other) technology in this manner amplified the commentary on systemic breakdown. For Kaprow, this commentary was not a sermon on what had been lost in modern living, since even a handshake can break down. Rather, he saw that machines like those in *3rd Routine* can be used to complicate, objectify, distort, and fantasize about others. They can also intensify awareness of physical sensations and influence evolving relationships within the works. More than anything, in *3rd Routine* the video cameras and monitors reframed self-presentation into an oblique commentary on the self-as-other. The underlying breakdown was not technological, but between partners—it was psychological.

Kaprow had always been interested in systems breaking down, but by 1974 those systems were more personal and psychologically charged. They involved marriage and family and sex roles and power relations. In 1974 he left CalArts and took a position at the University of California, San Diego. Kaprow and his wife were having marital problems, a situation that had been accelerated, if not precipitated, by the feminist-inspired sensitivity-training sessions available at CalArts. There, "abusers" were confronted with the experiences of their "victims," and the authority of the therapist was taken over by the group in the name of co-counseling and the democratization of the professional therapies. Such groups, which Kaprow and Vaughan attended, were testing grounds for experiments in relationships, including the experiment of breaking up. At the same time, they too often settled into "mushy goodwill, in which everybody wanted to hold hands." Kaprow and Vaughan were soon divorced.[14]

During this period, late 1973 through 1975, Kaprow's

ENTERING A HOTEL ROOM (TOP) AND KAPROW AND PARTNER (BOTTOM) IN *3RD ROUTINE*, DOM HOTEL, COLOGNE, 1974 (PHOTOGRAPHERS UNKNOWN; COURTESY GETTY RESEARCH INSTITUTE)

work exhibited a playful skepticism about human relations—there were no epiphanies or healing insights. It also sounded a harsher note, involving aggressive gestures (clasping hands and not letting go for a long—and longer—time), painful thresholds (when the water becomes too hot or too cold), invasive intimacies (breathing into a partner's mouth), panicky recoveries (hyperventilating into a microphone or breathing into a plastic sack), and unrequited courtesies. Although the works of the mid-1970s were not strictly autobiographical, they did tend to explore the ways in which relationships break down when conventional forms of social intercourse are analyzed through conscious enactment. What's more, men were on notice, and a little enlightened self-criticism was clearly in order. Kaprow's self-consciousness in this regard is evident in his written notes for *3rd Routine,* where he makes some observations about his partner, Baecker: "I was a guest in her country, to whom she wished to be as gracious as possible. Yet as a quietly committed fem-

inist, she was aware that my concurrence in that cause was offset by her assistance in a man's art work. Independence for her was a struggle while mine was an historic assumption."

Although Kaprow was not interested in politics as a subject of his work, preferring instead to convert thematic material into behavior, the behavioral scenarios of the mid-1970s were charged with political and social themes that could not be entirely exhausted through enactment. Given his lifelong methodism, Kaprow's two-year plunge into the personal seems precipitous, but it was driven by the forces of change in society that were also forcibly changing his personal life. He did works about repetition and boredom (*Routine*, Portland, Oregon, December 1973), people being a drag on each other (*2nd Routine*, New York, March 1974), hot and cold personalities (*Affect*, Turin, Italy, October 1974), and truthfulness, loyalty, and collusion with confederates in a scheme where everybody knows what everybody else knows. This last piece, *Take Off*, also from October 1974, marked the beginning of a transition from works whose "playful skepticism" masked a certain aggression to works where the "personal," with all its psychic voltage, softened into something closer to privacy.

BECOMING A DRAG ON ONE'S PARTNER IN *2ND ROUTINE*, NEW YORK, 1975 (PHOTOGRAPHER UNKNOWN)

"I'M TAKING OFF MY PANTS/SKIRT TO BE DRY CLEANED"
(TOP LEFT), KAPROW EXAMINING HIS FACE
(TOP RIGHT), AND "I'M REMOVING MY RIGHT SHOE
BECAUSE IT'S TIGHT" (BOTTOM), FROM *RATES OF EXCHANGE*,
BOOKLET, 1975 (PHOTOS: BEE OTTINGER)

rates of exchange

For Kaprow, the "personal" always unfolded in relation to the "other." Loaded scenarios often gave way to tense, formalized negotiations with strangers, partners, even friends. Privacy, by contrast, involved doing something by (and with) oneself, something that might include others but did not require them. It took until nearly the end of the 1970s for Kaprow to make this transition in his work. In essence, he moved from formalism to Zen, from an almost mechanical analysis of the components of behavior to an ongoing awareness of the present moment.

In *Rates of Exchange*, sponsored by Stefanotty Gallery and enacted in New York in March 1975, this change was beginning to taking place. The plan asked participants to individually tape-record questions and then listen to them while looking at their own reflection in a mirror:

is your hair dirty
is your brow creased with care
do you see the soft glow in your eye
are your cheeks hot
is your nose pinched
is your mouth generous
do you have a weak chin
is your neck attractive

Each participant then exchanged tapes with a partner and listened to the partner's tape while examining their face again. The partners also met face-to-face, conducting and recording "an apparent dialogue of questions and answers which don't match"[15]:

is the foot one-third the length of a step . . . yes, there are small changes along the way
are there 500 equal steps to take . . . yes, one foot is normally in a stabilizing position
does the back foot go down when the forward one comes up . . . yes, there is a slight tension in the arch and this readies the leg for its springing motion
do both feet leave the ground if one is walking fast . . . yes, there is a sliding motion of the inside toe as it strikes the ground
does covering long distances affect the length of the stride . . . yes, city pavement alters the walking movement used in the country

In addition, each partner found a private place to walk, "carefully watching each step" and "gradually freezing walking motions into segments, holding each for a time" while listening to the tape-recorded questions and answers. They also segmented the motions of a handshake, freezing them for longer and longer periods until continuing was impossible. Next, they privately undressed and dressed, taping these statements of purpose at the same time:

I'm removing my right shoe because it's tight
I'm removing my left one because it belongs with my right one

I'm taking off my socks / stockings to see my feet
I'm taking off my shirt / blouse to change it
I'm taking off my pants / skirt to be dry cleaned
I'm removing my underwear because I'm warm
I'm undressed because it's natural
. . .
I'm putting on my underwear because I'm naked
I'm putting on my pants / skirt to be more comfortable
I'm putting on my shirt / blouse for a change
I'm putting on my socks / stockings because I look ridiculous without them
I'm putting on my shoes for added height
I'm dressed to be seen

Finally, the partners met again and watched each other undress and dress as they listened to the tape-recorded statements.

Rates of Exchange was about the difference between what we say and think and what we do, differences stressed both by the "abnormally prolonged" rate at which information was exchanged between partners, as well as by a string of physical and linguistic disconnections: walking stiffly and listening to the questions and answers on a tape recorder; looking at your face in a mirror while recording questions about your partner's face; exchanging questions and answers that don't quite match up; trying to pay attention to walking mechanically while being distracted by the noise in your head. Pretend questions, apparent dialogue, step-by-step disclosure, and "plausible but evasive" statements of purpose were formally arranged in relation to kinetic and durational moves that had the effect of breaking life down into its dysfunctional parts.[16] If you slow the motion of a handshake enough, it becomes impossible to shake hands; some other exchange takes place.

useful fictions

For *Useful Fictions*, enacted in Florence in December 1975, couples walked up and down long hills or flights of stairs,

WALKING UP HILL, TELLING STORY OF ASCENT, WALKING BACKWARD DOWN HILL

HOLDING MIRROR AND COPYING MOVEMENTS, WALKING BACKWARD UP HILL, HOLDING MIRROR AND COPYING MOVEMENTS

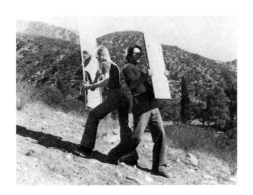

WALKING BACK-TO-BACK UP HILL, WALKING BACK-TO-BACK DOWN HILL, NOT LOOKING INTO MIRROR AND COPYING SENSE MOVEMENTS

USEFUL FICTIONS, 1975 (PHOTOS: BEE OTTINGER)

with the leader looking into a large mirror that reflected an over-the-shoulder image of the following partner, who copied the leader's movements as they walked. They walked up, then walked down backward, then up backward, down forward, and, finally, back-to-back both uphill and down, this time each holding a mirror. At the termination of each of these segments, one or both of the participants would "tell the story" of getting there while the other listened. These would be recorded on tape. At the final descent, the couple parted ways, and each person recorded his or her own story.

The routine disintegrated into a field of experience that was hard to understand. As the moments piled up, a loss of equilibrium ensued. Where is up? Where is down? Who is leading? Who is following? The telling of stories emerged in this work as a useful way of reconciling, say, one's physically disjointed experience of copying another's body movements with the comparatively coherent flow of a narrative. As stories were told and retold, recorded and listened to, they changed the experience they described, smoothing out its craggy topography,

overstating its exertions, understating its tedium, or exaggerating its comedy.[17] Locked in a closed but mobile system of mimicry, reflection, and retraced steps, the couple became a parody of itself going nowhere, literally enacting the figurative "ups and downs" that mark the paths of most relationships. In this sense, *Useful Fictions* takes its place alongside *Rates of Exchange* in Kaprow's psychologically laden works of the mid-1970s.

In *Rates of Exchange* and *Useful Fictions,* the formalistic rendering of behavior generated nonsense. More important, the mechanistic routine of *Useful Fictions*—with its herky-jerky fits and starts, its lockstep mimicry, its part-by-part segmentation, its self- (and other-) reflecting blindness—broke down physical movements and mental concentration into a succession of steps that, in time, Kaprow began experiencing as one present moment after another. The experience of that moment was paradoxical—solitary and yet one in a chain of many. Like a horse to a barn, the moment always returns to itself if you let go of it. Once-public Happenings were now moments of private detachment. And there was Zen waiting.

zen

Zen had been a philosophical interest and an aesthetic influence for Kaprow since his involvement with John Cage—that is, for most of his career. Zen is commonly cited as a major underlying influence for the postwar American avant-garde, and Cage had been the principal agent of its dissemination to Kaprow's generation of artists. But what kind of Zen waits at the bottom of a hill, hangs in the spaces between mismatched questions and answers, or lingers in the breakdown of a handshake?

In *Into the Light of Things* (1994), George Leonard argues that D. T. Suzuki, who popularized Zen Buddhism in the United States though he was not himself a Zen master (he was an English teacher in Japan before moving to Chicago in 1897), in fact introduced a "new variant" of the long-held American taste for seeking divine potential in everyday things. Suzuki's variant of the transfigured commonplace, or what Leonard refers to as "Natural Supernaturalism," was new because it secularized East Asian metaphors instead of Western ones. "The temple-going Zen religious sects," Leonard writes, "which have grown up in the last twenty years, more faithful to the East Asian tradition, really are Zen, and so they matter to ten or twenty thousand American devout. On the other hand, some version of the bastard, compromising spiritual philosophy which Suzuki, Cage, and a few others fused from Zen and Natural Supernaturalism may already, by suffusion, be the spiritual life of a majority of educated Americans."[1] Leonard credits Cage with "completing this new suffusive transmission because it reached America not through Zen temples but through the universities."[2] Cage's temples, so to speak, were Black Mountain College and the New School for Social Research. Kaprow's were Rutgers, Stony Brook, CalArts, and the University of California, San Diego (until his retirement in 1993). The ideas of Zen that Cage helped to sow "throughout the art world, universities, and educated public" he later "rediscovered" in the writings of Henry David Thoreau, assuming that Thoreau got them, as Cage had, "from the Orient." Leon-

ard then cuts brilliantly across the grain of historical convention when he writes: "But in Cage's case, the 'Orient' he got the ideas from was Dr. Suzuki, primarily. What if Suzuki got them from Emerson and Thoreau?"[3]

In the 1950s—the years of the "Zen boom" in the United States—artists in the Cagean vein saw Zen as an aesthetic philosophy underlying the American high regard for everything vernacular. Rich and deep, that vein tapped the works not only of Thoreau, but also of Walt Whitman, Ralph Waldo Emerson, and William Wordsworth. "I hear America singing," declaims Whitman in *Leaves of Grass* (1855), and the "varied carols" he discerns, those of the mechanics, carpenters, masons, boatmen, shoemakers, woodcutters, and mothers of the land, echo fifty years later in John Dewey's "sights that hold the crowd—the fire engine rushing by; the machines excavating enormous holes in the earth; the human fly climbing the steeple side; the men perched high in air on girders, throwing and catching red hot bolts."[4] Leonard tells us that in the late 1890s Suzuki was investigating University of Chicago courses and "considering Dewey's."[5] As a young philosophy student in 1949, Kaprow kept a copy of *Art as Experience* close at hand, penciling in its margins phrases such as "art not separate from experience," "what is an authentic experience?" and "environment is a process of interaction"—jottings that not only indicate his philosophical interest in commonplace experience, but that forecast the underlying themes of his career. Two years later, he met Cage, whose silence was America singing, and soon after that he recognized in the "simplicity and directness" of Jackson Pollock's painting a "Zen quality."[6]

Perhaps an American Zen is a Zen that lets you live an American life; it is not monastic, but pragmatic, keeping its ear to the rail of modern living. The prophets of American Zen were the Beats, for whom the instant enlightenment of satori (associated with the Rinzai school promoted by Suzuki) suited their romantic, transcendentalist temperaments. Instant enlightenment, like epiphanies, liberated the streams of consciousness that coursed through their poems like rheumy-eyed jazz. The nothingness of Zen was an existential void, infused with both dread and a romantic, liberating impulse, and the prospect of apocalypse (the Bomb) was one of the factors that drove the Beat sensibility toward it. Satori, for the Beats, was a cosmic trigger, a spiritual release followed by an endless highway of poetry and prose. (Jack Kerouac once told Kaprow that the perfect format for writing was a roll of toilet paper; you could just write without revising until the roll ran out.[7]) Yet despite their common interest in Zen, there wasn't much overlap between the Beats and the Cageans. Cage wanted to be in the world as a witness; he was not an enthusiast for transcendence.

Whatever the effects of Zen upon the avant-garde arts, Kaprow—and most of the artists he knew—never practiced it as a spiritual discipline. (An exception was Robert Filliou, who picked up the practice while serving with the United States Army in Japan in the early 1960s and later became a Tibetan Buddhist in France.) Kaprow heard, read, and talked about Zen, even likened his (and others') work to it. But it wasn't until 1978, when he first began "sitting" under the guidance of a teacher on a daily basis that Kaprow noticed just how like certain aspects of Zen practice his works had actually become. The reduction of formalistic maneuvers to nonsense; the heightened awareness of the present moment; methodism (akin to the gradualism of the Soto school of Zen, not the sudden enlightenment of the Rinzai); the willingness to let meanings drift through experience and then let them go—these were attributes of Zen practice that were also integral to the forms of Kaprow's art.

In doing his work, Kaprow had spent years training himself to live in the present moment. The throwaway impulse traceable to the action collages of the mid-1950s had been refined into an improvisational nimbleness that was relatively unencumbered by expectations or analysis. Ironically, the early Happenings, so often touted as

spontaneous events, were not, while the rigid-seeming activities of the late 1970s were skilled toss-offs. In this sense, Kaprow's works from the late 1970s were not only close to Zen philosophically, but also, arguably, instances of Zen practice.

If Kaprow was practicing a form of Zen in his art, the same cannot be said for his life. In 1978 he was about to be divorced and about to become chair of the Visual Arts Department at the University of California, San Diego. Few commissions were on the horizon, and he had never felt more cut off from the art world. Whatever his protestations about being uninterested in that world, he was disturbed by the sense that, as an artist, he was pretty far out on a limb. Minimalism and Conceptualism, with which the work of the 1970s was stylistically identified, were played out. European nationalism—an impulse opposed to the internationalism of Happenings and Fluxus—was emerging in the Italian Transavantgarde and the German-inspired zeitgeist, with the Neo-Expressionism of the young New York painters not far behind. Despite his booklets, he didn't think that anyone was enacting his scores. After decades of refining his work—having created a unique adult analogue of childsplay—Kaprow suddenly realized that he wasn't having any fun. This was his bitter satori.

Kaprow wasn't happy with his work because it wasn't cycling back into his life. He was practicing a form of Zen as an artist, but he didn't feel the better for it as a person. By feeling he "should" be happier, that he ought to be at least as engaged by his works as his participants were, Kaprow was making a judgment that was keeping him from what he was actually, in fact, experiencing. This became clear in his first year of Zen practice, a long and painful period in which Kaprow recognized the "endless complaining" going on in his head.[8] There is a difference between judging one's experience and experiencing one's judgments; he soon began listening past the complaining, toward silence. By practicing under the guidance of a teacher (the noted Charlotte Joko Beck), Kaprow was, in effect, becoming like one of his participants. Twenty years after the inception of Happenings, the work had finally forced the question, not of whether his art was life, but of whether his art was *his* life.

team

The practice of Zen came at just the right moment in Kaprow's career. With fewer commissions in the offing, the idea of doing pieces by himself made practical sense without seeming—as once it would have seemed—like failure. Indeed, failure was impossible if he did the works by himself. For several years, from 1980 to 1985, Kaprow enacted numerous private or semiprivate works that were barely noticed in the professional art world, but which are some of the most elegant and even playful works of his career.

They began with a comedy of errors. In October 1980 Kaprow and Coryl Crane (whom he would marry in 1987) drove out to the Anza-Borrego Badlands next to the Salton Sea and, in the heat of the desert, performed the following plan:

1. two partners in the desert
(a mile or so apart)
(in touch by walkie-talkie)

one unrolling about a five mile line to the east
(moving right or left around obstacles)
telling the other to unroll his/her line the same way
(straight ahead, so many paces to the right or left)

partner complying
except when obstacles prevent it
(moving then to the right or left)

telling the other to do the same
each complying as much as possible

continuing in this way
until for each
there is no more line

1

two friends
driving at dawn on a desert highway
parking

walking away from each other
(walking well into the desert
but parallel to the road)

2

each with walkie-talkies and
and carrying two suitcases
(one containing some clothes of the friend
the other empty)

walking silently for about two hours
(always in the same direction
away from the other) ~~(a cold)~~

**2. partners walking to the south and north
finding the ends of each other's lines**

**3. rewinding the line
telling each other
to move in the directions they find it
(to the right, straight ahead, or left)**

**both winding as they continue
making adjustments to the positions
of each other's lines
(both adjusting further for new obstacles)
until for each there is no more line**

Coming off his divorce and the psychologically charged relationship pieces of the late 1970s, Kaprow scored an enactment in which two people were to move in parallel, exchange places, pick up each other's trail (and cover each other's tracks), communicate at a distance, and eventually "find" each other at the beginning. The enactment was called *Team*.

Kaprow figured that the irregularities of the landscape, the variation in his and Coryl's walking speeds, the inevitable garbling of walkie-talkie communication, the difficulty in laying out a straight line across miles of rugged terrain, and the general disorientation one experiences in the desert were variables that would function to mock the pretense of navigation.[9] He wanted to be lost and to be found, but he didn't really want to *get lost*—hence the walkie-talkies. Rented for the occasion, they were supposed to be dependable instruments of communication, like the telephones in previous activities. On this day, however, the walkie-talkies failed, blaring only static. The "team" found itself separated and unable to communicate over a vast tract of desert.

Because he thought the walkie-talkies would help them navigate the terrain, Kaprow had looked for a section of the desert where it might be easy to stray from the intended parallel routes. He expected the scenario to play itself out over two or three hours in the morning, when temperatures were cooler. Instead, he and Coryl quickly

became lost, the string unraveling less like a navigational bearing than a tracing of unconscious veerings and midcourse corrections.

Ironically, all they had now was the plan, and carrying it out precisely was their only hope of finding each other. Kaprow hoped that he and Coryl would meet somewhere near the midpoint when they were exchanging places. Unfortunately, the exchange brought even more confusion. Within several hours, the plan was as useless as the walkie-talkies, and the rest of the day unfolded in an increasingly anxious pattern of hesitant probes, panicky backtracks, bold forays, and squinty-eyed sightings. Lifelike art degenerated into life—and life becomes serious when it's threatened. The day became hot; the water ran out. After nearly eight hours of wandering in the desert, the couple found each other at an old gas station along a remote stretch of highway. There, the owner mocked them with stories of city types who'd actually gotten lost in the desert and died. Later that evening, Kaprow drove to a gallery in Los Angeles, where he told a small audience the story of getting lost near the Salton Sea.

koans

As a daily practice, Zen involves everyday experience. One hopes to know life in its present tense without getting lost in the myriad thoughts, desires, and judgments that continuously make claims upon awareness. In this sense, Zen is a nearly anti-intellectual practice in which the mind is seen, simply, as a part of consciousness, not its determinant. By training awareness on the everyday, Zen implies that commonplace experience is meaningful.

Is it really fair to say, though, that works like *Team* and those that followed it were literal instances of Zen practice? Most Zen practitioners would probably not think so. In fact, after he began regularly attending the Zen Center in San Diego, Kaprow briefly entertained the hope that fellow "Zennies" might become his new "community,"

but, beyond bemused curiosity, few were interested in his work; they were interested in Zen. Still, to pick up on Leonard's idea of "sage techniques,"[10] in which one creatively misreads the work of one's teacher (as Suzuki did Japanese Zen, Cage did Suzukian transcendentalism, and Kaprow did Cagean indeterminacy), we can see Kaprow's mature works as secular, operational analogues of certain forms of Zen practice, especially the koan.

Koans, developed primarily by the Rinzai school of Zen Buddhism, are study forms in which problems with no logical solution are assigned to a student as subjects for meditation and interpretation. While a koan could be a slap on the head with a wet fish, it is more likely given as stories, anecdotes, questions, or paradoxical statements. (What is the sound of one hand clapping? Show me your face before you were born.) Intended to outwit the limitations of ego and intellect, koans are said to lead to intuitive flashes of insight.

To Westerners, koans can seem like charming riddles rather than rigorous forms of study. To Kaprow, their key feature was that *any answers were worked out in experience,* not just in the head, and were thus different for each devotee. In this sense, koans were very like his works: individual enactments of philosophical conundrums. One might say he Americanized the koan study form in his activities. The first koan offered him after he began sitting at the Zen Center was "What is Zen for our time and place?" Not as "charming" as a slap on the head with a wet fish, this rather prosaic question was nonetheless perfect for Kaprow. One possible answer: "The 50-watt lightbulb is only slightly warmer."

Coming from the arts, Kaprow was not copying Zen forms as a Buddhist devotee; the Zen-likeness of his works had developed over decades in relation to an American avant-gardist (and sometimes romantic) infatuation with Zen philosophy. As an artist, Kaprow came of age alongside an idea of Zen as an aesthetic theory, not an ascetic practice. By the time be began actually practicing Zen, his works were already secular analogues of its forms, but analogues based on an intellectual appreciation, not practical experience. Therein lay his particular creative misreading.

Still, the daily practice of Zen—the effort to pay attention to present-tense experience—was enough like Kaprow's works to finally lift the intellectual veil that separated what he did as an artist from what he did as a Zen practitioner. In the dance between theory and practice, he realized that practice is practice is practice. Making sense of what we do is finally less important than paying attention to what we are doing. Lifelike art, artlike Zen, Zen-like life—each slipped easily into the other like attentiveness passing from noticing metaphors to sitting on a cushion to picking lint from a sweater. Kaprow now felt he could just do his works by—and as—himself.

european tour suite

In 1981 Kaprow was supposed to have a retrospective exhibition at the Museum Ludwig in Cologne, but it fell through. Having taken a sabbatical leave for this purpose, he decided to take advantage of the time away from teaching by composing a suite of works for various friends in Europe. To this end, he wrote letters to Wolf Vostell, Richard Hamilton, Stephan von Huene, Jean-Jacques Lebel, Robert Filliou, and Pierre Restany, among others, offering a private work for each if, in return, they would provide food and a place to stay for him and Coryl. All responded enthusiastically, and Kaprow set the itinerary of his "European tour." The idea was that he would arrive at the home of his hosts, settle in, talk, eat, and then, having gotten to know them better, compose the activity. After enacting it, they would gather and talk about their experiences. In a January letter to Petra Kipphoff (then the art editor of *Die Zeit,* the German daily newspaper), Kaprow wrote that the works would be done for the personal benefit of his friends and himself, noting, "Like all my work, they'd be carried out in the everyday environment of houses, streets and fields, without audiences."[11]

The activities, performed during the spring and early summer of 1981, were:

HOW TO RENEW YOUR LIFE
On successive days of a week, friends rearrange the furniture of each other's houses. Daily affairs continue normally.

DINNER MUSIC
A group of friends eat a great dinner. Afterwards, they lie down to rest. They put contact microphones on their bare stomachs and, for the next couple of hours, listen to their digestion sounds amplified on surrounding loudspeakers.

SIGNS
Two friends, each alone, looking into a mirror, smiling. They hold their smiles a long time. They meet somewhere, gaze at each other silently, and smile for a long time. Then they return to look into their mirrors for a long time, this time not smiling. They meet somewhere again, and silently smile at each other for a long time.

MOOD MUSIC
A group of friends spend an ordinary day together—doing business, going to school, doing housework, gardening, traveling, telephoning, shopping, etc. They each carry a tape recorder with a small earphone placed in one ear. The recorders all play the same program of sad, dramatic, lyrical and tragic music. Whatever the friends do, there will be a musical accompaniment. Just like the movies!

TEST
Two friends spend a day together. At some point, one or the other says give me some money, I need it. The money is given without question. Later, the money is demanded back and it is returned. In the next few days, the friends are together again and one or the other says give me your jacket, I'm cold. The jacket is given without question. Later, the jacket is demanded back and returned.

RECYCLE
The hallways of a large office building are carefully swept clean by a group of friends. When everything is finished, all the dust, paper and debris are carefully put back on the floors as they were found. Later in the night, the professional cleaning team arrives to do its normal job.

MONKEY BUSINESS
Two acquaintances spend a sunny day together. They don't speak. One follows the other by walking on the head of the other's shadow. Sometimes, the head of the shadow is in front, sometimes behind. When either one feels the distance between them is too close, or too far, a bell is sounded.

RHYME
A person records the sounds of her or his breathing at different times: reading a book, walking to the store, sleeping. One night later on, the person sits alone at the sea edge, head encased in earphones. Through them is heard the previously recorded sounds of breathing and the rolling of the waves watched.

Some of the actions were repeated from past works: moving furniture around, sweeping up, stacking blocks, listening to recordings in conjunction with real sounds, and looking in a mirror. But there was a new emphasis on the term "friends." Making friends had long been a motive for Kaprow's works, but here friendship was the premise of each activity. Any artistic, social, or psychological content arising from its enactment played off the personal bond between participants. Getting to know each other was prerequisite to the performance of these works, marking a clear shift away from the more generalized behavior pieces of the late 1970s and toward increasingly personalized exchanges taking place in the context of actual (or emerging) friendships.

Real relationships, then, rather than random pairings, underlay the works Kaprow offered his European friends. Unlike the European pieces of the 1970s, there was no premeditated agenda in which the clichés of national identity were enacted. With this suite of activities in Essex, Berlin, Amsterdam, Cologne, Paris, Pouillac, Florence, Munich, and Hamburg, Kaprow crossed a threshold of inti-

macy in his works. Thereafter, the idea of participation gave way to that of the rituals and processes of intimate exchange. The everyday environment as the site of enactment became the spaces of participants' lives: the kitchens they cooked in or the streets they took when buying groceries or walking the dog. Formal routines softened into informal encounters. The conventional roles of artist and patron eased into exchanges of food, accommodation, and courtesies between guest and host. In effect, Kaprow recalibrated the "art world" to the social proportions of friendship—to *his* world.

company

In April 1982 Kaprow was invited to participate in a weeklong series of lectures, workshops, exhibitions, film screenings, performances, concerts, and panel discussions at Rutgers University to mark the twentieth anniversary of the school's graduate program in the visual arts. It was intended to highlight the university's role in turning out experimental artists during and since the early 1960s. Some of the speakers that week were Peter Schjeldahl, Peter Frank, Martha Rosler, Carter Ratcliff, Ingrid Sischy, Richard Martin, and Kate Linker. Panels were convened on such subjects as art as a social and political act, arts education, public art, and computer arts. Kaprow shared a panel called "What Happened: 1958–63?" with Roy Lichtenstein, Robert Watts, George Segal, and Henry Geldzahler.

Against this luminous background, Kaprow offered a new work, which, by prior arrangement, was made available for participation five days before the official start of the festivities. Designed to be performed by individuals, it was to take place in an isolated basement room of a large campus building called Ballantine Hall, which had once contained an indoor pool. Small black-and-white posters urged participants to sign up by reserving an eight-hour block of time between April 5 and 15 on a schedule posted on the door of the hall. Each participant had a copy of this written plan:

A person locates a bare room and sits in it for a long time. Then she or he brings into the room a cement block and sits with it for a long time. A second block is brought in, a third, a fourth, a fifth and so on, up to the number corresponding to the person's age. At each addition, the person sits with the blocks for a long time. Then, one by one the blocks are removed. The person sits, as before, at each stage, for a long time, until the room is empty. Then, she or he sits in the empty room.

The timetable of *Company* was based on the eight-hour work cycle. Participants could sign up from 9 A.M. to 5 P.M., 5 P.M. to 1 A.M., or 1 A.M. to 9 A.M. Since the room was dark, windowless, and underground, the participants' experience of time was abstracted from the world outside. A lone chair sat in the middle of the room, and a single lightbulb hung above the chair. Off to the sides, near the walls and steam pipes, about a hundred cement blocks were stacked. One entered the room at the appointed hour and began enacting the plan.

The plan for *Company* seemed straightforward, but actually raised more questions than it answered. Following its directions required lots of active interpretation: How do I sit in a bare room for a long time? Do I sit in the chair or on the floor? Am I quiet? Am I still? How long is a long time? Do I use a watch or do I sense the passage of time in my body? What does it mean to sit with a cement block? Do I retrieve it from the nearby stack of blocks and place it somewhere special on the floor? What is special about a patch of floor? Do I put the block back when I'm done, or do I leave it? If I leave it, does it become a marker of the long time and special place I shared with it? How long is the *next* long time? And the next? If I'm expected to sit with as many blocks as the years of my life, do I begin thinking of each block as having a particular age—say, age six? If so, how much time do I sit with each? Is age six more deserving of time than age thirty-six? Do I re-

live each year in succession? If so, are some blocks more emotional than others? Does emotional intensity make the time seem shorter? (Has the art of this enactment degenerated into therapy?) As I count the years, does the time I spend with each seem to quicken? Are some years boring or forgettable? Do I remember every year? Does one year slip into the next with a momentum that drives remembered experience into narrative? Does my life seem like a movie? Is a year the unit with which we actually remember our lives? Or is memory just a block of experience? Is the memory of experience blocked from time to time? Or, is the block just a block and not a symbol? If so, am I sitting for a long time in front of nothing? Is this satori?

The questions posed were both practical and philosophical. Tucked between the lines of the written plan, they became truly apparent only at the time of enactment. When it was time to move and sit with a block, the questions of how, where, and how long suddenly presented themselves—and in time, the question of why as well. Physical experience slipped into philosophical reflection.

Yet however minimal in conception, *Company* was an intensely physical enactment. Performing it was exhausting. The individual blocks were heavy. The oldest participants had the burden of moving the most blocks; the youngest had to move the fewest. To move them was to animate memory; to sit with them was to give memory its time. The blocks became physical metaphors of what participants remembered about the years of their lives, and what they had forgotten as well: they were either dense objects or deadweight.

Over the course of eight hours, the participants' sense of time became distorted, at least compared with the tempo of everyday life. Time was compressed by emotion and extended by fatigue; it seemed to run on forever or just run out. Mostly, it conformed to the narrative contours of the participants' "stories," by turns episodic, chaptered, seasonal, cinematic, punctuated by moments of terror, driven by vaguely familiar characters, softened by instances of love and acceptance, or composed of the fragments of other people's stories. In the dark, quiet basement, Kaprow provided time for participants to live with their stories, and the stories, in turn, kept them company.

Company was billed as a "unique performance prepared especially for the celebration," but it couldn't have been less celebratory. Kaprow's relationship with Rutgers was deeply ambivalent. On the one hand, it had given him his first teaching job. Photos of him as a young, somewhat tweedy, usually pipe-smoking professor suggest the ease with which he'd assumed the academic role, and he valued the distance that teaching at Rutgers had given him from the New York art world—it had positioned him sufficiently far from the city's galleries and loft parties to allow him the critical detachment necessary to conduct his experimental art. The campuses and farms (Segal's and his own) of New Jersey had been the laboratories of his early environments and Happenings as much as the Hansa and Judson galleries or even Cage's class. On the other hand, Kaprow had been denied tenure by Rutgers. Now, twenty-three years later, he returned with a work so private and reserved that it seemed like a refusal to participate in the festivities. University officials undoubtedly hoped he would create a Happening, but he gave them an anti-Happening instead. Its setting—a bare room with a lone chair beneath a single bulb—echoed the inquisition he had experienced prior to his dismissal. He had always felt alone at Rutgers, and the piece he now gave to the university, though one of his most elegant, was valuable only to those willing to keep themselves company for a long time. The Happening was internal now, a play of memory and imagination catalyzed by rote physical enactment—like saying one's prayers or doing one's chores. Doing brought some kind of knowing—perhaps a long-sought "beautiful privacy."[12]

storytelling

As his works achieved greater intimacy throughout the 1980s, integrating more fully into the contexts of friendship and everyday experience, Kaprow began to see storytelling—his own, his participants'—as their most public aspect. It was as if the once public spaces of Happenings were filling up with the telling of what had happened. Though he had earlier adopted the "consciousness-raising follow-up" of feminist art and adapted it to his own ends, it wasn't until 1981 that Kaprow began emphasizing storytelling as a way of both documenting and extending a work. "What will remain with us afterward," he wrote to Petra Kipphoff, "will be memories and the stories we can tell."[1] Telling stories thus became Kaprow's way of cycling the experiences of his works back into a public, albeit intimate, sphere, as narratives.

As a form of documentation, Kaprow's storytelling was genially ironic. Friendly and engaging, it was only as archival as his memory. Often, Kaprow took conscious liberties with "the facts" in his retellings, embellishing, forgetting, reinventing, or just making up details as he went. His stories were more like gossip than oral history. The point was not to misrepresent or exaggerate given enactments, but to extend them into the present—to (re)animate them—which was the role gossip had played in his work since his earliest Happenings (the number of people experiencing his works through gossip and rumor far exceeding those who actually participated in the events). By telling stories, Kaprow once again became his own carnival barker, inviting people inside the tent, but this time through the back door. Instead of enticing them with "something to take place, a happening," he enticed them with stories of happenings that had taken place already.

Following is a selection of six stories told by Kaprow between 1981 and 1986, retold here in the third person.[2]

tail wagging dog

Kaprow and a friend, the musician Jean-Charles François, did small events for each other over the course of a year to provide some diversion from their administrative duties at the University of California, San Diego. They performed the events together, usually just the two of them, but sometimes with one or two others. *Tail Wagging Dog* involved going out to the hills behind Del Mar. The idea was that one of them would follow the other without saying a word, only making sure to step constantly on the shadow of the other, no matter where he went. In practice, this was more difficult than it might seem. Since the leader went over stones, around cacti, up and down ravines, and so on, the length and relative position of the shadow changed often. Sometimes it was in front of the leader, if he was walking away from the sun; in that case, the follower had to walk backward to keep the shadow in view. If the leader swung around to a different direction, the follower would have to make a quick change. The leader, in theory, had no obligation to his follower. At certain moments—for example, when they were walking up a ravine—the shadow would be shortened by the angle of the ground. Then they would find themselves nearly on top of each other, their shoes touching. When the follower lost contact with the shadow (as frequently happened), he would loudly strike together two stones he held in his hands. This single sound marked the moment when they exchanged positions; the follower became the leader. But, of course, since contact was lost so often and their directions kept changing, it all got pretty unclear as to who was what. Nevertheless, it was very formally executed.

clean graffiti

For another piece, *Clean Graffiti,* Kaprow and François drove out into a semi-industrial area east of San Diego. This work made use of the sun as an evaporator. The two of them separated and went their own ways among the area's buildings and parking lots. They wrote their first name with spit on places that they liked, such as walls, pavements, truck tires, and so on. They watched their name disappear in the sunlight, sometimes slowly, sometimes fast, then went on to find another place. Each signed his name this way in as many different locations as the number of letters in his first name: five for Kaprow and eleven for François. Now and then, Kaprow or his friend would catch glimpses of the other turning a corner in the distance or standing attentively in front of a wall. Once, Kaprow discovered the faint traces, the afterimages, of François's name near his on a glass office door.

putting on your face

For *Putting on Your Face,* a friend, Steed Cowart, joined Kaprow and François. Each took a small pocket mirror and went off, separately from the others, to a designated spot on the campus of the university. Once there, each sat down and looked into his mirror. They were to decide either to smile or to frown, and then were to hold that expression indefinitely or until one of the other two friends came for a visit.

Visiting another was a choice. Consequently, their smiles or frowns could go on for a long time (and for Kaprow it felt strange to look at a frozen smile that seemed less and less funny). If one of them chose to visit another, he had to walk across the campus with his smile or frown fixed on his face as before, still looking in the mirror. When he arrived at the other sitting spot, he and the other participant would compare expressions. If they were the same, they would simply exchange places but maintain their facial expressions; if they were different, they would exchange places and reverse expressions. This way, the situation was prolonged.

At one point, Kaprow's two friends came to his place at about the same moment. One was smiling and the other was frowning. It was impossible for all three of them to avoid laughing out loud. François turned around and went back to his spot, still giggling. He told Kaprow af-

terward that he'd gotten lonely because no one had come to see him frowning and his face hurt.

walking light on the world

One time, Ludwig Thurmer, Barbara Glas, Kaprow, and Coryl were together in Berlin. Thurmer and Glas had a new baby. So each couple went off into the streets to find some young grass, since it was spring. When they found a field of grass, one of them walked slowly into the grass, leaving clear impressions of his or her shoes. The other followed exactly in the same footsteps, but reached behind each step to lift up all the flattened blades of grass so that no marks were left behind. Looking back, they couldn't tell they'd been there.

building muscles

Kaprow remembered that in his childhood he had read advertisements by Charles Atlas, a body builder who promised to build the boy's muscles as big as his. It was done by "dynamic tension": you simply pitted one muscle against another—say, one fist against another fist—pressing as hard as you could. Soon you would have muscles.

So Kaprow decided he would do a funny play on this: he would attempt to accomplish nothing using the Atlas method. The idea would be to open a door while trying to keep it closed, and to close a door while trying to keep it open. There were two doors in his living room, one to the outside and one to the garage. For half an hour, he pushed open the outside door as slowly as he could with his right hand, while with his left he pulled it back almost as much. He used a lot of effort, tensing his arms and body, trying to keep the door moving outward as if it were the minute hand of a clock. That way, the door was fully opened when an egg timer rang at the end of the half hour. He noticed that he was standing on the threshold exactly between inside and out. With the other door, Kaprow began on the threshold and moved slowly into the garage as he pulled the door closed. Since he was facing the other way this time and the position of the doorknob was reversed, he pulled now with his right hand while pushing back with his left.

During the first period, when he began practicing this "dynamic tension," Kaprow began to sweat and then to shake. He thought this was quite humorous. When the egg timer rang, he was a little faint. In the second half hour, the shaking became pronounced and he wondered what was happening to him. At the end of the half hour, he barely heard the bell as he took his hands away from the closed door. They felt as if they weren't his hands; they had no feeling in them. He was quite dizzy and couldn't keep his balance. Still shaking, Kaprow managed to get to bed and lie down. Several hours passed before he could get up and walk safely. Later, a doctor told him that he had nearly put himself into a convulsion because he hadn't breathed normally.

another spit piece

Kaprow decided to clean a kitchen floor with Q-tips and spit. It was very intense work on his knees, but he found it an interesting process. He got to see, at close-up range, crumbs, dead flies, pieces of hair that he'd never noticed. (He supposed that dogs and babies also saw these things.) In the process, he used up several boxes of Q-tips and often ran out of spit, which he replaced by drinking beer. Altogether, it took almost four days to clean the floor. Later, he told some people about this cleaning activity and they said, "What! You used dirty spit to clean the floor?"

Chasing shadows like a rodeo clown, writing illicitly on surfaces with evaporating spit (a kind of invisible ink, like the kitchen cleanser in *Eighteen Happenings in Six Parts*), making faces that harden into masks, covering tracks by walking lightly on young grass, building muscles even if it makes you dizzy and sends you to bed (even if it reveals you as a weakling): these are among the motifs—often furtive, occasionally ornery, both stubborn and penitent—

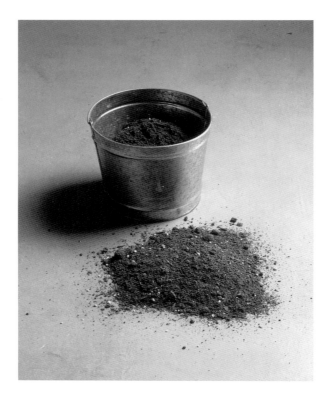

BUCKET HALF FULL OF DIRT FROM *TRADING DIRT*,
1983–86 (PHOTO: BOB COOK)

arising in Kaprow's stories of the early 1980s. But there is one story in particular that best captures the spirit of this period.

trading dirt

One day in 1983 Kaprow woke up with the idea "to do an extended piece." It occurred to him that it might be fun to trade buckets of dirt with unsuspecting, or somewhat suspicious, others. He would dig a bucket's worth of dirt from his garden and place it, along with a shovel, in the back of his pickup truck. He would then ask a friend or an acquaintance for a bucketful of dirt and offer his bucketful in return. Charmed by the idea, he dug the dirt ("it was good dirt; we'd been working that dirt"), put it in a bucket, put the bucket in the truck, and forgot about it for several months.

One night, as he was preparing to leave the Zen Center after several cross-legged hours on a pillow, he suddenly remembered the dirt (an earthy satori?). He asked one of the young men who lived there if he could have a bucketful of dirt. Taken aback, the fellow shrugged, pointed toward the plantings, and said, "Sure. You can have all the dirt you want." Kaprow said thanks and went to his truck to get his bucket of garden dirt and the shovel. When he returned, the young man, having recovered from his incredulity, met him by saying, "Wait. I have a better idea. Instead of taking the dirt from around the plantings here, let's go under the house and take it from beneath the seat of our teacher. That way, it will be heavy-duty Buddhist dirt. It will have all the vibes of her ass."

Crawl spaces under Southern California houses aren't very roomy, and Kaprow had to scoot along on his belly with a flashlight, dragging his bucket of dirt and the shovel behind him as he brushed away cobwebs. The ground was hard and dry and laced with concrete rubble and nails from when the house had been built. As he struggled to find the spot beneath his teacher's seat, he

began having "some pretty uncharitable thoughts" about giving up his good dirt for "this crap." Unable to locate the exact spot—"we wanted a direct beam from her ass to the ground"—Kaprow asked his friend to go back upstairs and knock on the floor where their teacher sat.

Once he found the spot, Kaprow realized his shovel was useless, since there was not enough room to stand it up. Improvising, he poured out his garden dirt and began scooping away at the ground with the empty bucket. With some effort, he got the bucket filled, set it aside, and pushed his good dirt—loamy and rich with nutrients—into the hole. The exchange was complete and fair. Although the dirt from under the Zen Center was dry and depleted, it was spiritually "vibrant" from prolonged exposure to "Buddhist vibes." Presumably, the rich garden dirt would now acquire a less material nutrition, while the heavy-duty Buddhist dirt—that's what Kaprow called it—would test its faith out in the material world.

Kaprow wiggled out from under the house, and as he dusted himself off several other Zen Center attendees who had gathered asked what he was doing. When he told them he was trading dirt, they asked why. When he told them, "That's what I do," someone said, "That's stupid." Kaprow replied, "I suppose you think sitting on a cushion day in and day out is smart." Everyone laughed. "That was a flash, you see, about the meaning of life"—it can only be discussed in particular, in terms of dirt, or stupidity or silliness, or childsplay. Kaprow and his friends talked for hours about the meaning of life and drank beer from a cooler in someone's truck. They all knew that a profound, if silly, exchange had taken place. They also knew they wouldn't have been discussing it if the metaphors of that exchange had been religious or philosophical. A bit drunk, they all went their separate ways, and Kaprow put the bucket and shovel back in his truck, where he again forgot about them.

Several months later, he chanced upon his friend Eleanor Antin, who was also then attending the Zen Center. She said, "I hear you're trading Buddhist dirt." Kaprow told her the story of the earthy exchange beneath the teacher's seat, then asked, "Hey, can I have a bucket of your dirt?" Antin, familiar with these kinds of involvement, said, "Sure. You're up to your old tricks." He followed her up a weathered dirt road to her house on a dusty hilltop outside Del Mar. When they arrived, Antin asked Kaprow to wait because she wanted to talk to David, her husband, about making the trade "together with him." Shortly, they emerged from the house, "looking rather pensive," and announced to Kaprow that they wanted to dig the dirt themselves and that they had "chosen the grave of their dog," Hyden, who was buried in the garden. "That's very . . . touching," Kaprow offered. David and Eleanor, "already teary-eyed," dug soil from the grave and, after pouring the heavy-duty Buddhist dirt into the hole, handed him a bucket full of Hyden. He put it in the back of his truck and drove off down the hill.

One day later that spring, while he was buying fruits and vegetables at a farm stand near his home, Kaprow remembered the dirt. The woman who owned the farm stand knew him as a customer and, vaguely, as an art professor at UCSD. When Kaprow asked her, out of the blue, if he could have a bucket of her dirt, quickly offering one of his own in return, she seemed confused by the question. She stared at Kaprow as if trying to figure out if the question was for real or just a joke. "You want a bucket of dirt? From around here? For what?" Maybe she thought she hadn't heard him right. Seeing her perplexity, Kaprow began telling the story of the previous exchanges. "Listen, this is dirt from the grave of a dog of a friend of mine, which I traded for a bucket of heavy-duty Buddhist dirt, and . . ." "Heavy-duty Buddhist dirt?" she said slowly, shooting him a baleful look as another customer pulled up. With that ridiculous phrase, she knew he was playing a game—but she also knew that it wasn't a joke. "You see . . . ," he tried beginning again. "Fine," she declared. "There's plenty of dirt all around here. Take what you want."

Kaprow got a crowbar from the truck, and, as cus-

tomers came and went, he poked around, looking for a spot in the sun-baked clay that was soft enough to dig. He found one and dug a hole, piling the clay beside it. Kaprow then returned to the truck and got the bucket full of Hyden. As he passed in front of the farm stand on his way back to the hole, the woman grabbed a handful of pumpkin seeds from a basket on the counter and threw them in. Now it was Kaprow's turn to be startled. "What'd you do that for?" he asked. "Can't hurt," she replied. The game was on. "I thought you were a professor," she challenged. "I am," he answered. "I even have classes in this sort of thing." The woman was incredulous. "They pay you for this? That's stupid." "I've heard that one before," Kaprow said, "but what's smart?" She gestured toward her three-year-old grandson, playing behind the counter, and said, "I suppose I should say 'Making a living and all,' but look at him. He's doing what he wants. It's a pity he can't do it for the rest of his life." "Sure he can," said Kaprow. "You can send him to UCSD."[3]

Trading Dirt played itself out over nearly three years. Numerous other exchanges took place with various colleagues and friends. Kaprow decided to end the piece in 1986, when he and Coryl received notice that they would have to move out of the country guesthouse they were renting. Before leaving, he put the final bucketful of dirt in the garden. Nutritionally, it was probably poorer dirt than the original bucketful, but in the process of trading with others, he had acquired a great many stories, and these he told for years thereafter.

With *Trading Dirt*, Kaprow integrated storytelling as an aspect of the work: as part of the negotiating process, he told his trading partner the story of how he'd gotten this or that bucketful, where it had come from, what (or who) was in it, who he'd traded with to get it, and the like, using the story to confirm the relative value of his dirt as well as to establish trust with his partner. Stories can be used to obfuscate or inflate an item's value—as in the pitch of a used-car salesman—but Kaprow's telling of how meaningful the contents of his bucket were had to be trustworthy for a fair trade to take place. Since all fair trades are based on mutual trust, "the ethics of friendliness" were key to this enactment. With the wink of an eye and a firm handshake, Kaprow's storytelling moved the trading forward, animating its social interactions and adding narrative value to the dirt from bucket to bucket. It became clear to Kaprow that storytelling was integral to the work's unfolding: he was telling stories of the trading as the trading was generating stories. Storytelling, in this sense, is not recollection after the fact, but the metaphorical expression of what one is doing *as* one is doing it.

Of Kaprow's trading partners, those who knew him well immediately recognized the offbeat nature of the game. Those who knew him less well tended to struggle with whether to accept his proposition. Ironically, it was Kaprow's evident playfulness that convinced people of his seriousness. There is a difference between being invited to play a game and being made the object of a joke; once the distinction was clear to his partners, they all played along. Each added something to the transaction: suggesting alternative spots to dig, digging themselves, tossing seeds into the bucket, and so on. This was done to seek symbolic advantage. The unspoken but obvious agreement was to trade fairly, and trading fairly meant knowing the value of your own dirt relative to your trading partner's. But how do you determine the value of your bucketful of dirt?

Trading Dirt might be thought of as an "action parable" about value. It is no accident that Kaprow's trading partners took him to sites of transcendence, burial, and regeneration. Religious resonance, deep personal sentiment, hopes for one's grandchildren—these are some of the meanings of life that can be invested in dirt. Dirt from the garden, dirt full of Buddhist vibes, dirt from the grave of a beloved pet—which is worth more? Or, more to the point, how are they equal? Since the value of each person's dirt was so personally divined, the negotiating process itself became an object of negotiation. By tweak-

ing the rules (or making them up), traders brought the game into accord with their estimate of their own dirt's value—bringing it under the house where their teacher sat or to the graveside of their dog, where the "good dirt" lay. Or, being superstitious, they could seem to ignore the whole process but "add value" as the bucket passed by. (Couldn't hurt.)

So what did trading dirt symbolize? Transactions in general, perhaps, or how stories mutate from telling to telling. The play between contents and container, or between shape and shapelessness. The ephemeral nature of meaning as it cycles from garden to grave. Small-town conversations. The ongoing negotiations we enact every day, sometimes important, most times trivial. We trade glances, goods, affection, punches, credit, power, words, handshakes, four quarters for a dollar. In the most abstract sense, trading dirt is a metaphor for value itself; the dirt just makes the trading visible.

Trading dirt is Kaprow's idea of a good metaphor. It's not good because dirt has literary content per se, but because dirt can be traded; *something can be done with it.* When traded, dirt can be meaningfully enacted as a metaphor: it can be *like* a human process and *be* a human process. Metaphors, for Kaprow, are never passive, but active and engaging. Their literary content is not denied, but translated into forms of doing. This exchange— between symbolic content and the emergent meaning of physical enactment—has been a constant feature of Kaprow's work. In *Trading Dirt,* the process of negotiating the dirt's value was what gave the dirt meaning. The work had both dirt *and* trading, but it was the trading that mattered most; otherwise, the dirt would have just stayed in the bucket. By trading the dirt, the metaphor was an-imated: it extended from dirt to trading dirt; it slid toward the verb, but remained loosely tethered to the noun. This ambiguity inherent in the title—does it describe the dirt or the action of trading the dirt?—encapsulates the paradox that, when the metaphor is in play, it may be both. And if a metaphor is not in play, it's just a metaphor in waiting.

Trading Dirt might also be seen as a parody of the super-heated art market of the early 1980s, a time when painting was regaining popularity and collectors were retrenching in the wake of the "un-possessable" (that is, performative, conceptual, environmental, activist) art of the 1970s. Kaprow was not unconscious of the art boom when he woke up one morning in 1983 with an idea to trade dirt. When you think of it (and when you do, it's funny), the process of negotiating the relative value of this versus that bucket of dirt—with its arbitrary estimations, its rationalizations of sentiment and taste, its elaborate framing rituals, its citation of authoritative sources, its invention of a narrative, its passing of gossip, and, ultimately, its faith in the trader—is rather like the processes by which works of art are appraised by critics, curators, collectors, the public, and artists too.

If a parody, though, *Trading Dirt* was a parody in the back of Kaprow's mind, where most of his parodistic instincts lie. The heart of the matter was that the process of trading dirt gave him a way of coming into social contact with people and exploring "deep thoughts" about the meaning of life—thoughts you can't take seriously unless you name them something stupid, like trading dirt. So named, speculative philosophy takes its place as a practice in the everyday world of concrete things and lived experience.

rehearsals

People and institutions worldwide continue to solicit Happenings and environments by Kaprow, especially re-creations of his well-known works—the tire environment (*Yard,* 1961) in particular. Meeting these requests without simply restaging previous works became Kaprow's creative dilemma of the 1990s. Wanting to continue enacting his works in the present, he resisted restaging what would amount to a selection of his "greatest hits." Instead, he began offering sponsors "reinventions" of previous environments and Happenings. This question of redoing-versus-reinventing became apparent in the mid-1980s, when *Yard* was reinstalled in the sunken courtyard of the Whitney Museum of American Art, New York, as part of the exhibition *Blam! The Explosion of Pop, Minimalism, and Performance* in the fall of 1984. Newly commissioned works usually arose out of residencies and, increasingly, workshops to which Kaprow was invited. While in Salzburg, Austria, for the International Summer Academy, for ex-

ample, Kaprow conceived *A Private Act in a Public Place* (1984), a collaborative environmental work in which art students individually selected and positioned chairs and mirrors throughout the streets of the city. In the summer of 1986, in conjunction with a retrospective exhibition (of mostly reinvented environments, such as *Yard* and *Push and Pull* [1963]) organized by the Museum am Ostwall, in Dortmund, Germany, Kaprow enacted a work called *The Perfect Bed,* in which he and others carried beds and bedding around the streets of the city, looking for the perfect place to sleep.

precedings

The philosophical divide between restaging and reinventing past works came to a head for Kaprow in April 1988, when he was invited, by this author, to participate in a yearlong series of "retrospections" in which the artist

would reinvent and then enact particular works from between 1959 and 1985 that he believed had helped move his thinking forward over the course of his career. Called *Precedings,* the project was organized by the Center for Research in Contemporary Art at the University of Texas at Arlington. The reinvented works, including *Eighteen Happenings in Six Parts* (1959), *Sweeping* (1962), *Company* (1982), and *Trading Dirt* (1983–86), among others, were enacted in Arlington, Oakland, San Diego, New York, and along the Dutch coast. A weeklong gathering in Arlington, during which Kaprow spoke of his earlier work—or retrospected—over the course of three or four evenings and which concluded with a one-day symposium, served as the conceptual centerpiece of *Precedings.*[1] For Kaprow, retrospecting was a way of avoiding what he considered the trap of allowing his Happenings to be ossified as museum (and period) pieces in a retrospective exhibition. The idea was to retain the core metaphor of each work while enacting it according to the present-tense particulars of given times and places—with unpredictable results.

Trading Dirt, for instance, was reinvented for the Dutch coastline in 1989. Each participant (there were about thirty) was invited to place one hundred grains of sand into a plastic film container with tweezers, drive twenty or so miles up the coast (in a small caravan of cars), empty out the sand, and collect one hundred more grains, and so on, repeating the process until the entire coast had been traversed in a single day. Meanwhile, a second group enacted the same process in reverse, traveling south, but using small bottles with eyedroppers to collect and disperse one hundred drops of seawater at each stop. The activity of counting grains of sand or drops of water was psychically disorienting against the endless backdrop of the coastline, and, for most participants, the lure of the thundering sea and vast stretches of empty beach was irresistible; the attentiveness required for counting grains or droplets was under constant assault from the theater of waves and clouds and wind and changing light.

The water drops proved easy to count, but the damp grains of sand were impossible to pick apart (so people began estimating grains per pinch). As they traveled from site to site along the coast, participants drove through tidy Dutch villages and walked toward the beach past crumbling German entrenchments from World War II. The entire day was drenched in a dreary Northern European romanticism; the absurdity of the counting tended to give way to more soulful metaphors, such as the trickling sands of time or crying saltwater tears. By day's end, one student, a boy, wept at having been carried along by the communality of the journey only to be brought to his particular emotional abyss, signified, apparently, by the overwhelming scale of the sea. In Southern California, trading dirt had been about negotiating fair trades in the domain of one's daily movements. Along the Dutch coast, there was no fair trade, only repeated tradeoffs made at the water's edge—a few grains of sand and drops of water transported north and south the entire length of Holland. The effort—despite consuming all of one's attention— seemed an insufficient bargain with eternity, like trying to hold back the sea.

Trading dirt near San Diego, trading grains of sand and drops of water along the Dutch coast. Different places, different experiences; different experiences, different meanings. Same idea, new enactments. For some, Kaprow's reinvention of previous events seemed an ironic gesture; as Michael Kirby put it in an emotional tribute to Kaprow's work during the symposium in Texas, "I know this isn't *really* a retrospective—that it has 'quotes' around it."[2] Indeed, *Precedings* wasn't a retrospective in the customary sense. It was retrospection, allowing Kaprow to think about works he had already done—to think about his career—as a template for doing new works in various places with different groups of people. However, he retrospected proactively, drawing from his grab bag of metaphors-in-waiting for an audience—not only the one in Texas, but around the world—awaiting an accounting of his past.[3] Kaprow's enactments are works of art (despite his attempts to "un-art" them), and as such may be

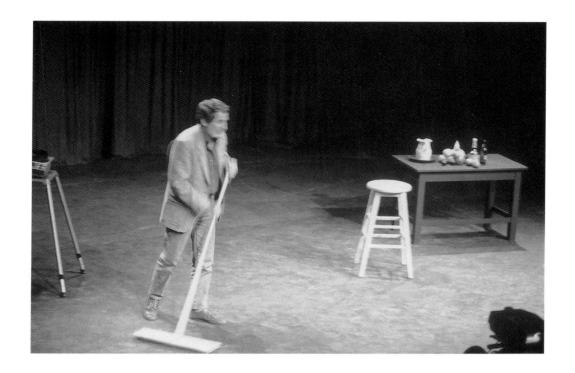

KAPROW SWEEPING THE STAGE DURING HIS RETROSPECTIVE
PRECEDINGS AT THE CENTER FOR RESEARCH IN CONTEMPORARY
ART, UNIVERSITY OF TEXAS AT ARLINGTON, APRIL 1988
(PHOTO: JEFF KELLEY)

HUNG LIU PICKING UP GRAINS OF SAND ALONG THE DUTCH
COASTLINE DURING A REINVENTION OF *TRADING DIRT,* 1989
(PHOTO: ALLAN KAPROW)

considered historical artifacts. But they are, first and always, enactments in the present. *Precedings* was not ironic at all. It was a strategy for acknowledging the passage of time as a way of continuing to work. It was poignant.

seven environments

In 1991 Kaprow was invited to reinvent seven early environments at the Fondazione Mudima in Milan. Installed in each of the building's four stories, including the basement, were updated versions of *Beauty Parlor* (1958, plates 16–17), *The Apple Shrine* (1960, plate 18), *Stockroom* (1960), *Yard* (plate 19), *Words* (1962), *Push and Pull,* and *Eat* (1964). In the new environments, Kaprow seemed to acknowledge the profound global and cultural changes of the previous three decades—what might be called the numbing of the body politic—by smoothing out his materials and consolidating his metaphors. The ragged expressionism of the early 1960s, for instance, was reconceived in terms of the regulated consumerism of the century's final decade; bohemian street junk was replaced by synthetic materials and standardized, easily consumable units; cardboard, chicken wire, broken glass, and tar were largely supplanted by rolls of carpet, etched glass, sheets of plastic, and walls of silk. The reinvented *Apple Shrine* was a good example of this shift from 1950s expressionism to 1990s corporatism. It consisted of about fifty black oil drums—once intended for drumming up noise in such works as *A Spring Happening* (1961) and *Out* (1963)—stacked in towers on a sawdust-covered floor in a room harshly lit by fifteen neon tubes suspended vertically from the ceiling like high-tech missiles (or the lightning bolts of God) about to strike. Decorating the gleaming black drums, emblazoned with corporate logos (the Logos?),

KAPROW MOVING CARPET ROLLS DURING A REINVENTION OF *PUSH AND PULL*, MUDIMA FOUNDATION, MILAN, 1991 (PHOTO: JEFF KELLEY)

were clusters of green and yellow apples, some natural and others plastic. As in 1961, one could not easily tell them apart by sight, and one's choices—to consume or "consume"—were basically the same. Only now, to pick an apple from a menacing tower of black drums in a desertlike setting bathed in an apocalyptic light, and then to either eat or steal that apple, was to participate on an individual level in the cycle of consumption and depletion in which modern societies are implicated on a global scale—particularly in terms of our consumption of fossil fuels (this in the immediate aftermath of the Persian Gulf War). Depending on whether one chose plastic or fruit, the parable of Eve's fateful choice either echoed in one's conscience or rumbled in one's stomach.

Accompanying each environment was a mural-scale photograph of its historical precursor, allowing people to make the visual comparison between then and now as well as to look to the frozen poses of these first participants for clues about what to do in the reinvented environments. Besides their obvious historical interest, the photographs helped collapse three decades of elapsed time by inviting members of the audience to perform tasks loosely modeled on the ones in the pictures. Which is to say, participants were invited to physically imitate the poses and behaviors of their historical predecessors, not in order to correctly reenact or properly experience earlier works, but as kickers for action in the present. (For example, a young George Segal is shown pushing a desk in *Push and Pull,* so visitors to the 1991 reinvention might decide to topple a roll of carpet.) If photographs had once played the role of mock documents (as in *Transfer* and *Record II* [both 1968]) or illustrations of possible enactments of written plans (in the booklets of the late 1970s), Kaprow now offered participants "authentic" images of works from his past as foils for their reinvention in the present. Anyone trying to imitate them precisely would inevitably get them wrong, since while images can be imitated, behavior cannot be duplicated, and because the reinvented environments looked nothing like the ones in the pictures. Kaprow's point was that getting it wrong was

A FIAT UP ON BLOCKS IN REINVENTED *YARD,* 1991 (PHOTO: JEFF KELLEY)

actually getting it right. Thus it was that Kaprow used historical photographs to hoodwink his Milanese audience into reinventing his environments—and, to some extent, his past.

In Milan, the famous photograph of the youthful Kaprow throwing a tire in the sculpture garden of the Martha Jackson Gallery drew a striking contrast with its 1991 version, in which a silly, tireless Fiat, jacked up on blocks in the back patio of the Fondazione Mudima, was surrounded not by a stormy black sea of used American rubber, but by a hot-pink wall with racks of smaller new Italian tires organized in neat, bureaucratic rows. Beneath the Fiat were tools for changing the tires. Instead of throwing them, visitors were invited to hunker down and change them. The artist's heroic (or mock-heroic) "gesture" was now rationalized as the audience's mechanical motions. One could not help but interpret the work—the crippled auto, the archived tires—as a reference to the body's aging process. Spry for his age, Kaprow could still have thrown a tire, but the world that would have recognized such an effort as modern and mythic and authentic had disappeared. In its place, something more calculating and standardized had come to pass.

With his seven Milan environments, Kaprow re-

membered a previous body of work. In re-membering, he reminded his audience of a world-space that once stood for the body and its functions, but which, having been mediated into semiotic oblivion, no longer existed in any meaningful sense. Through that space had moved a curiously American conception of the body as the existential core of human-experience-as-action, which meant that, in its postwar search for meaning in existence, the body had no choice but to fill up the modern void with evidence of itself. For some, that void was the American West. For others, it was a canvas laid on the studio floor. For still others, it was "the vastness of Forty-second Street." The differences between them were unbearable at the time, but we can now see that they are cut from the same cloth. It matters little that while Pollock threw paint, Kaprow threw tires, for both were making claims upon the world. But as the world changes, so do the metaphors we enact. Our metaphors today are informational, not industrial. We project language, assert images, offer services, purchase goods, generate wealth, estimate risk—take risks—archive memories, enact politics, practice health, manage illness, join communities, and read the *New York Times* on our luminous flat screens of choice. In 1966, describing the limitations imposed upon artists by architecture, Kaprow wrote: "If there are to be measures and limits in art they must be of a new kind. Rather than fight against the confines of a typical room, many are actively considering working out in the open. They cannot wait for the new architecture."[4]

The new architecture, as Kaprow understood it at the time, was something fluid and open, emerging from such innovations as Kurt Schwitters's *Merzbau,* John Cage's Black Mountain event, Robert Rauschenberg's Combines, Buckminster Fuller's geodesic domes, Frederick Kiesler's Endless House, the inflated balloons, mixed mud, and slashed paper walls of the Japanese Gutai artists, or his own environments of the early 1960s. Since then, artists and architects have probed the membranes separating the Modernist box from the spectacles of postmodern so-

ciety. Buildings and public spaces have been frequently (and sometimes literally) turned inside out or upside down. Artists and architects have collaborated and have formed collaboratives. Sculpture and architecture have been blended with words as memorials. Everyone learned from Las Vegas. The image world has taken up residence in the physical world. But for Kaprow, the "new architecture" never arrived. What arrived instead was old age; time had begun to catch up. It was the architecture that had been there all along.

In 1991 Kaprow was sixty-four years old. One of the conditions of being a famous artist and getting older is that one's audience begins requesting—Kaprow would say "demanding"—an accounting of one's past, especially if that past, which amounts to art history, cannot be otherwise accounted for by conventional objects of art. If, as in Kaprow's case, you *are* your past, then *you* become the object of the culture's retrospective desire. This desire to experience an artist's past settles upon him with the weight of art history, and it is the artist, not his work, who is asked to authenticate that desire. An artist who composes and enacts events becomes, in time, his own medium. Remembering can be illuminating for the rest of us. For Kaprow, it can clutter the moment with art history. That's why, when called to account for the past, he finds it more interesting to reinvent his history in the spirit of childsplay. Besides, when all is said and done, whose career is not essentially a fiction?

workshops

An innovation of the 1990s was the workshop. Continuing the parallel track he established in the 1970s, between public commissions and private or pedagogical activities, Kaprow has increasingly offered workshops to students and patrons. Lasting a week or more, these hands-on seminars on childsplay are scaled to classroom proportions (usually around twenty students), allowing Kaprow to deploy a range of tried-and-tested "exercises" from his

KAPROW WITH PARTNER DRAWING AND ERASING CHALK LINES ON THE GROUND, AT A
WORKSHOP AT MILLS COLLEGE, OAKLAND, CALIFORNIA, 1999 (PHOTO: JEFF KELLEY)

grab bag of metaphors in the throwaway spirit he has come to trust. At a workshop at Mills College in Oakland, California, in 1999, for example, he invited students to pair up and find a spot outdoors, where one person of each pair drew a chalk line on the ground while the other erased it. Echoing back through a hundred years of avant-garde erasures, this elegant, prolonged duet involved an unplanned social give-and-take that focused primarily on who was in charge, who worked harder, and when the activity was finished. The enactment yielded a lively discussion when the group reconvened. Typically, each workshop includes perhaps a dozen activities such as this, interspersed with conversation and storytelling about participants' experiences. The workshop format has allowed Kaprow to synthesize his interests in throwaway activities, the present moment, teaching, storytelling, intimate exchange, systems collapse, organic process, and the communal scales of friendship. To be sure,

they don't look very much like art, or even Happenings, but for anyone who wants to know where the Happenings went, the workshops of the late 1990s are a good place to look.

a total act

Looking back, one is tempted to suggest that Kaprow's career might have ended with *Trading Dirt,* given its elegance as a plan, its unpredictability as a process, its uncharted and rambling domain, its good-natured absurdism (and dash of fatalism), the oblique but unthreatening angle from which it engaged others, and its capacity for a small-town American form of conversation and maybe even friendship. *Trading Dirt* was everything Kaprow had ever imagined in a Happening, but it took decades of practice and experiment—and the end of Happenings themselves—to achieve it. The invitation to

trade bucketfuls of dirt was, in a sense, the one he had wanted to offer members of the New York art world back in October 1959, but he hadn't known how to. He had mailed little glassine envelopes filled with cinnamon sticks, matches, and torn bits of an oil-crayon drawing; heralding the end of art, these handmade announcements were seductive of the senses and slyly incendiary. He floated them in the urban environment beyond the gallery, hoping to lure an audience into participating in its own elimination. As is true for all great experiments, everything in the psychic vicinity of the Reuben Gallery those warm October nights was cast in the light of a new perspective. The spaces, objects, movements, materials, boundaries, patterns, performers, tempos, images, sounds, smells—"paint, chairs, food, electric and neon lights, smoke, water, old socks, a dog"—were made real in a way they had never been before. They were made real by an artist who insisted that the audience experience them as the stuff of a "new concrete art." By composing this "stuff" into performance analogues of everyday life, Kaprow helped catalyze the "alchemies of the 1960s" and beyond.[5]

No, Kaprow's career didn't end with *Trading Dirt*. Nor did it begin with *Eighteen Happenings*. One might say that it begins to end with every enactment in which lifelike symmetries, routines, exchanges, choices, conundrums, entertainments, tasks, maneuvers, games, and jokes are substituted for the time-honored conventions of the arts. As if trying to outsmart his shadow, Kaprow kept maneuvering just beyond the determined embrace of those conventions for the time it took to experience the meanings of life-in-particular. With each step forward (or sideways, or back), one imagines the idea of art lagging slightly behind, but only briefly, since, in part *because* of Kaprow's contribution to the field, the fabled gap between art and life has itself become a commonplace.

Playing, marching, measuring, calling, waiting, counting, coming, going, filling, emptying, eating, working, warming, sweating, cooling, trading, remembering, breathing, sleeping, running (away)—these are among the verb forms of Kaprow's art, the gerundive touchstones of his psyche. They testify to what is gained and lost—to what is risked—in the business of trying to live consciously. They remind us of the modern promise of art to intensify awareness, and they echo back through the artist's life to a childhood of anxious attentiveness to a fragile but exuberant body. Kaprow wanted to be a cowboy, but settled for being an artist. The practice of art—the artistic enactment of experience—allowed him to frame the fevers, parades, chores, rodeos, cool breezes, dust devils, asthma, loneliness, boredom, radio fantasies, and stolen horses of childhood into colloquial and commonplace forms of doing—into adult forms of childsplay. In so doing, he redeemed not only the experience of the sickly child, but gave experience back to the art of his time.

The price of giving experience back to art was that art became a gerund—it could be experienced only fleetingly, as a form of doing. Once the doing stopped, it became an artifact of memory, history, theory, and gossip. It threw itself away. Throwaway actions, throwaway myths, throwaway conventions, throwaway professions, throwaway identities, throwaway art—all beg the question of what remains for keeping. What remains from fifty years of throwing art away?

Life remains. The awkward embrace, the prolonged handshake, the forced smile, the passing thought, the silent partner, the abandoned plan, the mirrored reflection, the dry mouth, the heated body, the recorded pulse, the missed phone call, the heavy baggage, the domestic squabble, the endless sweeping, the big laugh, the small sigh, the highs and lows, the dead bugs, the traded dirt, the waiting, waiting, waiting. For in these and "a thousand other things" may be found instances of the meaning of life, if we attend to them with all our wits, as artists might.[6]

What is the thing as such? What is the moment? How does one eliminate the audience without canceling the performance? What might it take to move the spirit in

the modern age? Is meaningless work play? Can one play at life? How is accepting suffering joy? How is accepting life art? When is meaning experience? What is a Zen for our time? These are among the questions driving a fifty-year career devoted to the enactment of aesthetic experience. Behind them, the old vestigial question—What is art?—gives way to the more urgent question that was always present within it: What is life? In our cynical age, such a question is too easily dismissed as either a joke or a cliché. The joke would lie in our being too sophisticated to ask it, the cliché in our earnest expectation of an answer. Kaprow's art entails the enactment of the question, yielding, as it does, the particulars of experience. Holding a smile on one's face, undressing in front of a partner, sweeping up and then dispersing dust—the more conscious one's enactment of life's particulars, the richer and more elusive one's experience of living becomes. What is life? It's a question that can only be seriously enacted as play.

In "The American Scholar" (1837), Ralph Waldo Emerson wrote of thought as a "partial act" and living as a "total act." For him, action ripened philosophy into forms of living. John Dewey said as much a century later, when he cited doing as a form of knowing. In 1987, writing about John Cage, Kaprow, echoing back through American letters to Henry David Thoreau, observed that the experimental art of our time "can be an introduction to right living."[7] Like Walt Whitman, he attends to vernacular details and listens for the common cadence in the opera of the everyday. The art of experience has been his route to self-knowledge.

It also provided a constant "way out" for those artists who, during the second half of the twentieth century, sought to engage—each in his or her own way—the subjects, objects, processes, technologies, and meanings of everyday life as matters of aesthetic experience. It doesn't matter that few (if any) of the artists Kaprow influenced—in his or younger generations—have chosen, once having probed beyond the conventions of art, to set-

tle into the everyday as un-artists. That was Kaprow's goal for himself, probably as rhetorical as it was real—but the goal was stated. What we take instead from the example of Kaprow's art is simply that it happened, and, by happening, served as an example to others who may have been interested in blurring the boundaries between art and everything else. As Yoko Ono, speaking of the early 1960s, aptly put it, "It was just good to have Allan around."[8] In the final analysis, Kaprow's significance as an artist is not (or not only) that he draws subject matter from everyday life—this, after all, is the defining temperament of his generation—but that he creates participatory forms of enactment in which aesthetic awareness is trained on ordinary experiences, revealing their ecstatic potential (see plate 20). It is in this sense that Kaprow can be understood as an heir to the American tradition of the transfigured commonplace.

But he must also be understood as an artist. While he will forever be associated with the improvisations of the early 1960s, Kaprow's works have developed according to an experimental logic that preceded Happenings and in the decades following has played itself out in increasingly intimate forms of experience. He has gradually moved away from the public, spectacular features of the early Happenings toward a more genuinely participatory art in which the once-privileged content of the artist gives way to the personal experience of the participant. Today, the connection between Kaprow's enactments and the idea of art is, in practice, little more than a memory trace. Like "a faint memory of an old tale,"[9] art exists inside him as a network of practiced responses to the commonplace experiences of living. The "vastness of Forty-second Street," once the expanding, space-age envelope of avant-garde ambition, has been internalized as the open-ended play of consciousness seeking itself in physical and social experiences. It has been retrained to the proportions of childsplay. We can now see Allan Kaprow's Happenings for what they actually were: rehearsals for the rest of his life.

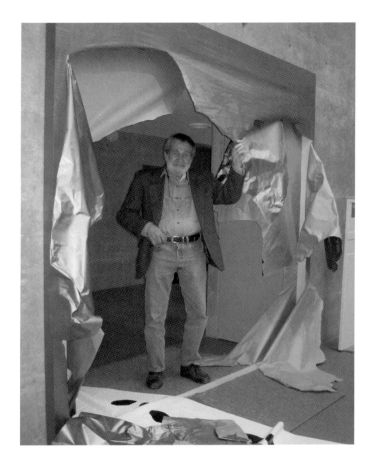

the stone starts from somewhere,
and moves, AS CONSISTENTLY AS CONDITIONS PERMIT, TOWARD THE PLACE AND STATE
WHERE IT WILL BE AT REST—TOWARD AN END. LET US ADD, BY IMAGINATION, TO THESE EXTERNAL
FACTS, THE IDEAS THAT IT LOOKS FORWARD WITH DESIRE TO THE FINAL OUTCOME; THAT IT IS
INTERESTED IN THE THINGS IT MEETS ON ITS WAY, CONDITIONS THAT ACCELERATE AND RETARD ITS
MOVEMENT WITH RESPECT TO THEIR BEARING ON THE END; THAT IT ACTS AND FEELS TOWARD THEM
ACCORDING TO THE HINDERING OR HELPING FUNCTIONS IT ATTRIBUTES TO THEM; AND THAT THE FINAL
COMING TO REST IS RELATED TO ALL THAT WENT BEFORE AS THE CULMINATION OF A CONTINUOUS
MOVEMENT. THEN THE STONE WOULD HAVE AN EXPERIENCE, AND ONE WITH ESTHETIC QUALITY.

john dewey, *art as experience*

epilogue

Late one summer afternoon in 1995, a friend was driving Kaprow, then sixty-eight, over the crest of a ridge near Oakland, heading back to the city from the redwood forest and fern groves in the canyon below where they had been talking about the meaning of life at a picnic table in a well-kept regional park. As they passed through the intersection at the top of the ridge, Kaprow noticed a man jogging along the road in a different direction, sparsely but brightly dressed in the way serious joggers so often are. Attached to his arm by an armband was a radio receiver connected by wires to earphones in the man's ears. Kaprow watched bemused for a few seconds as the jogger went his way, then wondered aloud: "I'm always amazed at how they count like that." "Count like what?" his younger friend asked, slightly befuddled. "Their hearts," Kaprow answered. "How they listen to their hearts beating while they run." His friend, knowing something of the artist's life and work (and especially his childhood), smiled but didn't laugh. "No, Allan," he explained. "The guy wasn't listening to his heart; he was listening to rock and roll." "Really?" Kaprow asked, sincerely surprised. "I always thought they were counting their heart rates while they ran." "No. It's music," his friend said knowingly. A few seconds later, though, it occurred to his friend, who was driving down the hill toward Oakland, that he had never once listened to the radio whenever Kaprow was in the car, though listening to music while driving was his habit. And now, for the first time behind the wheel, he became aware of the "silence" of the world passing by and, beneath that silence, felt in his chest and detected in his ears the beating of his own heart.

acknowledgments

I met Allan Kaprow in the fall of 1970. Then a painting student at the California Institute of the Arts, I recall him passing through the studio one night and saying something like, "I really dig the way your paint is building up." I knew who Kaprow was—I had recently been in a Happening (Publicity)—so his comment stuck with me. My paint was building up, of course, because I kept covering one failed attempt with another. Still, the fact that someone of Kaprow's stature would "dig" my effort was encouraging, and I needed encouragement.

Cal Arts was an intimidating place for an eighteen-year-old in 1970, but heady. Anything could be art. After a lecture on Duchamp by Max Kozloff I screwed a ham sandwich onto a white canvas and let it ripen. Several peers, now famous artists, were momentarily intrigued, but I had no follow-up, no second act. Eventually the sandwich fell off, to no particular consequence. Making non-art was not

so easy; I stuck with painting until I gave it up for writing.

I never studied with Kaprow at Cal Arts, though his general influence was such that I became increasingly attracted to the sites and occasions of non-art. (That had something to do with my leaving art school and working in a California gold mine for several years, an activity that reminded me of earthworks and Happenings.) Nor did I study with him at the University of California, San Diego, where in 1983 I met him for a second time while attending graduate school in art criticism. In time, however, we became friendly and developed a working relationship, talking often and at length about the kind of art he did and why he was less interested in its being art than I was. I respected him but I didn't believe him; to me, he was, and is, an artist. Thus began a decades-long creative tension between us—me continually asserting the art of his work, and he the work of his art.

The results of this ongoing exchange have been two books: *Essays on the Blurring of Art and Life,* a collection of Kaprow's writings I edited for the University of California Press in 1993, and this one. I took ten years to write this book because I'm slow, and also, I think, because I had to grow into my subject—Allan Kaprow's work. Although I taught theory and criticism in the art department at Berkeley from 1993 to 2004, I am not really an academic; I sometimes confuse academic inquiry with artistic process; both are slow in different ways.

Thus, I would like to acknowledge the support (and forbearance) of the following: Deborah Kirshman, my editor, whose precise professional pitch ranged from more encouragement to less pressure than I deserved; Henry Sayre, for noticing, with a very bright eye, my passion for this project at an early stage; Sheldon Nodleman, who once said to me that "maybe life is a debased form of art"; Paul Brach, one of the great teachers of American modernism, who tempered my interest in Happenings by reminding me that "real action," for him, had been the second wave at Omaha Beach on June 6, 1944 (800 yards from my father on that fateful day); William L. Fox, poet and writer about isotropic landscapes, as well as one of my best friends since 1979, whose reading and thinking about this book was honest like our friendship; Moira Roth, an advisor in graduate school, for her feminist perspective and, more importantly, her generous spirit; George Leonard, whose insights about American Zen were spellbinding reading and crucial to my thinking about Kaprow's koanic works of the late 1970s; George Lakoff, whose ideas about metaphors as enactments are never quoted in this book but move between many of its lines; Jim Breslin, Mark Rothko's biographer and former art department chair at Berkeley, whose conversations with me were always after office hours (he died in 1996); Wendy Sussman, a painter and colleague at Berkeley, whose sensibility shared nothing with Kaprow's but who was endlessly interested in my effort (she died in 2001); Jim Melchert, a decorous man who helped me learn how to get out of the way of my subject; David Antin, advisor for decades, whose literal mind helped me understand the difference between thinking as a writer and writing as a thinker (my thanks also for his foreword to this book, an essay I think he has always wanted to write); and Hung Liu, my wife, partner, and friend, a student of Kaprow's at the University of California, San Diego, when she came from China in 1984 (and where we met in graduate school), who offered her impatience and the breadth of experience, wisdom, and courage that drives it (and her)—all of which, in a curiously Chinese way, adds up to support.

Finally I would like to thank Allan Kaprow, whose willingness to allow me to peruse his files and tap his memory year after year in such places as San Diego, Encinitas, Oakland, New York, Paris, Milan, Kauai, and a cattle ranch in southwestern New Mexico has always seemed unearned, except now, upon the completion of this book. Though he likes to think of his art as "flat-footed," he is a man of elegant intellect, aesthetic grace, and philosophical substance. It has been an honor to engage him.

notes

foreword: allan at work

1. John Dewey, *Art as Experience* (1934; New York: Perigee, 1980), 44.
2. See Walter De Maria, "Meaningless Work," in *Esthetics Contemporary,* ed. Richard Kostelanetz (Buffalo, N.Y.: Prometheus Books, 1978). Emphasis added.
3. See Edward T. Hall, *The Hidden Dimension* (Garden City, N.Y.: Doubleday, 1966).
4. Allan Kaprow, *Some Recent Happenings,* Great Bear Pamphlet, no. 7 (distributed by Something Else Press, New York, 1966). The pamphlet contains texts for four scenarios.

introduction: sweeping the stage

1. See Richard Schechner, "Happenings," in *Happenings and Other Acts,* ed. Mariellen R. Sandford (New York: Routledge, 1995), 216–18.

chapter one: john dewey and the ranch

1. This latter phrase is from an announcement/press release for *Eighteen Happenings in Six Parts* (1959).

2. See the distinction that Kaprow makes between "art-like art" and "lifelike art" in his essay "The Real Experiment" (1983), in Allan Kaprow, *Essays on the Blurring of Art and Life,* ed. Jeff Kelley (Berkeley: University of California Press, 1993), 201.
3. Allan Kaprow, "The Meaning of Life" (1990), in Kaprow, *Essays on the Blurring of Art and Life,* 241.
4. John Dewey, *Art as Experience* (1934; New York: Perigee, 1980), 3.
5. Ibid., 5.
6. Ibid.
7. Ibid., 35.
8. As such, Dewey foreshadowed the emergence in the 1950s and 1960s of artistic experimentation and situational aesthetics.
9. Allan Kaprow, conversation with the author, Encinitas, California, April 1994.
10. Dewey, *Art as Experience,* 10.
11. Allan Kaprow, conversation with the author, Milan, October 1991.

chapter two: a prelude

1. Allan Kaprow, *Assemblage, Environments and Happenings* (New York: Harry N. Abrams, 1966), 160.
2. Allan Kaprow, "Experimental Art" (1966), in Kaprow, *Essays on the Blurring of Art and Life,* ed. Jeff Kelley (Berkeley: University of California Press, 1993), 69.
3. All scores and plans quoted in this publication are located in the Allan Kaprow Papers, 1940–1997, Getty Research Institute, Research Library, Accession no. 980063.
4. Allan Kaprow, "Right Living" (1987), in Kaprow, *Essays on the Blurring of Art and Life,* 224.
5. Allan Kaprow, conversation with the author, Encinitas, California, April 1994.
6. Allan Kaprow, "The Legacy of Jackson Pollock" (1958), in Kaprow, *Essays on the Blurring of Art and Life,* 5.
7. Allan Kaprow, conversation with the author, Oakland, California, July 1994.
8. Harold Rosenberg, "The American Action Painters," *Art News* (December 1952), 22.
9. Kaprow, *Assemblage, Environments and Happenings,* 151.
10. Ibid., 159.
11. Kaprow, conversation with the author, Encinitas, California, October 1994.
12. Kaprow, *Assemblage, Environments and Happenings,* 160.
13. Kaprow, "The Legacy of Jackson Pollock," 9.
14. Ibid., 7–9.
15. One senses here a harbinger of the Minimalism of the 1960s, in which processes and events took the time—and often the form—they needed to take, and no more.
16. Allan Kaprow, notes on *Communication,* Allan Kaprow Papers, 1940–1997, Getty Research Institute, Research Library, Accession no. 980063.
17. Allan Kaprow, conversation with the author, Encinitas, California, October 1994.
18. George Segal, in a symposium discussion held in conjunction with *Precedings,* a retrospective of works by Kaprow, Center for Research in Contemporary Art, University of Texas at Arlington, April 16, 1988.
19. Kaprow, conversation with the author, Encinitas, California, October 1994.
20. Ibid.
21. Ibid.

chapter three: *eighteen happenings in six parts*

1. Fairfield Porter, "Happenings," in *Fairfield Porter: Art in Its Own Terms: Selected Criticism, 1935–1975,* ed. Rackstraw Downes (Cambridge, Mass.: Zoland Books, 1979), 61–62.
2. All quotes in this chapter, unless otherwise attributed, are from Michael Kirby, *Happenings: An Illustrated Anthology* (New York: Dutton, 1965), 67–83.
3. Leslie angered Kaprow by painting a four-letter word on the canvas instead of abstract strokes; his ten-dollar donation was returned.
4. Allan Kaprow, conversation with the author, Encinitas, California, October 1994.

chapter four: happenings in the new york scene

1. Barbara Haskell, *Blam! The Explosion of Pop, Minimalism, and Performance,* exh. cat. (New York: W. W. Norton, 1984), 42.
2. Claes Oldenburg, quoted in ibid., 40.
3. Allan Kaprow, "'Happenings' in the New York Scene," *Art News* 60, no. 3 (1961); reprinted as "Happenings in the New York Scene," in Kaprow, *Essays on the Blurring of Art and Life,* ed. Jeff Kelley (Berkeley: University of California Press, 1993), 15–16.
4. Ibid., 16.
5. Allan Kaprow, conversation with the author, New York City, December 1994.
6. Darko Suvin, "Reflections on Happenings," in *Happenings and Other Acts,* ed. Mariellen R. Sandford (New York: Routledge, 1995), 301.
7. These are the first three words that appear in Kaprow's book *Assemblage, Environments and Happenings* (New York: Harry N. Abrams, 1966).
8. Allan Kaprow, conversation with the author, Encinitas, California, May 1995.
9. Kaprow, "Happenings in the New York Scene," 25–26.
10. Johan Huizinga, *Homo Ludens: A Study of the Play-Element in Culture* (Boston: Beacon, 1955); Erving Goffman, *The Presentation of Self in Everyday Life* (Garden City, N.Y.: Doubleday, 1959).
11. All quotes in this section are from Allan Kaprow's notes on *The Apple Shrine,* Allan Kaprow Papers, 1940–1997, Getty Research Institute, Research Library, Accession no. 980063.

12. See Michael Kirby, *Happenings: An Illustrated Anthology* (New York: Dutton, 1965), 94–104.
13. Allan Kaprow, conversation with the author, Encinitas, California, May 1995.
14. Ibid.
15. Allan Kaprow, "The Legacy of Jackson Pollock," in Kaprow, *Essays on the Blurring of Art and Life*, 7.
16. Allan Kaprow, notes on *A Service for the Dead*, Allan Kaprow Papers, 1940–1997, Getty Research Institute, Research Library, Accession no. 980063.
17. Allan Kaprow, conversation with the author, Encinitas, California, March 1996.
18. Paul Brach, conversation with the author, Reno, Nevada, 1981.
19. Allan Kaprow, conversation with the author, Encinitas, California, March 1996.
20. All quotes in the following description are from Allan Kaprow's notes on *Sweeping*, Allan Kaprow Papers, 1940–1997, Getty Research Institute, Research Library, Accession no. 980063.
21. Allan Kaprow, conversation with the author, Encinitas, California, March 1996.

chapter five: hoopla

1. Allan Kaprow, notes on *A Service for the Dead II*, Allan Kaprow Papers, 1940–1997, Getty Research Institute, Research Library, Accession no. 980063.
2. Allan Kaprow, conversation with the author, Encinitas, California, March 1996.
3. Allan Kaprow, notes on *Words*, Allan Kaprow Papers, 1940–1997, Getty Research Institute, Research Library, Accession no. 980063.
4. Allan Kaprow, Introduction, in *Words*, exh. cat. (New York: Smolin Gallery, 1962).
5. Allan Kaprow, notes on *Words*, Getty Research Institute.
6. Allan Kaprow, conversation with the author, Encinitas, California, March 1996.
7. Allan Kaprow, notes on *Chicken*, Allan Kaprow Papers, 1940–1997, Getty Research Institute, Research Library, Accession no. 980063.
8. Michael Kirby and Richard Schechner, "An Interview with John Cage," in *Happenings and Other Acts*, ed. Mariellen R. Sandford (New York: Routledge, 1995), 51–71.
9. Vincent Van Gogh, letter to his brother, Theo, September 8, 1888, in *Van Gogh in Arles*, exh. cat. (New York: Metropolitan Museum of Art; New York: Harry N. Abrams, 1984), 101.
10. Later that evening, after the reception in his honor, Hans Hofmann's wife passed away.
11. Allan Kaprow, notes on *Push and Pull*, Allan Kaprow Papers, 1940–1997, Getty Research Institute, Research Library, Accession no. 980063.

chapter six: on the road

1. "A Day in the Country," *Village Voice*, May 23, 1963.
2. All quotes in this section, unless otherwise attributed, are from Allan Kaprow's score for *Tree*.
3. Allan Kaprow, conversation with the author, Encinitas, California, May 1996.
4. Ibid.
5. All quotes in this section, unless otherwise attributed, are from Allan Kaprow's notes on *Out*, Allan Kaprow Papers, 1940–1997, Getty Research Institute, Research Library, Accession no. 980063.
6. Allan Kaprow, conversation with the author, Encinitas, California, May 1996.
7. Ibid.
8. Ibid.
9. All quotes in this section are from these notes, for a lecture intended for the broader student population but never delivered, Allan Kaprow Papers, 1940–1997, Getty Research Institute, Research Library, Accession no. 980063.
10. Allan Kaprow, conversation with the author, Encinitas, California, June 1996.
11. From Krauss's "Sculpture in the Expanded Field," *October*, no. 8 (spring 1979); reprinted in Krauss, *The Originality of the Avant-Garde and Other Modernist Myths* (Cambridge, Mass.: MIT Press, 1985).
12. Allan Kaprow, "Calling," in *Happenings and Other Acts*, ed. Mariellen R. Sandford (New York: Routledge, 1995), 200.
13. Allan Kaprow, conversation with the author, Encinitas, California, May 1996.

chapter seven: passing through

1. Allan Kaprow, "Experimental Art," *Art News* 65, no. 1 (1966); reprinted in Kaprow, *Essays on the Blurring of Art and Life,* ed. Jeff Kelley (Berkeley: University of California Press, 1992), 68–69.
2. Allan Kaprow, conversation with the author, Encinitas, California, May 1996.
3. To Kaprow's considerable consternation, Hyatt, who was directing from the boat, ordered it to be turned around and the nurses reassembled on the dock so that the scene could be reshot.
4. Allan Kaprow, conversation with the author, Encinitas, California, May 1996.
5. Allan Kaprow, notes for *Flick,* Allan Kaprow Papers, 1940–1997, Getty Research Institute, Research Library, Accession no. 980063.
6. Walter De Maria, "Meaningless Work," in *Esthetics Contemporary,* ed. Richard Kostelanetz (Buffalo, N.Y.: Prometheus Books, 1978), 242.
7. Ibid.
8. In this, one is reminded of the 1970 film adaptation of Aleksandr Solzhenitsyn's 1962 novel *One Day in the Life of Ivan Denisovich,* in which Denisovich, a prisoner in a Siberian gulag, takes personal pride in whether the bricks he's being forced to lay for some anonymous frontier building are true and plumb, which he does under freezing, dehumanizing conditions *as a way of making it meaningful.*
9. Allan Kaprow, conversation with the author, Encinitas, California, May 1996.
10. David Antin, conversation with the author, Arlington, Texas, April 1988.
11. Many of these Happenings were documented in 1970 in a newsprint calendar commissioned by the Junior Arts Council of the Museum of Modern Art, New York. It was called "Days Off," and, besides punning on the idea of tearing the days off a calendar one by one, the title may also have signified what Kaprow secretly longed for at that time—a vacation.
12. Allan Kaprow, notes on *Runner,* Allan Kaprow Papers, 1940–1997, Getty Research Institute, Research Library, Accession no. 980063. Kaprow writes that these three levels of meaning are generally applicable to his works of this period.
13. Allan Kaprow, conversation with the author, Encinitas, California, May 1996.
14. It was only when production of this book had begun, in June 2000, that he became aware of Fred McDarrah's pictures of the actual performance—images of the audience waiting in the rooms, conversing with one another, or observing Robert Whitman and Lucas Samaras playing blocks at the small table.
15. Allan Kaprow, conversation with the author, Encinitas, California, January 1997.
16. Also noticing the reference to Courbet, art historian Judith Rodenbeck makes an insightful connection in Kaprow's works—in *Record II* in particular—between photography, as visual copies (or "records") of an action, and the copying, or repetitions of lifelike actions, already and everywhere going on in Kaprow's events. Indeed, one of Kaprow's senses of the title of this work was as the verb "to record." See Judith F. Rodenbeck, "Foil: Allan Kaprow before Photography," in *Experiments in the Everyday: Allan Kaprow and Robert Watts, Events, Objects, Documents,* exh. cat. (New York: Columbia University, Miriam and Ira D. Wallach Art Gallery, 1999), 61.

chapter eight: the education of the un-artist, I

1. If Brecht was something of a mentor to Kaprow, French artist Robert Filliou was more like a brother. Filliou's sense of the "genial creation"—he would often show friends small objects he made and kept in his hat—reinforced Kaprow's own cordiality and playfulness. Eccentric, philosophical, nearly childlike, Filliou, who was trained as an economist, conveyed through his objects, actions, films, plays, and little demonstrations a provocative but generous humor with which Kaprow felt a kinship in spirit. Together with Brecht, Filliou had the effect of establishing a polar field of attitudes ranging from the laconic to the whimsical in which Kaprow could better get his own attitudinal bearings.
2. Allan Kaprow, conversation with the author, Encinitas, California, May 1998.
3. Ibid.
4. Kaprow believes the program was accepted by the district largely because its superintendent had already decided to take another job and could thereby wash his hands of it if it failed but still take credit for it if it succeeded. (Ibid.)

5. Thomas Albright, "What Would Happen If . . . ?" *San Francisco Chronicle,* May 18, 1969, 37–38.

6. Ibid.

7. Allan Kaprow, conversation with the author, Encinitas, California, June 1998.

8. Kaprow's view that the vanguard arts might have some liberating effect on the tedium of American education did not begin with Project Other Ways. During the Kennedy administration, he had served on a presidential commission on arts education with Robert Motherwell and George Segal, among others. The commission was part of the general reappraisal of American education that followed the launch of *Sputnik.* The commission recommended the implementation of what later became the Artist-in-the-Schools program, which was sponsored by the National Endowment for the Arts.

9. Allan Kaprow, conversation with the author, Encinitas, California, June 1998.

10. Allan Kaprow, quoted in Albright, "What Would Happen If . . . ?," 38.

11. See Allan Kaprow, "The Legacy of Jackson Pollock" (1958), in Kaprow, *Essays on the Blurring of Art and Life,* ed. Jeff Kelley (Berkeley: University of California Press, 1993), 7.

12. The trustees were outraged when they discovered that Stein had been courting the German Marxist philosopher Herbert Marcuse, then living in La Jolla, for a teaching position.

13. For Brach, this may have been a necessary corrective given Disney's initial idea, visible in preliminary architectural drawings but later abandoned, that students ought to be on public display, viewable from mezzanine walkways as they worked in their studios below.

14. Allan Kaprow, notes on *Publicity,* Allan Kaprow Papers, 1940–1997, Getty Research Institute, Research Library, Accession no. 980063.

15. The Hollywood hallucination about the American experience of the "Old West" reached its peak in the 1960s and was about to be parodied by such revisionist films as *Little Big Man* (1970), with its Vietnam-era commentary about American imperialism and genocide, and Mel Brooks's irreverent *Blazing Saddles* (1974), which was filmed at Vasquez Rocks.

16. See Susan Sontag, "The Image World," in Sontag, *On Photography* (New York: Farrar, Straus and Giroux, 1977), 153–80.

17. Looking at a reflection of oneself is unlike looking at a painting or a movie, which are more critical and astute forms of perception. Rather, it's frozen in judgment and self-estimation; one is wary, cynical, cautious, and comparative in a way that almost begs a return to the world. Pictures of ourselves stop us in our tracks. They do so long enough to serve our narcissistic curiosity, but ultimately too long, because, while pictures hold us in suspension, life moves on. This we know instinctively, and so, when we see ourselves reflected in mirrors or television monitors, we pause momentarily and then snap out of it, getting back to work.

18. Vasquez Rocks was named for an infamous nineteenth-century bandit, Tiburcio Vasquez, who terrorized Southern California—Los Angeles County in particular—in the decades following the Civil War. On several occasions, while he was being hunted by posses of lawmen, he and his *compadres* disappeared into the gnarled and twisted spires of what is now Vasquez Rocks, where they always managed to hide out, successfully eluding authorities. Kaprow was well aware that behind the rocks' Hollywood renown lay a history of marauding bandits, horse thievery, and waylaid wagons.

19. Allan Kaprow, conversation with the author, Encinitas, California, October 1997.

20. Lacy and Rahmani were Kaprow's students; Rush and Wilding were not.

21. Allan Kaprow, conversation with the author, Encinitas, California, June 1998.

chapter nine: the education of the un-artist, II

1. Allan Kaprow, "The Education of the Un-Artist, Part II" (1972), in Kaprow, *Essays on the Blurring of Art and Life,* ed. Jeff Kelley (Berkeley: University of California Press, 1993), 112. In Part I, Kaprow speculates that if the "difficulty" artists faced in creating art after World War II had, by the late 1960s, been transposed to "an arena of collective uncertainty" about whether it was art at all, then perhaps we might see the imitation of imitating as a more worldly expression of the reflexive self-consciousness that had once been the hallmark of Modernist creativity ("The Education of the Un-Artist, Part I" [1971], in Kaprow, *Essays on the Blurring of Art and Life,* 98).

2. Kaprow, "The Education of the Un-Artist, Part II," 112.

3. Kaprow, "The Education of the Un-Artist, Part I," 104.

4. Ibid., 105.

5. Ibid., 108.

6. Ibid.

7. Clearly, instead of "phasing out," the arts since the late 1970s have more firmly entrenched themselves in American culture. Arguably, they have not so much merged with the "life fields" as carved out their own exclusive domains within society. It is perhaps in this trivial sense that art *has* merged with life, although not as the "un-artistic" practice of everyday meaning Kaprow was writing about. As we saw in the 1980s, the art "scene," once marginalized on the perimeters of the avant-garde, became a mainstream social spectacle in the context of an international market. The artist-as-man-of-the-world, referred to as such by Kaprow in a 1964 article of the same name ("Should the Artist Be a Man of the World?" *Art News* 63, no. 6 [1964]; reprinted as "The Artist as a Man of the World," in Kaprow, *Essays on the Blurring of Art and Life,* ed. Jeff Kelley [Berkeley: University of California Press, 1993]), developed twenty years later into the artist-as-art-star.

8. Jack Burnham positions Happenings in relation to the emerging paradigm: "In the past ten years Kaprow has moved the Happening from a rather self-conscious and stagy event to a strict and elegant procedure. [It] now has a sense of internal logic which was lacking before." Burnham, "Systems Esthetics," in *Esthetics Contemporary,* ed. Richard Kostelanetz (Buffalo, N.Y.: Prometheus Books, 1978), 170.

9. Allan Kaprow, conversation with the author, Oakland, California, March 1998.

10. Ibid.

11. Ibid.

12. Robert Smithson, "A Sedimentation of the Mind: Earth Projects," in *The Writings of Robert Smithson,* ed. Nancy Holt (New York: New York University Press, 1979), 88–89.

13. Ibid.

14. Kaprow, always on the lookout for a new kind of patronage, was hoping to convince Baecker—who was known for her interest in Happenings and Fluxus—to act as his agent in Europe.

15. The reigning artistic presence in Düsseldorf at that time was Beuys, and Kaprow was aware that *Meteorology* seemed gently to parody the German artist's activist "so-cial sculpture" in its apparent redemption of the poisoned Rhine with rainwater. Allan Kaprow, conversation with the author, Oakland, California, March 1998.

chapter ten: the education of the un-artist, III

1. Kaprow traced this distinction back to the "Days Off" calendar he did for the Museum of Modern Art in New York in 1970, in which pictures and the written scores of nine Happenings of the mid- to late 1960s (including *Fluids* and many of the street pieces from Project Other Ways) were printed on low-grade newsprint of the kind intended—as Kaprow intended his calendar—for quick legibility and equally quick disposal. "Days Off" was a somewhat perverse response on Kaprow's part to an invitation by the museum to produce a calendar of Happenings. One assumes that the museum expected a version of those calendars in which Impressionist paintings or Ansel Adams's photographs of Yosemite illustrate the twelve months, but Kaprow was determined that his works would not end up as kitschy images in museum bookstores. Thus, he subverted the idea of a glossy kitchen-art calendar by producing—in consultation with museum officials—thirty thousand rolled-up newsprint chronologies (from which the days could be torn off, one by one), with the various Happenings represented by low-resolution black-and-white photographs and greatly simplified texts. The museum hated them, demanding that Kaprow take them back, which he did, thereafter spending the better part of a decade pawning them off on museum bookstores around the country to either sell or give away.

2. Allan Kaprow, conversation with the author, La Jolla, California, May 1993.

3. Allan Kaprow, conversation with the author, Encinitas, California, January 1998; Paul Brach, conversation with the author, Reno, Nevada, 1981. This apocryphal story is told often, in one version or another, by both Kaprow and Brach.

4. Allan Kaprow, conversation with the author, Encinitas, California, January 1998.

5. Allan Kaprow, "The Artist as a Man of the World" (1964), in Kaprow, *Essays on the Blurring of Art and Life,* ed. Jeff Kelley (Berkeley: University of California Press, 1993), 58.

6. Allan Kaprow, "Video Art: Old Wine, New Bottle" (1974), in Kaprow, *Essays on the Blurring of Art and Life,* 152–53.

7. Allan Kaprow, "how-to" booklet for *Time Pieces* (1973).

8. This was related to the author by a performance-art critic, Arlington, Texas, April 1988.

9. In this, Kaprow's works of this period echoed the performances of such artists as Eleanor Antin, who sculpted her body by going on a prolonged diet, and, a bit later, Martha Rosler, whose *Vital Statistics of a Citizen, Simply Obtained* (1977) suggests the very index of a socially constructed self.

10. *Webster's New Twentieth Century Dictionary of the English Language,* unabridged, 2nd ed. (New York: Simon and Schuster, 1983).

11. The plan is reductive: It isn't clear, for example, that the imagined greetings and goodbyes videotaped by A pertain to A's fantasies of some business A and B have already had together (which is why they are meeting in the first place). It also isn't clear that B arrives (late) in A's apartment, knowing that the video camera is feeding his or her image to a monitor being watched by A in an adjacent room, so that B's "greeting" (or excuse for being late) is consciously offered to A through the video equipment.

12. Leo Steinberg, "The Flatbed Picture Plane," in Steinberg, *Other Criteria: Confrontations with Twentieth-Century Art* (New York: Oxford University Press, 1972), 82.

13. All quotes in this section, unless otherwise attributed, are from Allan Kaprow's notes on *3rd Routine,* Allan Kaprow Papers, 1940–1997, Getty Research Institute, Research Library, Accession no. 980063.

14. Allan Kaprow, conversation with the author, Encinitas, California, January 1998.

15. All quotes in this section, unless otherwise attributed, are from Allan Kaprow's notes on *Rates of Exchange,* Allan Kaprow Papers, 1940–1997, Getty Research Institute, Research Library, Accession no. 980063.

16. David Antin, in conversation with the author, once said that Kaprow is like a Martian who has just landed on Earth and is busy studying the languages and metalanguages of human social communication.

17. Actually, its comedy was hard to exaggerate, since the sight of one person walking uphill behind another, copying every uncertain step forward or arch in the back, is inevitably Chaplinesque.

chapter eleven: zen

1. George Leonard, *Into the Light of Things* (Chicago: University of Chicago Press, 1994), 150.

2. Ibid.

3. Ibid., 151.

4. John Dewey, *Art as Experience* (1934; New York: Perigee, 1980), 5.

5. Leonard, *Into the Light of Things,* 151.

6. Allan Kaprow, "The Legacy of Jackson Pollock" (1958), in Kaprow, *Essays on the Blurring of Art and Life,* ed. Jeff Kelley (Berkeley: University of California Press, 1993), 7.

7. Allan Kaprow, conversation with the author, Encinitas, California, October 2001.

8. Allan Kaprow, conversation with the author, Encinitas, California, January 1998.

9. Allan Kaprow, conversation with the author, Oakland, California, March 1998.

10. Leonard, *Into the Light of Things,* 151.

11. Allan Kaprow, letter to Petra Kipphoff, January 18, 1981, Allan Kaprow Papers, 1940–1997, Getty Research Institute, Research Library, Accession no. 980063.

12. Allan Kaprow, "Happenings in the New York Scene" (1961), in Kaprow, *Essays on the Blurring of Art and Life,* 26.

chapter twelve: storytelling

1. Allan Kaprow, letter to Petra Kipphoff, January 18, 1981, Allan Kaprow Papers, 1940–1997, Getty Research Institute, Research Library, Accession no. 980063.

2. The original stories appear in the exhibition catalogue *Allan Kaprow: Collagen, Environments, Videos, Broschüren, Geschichten, Happening- und Activity-Dokumente 1956–1986* (Dortmund, Germany: Museum am Ostwall, 1986), unpaginated.

3. The preceding description of *Trading Dirt* is from a videotaped story told by Kaprow on April 14, 1988, on the occasion of *Precedings,* Center for Research in Contemporary Art, University of Texas at Arlington.

chapter thirteen: rehearsals

1. The gathering included David Antin, Franticek Deak, Michael Kirby, Suzanne Lacy, Lucy Lippard, Claes Ol-

denburg, Jim Pomeroy, Moira Roth, Richard Schechner, George Segal, Ingrid Sischy, and Barbara Smith, among others, many of whom participated in reinventions enacted during the week.

2. Author's notes, University of Texas at Arlington, April 16, 1988.

3. Kirby's assessment of Kaprow's retrospective as ironic was blinded by the emotional vividness of his own retrospection. Without intending to, the man who had written the book on Happenings (in 1966) now embodied the central premise of *Precedings,* which was that remembering is the present-tense enactment of the object of one's memory.

4. Allan Kaprow, *Assemblages, Environments and Happenings* (New York: Harry N. Abrams, 1966), 155.

5. The phrase is from Kaprow's "The Legacy of Jackson Pollock" (1958), in Kaprow, *Essays on the Blurring of Art and Life,* ed. Jeff Kelley (Berkeley: University of California Press, 1993), 9.

6. Ibid.

7. Allan Kaprow, "Right Living" (1987), in Kaprow, *Essays on the Blurring of Art and Life,* 225.

8. Yoko Ono, conversation with the author, Santa Barbara, California, September 10, 1994.

9. Allan Kaprow, notes on *The Apple Shrine,* Allan Kaprow Papers, 1940–1997, Getty Research Institute, Research Library, Accession no. 980063. Kaprow refers here to the tale of Adam and Eve in the Garden of Eden as it is embodied in the environment's offering of real and fake apples to its audience.

illustrations

index

SPONSORING EDITOR: DEBORAH KIRSHMAN

ASSISTANT ACQUISITIONS EDITOR: ERIN MARIETTA

PROJECT EDITOR: SUE HEINEMANN

EDITORIAL ASSISTANT: LYNN MEINHARDT

COPYEDITOR: JENNIFER KNOX WHITE

INDEXER: RUTH ELWELL

DESIGNER: NOLA BURGER

PRODUCTION COORDINATOR: JOHN CRONIN

TEXT: 8/13.5 CAECILIA

DISPLAY: AKZIDENZ GROTESK CONDENSED

COMPOSITOR: INTEGRATED COMPOSITION SYSTEMS

PRINTER AND BINDER: FRIESENS CORPORATION